# In the American Grain

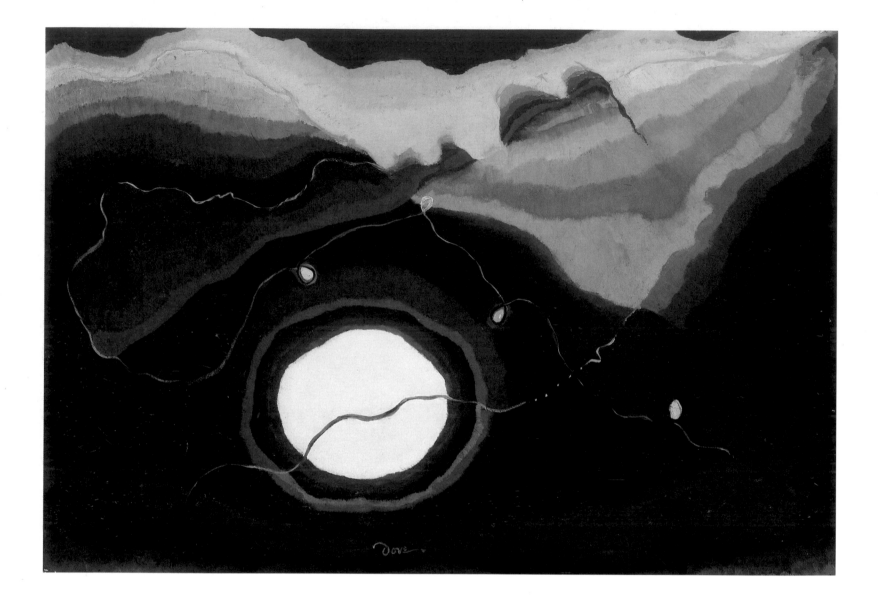

Arthur Dove, *Me and the Moon*, 1937, wax emulsion on canvas

# In the American Grain

*Arthur Dove, Marsden Hartley, John Marin, Georgia O'Keeffe, and Alfred Stieglitz*

THE STIEGLITZ CIRCLE AT THE PHILLIPS COLLECTION

Elizabeth Hutton Turner

COUNTERPOINT

WASHINGTON, D.C.

IN ASSOCIATION WITH THE PHILLIPS COLLECTION

**Library of Congress Cataloging-in-Publication Data**

Phillips Collection.
In the American grain: Arthur Dove, Marsden Hartley, John Marin, Georgia O'Keeffe,
and Alfred Stieglitz: the Stieglitz circle at the Phillips Collection / Elizabeth Hutton
Turner.
"In association with the Phillips Collection."
1. Stieglitz Group.     2. Painting, Modern—20th century—United States.
3. Stieglitz, Alfred, 1864–1946—Art patronage.     4. Painting—Washington (D.C.)
5. Phillips Collection.     I. Turner, Elizabeth Hutton, 1952– .     II. Title.
ND212.5.S75P55     1995
759.13'09'041074753—dc20            95-19585
ISBN 1-887178-01-5 (hc)    ISBN 1-887178-26-0 (pb) (alk. paper)

FIRST PRINTING

Front cover: Marsden Hartley, *Gardener's Gloves and Shears,* ca. 1937,
oil on canvas board
Back cover: Georgia O'Keeffe, *Pattern of Leaves,* ca. 1923, oil on canvas

Photography of works at The Phillips Collection by Edward Owen, Washington, D.C.
Photography of works at the Philadelphia Museum of Art by Lynn Rosenthal
Book design by Bruce Campbell
Composition by Wilsted & Taylor
Printed in the United States of America by Parker Polychrome, Princeton, N.J.,
on acid-free paper that meets the American National Standards
Institute Z39-48 Standard.
Binding by Horowitz/Rae, Fairfield, N.J.

COUNTERPOINT
P.O. Box 65793
Washington, D.C. 20035-5793

Distributed by Publishers Group West

*Who will recognize them? None but you. To the rest without
definition but to you each a thing in itself, delicate, pregnant
with sudden meanings.*

William Carlos Williams
IN THE AMERICAN GRAIN

## ACKNOWLEDGMENTS

*The exhibition and its international tour are sponsored by the John S. and James L. Knight Foundation, Sotheby's, and the National Endowment for the Arts.*

This book builds on the efforts of the research office at The Phillips Collection, whose careful organization and study of Duncan Phillips's manuscripts and papers made it possible to analyze the early history of the Collection. I owe a special debt of thanks to Leigh Bullard Weisblat, Assistant Curator for Research, for her expertise and tireless assistance throughout this project.

In addition, I would like to thank the entire staff of The Phillips Collection for adopting this project with enthusiasm and hard work. It is a pleasure to offer heartfelt thanks to those who have helped in special ways: Pamela Steele, Director of Visual Resources and Associate Registrar; Karen Schneider, Librarian; Elizabeth Steele, Associate Conservator; Rocio Prieto, Conservation Intern; Penelope Saffer, Director of External Affairs; Cathy Card Sterling, Director of Corporate and Foundation Relations; Karen Porterfield, Development Associate; Kristin Krathwohl, Director of Public Affairs; Andrea Barnes, Director of Membership and Programing; Interns Elizabeth Marx, Andrea Briere, Kimberly Hamlin, and Erica Niemeyer; as well as Donna McKee, Director of Education; Suzanne Wright, Assistant Education Director; Lisa Portnoy, Education Assistant; Katherine Rothkopf, Assistant Curator; Valerie Guffey-Defay, Assistant to the Director; Stephen Phillips, Assistant Curator for Administrative Affairs; Joseph Holbach, Registrar; Shelly Wischhusen, Chief Preparator; Bill Koberg, Installations Manager; and Jim Whitelaw, Preparator. Special thanks go to photographer Ed Owen, who provided the high-quality transparencies of the works for this catalogue.

The success of this project has depended upon the generous help and cooperation of many people and institutions. The Phillips Collection is immensely grateful for the sponsorship of the National Endowment for the Arts, the John S. and James L. Knight Foundation, and Sotheby's. I am also deeply indebted to those willing to loan their significant works to our exhibition. I especially want to thank Katharine Graham, Elizabeth B. Heffernan, Edward J. Lenkin and Katherine Meier, Dorothy Norman, and Harry Turner for their generosity and cooperation. I am also very grateful to Kevin Grogan, Director of The University Galleries, Fisk University; Philippe de Montebello,

Director, and Maria Morris Hambourg, Curator in Charge, Department of Photographs, at the Metropolitan Museum of Art; and Anne d'Harnoncourt, Director, and Martha Chahroudi, Associate Curator of Photographs, at the Philadelphia Museum of Art.

Neither this book nor the exhibition could have come into being without the generous help and cooperation of scholars, archivists, librarians, and editors. I am grateful to Donald Gallup and Patricia C. Willis at the Beinecke Rare Book and Manuscript Library, Yale University; Elizabeth Glassman, Juan Hamilton, and Judy Lopez of The Georgia O'Keeffe Foundation; Sarah Greenough, Curator of Photography, Sarah Sibbald, Museum Technician, and Christian Carr, Staff Assistant, at the National Gallery of Art; Caroline Demaree, Permissions Assistant, Nancy S. Quaile, Associate Registrar, and Laura Steward, Curatorial Intern, at the Philadelphia Museum of Art; Eileen Sullivan, Senior Library Assistant, Photographs and Slide Library, and Laura Muir, Research Assistant, at The Metropolitan Museum of Art; and Helen Shannon, Smithsonian Fellow at the National Museum of African Art. I am very grateful for the guidance provided by Frank H. Pearl, Jack Shoemaker, and the staff at Counterpoint. I am especially indebted to Carole McCurdy for her careful reading and editing of this manuscript and for her supervision of the production of this book. A special word of thanks is also due to Bruce Campbell Design and David Johnson and Joseph Crilley of Parker Polychrome.

Finally, I would like to thank Charles Moffett, Director; Eliza Rathbone, Chief Curator; and Laughlin Phillips, President of the Board of Directors of The Phillips Collection, for their unfailing support throughout this project.

Elizabeth Hutton Turner
*Curator*

## EXHIBITION ITINERARY

*The Phillips Collection,* September 23–December 31, 1995
*Seattle Art Museum,* February 8–May 5, 1996
*Museum of Modern Art,* Saitama, Japan, June 8–July 14, 1996
*Fukushima Prefectural Museum of Art,* Japan, July 20–August 18, 1996
*Chiba Municipal Museum of Art,* Japan, August 24–September 23, 1996
*Portland Art Museum,* October 1996–January 1997

# Contents

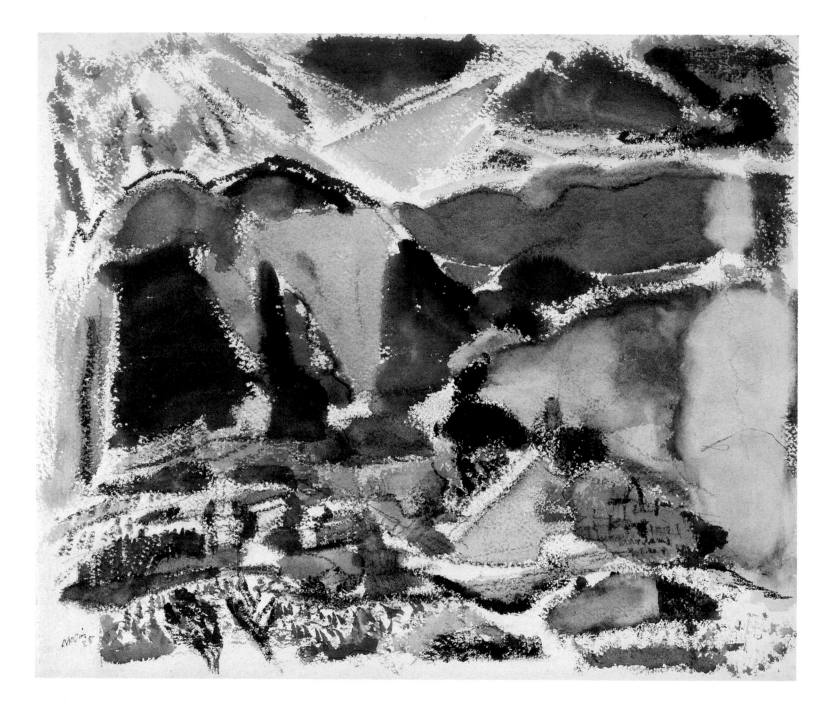

John Marin, *Back of Bear Mountain,* 1925, watercolor and charcoal on paper

# The Stieglitz Circle at The Phillips Collection

ELIZABETH HUTTON TURNER

## ALFRED STIEGLITZ: "A HEART THAT FIGHTS THE WORLD"

In December 1925 Alfred Stieglitz opened his Intimate Gallery. Like a seasoned commander assuming the bridge, he was, as he told his friends, back "on deck."[1] The new gallery occupied only one room in the northwest corner of the Anderson Galleries building on Park Avenue at Fifty-ninth Street. Stieglitz referred to it alternately as "the Room" or "Room 303." Its scale and simplicity carried the hallmarks of Stieglitz's lifelong stance against American materialism and commercialism.

Underscoring the significance of the opening was the coincidence that 1925 marked the twentieth anniversary of the founding of his first gallery, the Little Galleries of the Photo-Secession at 291 Fifth Avenue. From 1905 to 1917 this gallery, known simply as 291, had planted the seeds of modernism now flourishing on the booming American art market of the 1920s. It had been a modest suite of three rooms, with burlap-covered walls suitable for prints, on the attic floor of a brownstone. From the street it promised almost nothing—no advertising except a small notice with the 291 insignia near the door. No invitations were needed. No records of accounts were kept. By way of explanation to a reviewer in 1908, Stieglitz boasted that 291 was "the only free place" on Fifth Avenue.[2]

Stieglitz was perhaps America's best-known photographer when he and his young colleague Edward Steichen established 291. He called 291 the "headquarters" in the "fight for photography."[3] But he was not the only commander on the field. What distinguished Stieglitz's campaign from the others' was his alliance of photography with the modern artist's struggle for personal expression. With Steichen serving as its agent in Paris, 291 became a "storm center" for revolt, attracting all that was new in art at home and abroad.[4] Between 1905 and 1915, the gallery introduced Auguste Rodin, Henri Matisse, Pablo Picasso, and Paul Cézanne to New York, while Stieglitz's magazine *Camera Work* became the first in America to translate and publish Wassily Kandinsky's writings on abstraction.

The impact of Rodin's seemingly senseless scribbles and Matisse's blots of color shook the foundations of the established art world in America. Many found the new works unreadable. Critics derided them as "subterhuman [*sic*] hideousness" and "impossible travesties." Their "slight . . . workmanship" threatened to eradicate traditional notions of skill, quality, and merit, replacing them with self-definition, irratio-

1. Stieglitz to Dove, Feb. 21, 1924, quoted in Ann Lee Morgan, ed., *Dear Stieglitz, Dear Dove* (Newark, 1988), 101.

2. "Alfred Stieglitz, Artist, and His Search for the Human Soul," *New York Herald,* Mar. 8, 1908, pt. 3, p. 5, quoted in Edward Abrahams, *The Lyrical Left: Randolph Bourne, Alfred Stieglitz and the Origins of Cultural Radicalism in America* (Charlottesville, Va., 1988), 134. To anarchist writer Emma Goldman, Stieglitz boasted that "to keep the place absolutely free," he kept at 291 "no books, or records of any kind"; Stieglitz to Goldman, Jan. 6, 1915, Yale Collection of American Literature, Beinecke Rare Book and Manuscript Library, Yale University, New Haven, Connecticut (cited as YCAL), quoted in Abrahams, *The Lyrical Left,* 134.

3. Quoted in Abrahams, *The Lyrical Left,* 113.

4. Stieglitz to Marsden Hartley, Mar. 3, 1913, YCAL, quoted in Bram Dijkstra, *Cubism, Stieglitz, and the Early Poetry of William Carlos Williams* (Princeton, N.J., 1978), 15.

nality, and anarchy. On the other side stood Stieglitz, celebrating what he called "fresh experience, freshly seen and communicated."[5] As if to ensure that the debate might be fully joined, Stieglitz preserved and reprinted some of the harshly reactionary reviews in *Camera Work*.

Agnes Meyer, a reporter for *The New York Sun,* was among the first on the scene. She convinced her editor that curious people with curious ideas about photography and art made good copy. She arrived at 291 to find a slightly built man with beetled eyebrows, and left six hours later firmly convinced of the merits of Stieglitz's struggle against academic smugness. Believing that Stieglitz's attic gallery represented not only the future of photography and painting but her own liberation in modern society, Meyer often returned to find "the free air" she craved.[6]

Assisted by a growing band of writers, poets, anarchists, and painters, 291's campaign grew to stand "against customs, traditions, superstitions" that impeded the true artist's vision.[7] For a time it seemed that Stieglitz moved on all fronts at home and abroad, and that he and his cohorts would accept no standards, no values, no customs outside their own choosing. Their willingness to mock "autocracy of convention" and revitalize art seemingly knew no limits: the scene was set by Gertrude Stein's word portraits, Marius de Zayas's caricatures, Francis Picabia's New York drawings, feminism, children's paintings, Freudian dream sequences, African art, a fake Cézanne, a urinal signed R. Mutt.[8]

Where was all this leading? Paul Haviland, who paid the lease on 291, said that he believed he was participating in a movement to change the whole world. Yet no one could say exactly what lay beyond the breach with tradition. Writing Stieglitz from Paris in 1913, Steichen seemed on the verge of naming it: "One is conscious of unrest and seeking—a weird world hunger for something we evidently haven't got and don't understand. . . . I have a vague feeling of knowing it and yet it looses [*sic*] itself in its vagueness. Something is being born or is going to be."[9] This new world suggested itself in odd conjunctions and juxtapositions. In the pages of *Camera Work,* Benjamin Casseres proclaimed Whitman the father of the futurists, while on the walls of 291 a Kota reliquary figure hung between a giant wasp's nest and a Picasso assemblage.

Would the revolutionary 291 become the center for a worldwide movement? As artistic activity in Europe ceased with the start of the war, Marius de Zayas urged Stieglitz to act decisively, to consolidate support among the wealthy intelligentsia at home, and to maintain the commerce of ideas abroad. But Stieglitz made no firm alliances with futurists, fauvists, cubists, dadaists or any of the multifaceted movements frequenting 291. In 1913 he actually distanced himself from what he called the "circus" of the widely publicized and immensely popular European section at the Armory Show, choosing instead to exhibit his own photographs.[10] By 1915, with the audience for European modernism in America growing and the field of modern galleries ever widening, Stieglitz actually loosened the reins, ceased regular publication of *Camera Work,*

5. "J. E. Chamberlain in the *N.Y. Mail,*" *Camera Work,* no. 30 (Apr. 1910), 51; "Arthur Hoeber in the *N.Y. Globe,*" *Camera Work,* no. 38 (Apr. 1912), 45; and "Drawings by Matisse," *Bulletin of the Metropolitan Museum of Art* 5 (May 1910), 126, quoted in Abrahams, *The Lyrical Left,* 154 and 155. Phrase from Stieglitz in Dorothy Norman, *Alfred Stieglitz: Portrait of an American Seer* (New York, 1960), 25, quoted in Dijkstra, *Cubism, Stieglitz, and the Early Poetry of William Carlos Williams,* 96.

6. Agnes E. Meyer in her autobiography, *Out of These Roots* (Boston, 1953), 68, quoted in William Innes Homer, *Alfred Stieglitz and the American Avant-Garde* (Boston, 1977), 55.

7. Stieglitz to Selma Schubart, Oct. 4, 1909, YCAL, quoted in ibid., 67.

8. *Camera Work,* no. 18 (Apr. 1907), 37, quoted in ibid., 42.

9. Edward Steichen to Stieglitz, Nov. 1913, YCAL, quoted in Abrahams, *The Lyrical Left,* 1–2.

10. Quoted in ibid., 171.

Alfred Stieglitz, *Picasso-Braque Exhibition at 291*, 1914–15, gelatin silver print, Philadelphia Museum of Art, from the Collection of Dorothy Norman

and left de Zayas and Meyer at the helm of a smaller, more radical publication called *291* and a separate Modern Gallery to garner commercial support for avant-garde art.

Much to the dismay of his supporters, Stieglitz refused to build on his success with the European avant-garde. De Zayas criticized such seeming lethargy. In *291*, he caricatured Stieglitz as a broken camera and Haviland as a cordless lamp. More specifically, the dissatisfied disciple chastised his mentor for not being as bold as his European counterparts, whose enthusiasm for mechanomorphic images of urban America abounded during the war years. De Zayas wrote admiringly that Picabia, like Cortés, came to America and "burned his ship behind him," and added disparagingly that Stieglitz "wanted to work this miracle" but failed.[11]

Did Stieglitz fail? Perhaps. From 1915 until 1917, when the war depleted his finances and 291 closed, his gallery was no longer at the forefront in exhibiting European art. Most installations at 291 consisted of idiosyncratic combinations from his storeroom, as well as new works by lesser-known Americans. The last issue of *Camera Work* featured objective close-ups by the young photographer Paul Strand, and the last exhibition at 291 featured watercolor abstractions by a young Texas schoolteacher, Georgia O'Keeffe. Stieglitz photographed "the last days of 291" as a shambles, with a warriorlike statue of Judith standing amid heaps of burlap and gauze, broken statuary, twigs, and piles of discarded issues of *Camera Work*. In the winter of 1917–18 Stieglitz paced the confines of a small, unheated room below his defunct gallery and compared himself to Napoleon retreating from Moscow. In his words, he "had nowhere else to go—no working-place, no club, no money."[12]

Did Stieglitz fail? Perhaps not. In retrospect Stieglitz would say, "What was *291* but a thinking of America?"[13] Stieglitz's agenda was separate from Europe. It was as if the drawings by Rodin and Matisse, the Constantin Brancusi sculpture and Picasso assemblages, were simply catalysts for a more radical objective. Stieglitz made it clear to his artists and to any collectors who darkened his door that he did not want simply to theorize or envision modern culture; he actually wanted to create it. He wanted to

11. Marius de Zayas in *291*, no. 5–6 (July–Aug. 1915), quoted in Jonathan Green, ed., *Camera Work: A Critical Anthology* (New York, 1973), 325 and 323.

12. Stieglitz in Dorothy Norman, *Alfred Stieglitz: An American Seer* (New York, 1973), 134, quoted in Homer, *Alfred Stieglitz and the American Avant-Garde*, 260.

13. Stieglitz, "Ten Stories," *Twice a Year*, V–VI (1940–41), 135–63, quoted in Dijkstra, *Cubism, Stieglitz, and the Early Poetry of William Carlos Williams*, 94.

create culture in an America where there was none—no cultural capital, no uniquely American expression, and no community of support for living American artists. To his fault and credit, instead of commandeering vast global forces, Stieglitz thought and acted locally.

As early as the summer of 1915 at Lake George, Stieglitz began looking back and taking stock. Reviewing his photogravures, he made a selection as a gift for Paul Haviland, who was then leaving New York to join the war in France. Among the inscriptions there was the message "To Haviland from Stieglitz—Seven Years of Combined Struggle—No Misunderstandings!—291."[14]

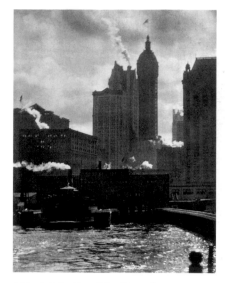

Alfred Stieglitz, *The City of Ambition,* 1910, photogravure, private collection, Washington, D.C.

Stieglitz selected several from his New York series for his departing friend. The sharp lines and hard contrasts of this series, which vividly demonstrated the strengths inherent in his medium, also underscored the fact that the America outside his doorstep was without precedent in the visual arts. The team of taxi horses standing at the station, the train moving across the railyard, and the towering skyscraper seen from the harbor convey the city as a vibrant, living creature whose steaming breath billowed out in the streets and up against the sky.

Daunting, forever growing, tearing down, building up ever higher, Stieglitz's New York never failed his imagination. The inscription to Haviland on *City of Ambition* read, "Does it tower into the skies? Beyond them?" Stieglitz urged American modernists to adopt the photographer's struggle, to seize salient forms from objective reality—just as the pages of *Camera Work* had suggested by juxtaposing Picasso's cubist drawing and the angular configuration of decks in Stieglitz's photograph *Steerage.* In giving *Steerage* to Haviland, Stieglitz felt certain he was placing his most prized photograph in the hands of, as he wrote on the mat, "One who fully comprehends the significance of cooperation—Friendship—Photography—291."

Though the war dispersed many of his associates, Stieglitz, like the ancient prophet Jeremiah, gathered the remnant of his artist flock. It comprised only four—Arthur Dove, Marsden Hartley, John Marin, and Georgia O'Keeffe. They had come to 291 in their youth and had renounced outmoded conventions. Exposed to the revolutionary artworks shown at 291 and discussed in *Camera Work,* they became convinced of the independence of color and form from naturalistic representation. By 1915, each was to some degree influenced by Kandinsky's theory that purely abstract forms could communicate feelings and ideas. Stieglitz had proudly exhibited their early discoveries. Out of the new conditions and constraints of the times, Hartley's dark mountains (1909), Dove's leaf abstractions (1910), Marin's series of the Woolworth Building (1913), and O'Keeffe's Texas watercolors (1917) had expressed something unique, without a hint of compromise or smug repetition.

It was as though Stieglitz's photography, by example, encouraged the artists around him, giving them the confidence to redefine the parameters of American art. Their disparate methods convey their intense awareness of the formal problems as well

14. This and other inscriptions to Haviland are found on the mats of the photogravures.

12

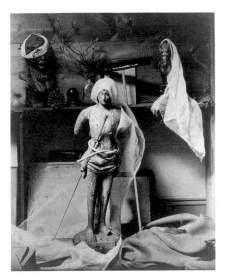

Alfred Stieglitz, *The Last Days of 291*, 1917, gelatin silver print, Philadelphia Museum of Art, from the Collection of Dorothy Norman

as the technical possibilities of their respective media. Stieglitz immediately responded to the brooding intensity of Hartley's thatched strokes of color and his strong identification with form. The spontaneity of Marin's watercolors shared close kinship with the immediacy of Stieglitz's photographs. O'Keeffe's stark simplicity and intense color very deliberately set her apart from—or, as Stieglitz would say, out in front of—the men. More so than the others, Dove needed and embraced the matter and texture of real objects in order to shape his most radical abstractions.[15]

Stieglitz and his artists shared an aesthetic impulse—what poet William Carlos Williams called a desire for contact—that led them to work from experience in nature. They believed that truth resided in even the smallest details. They wrote of themselves in a Whitmanesque manner, invoking mentors from the American past such as Ralph Waldo Emerson, Henry David Thoreau, and Albert Pinkham Ryder. Being *of the earth* came to measure authenticity for them. O'Keeffe once contrasted Marin and Dove: "Dove is the only American painter who is of the earth. . . . Where I come from the earth means everything. Life depends on it. You pick it up and feel it in your hands. . . . Marin is not of the earth. He walks over the earth, but Dove is of it."[16] Though after the war Stieglitz's artists were dispersed across the country from New York to Maine and as far west as New Mexico, evidence of their most current discoveries could be found at his final two galleries, The Intimate Gallery and An American Place. With Stieglitz presiding, these galleries remained the center of the circle, a constant amid the artists' ever-changing and sometimes precarious circumstances.

Stieglitz called these artists "my babies."[17] To any and all who would listen he recounted the circumstances of their development—how Dove's father had disinherited him and how he struggled to survive; how Marin renounced his lucrative etchings for modern expression in Paris; how, sometimes regrettably, Hartley was prone to wander through Europe for subjects; how O'Keeffe had once asked him for a break from teaching to paint for a year and had stayed on to continue her work. These were artists abandoned by kith and kin, and he, Stieglitz, had fostered their work, showing and storing it, providing it a home. He spoke of how he tired of carrying the "placenta," as though he stood ready to deliver them into the world.[18]

Stieglitz continued his fierce nurturance in a series of well-orchestrated exhibitions, culminating with the opening of his Intimate Gallery in 1925 and An American Place gallery in 1929. By this period Stieglitz was no longer the nexus of *all* that was new in New York, though he insisted that the revolution of 291 lived on in his later exhibitions. By continuing to present Dove, Hartley, Marin, and O'Keeffe, he would question the success of European art, which now represented to him the commercialism and conventionalism he had always abhorred. Not being a dealer, Stieglitz saw himself as more of a matchmaker, facilitating the transaction between the likely couple of artist and patron. Whether Americans, with their money and modern pretensions, would recognize and sustain their own living artists was a matter to be tested and

15. For a thorough discussion of the importance of the object to Stieglitz and his followers, see Dijkstra, *Cubism, Stieglitz, and the Early Poetry of William Carlos Williams,* 145–60.

16. O'Keeffe, as quoted in Barbara Haskell, *Arthur Dove* (San Francisco Museum of Art, 1974), 118.

17. Stieglitz to Phillips, Feb. 1, 1926. Unless otherwise noted, all letters cited are in The Phillips Collection Archives.

18. Stieglitz to Sherwood Anderson, Dec. 7, 1924, YCAL.

proven. Who would or could measure up? Stieglitz's agora was reopened to receive all comers, to dispute their misconceptions, and to strip away their tired conventions. Stieglitz never gave up waiting for someone like himself to adopt and shepherd the chosen remnant of 291's revolution. At stake was not only the affirmation of four artists, but a hand in creating culture in America. It was his last and longest struggle. Ever vigilant, ever faithful to the end, he wrote from his post in 1943: "Here I am, virtually alone, with the walls bare white, but marvelously beautiful, so extraordinarily human —untouched—and I dread the moment when I will have to drive a nail into them. And this because the new Marins, which I haven't seen but which I feel must have some extraordinarily wonderful pictures amongst them, need to be put up and the people given a chance to come and see, if they wish to. I will not move a finger for publicity— I haven't for some years. I have neither the inclination nor the energy nor the money for such seeming necessities, in order to attract attention. Marin is Marin, O'Keeffe is O'Keeffe and Dove is Dove. And who I am at 80 years old, clearer than ever in my mind, with a body that has difficulty to keep up with it—with a heart that fights me, but a heart that fights the world."[19]

Ansel Adams, *Arthur Dove Exhibition, An American Place,* 1944, gelatin silver print, Philadelphia Museum of Art, from the Collection of Dorothy Norman

DUNCAN PHILLIPS: "PULLING AN OAR"

*"I feel that you will not only have to have a large group of Marins but undoubtedly groups of Doves and O'Keeffe, Hartley, not to speak of my own photographs, if you really want your gallery to reflect a growth of something which is typically American and not a reflection of France or Europe."*
Alfred Stieglitz to Duncan Phillips, December 11, 1926

Duncan Phillips, a Washingtonian and the second son of a retired Pittsburgh industrialist, and Alfred Stieglitz, the weathered avatar of modernism, met on the crossroads of aesthetics and finance, as all dealers and patrons do. Yet, peculiarly, in order for the exchange of art and money to take place between them, Phillips had to see Stieglitz as someone other than a dealer, and Stieglitz in turn had to see Phillips as someone other than a patron. Both seemed to accept this precondition of sale, as though America did not yet have a name for them or for what they were doing.

Phillips's Memorial Gallery and Stieglitz's Room 303 reflected highly idiosyncratic, somewhat autobiographical collections of art. The aesthetic sensibilities of the two men were formed early in the century during the Progressive Era. Like Stieglitz, Phillips retained the rather romantic conviction that modern art could affect the course of American society and culture, even as it had changed the direction of his

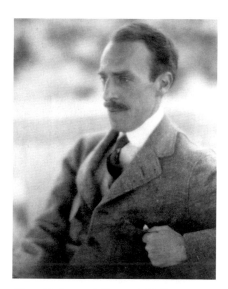

Clara E. Sipprel, *Duncan Phillips,* summer 1921, gelatin silver print, The Phillips Collection, Washington, D.C.

19. Stieglitz to Phillips, Oct. 15, 1943.

own life. For supporting Dove, Hartley, Marin, and O'Keeffe, Stieglitz thanked Phillips for "pulling an oar" in "The Cause."[1] Phillips in turn assured Stieglitz that the abiding presence of his artists in Washington would bolster claims for a new American art, one that was "sown in her own native soil."[2]

Both Phillips and Stieglitz had traveled great distances in their thinking about modernism in order to forge such an alliance. In 1913 Phillips and Stieglitz had been on opposites sides of the barricades at the revolutionary Armory Show. A neophyte collector and conservative critic, Phillips had railed against Matisse's "not only crude but deliberately false" patterns and thrown his support to an older generation of Americans represented by Arthur B. Davies and Maurice Prendergast, while Stieglitz cast his lot with the younger, less formed American modernists who were experimenting with line, shape, and color.[3]

For most of the decade of the 1910s, even after extensive discussions with artists and his considered reading of contemporary critics Clive Bell and Roger Fry, Phillips remained unconvinced about abstraction: to his way of thinking, it meant the loss of inspirational subject matter. In May 1917, a year prior to the announcement of his proposed modern museum, an incredulous Phillips recounted to a convention of the American Federation of the Arts how Davies had once given him a demonstration of abstraction by marking in chalk over one of his early drawings: "And Mr. Davies said in all seriousness that this skeleton of form contained all the aesthetic emotion suggested by the subject, but now the rhythm was released from all extraneous interest, from all sentimental irrelevance."[4]

By 1926, after eight years of collecting for his museum, Phillips had turned a new corner of acceptance. When he resigned from the AFA that year, he said simply, "I have changed my mind as to the proper attitude towards experimental work in painting and sculpture."[5] Signs of Phillips's widening scope could be found as early as November 1924, with the addition of the Little Gallery for contemporary exhibitions adjacent to his larger Main Gallery of Daumier, Chardin, Courbet, El Greco, and Renoir. By the 1925–26 season, Dove, Hartley, and O'Keeffe had arrived in the new space.[6] Starting with Dove's abstractions, as Phillips later recalled, he became attracted to work that was "strictly yet sensuously visual," absolutely free from anecdote or metaphor.[7] Phillips believed the Stieglitz circle harnessed revolutionary abstraction to poetic expression.

If Stieglitz interpreted Phillips's aesthetic awakening as nothing less than a "sudden conversion to red blood," then Phillips must have equally marveled at Stieglitz's seemingly sudden conversion to ethnic Americanism.[8] Sounding like the nativist critics of the Armory Show, Stieglitz in the 1920s pushed for "America without that damned French flavor."[9] Signs of change actually had come as early as 1915 when, finding a need to directly confront the facts of nature in his own work, Stieglitz had begun to turn away from the intellectualism dominating the European drive toward abstraction.

1. Stieglitz to Phillips, Feb. 8, 1926. Unless otherwise noted, all letters cited are in The Phillips Collection Archives.

2. Phillips, "Nationality in Pictures," *The Enchantment of Art* (New York, 1927), 70.

3. Phillips in "Revolutions and Reactions in Painting," in ibid., 1914 ed., 66. For the second edition of *The Enchantment of Art,* published in 1927, he revised this essay to reflect his new views toward abstraction and modern painting. He also drafted an introduction that apologized for his youthful and harsh reaction in the first edition to the 1913 Armory Show.

4. Phillips, "Fallacies of the New Dogmatism in Art," *The American Magazine of Art* 9, part 1 (Dec. 1917), 45.

5. Phillips to Leila Mechlin, American Federation of Arts, Mar. 26, 1926. The museum was incorporated in 1920, initially as the Phillips Memorial Art Gallery; it was originally conceived by Phillips in late 1918 as a memorial to his father and brother, both of whom had recently died.

6. Phillips had purchased a Hartley before 1921, probably in 1914; see Phillips, *Extracts From the Minutes of First Annual Meeting of Trustees of Phillips Memorial Art Gallery* (Washington, D.C., 1921), and "To the Editor," *The Art News* (Feb. 13, 1926), 7.

7. Phillips, "Arthur G. Dove, 1880–1946," *Magazine of Art* 40 (May 1947), 195.

8. Stieglitz to Phillips, Feb. 1, 1926; see also Phillips's previous letter to Stieglitz about his comment, Jan. 30, 1926, Yale Collection of American Literature, Beinecke Rare Book and Manuscript Library, Yale University, New Haven, Connecticut (cited as YCAL).

9. Stieglitz to Paul Rosenfeld, Sept. 5, 1923, YCAL.

Clara E. Sipprel, *Marjorie and Duncan Phillips in the Main Gallery,* ca. 1922, gelatin silver print, The Phillips Collection, Washington, D.C.

By 1917 the painters in his circle had turned away from symbolic abstractions and returned to some form of representation—what Dove called "the reality of the sensation."[10] Faced with the lack of an American visual tradition, yet fearing the dominance of Europe, they came to view abstraction as only a means to an end, a way to see a thing for itself and to affirm a uniquely personal expression. By 1919 writers in the Stieglitz circle advocated a return to native surroundings and local experience by invoking the paintings of Ryder and Winslow Homer and appropriating adages from the Transcendentalists. Waldo Frank's *Our America* (1919) intoned Whitman: "I will make the poems of materials, for I think they are to be the most spiritual poems."[11] That same year William Carlos Williams likewise admonished in *The Little Review,* "Take anything, the land at your feet, and use it."[12]

The quest to revitalize America's future expression through the rediscovery of spiritual kinship with past heroes placed Phillips and Stieglitz at last on the same side of the barricade. This probably was made clear to Phillips as early as Stieglitz's March 1925 exhibition called *Seven Americans,* even though they did not acknowledge each other until after the opening of Stieglitz's Intimate Gallery (Room 303) nearly nine months later. In January 1926 Duncan Phillips visited Stieglitz's gallery three times to see an exhibition of Arthur Dove, whose work recalled Albert Pinkham Ryder's *Moonlit Cove,* recently acquired by Phillips's museum. Phillips came away with three paintings: one by Dove, *Golden Storm,* and two by Georgia O'Keeffe, *My Shanty, Lake George* and *Leaf Motif No. 9.* He had also taken out an option to buy a second Dove entitled *Waterfall.* In the flurry of correspondence that finalized the arrangements for payment and shipping to Washington, Stieglitz wasted no time in staking out common ground, identifying and articulating the American theme that would unite them for the next twenty years.

Baiting his prose with Phillips's own words, Stieglitz wrote, "What naturally interested me most is your growing interest in the 'gallant experiments of the living American modernists.'"[13] In some twenty-three letters from January to December of

10. Dove, in catalogue of *The Forum Exhibition of American Art,* 1916, quoted in Sherrye Cohn, *Arthur Dove: Nature as Symbol* (Ann Arbor, 1985), 16.

11. Waldo Frank, *Our America* (New York, 1919), 71.

12. William Carlos Williams, "A Maker," *The Little Review* VI, no. 4 (Aug. 1919), 37–38, quoted in Dickran Tashjian, *William Carlos Williams and the American Scene, 1920–1940* (New York, 1978), 27.

13. Stieglitz to Phillips, Feb. 1, 1926.

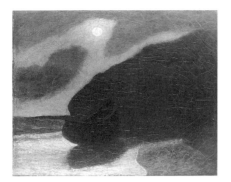

Albert Pinkham Ryder, *Moonlit Cove,*
early to mid-1880s, oil on canvas

1926, Stieglitz wrote earnestly and often about the freedom and well-being of his artists, and in so doing appealed to Phillips's sense of nationalism. "You see, I have a passion for America and I feel, and have always felt, that if I could not believe in the worker in this country, not in the imitator of what is European, but in the originator, in the American himself digging from within, pictures for me would have no significance."[14] On another occasion he wrote, "My great problem is to keep these workers alive. . . . To preserve their integrity—to keep them free."[15] Stieglitz's impassioned pleas read as though he had taken a page from Phillips's own case for the independent American artist written more than a decade earlier; Phillips's 1914 essay "Nationality in Pictures" advocated a new American art growing "out of the soil." Phillips also spoke of the urgent need "to record [our] own life," of a native sense of "beauty and truth."[16] He argued that such an art could not thrive in the presence of foreign influences and without opportunity and encouragement of free expression in America.

During the first heady year of exchanges, Stieglitz worked hard to win Phillips. Stieglitz spoke of his passion for Renoir, Daumier, and El Greco, indicating his understanding of Phillips's desire to see historical and contemporary works exhibited together. "I realised what had happened to you when you bought the Renoir and the Daumiers and pictures of that type. For these are certainly of red blood. . . . As for the abstract, I also know that anyone who really *sees* true pictures must also see the abstract."[17] Stieglitz rarely left New York, except to stay at Lake George, but he promised more than once to visit Washington and see Phillips's collection for himself. O'Keeffe's visit in March 1926, soon after Phillips had installed Dove's *Golden Storm* and *Waterfall,* seems to have sufficed. As recounted by Stieglitz, O'Keeffe's response verified Phillips's most fervent hope: that his museum should inspire American modernists, just as the Prado had once engaged Manet with the modern spirit of Goya, Velázquez, and El Greco. "O'Keeffe tells me how beautiful the two Doves look in your home. She returned from Washington full of rare enthusiasm. She thoroughly enjoyed every moment with you & Mrs. Phillips & the pictures—She tells every one worth while what a splendid work you are doing.—Your Courbets & Daumiers, the Renoir, & Greco she tells me about. Is full of them. She is painting & doing incredible work."[18]

For a brief time, and despite his irritation at never being alone with the paintings at Room 303, Phillips came to trust Stieglitz. In December 1926 Phillips wrote to thank Stieglitz for reading his new book, *A Collection in the Making:* "I am not surprised but deeply gratified that you are able with perfect sincerity to speak of it as highly as you do even though so much that is written about and illustrated is not at all up to your taste. You have a broad and kindly understanding and can recognize in it the rare sort of consecration which you have yourself to a Cause and a special mission."[19] Further evidence of Stieglitz's "broad and kindly understanding" arrived in Washington on the heels of this missive. Stieglitz's next letter reported, "I have been looking much at your book & every day it is discussed by people coming. Many criticize! I laugh & ask them

14. Ibid.
15. Stieglitz to Phillips, Oct. 20, 1926.
16. Phillips, "Nationality in Pictures" and "The Impressionistic Point of View," in *The Enchantment of Art,* 1914 ed., 74, 81, and 24.
17. Stieglitz to Phillips, Feb. 1, 1926.
18. Stieglitz to Phillips, Mar. 4, 1926.
19. Phillips to Stieglitz, Dec. 27, 1926.

what they find good. That flusters them. And then I point out many of the 'good' things & I ask them whether they wouldn't like to help them live—That thought seems to strike the fewest until pointed out to them.—Once more my congratulations."[20]

*A Collection in the Making* effectively chronicled the initial phase of Phillips's collecting history and announced the beginning of another phase with even greater ambition for quality and depth in contemporary art. No American museum had yet undertaken such a commitment to postwar American painting, certainly none in New York, since no museum of contemporary art yet existed. In this endeavor Phillips took a page out of Stieglitz's book. He began referring to his gallery alternately as an "Intimate Museum" or "Experiment Station."[21] His immediate plan for 1927 was to highlight his forthcoming acquisitions of John Marin, then Stieglitz's most prominent artist, in the Main Gallery alongside his new acquisitions of Bonnard and Matisse, thereby signaling the parity between currents in American and European modernism. His forthcoming exhibition of the permanent collection had as its main attraction an installation entitled "Simplicity and Simplification," qualities celebrated at Stieglitz's gallery.[22] He wanted this exhibition to be seen and reviewed by the critic Henry McBride, a longtime friend of Stieglitz. Support from Stieglitz was important at a time when Phillips hoped to raise the visibility and influence of his museum. At this moment Phillips believed he could count on the impresario of Room 303, but he hardly could have anticipated the cost of Stieglitz's enthusiasm.

Within a matter of weeks after December 1926, the plans of both men began to unravel. What went wrong? The short answer is that Phillips bought a work of art for too much money, and Stieglitz made a promise he never intended to keep. Explaining why this happened is a bit more complicated.

*The Six-Thousand-Dollar Marin*

The story begins with the Marin exhibition at Room 303 in the fall of 1926. Stieglitz placed a six-thousand-dollar price tag on *Back of Bear Mountain*.[23] With the possible exception of Sargent, no American watercolorist, living or dead, could have commanded such a price at that time. Obviously Stieglitz was not a businessman. Stieglitz spoke about "stipends" and "artist annuities" when money changed hands at his gallery. Time and again he reminded Phillips, "I am in no way a dealer."[24] But Stieglitz at times played that role, using the language of business as expediently as he used the language of cultural nationalism to suit his purposes. Stieglitz's strategy during the 1926–27 season was for his artists to have an impact on the art market comparable to the trade in European art. Perhaps by rearranging market values he could reorient cultural priorities, particularly America's long-standing prejudice against its own living artists.

Stieglitz placed the price of a masterpiece on the Marin and left it to his reviewers

20. Stieglitz to Phillips, Dec. 29, 1926.
21. See Phillips, "Welcome Art Experiments," *New York Herald Tribune*, Feb. 13, 1927, sec. 3, p. 7; his exhibition catalogue, *An Exhibition of Expressionistic Painters from the Experiment Station of the Phillips Memorial Gallery* (Washington, D.C., 1927); and Phillips's letter to Deoch Fulton, editor, *The Art News*, Mar. 22, 1927.
22. See Phillips's catalogue, *A Bulletin of the Phillips Collection Containing Catalogue and Notes of Interpretation Relating to a Tri-Unit Exhibition of Paintings and Sculpture* (Washington, D.C., 1927).
23. Equivalent to about fifty thousand dollars in 1995.
24. Stieglitz to Phillips, Feb. 1, 1926.

to frame a question that was tailor-made for Phillips to answer. "Is it unreasonable to hope that the country which had harbored Marin might even produce a permanent anchorage for his pictures?" asked Lewis Mumford. "What better nucleus could there be for a collection of American art, or what better pictures to present modern America alongside the fine achievements of the past?"[25] Certainly the purchase of *Back of Bear Mountain,* whose price approached the going rate for Daumier and Ryder, or for Matisse or Picasso for that matter, would test whether Phillips was willing to place his money with his new convictions about the arrival of American modernism at his museum.

Having lived with *Grey Sea* and *Maine Islands* in his gallery since spring, Phillips had already made up his mind about the quality of Marin prior to the fall exhibition at Room 303.[26] In November Stieglitz had already promised to send a dozen more Marins to Washington in the new year so that Phillips could have his own show. Stieglitz knew that if Phillips wanted *Back of Bear Mountain* badly enough, he could and would pay the record price; he had already paid a record price for Renoir's *The Luncheon of the Boating Party.* By the end of the day on December 2, after a two-hour conversation, Phillips bought the Marin. The only concession Phillips asked of Stieglitz was to not make his purchase public. Such publicity, in his opinion, harmed his museum, which operated with extremely limited capital. Much to the chagrin of most dealers, including Stieglitz, Phillips often bought and exhibited first and either paid or traded later. Yet four days after the purchase, in his great haste to have what he called "the big Marin" in Washington immediately, Phillips sent a telegram with a second request that clouded the issue. It read simply: "SAY AS MUCH OR AS LITTLE AS YOU PLEASE ABOUT OUR AGREEMENT. ALL THAT MATTERS IS OUR HAVING THE MARINS, ESPECIALLY THE BIG ONE."[27]

Stieglitz found Phillips's second request as baffling as his first. He would not send the Marins to Washington before the end of his own show, nor would he keep completely silent about the six-thousand-dollar purchase. In his initial letter to Phillips after the sale, he confessed sharing the information with "a very small inner circle."[28] In fact, on the day of the purchase Stieglitz wrote to a potential buyer about the episode and predicted a "stampede" in the market for Marin.[29] When Phillips's telegram arrived four days later, Stieglitz took it as permission to broadcast the news even further. The record-breaking price was, after all, a great victory for the cause; as he saw it, the conversion of Phillips to "the spirit of 291" was nothing less than "a miracle."[30] Despite Phillips's initial squeamishness, Stieglitz wanted this profession of faith to be made public.

On January 1, 1927, Murdock Pemberton reported in *The New Yorker:* "The Rotarian can now admit he likes Marin because he has become successful. Last week Duncan Phillips came over from Washington to seek new stuff for his remarkable experimental museum in that town. Phillips bought four Marins, the largest fetching $6,000. We understand from those who know that it would take someone with the

25. Lewis Mumford, "Brancusi and Marin," *The New Republic* (Dec. 15, 1926), 112.

26. In March 1926, the same month Phillips first saw these two watercolors in Room 303, he also purchased *Black River Valley* (1913) by Marin from Daniel Gallery.

27. Phillips to Stieglitz, Dec. 8, 1926.

28. Stieglitz to Phillips, Dec. 8, 1926.

29. See Stieglitz to Philip Goodwin, another patron of Marin, Dec. 3, 1926, YCAL, quoted in Timothy Robert Rodgers, "Alfred Stieglitz, Duncan Phillips and the '$6,000 Marin,'" *Oxford Art Journal* 15, no. 1 (1992), 54: "To-day three Marins were purchased for a Washington Gallery. . . . It's only a question of a few years when there will be a great 'stampede' towards Marin." What is misleading is that Stieglitz implies that Phillips purchased three works, whereas in later letters to Phillips he is quite insistent that the world should know that the third one was a gift to Marjorie Phillips. Stieglitz intended that Phillips not only purchase one work for a large sum of money, but also leave with more than one work of art.

30. Stieglitz to Phillips, Apr. 7, 1927.

courage and foresight of Mr. Phillips to cinch the market value of a painter while he is still in good health. Whereas two or three hundred persons have felt that Marin was the greatest American, now that a picture of his has brought $6,000, hundreds of thousands will know it."[31] The notice seemed to cast the purchase in the best possible light for all concerned. Certainly it placed Phillips and Stieglitz squarely within the same camp, casting them as messengers to those unenlightened about modern art. Phillips was busy preparing to make his own pronouncements on Marin; if he saw the *New Yorker* article he made no mention of it to Stieglitz. It was not until February, when a notice appeared in *The Dial,* that Phillips got angry.

As usual, Henry McBride's commentary for *The Dial* carried a light and breezy tone. "The report is widespread and as yet uncontradicted that one of the John Marin water-colours in this year's exhibition in the Intimate Gallery has been sold for $6,000 to Mr. Duncan Phillips for the Phillips Memorial Museum at Washington. Such an unlooked-for achievement in finance strikes my mind into numbness and it knows not what to think. . . . The immediate cause for the $6,000 is the fact that Marin, the artist, found himself in a serener mood last summer than for several seasons past. Gone are the nervous zig-zags. . . . He has, *tout simplement,* been Wordsworthianizing up the river."[32] Though Stieglitz would later attribute the article to "an artist's joke," Phillips felt McBride was joking about a serious issue.[33] Did McBride and Stieglitz see Phillips as merely a conservative speculator without aesthetic confidence? The unwelcome publicity about the price was one matter. The slighting references to his selection were quite another.

On this occasion Phillips wasted no time in sharing his displeasure with Stieglitz. "McBride's 'stupefaction and numbness of mind' about my paying $6000 for a Marin as publicly expressed in the Dial following upon a similar announcement by Pemberton in the New Yorker has annoyed me considerably. As you remember, I asked you to keep our arrangements confidential since I was not prepared to spend that amount for one picture, and only agreed to your plan because the three pictures averaged $2,000 each. In a later telegram I may have given you the idea that I was ready to give publicity to the wrong impression but this was only because you had said that you would keep the matter confidential within your immediate circle."[34] Phillips demanded a retraction from Stieglitz. He would see none.

Phillips's protests did not dissuade Stieglitz from moving ahead with his plan. In March, with his O'Keeffe exhibition well under way, Stieglitz sent an open letter to *Art Digest* that mentioned the six-thousand-dollar Marin as a prelude to his announcement of nine thousand visitors to Room 303 in forty-two days and the purchase of a six-thousand-dollar O'Keeffe. Anticipating accusations of commercialism from his critics, Stieglitz hastened to add that he had not set the price. "Those who wanted O'Keefes [*sic*] were forced to make their own 'prices.'"[35] To Stieglitz's way of thinking, this success had nothing to do with advertising or commerce and everything to do with the

31. M. P. [Murdock Pemberton], "The City Overflows with Color—A Deep Bow to Henri Matisse," *The New Yorker* (Jan. 1, 1927), 33.

32. Henry McBride, "Modern Art," *The Dial* (Feb. 1927), 174.

33. Stieglitz to Phillips, Feb. 13, 1927.

34. Phillips to Stieglitz, Feb. 4, 1927.

35. Stieglitz's open letter to *Art Digest* (Mar. 1, 1927), 20.

growing public acceptance of his artists. Adding to the momentum of this publicity, Murdock Pemberton wrote another article, this time stating that *Back of Bear Mountain* had been purchased by "a reactionary institution which hitherto had bowed only to Academicians."[36] Phillips found it embarassing that Pemberton reviewed his accomplishments in such poor light just as he was launching out in a new direction.

What follows in the correspondence from February to April reads like a play-within-a-play. Phillips and Stieglitz tried to maintain the spirit of their original arrangement to bring American modernism to Washington even while they tried to reconcile their differences about the deal that had been struck for the six-thousand-dollar Marin. Phillips's letter of February 8, 1927, begins with a warm invitation and ends with a stern warning. "All this genuine enthusiasm for the beauty that I have created on these walls leads me to insist that you and such men as McBride and Pemberton . . . should come down at your very earliest convenience. New York has seen no such exhibition as this. Art has never been thought of quite in this way. . . . Pemberton in the New Yorker and McBride in the Sun and Dial should really be made to give the whole truth of our arrangement, retracting what they have written, but I dislike a continuation of the publicity and must merely ask you to please put an end to it and to tell these men and all others the strict truth, in the interest of Marin as well as of myself."[37]

Stung by Phillips's criticism as well as his absence from the O'Keeffe show, Stieglitz flatly refused the invitation to Washington. He wrote, "As for your Tri Unit Exhibition, undoubtedly it must be a magnificent exposition. But for the world of me I don't see how I can get away from the Room. I am needed there every moment. The world is moving fast and there are greater things happening in the Room than the procuring of either Marins or O'Keeffes, things entirely unrelated to money. As for McBride and Pemberton coming down, I don't see my way clear in suggesting any such thing to them."[38] Phillips did not write again for a month.

From March until the beginning of April, the pride of both men made the matter of *Back of Bear Mountain* paramount in their exchanges. Their escalating explanations and protestations, charges and countercharges, polarized the discussion and ultimately led them to interpret the question in very personal terms. In order for one answer to be true the other had to be deliberately false. Had Stieglitz betrayed Phillips's confidence in publishing the story of the six-thousand-dollar Marin? If Phillips believed he had been misrepresented for Marin's benefit, then was Stieglitz a liar? If Stieglitz considered Phillips courageous for purchasing the six-thousand-dollar Marin, did he also believe Phillips a coward for concealing the purchase? By stating he had received three Marins on the day of the sale of the six-thousand-dollar Marin, was Phillips reneging on his commitment? Both felt compelled to take their cases to the public in order to redeem their reputations. For his part, Stieglitz published and distributed a pamphlet that quoted letters and documents concerning the sale, including Phillips's telegram

36. [Murdock Pemberton], "Art," *The New Yorker* (Mar. 19, 1927), 20 and 21.
37. Phillips to Stieglitz, Feb. 8, 1927.
38. Stieglitz to Phillips, Feb. 13, 1927.

granting him permission to tell all. Phillips published an open letter in *The Art News* describing the sale as one arrangement in a series of gifts, trades, and discounts.[39]

Certain remarks among the last letters exchanged that spring surely extinguished what remained of their original rapport. At one point Stieglitz told Phillips, "Your museum is your personal expression. It cannot be considered a museum in the usual sense even though it may be one."[40] Phillips then wrote Stieglitz, "All this is not a boost—but a boomerang for Marin. And it spoils my Marin season which had done so much for the Cause which we both are working for."[41] Stieglitz replied, "You say in your letter we are both working for the same cause. I wonder whether we are."[42] Phillips did not write after April. Stieglitz's letters hammered away for clarification until June. Then there was a great silence.

*The Reconciliation*

Could Phillips salvage anything from such an episode? For a time he must have concluded that he could not. With the door to Room 303 shutting and the possibilities of further comparison and study of the Stieglitz circle growing dim, Phillips increasingly looked to Europe in 1927. In the isolationist climate of the late twenties, such a shift toward the French moderns would be interpreted as an act of disloyalty to American art. Stieglitz did not withhold comment. In March, after rebuffing Phillips's request for O'Keeffe's *Shelton at Night,* Stieglitz wrote concerning Phillips's growing interest in Bonnard, "So you have bought two more Bonnards. It is always good to be able to satisfy a passion. I like Bonnard well enough but he never could become a passion of mine."[43] In little more than a year, Phillips's contemporary French collection went from two to fifteen. By the fall of 1927 he had enough works to fill the Little Gallery for an exhibition entitled *Leaders of French Art Today,* which included new works by Bonnard as well as Matisse, Picasso, Braque, and Derain. Though he had told Stieglitz that Marin was "bigger and more elemental" than Bonnard, Phillips's new exhibition catalogue now stated, perhaps in defiance of Stieglitz, that he could not yet convince himself that the lead had passed from French to American painting.[44]

Back in New York, at Room 303, the fall exhibition featured new works by Arthur Dove. Dove broke the silence with Phillips in order to tell him about this show. He wrote, "A vital step has been taken in modern expression."[45] Phillips reluctantly received the letter as an invitation to explore the wreckage of an abandoned idea. It was Dove's work that had initially brought Phillips to Room 303 in January of 1926, but was Phillips's interest in Dove strong enough now to overcome his anger at Stieglitz? At this point Phillips's reply was mixed. His faith in Dove's originality was still strong. "You are one of the few modernists thoroughly original and American and free from any confinement within a tedious formula," Phillips wrote.[46] But he refused to come

39. See Stieglitz's pamphlet (YCAL) dated Apr. 17, 1927, published Apr. 27, 1927; and Phillips's letter to *The Art News* (dated Apr. 5, 1927, published Apr. 16, 1927), 8.

40. Stieglitz to Phillips, Mar. 24, 1927.

41. Phillips to Stieglitz, Mar. [Apr.] 4, 1927, YCAL.

42. Stieglitz to Phillips, Apr. 7, 1927.

43. Stieglitz to Phillips, Mar. 24, 1927. In his letter to Stieglitz, Mar. 8, 1927, Phillips had asked for *Shelton At Night,* after having seen it reproduced in Louis Kalonyme, "Scaling the Peak of the Art Season," *Arts and Decoration* (Mar. 1927), 57.

44. Phillips to Stieglitz, Mar. 26, 1927, and Phillips, *Leaders of French Art Today,* (Washington, D.C., 1927).

45. Dove to Phillips [after Dec. 12, 1927].

46. Phillips to Dove, Dec. 19, 1927.

to the exhibition. Further, he maintained that although Dove might send him paintings to consider, he would not buy. He could not work with Stieglitz, not without an apology. "Perhaps in time he will feel like telling me how sorry he is," Phillips wrote, "and if that time comes I shall be able to resume my active and wholehearted interest in the work of the artists who exhibit under his patronage."[47] Dove saw a window of opportunity in this remark.

Dove brought Phillips's letter to Room 303. It took someone like Dove to introduce the idea of reconcilation to Stieglitz, someone who had known Stieglitz for nearly twenty years and could put the weight of friendship behind his request. Stieglitz drafted five letters before sending one. Out of each succeeding draft he began to purge his bitterness about the *Back of Bear Mountain* fiasco. What remained in the terse compilation of sentences was an apology.

Stieglitz's letter invited Phillips to return to Room 303. He asked Phillips to come not as a frustrated "buyer" but as a "student."[48] Their recent experience made it clear that Phillips was not the guardian for Room 303, just as Stieglitz was not the mentor for an intimate museum in Washington. Instead Stieglitz's letter of apology implied that Phillips would be treated as he wished to be seen—namely as a student of the artists. For his part Stieglitz would remain a self-admitted jealous guardian for his artists' gallery. Such clarification of roles was fundamental to their future rapport; they had fought vigorously to maintain their respective positions and passions.

On January 7, 1928, after more than a year's absence, Phillips visited Room 303 on the final day of the Dove show and purchased a collage, *Huntington Harbor.* From that day forward Phillips and Stieglitz forged an alliance out of mutual necessity and grudging admiration. Could Phillips in all honesty claim to study American painting without Stieglitz's artists? And where else could Stieglitz find such steadfast interest and support?

Though Stieglitz often said he wished for help from more collectors like Phillips, their alliance should in no way be construed as ideal. Difficulties were never far from any exchange of money and paintings. Stieglitz complained that it required "a special staff" to keep up with Phillips's trades, payments, and subsidies.[49] Phillips had to be repeatedly reminded that, despite his unique support, his interest was not proprietary. Phillips complained when Stieglitz withheld important works from sale or failed to accommodate his dashes to New York. When conflicts arose, old prejudices resurfaced. Stieglitz could never forget Phillips's shortsighted early rejection of Matisse at the Armory Show, just as he ultimately never accepted Phillips's late-arriving interest in contemporary French painting, which necessitated hanging Dove between Rouault and Braque, for example, or comparing Marin to Bonnard and Matisse. As Stieglitz once commented, "I feel Phillips has done good work through me really. But when let loose, well the work isn't quite as good."[50] Yet, as Dove had pointed out to Phillips, Stieglitz was never one to stand between a man and an idea.[51]

47. Ibid.; see Dove's response to Phillips [after Dec. 19, 1927].

48. Stieglitz to Phillips, dated "Xmas 1927." The drafts were begun on the twenty-third and three drafts were written on Christmas Day alone. See Stieglitz's papers at YCAL.

49. Stieglitz to Dove, Mar. 28, 1937, YCAL, quoted in Ann Lee Morgan, ed., *Dear Stieglitz, Dear Dove* (Newark, 1988), 371.

50. Stieglitz to Dove, Mar. 2, 1934, YCAL, quoted in ibid., 299.

51. Dove to Phillips, [after Dec. 19, 1927].

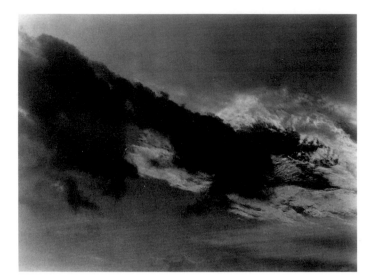

Alfred Stieglitz, *Equivalent* [Bry no. 228A], 1926, gelatin silver print

Phillips took Stieglitz at his word. He fully exercised his right to visit Room 303 and to measure, examine, and share in the spirit of the artists on his own. Perhaps Phillips's clearest quotations of Stieglitz were in his 1926 exhibition, *Nine Americans,* and in his 1950 essay, "Seven Americans."[52] Phillips also put his own mark on the vita for Stieglitz's four painters by offering them a number of museum firsts. His was the first museum to purchase O'Keeffe, to present a one-man museum show of Marin, and to mount retrospectives of Dove and Hartley. Less visible to the American public, but most important in Stieglitz's eyes, were the stipends Phillips gave both Marin and Dove during the Depression, in exchange for first choice of paintings.[53] When Phillips fell short, as he often did, he felt the sting of Stieglitz's hard words. In 1938 a reminder from Stieglitz regarding a late payment, coupled with an annuity offer to Marin, prompted the following frustrated reply from Phillips: "You still think of me as a rich collector indulging a luxurious hobby instead of as a baffled but loyal and determined patron of favorite painters, like yourself, one who buys only for a gallery which he founded and controls but which is not his property and which he has to go deep into his private principal to keep afloat during these years when no income is incoming."[54] Phillips wanted to live up to Stieglitz's standard, since it so closely approximated his own.

In the end Phillips hoped Stieglitz understood him. When Stieglitz died in 1946, Phillips tentatively stated, "I think that he knew we were allies in the same Cause; that we also had an 'experiment station' as well as an Intimate gallery where art can be at home."[55] Over the course of twenty years Phillips faithfully followed Stieglitz's initial advice to acquire "a large group of Marins . . . groups of Dove and O'Keeffe, maybe Hartley even, not to speak of my own photographs . . . to reflect a growth of something which is typically American and not a reflection of France or Europe."[56] Dispersing Stieglitz's estate in 1949, Georgia O'Keeffe in effect completed Phillips's collection by donating to the museum a set of nineteen cloud photographs by Stieglitz, two of them

52. See Phillips, *Nine Americans* (Washington, D.C., 1926) and his article, "Seven Americans Open in Venice: Marin," *Art News* 49 (summer, 1950), 21.

53. Phillips supported Dove, from 1930 until the artist's death in 1946, with a monthly stipend that he increased over the years. Later that decade, he began giving Marin an annual sum, but the artist never had to depend upon it for survival to the extent that Dove did.

54. Phillips to Stieglitz, July 16, 1938, YCAL.

55. Phillips, "Tribute," in Dorothy Norman, ed., *Stieglitz Memorial Portfolio: 1864–1946* (New York, 1947), 10–11.

56. Stieglitz to Phillips, Dec. 11, 1926.

Alfred Stieglitz, *Arthur G. Dove*, 1914–15, gelatin silver print, Philadelphia Museum of Art, from the Collection of Dorothy Norman

"Songs of the Sky" and seventeen "Equivalents." "Stieglitz so often spoke of intending to send them himself. I think they will feel very much at home with you," O'Keeffe wrote.[57] If Phillips needed any clarification, the deed of gift told him all he needed to know. All in all Stieglitz had been right. Phillips considered what had been gathered in his museum from Dove, Hartley, Marin, O'Keeffe, and Stieglitz "more American than all the American sceners put together."[58]

## ARTHUR DOVE: "HEWN OUT OF NATURE"

*"He was strictly yet sensuously visual. . . . One could not analyze him."*
Duncan Phillips, "Arthur G. Dove, 1880–1946," *Magazine of Art,* May 1947

Duncan Phillips first encountered the work of "a Whitmanesque painter named Arthur Dove" in 1922. The place was most likely an auction at the Anderson Galleries in New York. Given the nationalistic tenor of the times, the occasion was probably not too different from the 1921 showing of new tendencies in American art at the Pennsylvania Academy, where reviewers such as Paul Rosenfeld noted, "There was much talk of American earth."[1]

Dove focused on earthy substances: rushing water, pungent pastures, cows, old wood, rusting plows, and tree trunks. His colors ranged from gritty browns and greens to flashes of vibrant blue, copper, and silver. His forms collided like lightning bolts with the ground. They coiled like intestines or branched out like capillaries. Here was an abstract art emerging from sensation as well as sensibility or, as Rosenfeld put it, "not . . . from the head alone, but from the breast and belly."[2]

America had never seen an artist like him. In 1910 Dove had been the first to abandon any hint of narrative, to discard any semblance of figure, setting, or even titles in his paintings. In 1912 he defiantly told his baffled critics, "They [the forms] should tell their own story." In 1914 Jerome Eddy included Dove's groundbreaking work and ideas in his book *Cubists and Post-Impressionism,* one of the most widely read histories of modernism in America. When Eddy asked the artist to explain his radical point of departure, Dove replied, "I no longer observed in the old way, and, not only began to think subjectively, but also to remember certain sensations purely through their form and color, that is, by certain shapes, planes of light, or character lines determined by the meeting of such planes."[3]

It appealed to Phillips that Dove could not be classified easily by school, style, or movement. "Paintings should exist in themselves," the artist once told Phillips. Dove also liked to point out that his A.B. from Cornell in 1903 had led him into commercial art, not fine art. "My father wished me to become a lawyer," he said, "but I did even worse. I became an illustrator, and learned to make money." Looking back, Dove be-

57. O'Keeffe to Phillips, Aug. 11, 1949.
58. Phillips to Dove, May 7, 1935.

1. Paul Rosenfeld, *Port of New York* (New York, 1924), 167. Phillips recalls the date 1922 in his letter to Charlotte Devree, Nov. 30, 1954, and in his article "Arthur Dove, 1880–1946," *Magazine of Art* (May 1947), 194. Unless otherwise noted, all letters cited are in The Phillips Collection Archives.
2. Rosenfeld, *Port of New York,* 169.
3. Dove recorded by H. Effa Webster in *Chicago Examiner,* Mar. 15, 1912, quoted in Barbara Haskell, *Arthur Dove* (San Francisco, 1974), 21. Dove to Arthur Jerome Eddy, 1912, published in *Cubists and Post-Impressionism* (Chicago, 1914), quoted in Haskell, *Arthur Dove,* appendix.

lieved that his commercial work precipitated his encounter with "the new painting." His work for *Harper's Magazine, Collier's, The Saturday Evening Post,* and *McClure's* funded a trip to Paris in 1908. After his return to New York, Dove earned just enough doing illustrations to continue his own experiments in painting. Recalling what he had learned abroad, he jokingly told Phillips that it had made him forget "the making of money."[4]

Dove may have been converted to radicalism in Paris, but his move to abstraction in 1910 owed no obvious debt to Europe. As he explained at the time of his first show, the works were "based on 'mathematical laws' and geometric forms 'sensed in nature.' "[5] Dove, the futurists, and Kandinsky all drew independently from the same well of scientific sources and discoveries—Faraday's force fields, radio, and X-radiographs —to sustain their artistic claims upon seen and unseen forces. Yet while European artists used abstraction to separate the functions of art from nature, Dove used abstraction to renew and widen the connections. A popular translated text by German biologist Ernest Haeckel entitled *The Wonders of Life* (1905) invited such thinking.[6] Haeckel suggested that artists find the archetypal forms underlying the infinite variety of nature, just as science measures and reduces natural phenomena according to mathematical laws. Following Haeckel's suggestion, an artist should look at nature and paint abstractly—should give form to perception by discerning the intervals, repetitions, and proportions in nature's vast array. This idea was at the heart of Dove's method. As he later told Phillips, "the very essence of what I had found in nature [was] in the motif choice—two or three colors and two or three forms."[7]

As Phillips saw it, Dove's art did something that the aesthetic treatises of Clive Bell or Roger Fry could not. Dove's work finally convinced him that abstraction was not an arbitrary style but an artistic process. In 1926, after acquiring *Golden Storm,* Phillips immediately confided his new insight to Dove. "When there is a hint of great things going on in the mind of the artist and of his consciousness of the rhythm of the universe, abstract art ceases to be an amusement for the aesthete and becomes a divine activity."[8]

Phillips's initial choice of words cast Dove into the role of a Transcendentalist verifying his spiritual ideas and emotions with the immense power of the elements. Further contact with the artist and his works only reinforced this idea. In 1932 Phillips made the connection most directly when he wrote, "Dove is as American as Thoreau."[9] The painter's reclusive way of life away from New York indeed made him somewhat Thoreauvian. In 1910 Dove had come back from a camping trip in Geneva, New York, with six small sketches that ultimately give America new insights about art and nature. He clearly identified with Thoreau's need for a sense of place. As Dove once told Stieglitz, "The place to find things is in yourself and that is where you are."[10]

Whether Dove was reclusive by nature or by necessity is, of course, debatable, but during the 1920s, at the time Phillips made Dove's acquaintance, a particular quiet

4.  Dove to Phillips [probably May 16–18, 1933].

5.  Harriet Monroe, review in *Sunday Chicago Tribune,* Mar. 17, 1912, and Webster, *Chicago Examiner,* Mar. 15, 1912, quoted in Sherrye Cohn, *Arthur Dove: Nature as Symbol* (Ann Arbor, 1985), 22.

6.  See Cohn, *Arthur Dove: Nature as Symbol,* 24.

7.  Dove to Phillips, late Oct. 1946.

8.  Phillips to Dove, Mar. 13, 1926.

9.  Phillips, *American and European Abstractions* (Washington, D.C., 1932).

10. Dove to Stieglitz, May 5/7, 1931, Yale Collection of American Literature, Beinecke Rare Book and Manuscript Library, Yale University, New Haven, Connecticut (cited as YCAL), quoted in Ann Lee Morgan, ed., *Dear Stieglitz, Dear Dove* (Newark, 1988), 222.

intensity had come over the artist's career. He rarely traveled. By 1920, like Stieglitz, he had cut loose the strings of conventional domestic life, left wife and home to follow his artistic convictions with a new companion, painter Helen ("Reds") Torr. Attempting to limit his expenses as well as the need to do commercial illustration, Dove lived and worked from 1924 to 1933 on a houseboat named *Mona* moored near Huntington Harbor. His renewed focus, experimentation, and development appeared as if in answer to critics who previously failed to find a sustained drive toward maturity in his abstractions. The more practical question of financial support, however, continued to haunt him.

Among Phillips's initial purchases, *Golden Storm* and *Waterfall* (both completed in 1925) capture a particularly important range of propensities in Dove's mature work. *Golden Storm* highlights his endless fascination with surfaces and materials. Here Dove uses the burnished glow of metallic paint against the deep blue of oils to underscore the radiating repetition of symbolic forms in the clouds and billows. In *Waterfall* Dove, much like O'Keeffe, limits his palette of oils to a particular tonal range from deep gray to white and improvises within a singular swirling vortex to convey more specific observations and experience.

Living on a houseboat heightened Dove's attention to the action of water, and the limited space and meager accommodations must have influenced his new approach to his media during this period. Perhaps at no other time in his career did the artist grapple more fiercely with *real* things—or what Dove called "'things' . . . hewn out of nature."[11] From 1923 to 1927 Dove made at least twenty-five collages and assemblages. Phillips purchased two of them: *Goin' Fishin'* and *Huntington Harbor I*.

Composed of bits of wood, canvas, metal, sandpaper, bamboo, and denim, the assemblages draw their inspiration from the materials and anecdotes of a working dock, evoking boat repairs, flotsam and jetsam. These works move richly and freely between representation and abstraction. Placing a button glued to a piece of dock wood within a radiating configuration of bamboo, Dove captures the gleaming eye of a fisherman gazing out upon a denim-blue sea. Similarly, a square of sandpaper overlapping a larger piece of oilcloth describes the full sail of a lone boat traversing the horizon line painted on a metal panel. Phillips believed such assemblages rivaled cubism and folk art in their tongue-in-cheek cleverness and evocations of Americana. Working with such odd conjunctions of disparate materials later inspired Dove when he returned to larger-scale oils: in *Sand Barge* (1930), for example, a diagonal overlay of color squares against a lighter ground combines the slag of sand and gravel across a bridge of orange, blue, and ocher.

Even after he left the boat and became a farmer on his family homestead from 1933 to 1938 in Geneva, New York, Dove continued to keep a daybook in which he recorded the weather. Being out and about—ever mindful of the effects of rain or sun, wind, cloud cover, or snow upon cycles of growth and the seasons—became an artistic

11. Dove to Stieglitz, June 20 or 21, 1928, YCAL, quoted in ibid., 150.

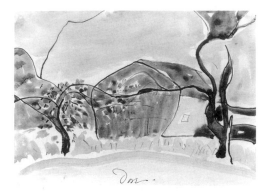
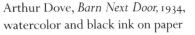

Arthur Dove, *Barn Next Door,* 1934,
watercolor and black ink on paper

Arthur Dove, *Me and the Moon,* 1937,
graphite pencil on paper

as well as an occupational necessity. He had once told Stieglitz that "objective things or elements . . . make my line vital."[12] Perhaps for this reason Dove renewed his efforts with a small sketchpad and watercolors out in the landscape during the 1930s. The resulting vignettes reveal how the artist's eye and brush could roam freely across sagging barn roofs, along limbs and lintels, swelling around haystacks in a single stroke. By 1935 Dove was able to imbue his paintings with this new combination of abstraction and automatic movement.

Phillips purchased no less than seven of Dove's works from 1935. Each is quite distinct in approach. In *Morning Sun,* for example, Dove seized upon picturesque patterns of plowed fields, a line of trees marching into the distance, and the marvelous conjunction where radiating lines of the sun meet the contours of the land. In another instance, *Cows in Pasture,* Dove abandoned the gleaming surfaces of oils for a mixture of wax emulsion, creating a velvety patchwork of grazing cows whose udderlike forms are swallowed up in an undulating field of green and brown.

Phillips wanted to learn the anecdotal origins of these works. "Is it the record of an experience in the fields on a summer day?" he asked regarding *Tree Forms II.* Dove mustered a single story: *Lake Afternoon,* indeed, had been created after a day out with friends on Lake Seneca.[13] But in this particular image—kissing amoebas afloat in undulating bands of greens and blues—the improvisation had traveled a great distance from the particular details of Dove's picnic. Connected to his interest in surrealism and perhaps to his experience with illustration, Dove developed a penchant for making shapes into fanciful creatures that could become almost cartoonlike if the idea was pressed too far. As Phillips once observed, "He was so whimsical that he would be embarrassing not only to the literary critics but to the painters and teachers of painting who deal in theories and group movements."[14]

By the end of the decade, after a serious episode of ill health and a retrospective at Phillips's museum, Dove increasingly turned inward and reviewed his past. This new self-consciousness revealed itself in various ways. Abandoning figuration, he revisited certain subjects, shapes, even colors. In this approach Dove risked losing contact with

12. Recorded by Hutchins Hapgood in "The Live Line," *The Globe and Commercial Advertiser,* New York, Mar. 8, 1913, 7, quoted in Frederick S. Wight, *Arthur Dove* (Los Angeles, 1958), 37.
13. Phillips to Dove, June 8, 1936.
14. Phillips, "Arthur Dove, 1880–1946," 194.

nature. In 1942 his diary reminded him, "Work at the point where abstraction and reality meet."[15] At times in the late thirties and forties Dove felt himself to be a "young old master," a title he gave to a 1946 painting. In *Me and the Moon* Dove acknowledged a debt to Stieglitz's cloud photographs by examining with glorious vigor and detailed concentration the features and reflections of the full moon in the night sky.[16] *Rain or Snow* was perhaps the crowning achievement of Dove's late work. It is marvelously abstract, completely free of anecdote. What are the two rectangles floating on the vertical expanse of white? Why do we imagine clouds or snowflakes or both? What is the condition of light on the periphery? Could the foil bands lining the outer edge be a window or the glimmer of sun? Painted five years after Dove's move to a retirement cottage in Centerport, New York, the work combined all the best aspects of the artist's experience in nature—space, balance, movement, and as Phillips liked to add, "joy."[17]

Phillips first came to Stieglitz's gallery because of Dove, and he repeatedly returned to Stieglitz because of the artist. The road was not easy. Phillips's support never completely measured up to Dove's immense need. Even so, Phillips would wear his allegiance to this artist like a thorny crown before Stieglitz's ongoing inquisition. In 1926 Phillips waited six weeks for Rosenfeld to give up his option to buy *Waterfall.* He waited even longer, sometimes up to three to four years, for special works Stieglitz considered part of his own private store. (Stieglitz never would sell Dove's early abstractions from 291.)

Soon after formalizing his stipend for Dove, Phillips began to ask to meet the artist. Stieglitz postponed it. He told Dove, "Phillips is eager to meet you & have a talk. There is no hurry."[18] The same was true for holding a retrospective for Dove. In 1934, after already broaching it to Dove, Phillips inquired about borrowing works. Stieglitz was annoyed. He told Dove, "His business is to buy your work & show what he buys. . . . All else is waste & vanity."[19] Indeed, Stieglitz took it as a point of pride that Phillips almost never received a discount on Dove. When the artist received the notice of sale, it often came with the assurance, "No 'sacrifices' have been made."[20]

For his part Dove was solicitous to his only regular patron. When Phillips sent his stipend for the upcoming summer, the artist wrote thanking him for "vital" support, and when that monthly support was doubled in 1934, Dove wrote: "Your idea of doubling the subsidy . . . really gives me the much longed for privilege of planning more extensive work ahead. This going out to paint then rushing back and stamping the door quickly to keep the wolf out is not soothing to the nerves."[21]

Dove's pride was as prickly as Stieglitz's, and there were many times when he resented Phillips. The artist gratefully acknowledged his patron but never actually befriended him. He promised to visit Washington, and even invited Phillips to come to Geneva, but they met only once, at Stieglitz's gallery in April 1936. Dove interpreted Phillips's desire to take his best paintings from Stieglitz's collection as a proprietary action; thinking of the inquiries that often came with the checks, he once told Stieglitz,

15. Dove diary entry, Aug. 20, 1942, Archives of American Art, Washington, D.C., quoted in Cohn, *Arthur Dove: Nature as Symbol,* 18.

16. In 1942 Dove was delighted to finally be able to purchase an "Equivalent"; see Dove to Stieglitz, June 7 and July 7, 1942, quoted in Morgan, *Dear Stieglitz, Dear Dove,* 470 and 471.

17. Phillips to Dove, Apr. 7, 1943.

18. Stieglitz to Dove, Apr. 11, 1933, YCAL.

19. Stieglitz to Dove, Mar. 2, 1934, YCAL, quoted in Morgan, *Dear Stieglitz, Dear Dove,* 299.

20. Stieglitz to Dove, Apr. 27, 1936, YCAL, quoted in ibid., 349.

21. Dove to Phillips, May 28, 1933, and Dove to Phillips, [after Feb. 2, 1934].

"I earn it twice."[22] Then too, Dove found it difficult to stifle his anger at Phillips's blundering suggestion that the painting *Bessie of New York* be cut in half.[23] Though he might rail about the incident in his correspondence with Stieglitz, Dove's letter to Phillips included only a mildly worded refusal: "The paintings . . . [are] like people to me."[24] Dove feared the worst when he turned down Phillips's offer to get him some commissions in the WPA, but the checks from Washington never stopped. In the end, much to the relief of an aging Stieglitz, Phillips's support for Dove continued whether new paintings appeared or not. If singularity was Dove's hallmark, then it was an equal compliment to his collector. In 1942 Marsden Hartley credited Phillips with "being the sole person in the entire universe that likes [Dove's] painting, and cares whether he lives or not."[25]

## MARSDEN HARTLEY: "GIVING OF THIS BIG COUNTRY"

*"Some day, perhaps some day not so far distant, Hartley will have to go back to Maine. For it seems that flight from Maine is in part flight from his deep feelings. . . . There dwell the people to whom he is closest akin; there is the particular landscape among which his decisive experiences were gotten; there every tree and mountain wall is reminiscent of some terrible or wonderful day. . . . For among them only can he get the freedom of his own soul."*
Paul Rosenfeld, *Port of New York,* New York, 1924

Marsden Hartley was born in Lewiston, Maine, in 1877. He died in Ellsworth, Maine, in 1943. During the intervening sixty-six years, he traveled widely in North America and in Europe, his longest stint abroad lasting from 1921 to 1929 when he was supported by a syndicate of buyers organized by the wealthy American diplomat William Bulliet. Hartley's penchant for wearing stylish hats and carrying a gold-headed cane conveyed an air of cosmopolitan elegance and refinement. He liked to appear as if he had the option to travel even when there was none.

During his days as an art student, Hartley had made the most of occasional scholarships and stipends, shuttling as far as the money would carry him between the National Academy of Design and the Art Students' League in New York in the winter and Maine in the summer. Largely self-taught, Hartley claimed to have read Emerson's *Essays* like "a priest read his latin breviary on all occasions."[1] As if following Emerson's instruction to "return to nature," he gathered both a definitive subject and approach by spending the winter of 1908–09 in the wilds of Maine. The originality and mysticism evident in his mountain landscapes made him equally accepted by two mentors of American modernism, Arthur B. Davies and Alfred Stieglitz. Such dual recognition put Hartley at the crossroads of two distinct approaches to painting, one conventional and the other defiant. Though Ryder's allegorical landscapes sustained him for a time, Hartley sought more radical inspiration. He told Stieglitz, "I want my own sight."[2] Having

22. Dove to Stieglitz, Mar. 7, 1934, YCAL, quoted in Morgan, *Dear Stieglitz, Dear Dove,* 301.

23. *Bessie of New York,* 1932, is now in the Edward Joseph Gallagher III Memorial Collection, Baltimore Museum of Art.

24. Dove to Phillips, [May, probably 16–18, 1933].

25. Hartley to Phillips, June 3, 1942.

1. Marsden Hartley, "Somehow a Past," Oct. 9, 1923, Yale Collection of American Literature, Beinecke Rare Book and Manuscript Library, Yale University, New Haven, Connecticut (cited as YCAL), quoted in Townsend Ludington, *Marsden Hartley: The Biography of an American Artist* (Boston, 1992), 20.

2. Hartley to Stieglitz, Sept. 11, 1911, YCAL.

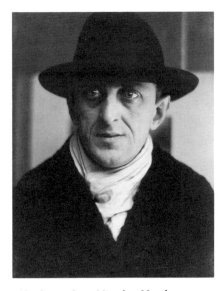

Alfred Stieglitz, *Marsden Hartley,*
1913–15, gelatin silver print, The
Metropolitan Museum of Art, New
York, gift of Marsden Hartley, 1938

decided this, it was only a question of time before he reached his next destination.

Hartley believed seeing the new painting firsthand in Paris would give him the means to express something all his own. Exhibitions of Matisse drawings, Cézanne watercolors, and Picasso drawings and watercolors at Stieglitz's gallery helped him verify his assumptions and set a course of action. His landscapes were now conveyed in bold strokes of pure color. He told Stieglitz, "I . . . have but one ambition—to put down with a sense of authority and artistic conviction an object—some days for form only—then for color."[3] Hartley's experiments with abstraction began a full year before his departure for Europe.

In April 1912 with letters of introduction in hand, Hartley easily stepped into the full stream of avant-garde Paris, from the public demonstrations at the Salons des In-dépendants to more intimate gatherings at Gertrude Stein's apartment on rue de Fleu-rus, where he would become a regular guest. He found still more new forms—more elemental than Picasso—while visiting exhibitions about Africa and the Americas at the Musée d'Ethnographie du Trocadero.[4] Away from the established American circles in Paris, Hartley befriended a contingent of German artists frequenting the Café Thomas. Here Hartley first learned about Kandinsky's ideas of pure abstraction in *Concerning the Spiritual in Art.* Hartley told Stieglitz that the talk of Kandinsky's book led him to begin his own series of abstractions demonstrating "Cosmic Conscious-ness."[5] He worked at devising a range of bold, coloristic insignia to capture the ele-ments and inventions of the new age. Hartley's vested interest led the American to meet Kandinsky in Berlin in January 1913.

In the fall of 1913, when Hartley told Stieglitz he wanted to move to Berlin, Stieglitz sent Hartley enough money to come home. Reminding the artist of his obli-gations and rewarding him with the promise of an exhibition, Stieglitz wrote, "You went abroad, as you remember, with one idea, and that was to study. And by studying I mean working and seeing. . . . I am not opening the little gallery until I know defi-nitely whether you are coming or not. Everything is held in abeyance for you. . . . A certain responsibility towards the others rests on your shoulders. There are other poor devils here struggling just as hard as you are and who are entitled to all you are."[6] This was Stieglitz's first appeal, but it would not be his last.

Hartley returned to America in November 1913, stayed five months, and then went back to Germany. He set up a studio in Berlin and completed a number of strik-ingly emblematic paintings—an "Amerika" series as well as a "German Officer" series. Had the war not come along, Hartley might have envisioned himself an expatriate. In Berlin Hartley had found friends, acceptance, and encouragement. Staying abroad could open up further prospects for artistic growth and change. But Hartley wrote Stieglitz from Europe, "I could never be French—I could never become German—I shall always remain American—the essence which is in me is American mysticism just as Davies declared it when he saw those first landscapes."[7]

3.  Hartley to Stieglitz, July 1911, YCAL.
4.  See Hartley to Stieglitz, Oct. 31, 1912, YCAL, discussed in Gail R. Scott, *Marsden Hartley* (New York, 1988), 37.
5.  Hartley to Stieglitz, Dec. 20, 1912, YCAL.
6.  Stieglitz to Hartley, Oct. 20, 1913, YCAL.
7.  Hartley to Stieglitz, Feb. 8, 1913, YCAL, quoted in Scott, *Marsden Hartley,* 44.

When Hartley was forced by the war to leave Europe in December 1915, he shifted course again, no longer giving precedence to the symbolic dictates of his inner eye. This meant more travel—from New York to Provincetown to Bermuda; from New York to Taos, from Taos to California. His search for a suitable subject seemed elusive until he settled in Santa Fe. In 1918, after six years' devotion to abstraction, Hartley told Alfred Stieglitz, "I shall go on copying nature indefinitely." He spoke of returning to the wealth of color—"rich red earth," "chocolate mesas," and "wide areas of blue sky." He said, "I want the bigness and the sense of giving of this big country in my system, and it is the one way to recreate myself."[8] Then, having said this, Hartley went on to spend the greater part of the decade of the 1920s traveling in Europe while painting recollections of New Mexico.

In 1926 Duncan Phillips's assessment of Marsden Hartley followed the conventional wisdom. "In his early painting of mystical little mountain landscapes and their autumnal tones he may have muddied his palette whereas now his colors are fresh and exhilarating. Yet those hills of his homeland in Maine stirred his emotions as his experiments with abstraction have failed to do."[9] Phillips based his discussion on a small painting entitled *After Snow* in which the mountain rises up through a thatch of trees and muted gray feathery brushwork. It had been in his possession since 1914. Stieglitz was surprised to learn that Phillips had come to Hartley so early and not through his own gallery. Perhaps Stieglitz was unaware of Davies's early impact on Phillips. In any case, the impresario was quick to claim the artist as his own discovery. Stieglitz told Phillips, "Hartley, like Marin and Dove and O'Keeffe, is one of my babies. One who has possibly given me the most worry." He added, "I wonder have you seen his recent work. I never thought of showing it to you. But there is time."[10]

In truth Phillips knew Hartley better as a writer than as a painter. During the late 1910s and early 1920s Hartley had circulated in the company of writers and critics and was often mistaken for one himself. For most of his life Hartley spent half of every day writing. In 1921 his essays and criticism, originally published in *Seven Arts, The Little Review, Poetry, Contact,* and *The Dial,* were compiled in a book entitled *Adventures in the Arts,* which Phillips owned and had read. The collector found Hartley's appreciations of Albert Pinkham Ryder, Odilon Redon, Arthur B. Davies, and Emily Dickinson "exquisitely worded" and "as true to his own rich emotional nature" as his early paintings.[11]

Rockwell Kent, a longtime friend of Hartley and protégé of Phillips, probably read of Phillips's preference for the early landscapes in *A Collection in the Making* and donated the early fauve-inspired *Mountain Lake—Autumn* to the collection in late December 1926. In November 1927 (perhaps in avoidance of Stieglitz) Phillips purchased from Charles Daniel a marvelous still life of a single vase with starlike camellias against a dark ground that may have remained at the gallery following Hartley's 1920 exhibition there. Phillips saw the results of Hartley's nearly ten-year European sojourn at Stieg-

8. Hartley to Stieglitz, Aug. 1, 1918, YCAL.

9. Phillips, *A Collection in the Making* (New York, 1926), 2.

10. Stieglitz to Phillips, Feb. 1, 1926. Unless otherwise noted, all letters are in The Phillips Collection Archives.

11. Phillips, *A Collection in the Making,* 62.

litz's Intimate Gallery in 1929. Although his friend and fellow painter Lee Simonson hailed Hartley's Cézannesque *Mont Sainte-Victoire*, indicating the price would be just the amount needed to pay the rent on Hartley's cabin in the south of France, Phillips selected *Pears and Grapes*, a decorative composition akin to Braque.[12] Perhaps Phillips, like most American critics, thought it was time for Hartley to come home. As Stieglitz explained it to Hartley, "Eventually . . . you will have to face a reality which I fear you never tried to understand. You have really made no 'practical' contact in Europe and you are really without contact in your own country."[13]

If Phillips depended upon Stieglitz's correspondence for reports on Hartley, he was disappointed. Unlike O'Keeffe, Marin, or Dove, Hartley did not exhibit annually at Stieglitz's gallery. In fact, during most of the Depression Hartley found he could not count on any one gallery. By 1935 relations between Hartley and Stieglitz were so strained that the artist had to destroy one hundred canvases because he could no longer pay for storage. In April 1936, after a desperate letter from Hartley, Stieglitz held at An American Place what turned out to be the artist's next to last exhibition with him. (Although titled *A Tribute to Maine*, it contained not one Maine painting.)[14] Despite Stieglitz's having informed him of it, Phillips missed the show.[15] It was not until 1939, when Hudson Walker became Hartley's dealer, that Phillips discovered the power of Hartley's late paintings. Over the course of the next four years, until the artist's death in 1943, Phillips purchased and exhibited Hartley with great enthusiasm, believing as he then wrote, "Hartley became not only a successful but an important painter," because of his "personal and powerful contribution to the outstanding traditions of American art—romantic mysticism and robust realism."[16]

When Hartley returned to the United States in 1930, it seemed questionable whether his mind and his heart could connect with the terrain. He told Paul Strand he felt as if he were doing penance.[17] In the summer of 1931, while preparing for a trip to Mexico, Hartley experienced an awakening of sorts. He began a series of sketches of the sea of boulders on the Dogtown Common just outside Gloucester, Massachusetts.[18] His aloneness and determination resonated with the granite monoliths. Filling his compositions with bold contours, he demarcated their position and form with certainty and clarity, and in so doing gave himself completely to the objects within his vision. This experience would lead to Hartley's return to New England once and for all.

Phillips's subsequent purchases demonstrate the artist's remarkable growth over a matter of a few years. In 1934, when Hartley returned to Dogtown, he also created a series that forever exorcised "the fetishes of Paris" from his still life compositions.[19] In *Sea-View, New England*, the fish before the open window suggested to Hartley a repast. The artist avoids the usual measured play of interior and exterior; the fish fills the frame, stretching longer than the horizon beyond it. A ring of brown and black ovals, animated with inscriptions made by the back of the brush, densely pack the

12. Lee Simonson to Phillips, Jan. 13, 1929. Both still lifes were later deaccessioned by Phillips.
13. Stieglitz to Hartley, Feb. 5, 1929, YCAL.
14. See Hartley to Stieglitz, Feb. 1, 1936, YCAL. Stieglitz gave Hartley one solo show at The Intimate Gallery (1929) and three at An American Place (1930, 1936, and 1937).
15. Stieglitz to Phillips, Apr. 21, 1937.
16. Phillips, "Marsden Hartley," *Magazine of Art* (Mar. 1944), 83. Hudson Walker gave Hartley three solo exhibitions (1938–40).
17. Hartley to Paul Strand, Aug. 8, 1930, quoted in Scott, *Marsden Hartley*, 87.
18. See discussion in ibid., 90.
19. Quoted in ibid., 70.

perimeter. Such dark framing does not overwhelm but magnifies the small central light of sky and sea. In *Gardener's Gloves and Shears,* painted three years later, Hartley dispenses with the polite distractions of table and drapery altogether and vests everything in the starkly simple contours of weathered white gloves against a field of deep blue over red.

Undergirding Hartley's growing originality and formal power was his uncompromising sense of realism, which went hand in hand with his extended sojourns to certain out-of-the-way villages and communities along the northern coast. In November of 1935 Hartley sailed to Nova Scotia. Four miles up the coast from Blue Rocks, he roomed with Francis and Martha Mason for seven dollars a week. The following year he returned like an adopted member of the family. Then, in September of that year, a hurricane killed the Masons' two sons and a cousin. This tragedy weighed heavily on the artist's mind and imagination for the remainder of his life. It led him to tackle a new subject. From 1936 to 1943, in a series of seascapes—serving as memento mori— Hartley summoned the immensity of the ocean with an expressive power equal to if not surpassing Ryder. In *Off the Banks at Night,* two distant ships sail against a white-capped sea. Heavy, angular clouds hang like boulders above. The white surf crashes against the black toothy rocks as if the jaws of Leviathan would close in the next moment. From this point on, Hartley never lost his momentum—was never daunted by the creative struggle. As Stieglitz exclaimed to Dove at Hartley's death, "What a lucky man Hartley to have passed out in his zenith."[20]

## JOHN MARIN: A "SUDDENLY LEVELLED GLANCE"

*"Is this Marin one of the far-sought important men?"*
Duncan Phillips, *A Collection in the Making,* Washington, D.C., 1926

Phillips never disputed John Marin's greatness. The collector had come to the artist at the height of his powers. During the 1920s Marin pushed watercolor, a medium traditionally known for its delicacy, to the limit of its energies—slashing rather than blending his strokes, scraping the paint into white sheets of Whatman paper, testing and defying conventional boundaries of field and frame.[1] The work imparted a daring sense of speed to Phillips. And his passion for it was immediate. From 1926 through 1927 Phillips acquired nine Marin watercolors. Remarking upon the rate of acquisitions in 1926, Stieglitz jokingly diagnosed Phillips with "Marinitis."[2] By 1927, with the work in hand, Phillips told his colleague Alfred Barr that he wanted Washington to experience "the bracing shock" of this artist.[3] With Marin's *Franconia Range, White Mountains, No. 1* hung near Cézanne's *Mont Sainte-Victoire* in Phillips's Main Gallery, who could fail to recognize the stature of "one of the most provoking, challenging in-

20. Stieglitz to Dove, Sept. 11, 1943, YCAL, quoted in Ann Lee Morgan, ed., *Dear Stieglitz, Dear Dove* (Newark, 1988), 487.

1. For a thorough discussion of Marin's working methods and techniques, see Ruth Fine, *John Marin* (Washington, D.C., 1990), 277–82.
2. Stieglitz to Phillips, Apr. 16, 1926. Unless otherwise noted, all letters cited are in The Phillips Collection Archives.
3. Phillips to Alfred Barr, director, Museum of Modern Art, Jan. 15, 1927.

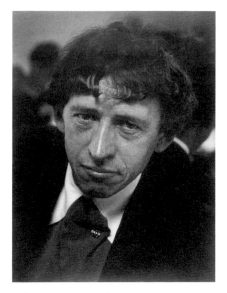

Alfred Stieglitz, *John Marin*, 1920, gelatin silver print, Philadelphia Museum of Art, from the Collection of Dorothy Norman

novators since Cézanne"?[4] Confident of Marin's ability to stand with the best of contemporary Europe, Phillips prided himself on his "wall of Marin."[5] In 1938 his Marin-Picasso installation reaffirmed this point. Marin never complained about such company. He once implied to Phillips, however, that if it were his choice, he would want his work hung with "one of our soil."[6]

Prior to Phillips, many writers, avant-garde and conservative alike, had testified to Marin's talent. Even if Phillips had missed articles by Marsden Hartley and Paul Strand in *Camera Work* or pieces in Stieglitz's later periodical *Manuscripts,* he undoubtedly read the glowing assessment of Marin in *American Watercolorists* (1922) by his colleague A. E. Gallatin. In 1923 there was also Scofield Thayer's "Living Art·Portfolio" in *The Dial,* which waved the flag for America by placing Marin's *Lower Manhattan* with the foremost in The School of Paris. In 1925 Forbes Watson's "American Collections" in *Arts* attested to support for Marin on the home front. In 1926 Stieglitz gave Phillips *Port of New York,* Paul Rosenfeld's collection of essays on American artists, including Marin.[7] Indeed, by 1926 the litany concerning Marin's biography was so well established there may have seemed little else to say. Phillips gave it only a cursory recitation in his book: "French descent—Yankee birth and independence—training as an architect—the influence of Whistler—then of the Chinese—then of Cézanne and Stieglitz—that is the story."[8]

Phillips believed that living with Marin's watercolors would take him far beyond any patented story. He observed, for example, that Marin was more modern in emotion than in method. Marin's etchings indeed could have been mistaken for the work of Whistler. His approach to watercolor was like that of a consummate Chinese calligrapher whose elegant economy of means reveals full command of eye, hand, and brush. Marin also worked by rough suggestion like an Impressionist, abstracting but never abandoning his immediate surroundings. He painted on site and, like his forebears, migrated seasonally through the Hudson River Valley into New England.

Painting came as naturally to Marin as breathing. Perhaps this was why Marin could make such ambitious claims upon seen as well as unseen rhythms. Phillips's first purchase and lasting favorite, a watercolor entitled *Maine Islands,* provides an excellent case in point. Perched on a hilltop on Bold Island, a small, rocky piece of land off the banks of Stonington Harbor, Maine, Marin saw a broad rapport of ocean and sky as well as an outcropping of islands dotting the sea.[9] He conveyed this in a matter of seven strokes. But beyond the picturesque rendering, or rather overlaying it, Marin created an internal frame of slashing diagonals. The effect spoke volumes to Phillips. He saw the rushing advance of the artist's eye into the distance met by the seeming oncoming rush of faraway forms. Phillips felt that Marin had depicted the world as a "suddenly levelled glance into distance," the way an Impressionist would. Yet he also saw how Marin's "travelling eye" represented a "new world" of expressive visual opportunities being born.[10] Among the visual opportunities in 1921 was an avant-garde film by Mar-

4. Phillips, *A Collection in the Making* (Washington, D.C., 1926), 60.

5. Phillips to Stieglitz, Feb. 8, 1927.

6. Marin to Phillips, Feb. 18, 1937.

7. Phillips quotes directly from Paul Rosenfeld, *Port of New York* (New York, 1924), 156, in his piece on Marin in *A Collection in the Making,* 59.

8. Phillips, *A Collection in the Making,* 60.

9. Mackinley Helm, *John Marin* (Boston, 1948), 59, states that Marin painted this work from a hilltop in Stonington Harbor; however, an inscription by Marin on the reverse of this watercolor states that it is looking outward from Bold Island.

10. Phillips, "John Marin," 22, and paraphrase of Phillips, "Notes on a Few Watercolors by John Marin," 35–36, both in *A Bulletin of The Phillips Collection Containing Catalogue and Notes of Interpretation Relating to a Tri-Unit of Paintings and Sculpture* (Washington, D.C., 1927). Marin is often erroneously assigned authorship of the "Notes."

in's contemporaries, Charles Sheeler and Paul Strand, derived from Walt Whitman's poem "Manhatta," that included images of skyscrapers and speeding vehicles, whose collapsing spaces and colliding forms resonate in Marin's *Maine Islands* painted a year later.

Though Phillips acknowledged the urban source of Marin's quickened pulse, initially he did not venture toward Marin's cityscapes. In 1929 Phillips's inventory of Marin read like a road map of the countryside between Cliffside, New Jersey, and Deer Isle, Maine, complete with titles such as *Near Great Barrington; Mt. Chocorua—White Mountains;* and *Sunset, Rockland County.* Two of these works hail from the same trip north to the Berkshires in the fall of 1925, when Marin stopped along the Hudson River Valley long enough to paint three watercolors of Bear Mountain, including the one that sold for six thousand dollars. Reviewers such as Henry McBride and Murdock Pemberton later commented upon a specific, very tangible sense of form in these works.[11] Phillips, who came to them from a more conservative vantage point, particularly enjoyed their abstraction. He often marveled how autumn could be summoned with such immediacy by a " 'wash' of water colour on white paper"—with no preparation, just raw, not tempered, not dampened in any way.[12]

Another lesson in abstraction came from Marin's sensitivity to the complexion of the ocean. The artist had spent practically every summer since 1914 along the shore of Maine and once said, "I find my brush moving in the rhythm of wave or sail or rock."[13] Engaged by the saturated tonalities in Marin's wavelike repetitions, Phillips actually renamed a painting in order to convey its overwhelming sense of the color gray. (The title was changed from *Sea Piece* to *Grey Sea.*) Marin's fascination with the disposition and description of boats—he loved any and all kinds—was another early and lasting interest of Phillips. *Fishing Smack,* purchased in 1930, and *Four-Master off the Cape,* purchased in 1942, demonstrate a range from animated improvisation to descriptive stillness and clarity. Even in the improbable marginalia of sails penciled across the bottom of *Four-Master off the Cape,* the representation remains convincing. Marin, like his hero Eugène Boudin, "put in all the lines but never spoiled the essence of boat."[14]

In December 1930 Stieglitz called his installation of Marin's New York scenes his "NY room," adding that he wanted to keep them together "to keep a vital idea *undiluted.*"[15] Out of this show, which he visited twice, Phillips asked Stieglitz for an option on a watercolor entitled *Street Crossing.* The work represented a departure for Marin. In 1913 Marin had been among the first to tackle the subject of New York's Woolworth Building, as he and all of New York watched the building's completion. By the late twenties and throughout the thirties, however, Marin's focus shifted from the arrival of specific landmarks upon the changing skyline to the ambient energy on the street. In 1928 his sketches described crowded clutches of pedestrians amid traffic and electric signs in canyonlike crossings. Marin's poetry echoed this urban energy: "glass metal

11. See [Henry McBride], "John Marin in Pastoral Mood," *The New York Sun,* Nov. 13, 1926, 5; L. K. [Louis Kalonyme], "Art Notes of the Week: John Marin's Water Colors as Music," *The New York Times,* Nov. 14, 1926, 10; and Murdock Pemberton, "News in Art Galleries: Marin Comes to Rest," *The New Yorker* (Nov. 20, 1926), 75–76.

12. Phillips, *A Collection in the Making,* 59.

13. Quoted in Edwin Alden Jewell, "A Marin Retrospective," *The New York Times,* Oct. 25, 1936, cited by Donna M. Cassidy, "The Painted Music of Arthur G. Dove, John Marin, and Joseph Stella: An Aspect of Cultural Nationalism" (Ph.D. diss., Boston University, 1988), 197.

14. Marin, quoted in Helm, *John Marin,* 74.

15. Stieglitz to Phillips, Dec. 7, 1930.

lights . . . lights brilliant noises . . . through wires . . . taut, taut, loose and taut."[16] In words akin to those of e. e. cummings, Marin later termed his new sensibility "a rhythmic-hearing-breathing." Gone were the lyrical watery washes cascading about the Woolworth. Replacing them was a new emphasis on line or, as Marin phrased it in a letter to Phillips, "movements in paint controlled by lines."[17] Lines put down as rectangles or rhombuses either built spaces for figuration and color or densely overlaid it. Eventually Marin found watercolor unsuitable for the sensations provoked by such complex terrain. He needed the weight and manipulable properties of oils. "Paint," he told Stieglitz, "builds itself up—moulds itself—piles itself up."[18] But how could he attune himself to the responses of this medium? The question remained with the artist for the next two decades.

Critics wondered whether Marin's oils would ever match his mastery in watercolor. The canvases seemed heavy and ponderous, lacking in the spontaneity expected from Marin. The jury remained out on Marin's oils for most of the 1930s, but in 1933 one reporter opined in a rare positive vein that his oils "have awakened new powers."[19] When Phillips saw *Pertaining to Fifth Avenue and 42nd St.* in 1934, he recognized the hallmarks of great oil painting. His enthusiasm was such that he made the unthinkable mistake of showing his hand immediately. "This one," he told Stieglitz, "I really covet for the collection."[20]

What Phillips saw among the black architectural schema and the gray effects of weather and crowds was Marin's remarkably rich and varied handling of paint. The surface demonstrated an exciting combination of flat and impasto, wet-into-wet strokes as well as lines brushed onto dry areas. Each aspect contributed to an overall effect of cacophony and movement. It took Phillips another three years to negotiate the price with Stieglitz. When the painting arrived in Washington on the occasion of a Marin retrospective in 1937, it was the first of six Marin oils that eventually became part of the collection. Soon after attending the opening, Marin told Phillips in so many words that he had chosen the right painting. "I do hope it will wear well . . . it will be in Some mighty good Company. But as I respect your judgment of pictures I must respect your purchase and say quite probably you have a good picture. . . . It is not that it is just a good picture—there are many in the world—but it has all through it that which I find so lacking [in others,] that which I am striving so after—rythm [*sic*]— and that to me hooks a picture right up with—music."[21]

Marin's remarks must have seemed gratifying to Phillips after the long and difficult negotiations with Stieglitz. The artist was secure in himself, secure enough financially, and secure enough in his relationship with Stieglitz to have a friendship with the Phillipses. He never missed the opportunity to attend one of his openings at their museum, and on one occasion gave a lecture. Marin entertained with equal good humor the suggestion that he paint the view from Phillips's home on Foxhall Road. In the 1930s, when Phillips himself tried his hand at landscape painting, Marin expressed

16. Marin's prose poem, "John Marin by Himself," *Creative Art* (Oct. 1928), 35–39.

17. Marin to Phillips, Jan. 6, 1949.

18. Marin to Stieglitz, July 20, 1931, Yale Collection of American Literature, Beinecke Rare Book and Manuscript Library, Yale University, New Haven, Connecticut.

19. Elizabeth McCausland, *Springfield Republican* (Massachusetts), Nov. 24, 1933, quoted in Sheldon Reich, *John Marin: A Stylistic Analysis and Catalogue Raisonné* (Tucson, 1970), 202.

20. Phillips to Stieglitz, Jan. 30, 1934.

21. Marin to Phillips, Feb. 18, 1937.

his admiration. "You are one of us," he told Phillips.[22] Among the last Marins to enter the museum's permanent collection was a small pencil sketch, a self-portrait that the Phillipses kept with them at home.[23]

GEORGIA O'KEEFFE: A "FEELING OF THE EARTH"

*"All must recognize the potency of her palette."*
Duncan Phillips, *A Collection in the Making,* Washington, D.C., 1926

In 1916 the arrival at 291 of O'Keeffe's "burning watercolors" from Texas had an immediate liberating effect upon Stieglitz and his circle.[1] Like her peers, she had seen Picasso and read Kandinsky's *Concerning the Spiritual in Art,* but O'Keeffe brought something all her own into the room. Stieglitz hung O'Keeffe's most austere, most accomplished watercolor of two blue lines near his office door. By 1918 the alliance was set, and Stieglitz named O'Keeffe "the spirit of 291."[2] She became 291's measure of authenticity in exchange for what she wanted most in the world, a year to paint without the restrictions of teaching school. O'Keeffe never turned back.

In later years Stieglitz liked to recall the moment when Dove first saw the blue watercolor and praised O'Keeffe for "doing without effort what all we moderns have been trying to do."[3] In 1920 Hartley likewise acknowledged O'Keeffe: "I progressed so far in my own esteem the past three days that I want to give you the credit for your share. . . . I got something in your room on Sunday that set me off like a new volcano. I think it was the honesty and freedom that exists in your room—in you—in A.S."[4] Taking his cue from Stieglitz, Paul Rosenfeld often used O'Keeffe as a point of comparison in his critical assessments. He noted, for example, that Hartley, like O'Keeffe, took risks with color. He took it as a sign of refinement that Hartley found his white in his black, his yellow in his violet, while O'Keeffe's close, taut harmonies, such as white against pearl, violet against red, were a product of instinct or feeling.[5] Observing that Dove and O'Keeffe shared a "direct sensuous feeling of the earth," Rosenfeld declared Dove to be "directly the man in painting, precisely as Georgia O'Keeffe is the female."[6]

When Phillips began to collect O'Keeffe in 1926, it became his task to separate the artist from the mountains of prose already projected upon her work. Given his complex relationship with Steiglitz, the collector was only partially successful. The fact that Phillips and Stieglitz were both married to painters had been partial grounds for their initial friendship. Stieglitz included encouraging words regarding Marjorie Phillips's exhibition at Durand-Ruel in his correspondence concerning the shipping of O'Keeffe's paintings to Washington in 1926, just as the talk of O'Keeffe's latest exhibition would thread through the heated correspondence about the six-thousand-dollar

22. Quoted in Marjorie Phillips, *Duncan Phillips and His Collection,* rev. ed. (New York, 1982), 104.

23. It came to the permanent collection as part of Marjorie Phillips's bequest in 1985.

1. Dove's reference to O'Keeffe in his autobiographical statement published in Samuel M. Kootz, *Modern American Painters* (New York, 1930), quoted in Ann Lee Morgan, ed., *Dear Stieglitz, Dear Dove* (Newark, 1988), 190.

2. Stieglitz to Paul Strand, May 17, 1918, quoted in Benita Eisler, *O'Keeffe and Stieglitz: An American Romance* (New York, 1991), 169.

3. In Herbert J. Seligmann, *Alfred Stieglitz Talking: Notes on Some of His Conversations, 1926–1931* (New Haven, 1966), 44.

4. Hartley to O'Keeffe, Jan. 14, 1920, Yale Collection of American Literature, Beinecke Rare Book and Manuscript Library, Yale University, New Haven, Connecticut (cited as YCAL).

5. Paul Rosenfeld, *Port of New York* (New York, 1924), 88, 201.

6. Ibid., 168 and 170. For similar ideas on O'Keeffe and landscape, see p. 206.

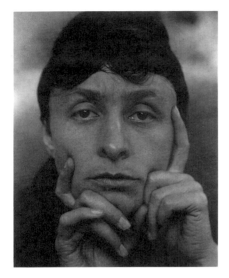

Alfred Stieglitz, *Georgia O'Keeffe: A Portrait—Head,* 1918, gelatin silver print, National Gallery of Art, Washington, D.C., Alfred Stieglitz Collection

7.  Phillips, *A Collection in the Making* (New York, 1926), 66.

8.  Ibid.

9.  Georgia O'Keeffe, *Georgia O'Keeffe* (New York, 1976), fig. 33.

10. Stieglitz to Paul Rosenfeld, Aug. 28, 1920, YCAL, quoted in Sarah Whitaker Peters, *Becoming O'Keeffe: The Early Years* (New York, 1991), 234.

11. Stieglitz to Dove, Aug. 28, 1920, YCAL, quoted in Morgan, *Dear Stieglitz, Dear Dove,* 70. For a discussion of the importance of photography to her art, see Peters, *Becoming O'Keeffe: The Early Years,* 183–221, and on their relationship, see pp. 223–75.

12. O'Keeffe to Elizabeth Stieglitz Davidson, [Nov. 24, 1923], YCAL.

Marin in 1927. Wary of her proximity to Stieglitz, Phillips kept his distance from O'Keeffe. His ideas and questions about her work remained relatively unchanged after 1929.

In March 1926, with the purchase of *Red Canna,* Phillips plunged headlong into O'Keeffe's most radical ideas about color—namely her ability to sustain the power and potency of red by adding minor highlights of lilac and yellow within the triad of petals. In his lengthy assessment on O'Keeffe for *A Collection in the Making,* Phillips marveled at what he called "her courage in so often prolonging the intensity of a theme based on one color or on the intricate elaboration and enlargement of one linear motif."[7] It never occurred to him to describe the specifics of the flower. It was as though her rendering, like a photographer's close-up, had created a wholly new and quite abstract context. Likewise, although Phillips recognized the symbolic intensity of the image, comparing it to "a hard gem-like flame," he never addressed its meaning; it embodied something unnameable.[8]

Phillips kept the red painting four years before trading it back to Stieglitz. Although he was as anxious as Stieglitz to see O'Keeffe accepted as an equal with her male peers, Phillips found that her most distinctive colors—what O'Keeffe asserted as hers alone—fought with the color of the other members of the circle. Phillips decided to keep only the paintings with a darker palette of burnt red with gray-green and deep blue-violet. O'Keeffe would later disdain the muted tones in Phillips's initial purchase, *My Shanty, Lake George,* referring to it as "one of those dismal colored paintings like the men."[9]

At the time it was painted, *My Shanty* celebrated O'Keeffe's sole occupancy of her own studio at Lake George—what Stieglitz called "her dream in concrete form."[10] It was then, as the painting shows, an old barn perched high in a verdant meadow against the dark mountain, a distant walk away from the house. Great enthusiasm had surrounded the old barn's renovation. For a short time she and Stieglitz even shared the space, calling it "our own shanty."[11] Her hands were photographed by Stieglitz near its door, and the line of hills behind it extolled their common source of inspiration: "Alfred just called me to look out the front window—The mountain on the other side of the lake is a dark burning red—The light trees in spots—each tree seems almost as clear—as the leaves on the poplar trees and a little grey cloud is lying along the top of the mountain—it is wonderfully clear—deep burning color—and near yellow trees—I wish you could see it."[12]

O'Keeffe began compiling a portfolio for her own use from the photographs Stieglitz threw away. In them she found a new approach to painting in oils. She explored the photographer's shallow depth of field, creating spaces in her paintings that wavered between illusion and surface pattern. She moved close up to leaves and flowers to extrapolate contours; she thinned down her paints and conveyed her colors with graphic clarity in controlled, anonymous strokes. In *Pattern of Leaves,* which Phillips

purchased in 1926, a red maple leaf fans across a frozen gray-green pattern of drier, thinner leaves. A warm yellow light radiates from behind the torn part of the leaf, emphasizing the defect in its otherwise singularly perfect aspect.

By the mid-twenties O'Keeffe openly challenged the men by adding a new subject to her repertoire: the city. She knew this was encroaching on their well-marked turf. Stieglitz had been photographing New York since 1893, and the vividly sharp reports of Marin's improvisations on the Woolworth Building—"flying around–falling down," as O'Keeffe described it—had captured the city's new tempo and pace.[13] O'Keeffe now proposed to build a crystalline architecture of color, based upon the geometry of the new skyscrapers she saw springing up around her and Stieglitz's lofty perch on the thirtieth floor of the Shelton Hotel. When O'Keeffe declared her intention, Stieglitz added a cautionary note: "Even the men had not done too well with it."[14] But from the start, in 1925, she promised critic Henry McBride that "my New Yorks would turn the world over."[15] Between 1925 and 1930 O'Keeffe painted more than twenty New York images.

Twice Phillips took interest in purchasing from this series. Both paintings were night scenes, both vertical compositions filled by a single tower of lighted windows. Both captured the "rude thrust" as well as the "glitter" of New York, as Herbert Seligmann once said.[16] Widely publicized and reproduced in 1927, Phillips's first choice, *Shelton at Night,* immediately marked a new American aesthetic in the mind and imagination of the intelligentsia. As early as 1926 Phillips had been hearing Stieglitz's accounts of their first exhibition in the Room. "Weyhe [Phillips's publisher] came today & I never saw him so excited. Says: O'Keeffe is in a class by herself here in America. Brancusi told me he felt she was the only *true American* painter he had seen."[17] Had Stieglitz and Phillips not fallen out, O'Keeffe's New York would probably have come to Washington sooner. As it turned out, in 1930 another painting, *New York Night,* hung in Phillips's museum on approval—only to be returned. Why?

By the end of the decade O'Keeffe's optimistic fascination with the city ended, as did her active enlistment in the Stieglitz circle's quest for an independent American aesthetic (what she later irreverently called "The Great American Thing").[18] In 1930, when Phillips returned O'Keeffe's *New York Night,* he also traded a Marin watercolor of Taos and purchased the O'Keeffe *Ranchos Church.* It was as though Phillips was acknowledging Marin's commitment to continue sketching on the streets of New York and O'Keeffe's claim to another plot of ground. When it came to selecting real estate, O'Keeffe chose what she knew to be her own inspiration—the West. She once told an interviewer in 1930, "Before I put brush to canvas, I question, 'Is this mine? Is it all intrinsically of myself? Is it influenced by some idea or some photograph of an idea which I have acquired from some man?'"[19] The expansive and undulating adobe Ranchos Church against a crystalline blue sky could not be further from the stark contrasts of machine-age New York.

13. O'Keeffe to Anita Pollitzer, Feb. 1916, YCAL, quoted in Clive Giboire, *Lovingly, Georgia: The Complete Correspondence of Georgia O'Keeffe & Anita Pollitzer* (New York, 1990), 148.

14. O'Keeffe's recollection quoted in Anna C. Chave, "Who Will Paint New York?: 'The World's New Art Center' and the Skyscraper Paintings of Georgia O'Keeffe," *American Art* (winter/spring, 1991), 97.

15. O'Keeffe to McBride, Mar. 1925, YCAL, quoted in Jack Cowart, Juan Hamilton, and Sarah Greenough, *Georgia O'Keeffe: Art and Letters* (Washington, D.C., 1987), 179.

16. Seligmann quoted in James Moore, "So Clear Where the Sun Will Come: Georgia O'Keeffe's Gray Cross with Blue," *Artspace* (summer, 1986), 35, quoted in Chave, *American Art,* 98.

17. Stieglitz to Phillips, Mar. 4, 1926, The Phillips Collection Archives. Weyhe was in the process of publishing Phillips's *A Collection in the Making,* which came out that December.

18. O'Keeffe, *Georgia O'Keeffe.*

19. O'Keeffe, interview with Michael Gold in Gladys Oak, "Radical Writer and Woman Artist Clash on Propaganda and Its Uses," *The World* [New York] (Mar. 16, 1930), women's section, 1, 3, quoted in Barbara Butler Lynes, *O'Keeffe, Stieglitz, and the Critics, 1916–1929* (Ann Arbor, MI), 158.

Phillips's lasting impression of O'Keeffe was in the West. His last purchases in the 1940s underscore this point. In 1941, after almost a decade, Phillips acquired another O'Keeffe, *From the White Place.* Like *Ranchos Church,* it featured a setting of signal importance to the artist. In the summer of 1940 O'Keeffe had purchased a house in the village of Abiquiu, a place where she could have a garden and where, eventually after Stieglitz's death, she could live year-round. During the renovations that followed, O'Keeffe cut a large window through her bedroom wall so that she could look out from the little house on the mesa to a wall of white volcanic ash rising in the distance. Her painting of the towering V-shaped rock sentinels merging with the gray sky takes us directly to O'Keeffe's solitary refuge.

In the end Phillips would return to the powerful palette of red and violet that O'Keeffe made all her own. In 1945 he purchased *Red Hills, Lake George.* Painted in 1927, it was an image that united the aspects of O'Keeffe's complex, somewhat divided life with Stieglitz. In it one finds the undulating hills of Lake George, whose lines were closely identified with Stieglitz, now stripped of the green O'Keeffe found so confining. The mountains glow red against a fiery sunset, animated by O'Keeffe's singular knowledge of a beauty full of contradictions—a landscape vast yet intimately revealing, consuming yet untouchable.

## ALFRED STIEGLITZ: THE "BREATHING OF MOMENTS"

*"[Stieglitz] had a curious intuitive faith that the black box and the chemical bath and the printing paper could be made to record to his satisfaction what he felt about the world."*
Paul Rosenfeld, *Port of New York,* New York, 1924

In December of 1926, when he first became aware of the collector's ambition, Stieglitz admonished Phillips: "You will not only have to have a large group of Marins but undoubtedly groups of Dove and O'Keeffe, maybe Hartley even, not to speak of my own photographs."[1] Phillips admired Stieglitz's photographs, even asked to publish and exhibit them, but he never purchased any.[2] According to O'Keeffe, Stieglitz thought to make Phillips a present of his works. Ultimately a set of cloud photographs arrived at the museum in 1949, at the time of the dispersal of Stieglitz's estate. By thus completing the Stieglitz circle at Phillips's museum, the photographer had a posthumous final word with the collector. The selection was telling.

Phillips was given nineteen four-by-five-inch silver prints. Unnumbered, they comprise not a sequence but a range of expression. The unfolding of patterns and tonalities, derived from sunlight and the gestures of clouds, denote a sense progression—light out of darkness, movement to rest, space opening up or closing down. Most of the prints are turned on a vertical axis. Only one retains the Lake George horizon. Two depict trees—one a lone poplar and the other a top of a dead chestnut

1. Stieglitz to Phillips, Dec. 11, 1926. Unless otherwise noted, all letters cited are in The Phillips Collection Archives.
2. Phillips wrote asking to reproduce Stieglitz's cloud photographs in his article, "Personality in Art: II," for *American Magazine of Art* (Mar. 1935), 148–55. See Phillips to Stieglitz, Dec. 1, 1934, and Stieglitz to Phillips, Dec. 12, 1934; and for his interest in exhibiting them, see Phillips to Stieglitz, Feb. 8, 1937, and Stieglitz to Phillips, Feb. 12, 1937.

tree against the sky. The remainder contain only clouds. Within this group there exists a "subset H" that is unique to Phillips's museum. There are a light and a dark print from the same negative, as well as two prints from what appears to be two consecutive exposures of an expanding cloud form. Also included is perhaps Stieglitz's most radical abstraction: a dense relief of white clouds weighted at the top by a thin band of black. Turned and mounted—effectively disassociated from place and time—these cloud photographs convey a great deal about the ideals that governed the artist himself.

Starting in the summer of 1922, and continuing every summer until 1931, Stieglitz made photographs of clouds, which he would hang on the gallery walls alongside works of the young painters he championed. Like Hartley's dark mountains, O'Keeffe's night skies, Dove's glowing suns, and Marin's ocean waves, they shared a source of inspiration from nature. Stieglitz took up the American landscape theme late in his career, drawing from the painters. He had looked out his Lake George window almost every summer since the age of nine without once desiring to make a photograph there. Clouds had not held his interest since 1883, when he had experimented with orthoplates in Switzerland during his student days. But in 1922 Stieglitz began to approach the subject with bursts of great enthusiasm, as if seeing the world for the first time. In the thick of a campaign, Stieglitz would report, "I have been busy with clouds" or "It's a wild glorious morning. Maddeningly beautiful. . . . I ought to be skying."[3] Equally engaged by selecting and mounting the resulting prints, he once remarked, "such fool things many—yet fascinating each. . . . There is life.—So simple—what is it?"[4]

The earliest group comprised a sequence of ten images called "Music," where a single mountain is variously silhouetted against the the clouds. In 1923 he composed a more loosely defined series of smaller prints called "Songs of the Sky," whose partial trees and horizon meet with an increasingly dominant complexion of sky. By 1925, when Stieglitz began to tilt his four-by-five-inch Graflex all the way up, the series abandoned vegetation and moisture and earth altogether.[5] Stieglitz called these later photographs "Equivalents" because he believed only these cloud forms were equal to the task of conveying his emotions and ideas purely.

The clouds could have told Phillips a great deal about Stieglitz's understanding of abstraction. They disclosed how the photographer found opportunities for texture and movement by pointing his camera where the dark undulating masses opposed the sky and where the sun's disk poured through radiating white vapors or through dense petals of black. Like Kandinsky, Stieglitz preferred musical analogies for his work. His open letter published in 1923 and entitled "How I Came to Photograph Clouds" explained his aim: "I wanted a series of photographs which when seen by the great composer Ernest Bloch he would exclaim: 'Music! Music!'"[6]

Paul Rosenfeld praised Stieglitz's new prints: "Snaps from the hand-camera and plates from the large camera of the tripod, all are infinite rhythms of warm wondrous light, choral symphonies and dances of the sun pour. The tiny scale between black and

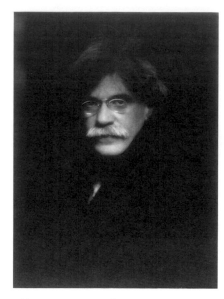

Alfred Stieglitz, *Alfred Stieglitz, Self-Portrait,* 1910, gelatin silver print, Philadelphia Museum of Art, from the Collection of Dorothy Norman

3. Stieglitz to Sherwood Anderson, Sept. 2, 1923, and to Herbert J. Seligmann, Oct. 6, 1923, both quoted in Sarah Whitaker Peters, *Becoming O'Keeffe: The Early Years* (New York, 1991), 245. For remembrances of Stieglitz's early cloud experiments, see his "How I Came to Photograph Clouds," *The Amateur Photographer and Photography* (Sept. 19, 1923), 255.

4. Stieglitz to Anderson, July 30, 1923, Yale Collection of American Literature, Beinecke Rare Book and Manuscript Library, Yale University, New Haven, Connecticut (cited as YCAL).

5. Discussed in Peters, *Becoming O'Keeffe: The Early Years,* 244. Stieglitz's full title for his first series was *Music: A Sequence of Ten Cloud Photographs.*

6. Stieglitz, "How I Came to Photograph Clouds," 255.

white is distended in these prints to an immense keyboard of infinitely delicate modulations. . . . The delicious variations of light utter exciting rhythms and many-voiced speech like the modern orchestra machine's. . . . And the fiercely burning points of illumination have the pierce of the brass."[7] The writer affirmed Stieglitz's greatest hope—that the forms of his clouds could launch a viewer's imagination as powerfully as could music or painted abstractions. Stieglitz meant to drive home this comparison when he held a joint exhibition of O'Keeffe's paintings and his photographs in the spring of 1924.[8]

Although O'Keeffe acknowledged the similarities between Stieglitz's tiny prints and her abstractions, she preferred to stress Stieglitz's fidelity to his medium. She explained to Sherwood Anderson, "He has done with the sky something similar to what I had done with color before. . . . He has done consciously something I did most unconsciously—and it is amazing to see how he has done it out of the sky with the camera."[9] O'Keeffe's observation made two points: if the new photographs revealed something about abstraction, they also said something about the capabilities of photography itself.

What amazed O'Keeffe about Stieglitz's clouds also captivated Phillips, who wrote: "Even the sharpest lens of that precise fact-finding instrument, the camera, can be as sensitive to the touch and as malleable to the mind as a violin."[10] Phillips, like many others, found it difficult to see how the mechanics of photography could yield anything of personal significance or aesthetic value. Stieglitz's desire to prove that the

7. Paul Rosenfeld, *Port of New York* (New York, 1924), 238–39.

8. This exhibition was held at Anderson Galleries, New York, from March 3 to 16.

9. O'Keeffe to Anderson, Feb. 11, 1924, quoted in Jack Cowart, Juan Hamilton, and Sarah Greenough, *Georgia O'Keeffe: Art and Letters* (Washington, D.C., 1987), 176.

10. Phillips, "Personality in Art: II," 154.

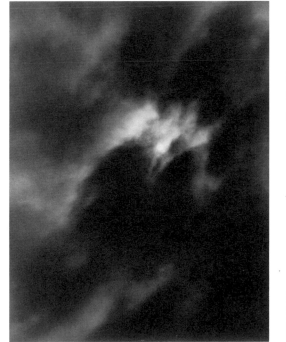

Alfred Stieglitz, *Equivalent* [Bry no. 175A], 1926, gelatin silver print

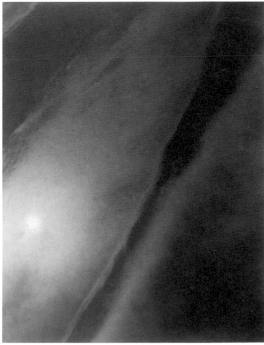

Alfred Stieglitz, *Equivalent* [Bry no. 149C], 1931, gelatin silver print

camera could be reconciled with artistic expression led him to search for a subject so elusive, so ephemeral that only a photograph could capture it.

Several events in 1922 may have served as catalysts for Stieglitz. Old prejudices about photography resurfaced in an artists' survey he had organized. The question was "Can a photograph have the significance of art?"[11] Waldo Frank, thinking to praise Stieglitz's portraiture in his response, spoke of how the photographer seemingly hypnotized his sitters. Then there was the matter of the "false success" of Man Ray, whose cameraless photochemical abstractions were widely publicized and much acclaimed in *The Little Review* and *Vanity Fair*.[12] By the end of 1923 Stieglitz had a retort that he would later display in the Brooklyn Museum's machine-age exhibition of 1926–27.[13] Introducing his new work to poet Hart Crane, he wrote, "I know exactly *what* I have photographed. I know I have done something that has never been done.—May be an approach occasionally [found] in music.—I also now that there is more of the really abstract in some 'representation' than in most of the dead representations of the so called abstract fashionable now.—I have scientific proof to show the correctness of that statement. The camera is really a wonder instrument—if you give it a chance."[14]

After more than thirty-five years in photography, what had Stieglitz discovered about the camera? His handheld Graflex was not the first to photograph clouds or the sun. Was it that he had chosen to photograph the sky alone or chose a new orientation from the horizon? No. Those decisions were independent of his instrument. What ultimately excited Stieglitz about the camera was something more than his mind or hand alone could accomplish. It was quite simply a sense of "wonder," which could connect the instant of vision and emotion, of seeing and feeling. His prints served as proof that, as he told Paul Strand, "I have really gotten the breathing of moments down."[15]

11. He asked the question of his circle, publishing their responses in the December issue of *Manuscripts*, no. 4 (1922).

12. For a discussion of Waldo Frank's reply, see Peters, *Becoming O'Keeffe: The Early Years*, 241. Marius de Zayas to Stieglitz, Aug. 3, 1922; reprinted in "Can a Photograph Have the Significance of Art?" *Manuscripts*, no. 4 (Dec. 1922), 18; quoted in Elizabeth Hutton Turner, "Transatlantic," in Merry Foresta et al., *Perpetual Motif: The Art of Man Ray* (Washington, D.C., 1988), 147.

13. The title of the Brooklyn exhibition is "International Exhibition of Modern Art"; Stieglitz included four of his cloud photographs. See Ruth Bohan, *The Société Anonyme's Brooklyn Exhibition: Katherine Dreier and Modernism in America* (Ann Arbor, Mich., 1982), 156–57. In May 1927 Jane Heap of *The Little Review* held a show called *Machine-Age Exposition.*

14. Stieglitz to Hart Crane, Dec. 10, 1923, YCAL, quoted in Greenough and Hamilton, *Alfred Stieglitz: Photographs and Writings* (Washington, D.C., 1983), 208.

15. Stieglitz to Paul Strand, Oct. 15, 1923, quoted in Peters, *Becoming O'Keeffe: The Early Years*, 245.

# In the American Grain

*"I . . . have but one ambition——to put down with a sense of authority and artistic conviction an object——some days for form only——then for color."*

*Marsden Hartley*

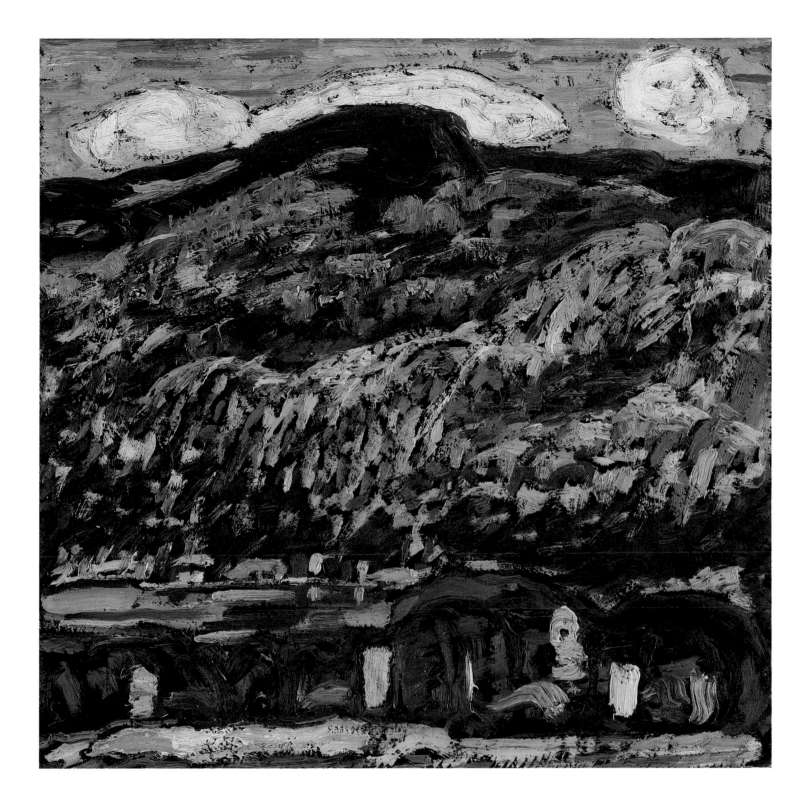

Marsden Hartley, *Mountain Lake—Autumn*, ca. 1910, oil on academy board

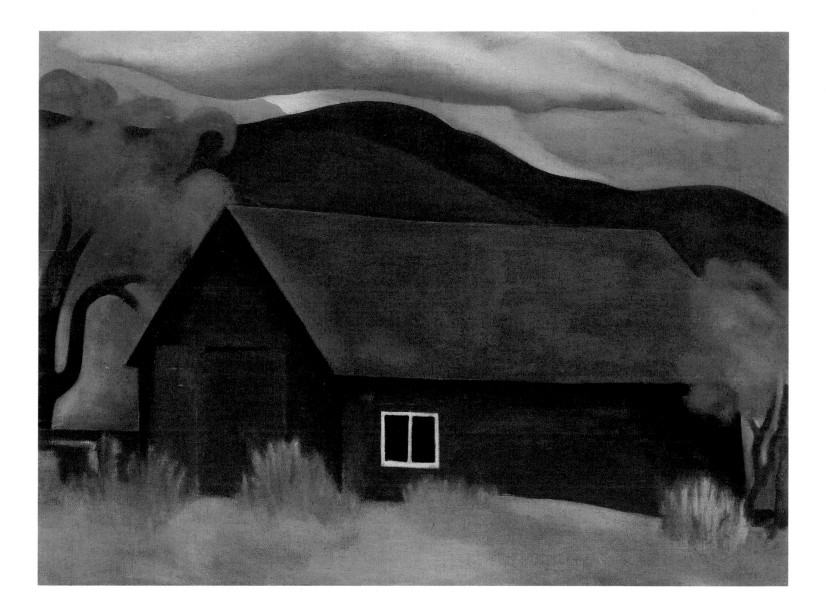

Georgia O'Keeffe, *My Shanty, Lake George,* 1922, oil on canvas

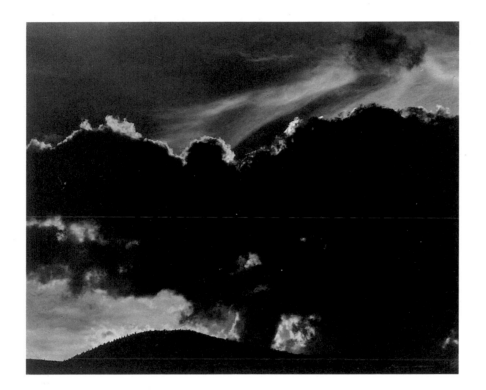

Alfred Stieglitz, *Songs of the Sky* [Bry no. 155B], 1924, gelatin silver print

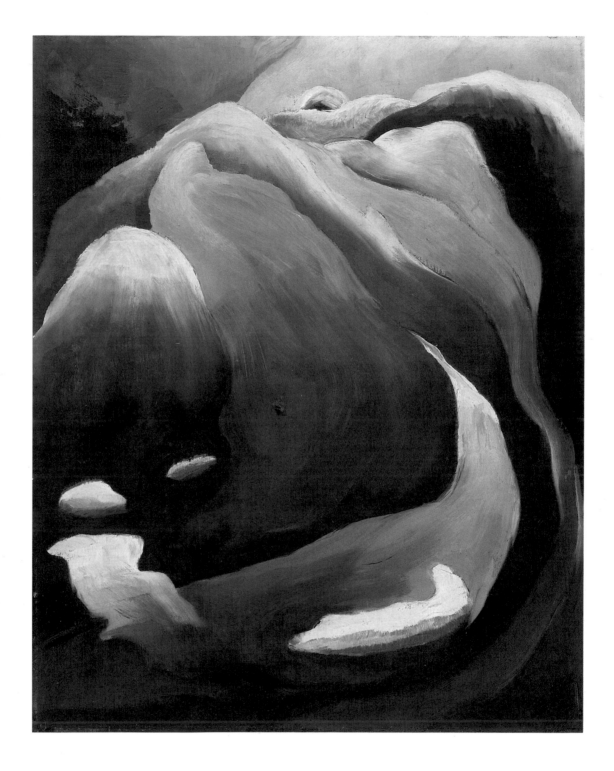

Arthur Dove, *Waterfall,* 1925, oil on hardboard

Arthur Dove, *Golden Storm,* 1925, oil on plywood panel

John Marin, *Weehawken Sequence, No. 30,* ca. 1916, oil on canvas board

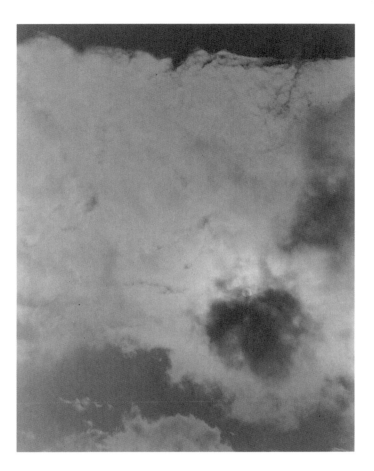

Alfred Stieglitz, *Songs of the Sky* [Bry no. 159E], 1923, gelatin silver print

*"I find my brush moving in the rhythm of wave or sail or rock."*

*John Marin*

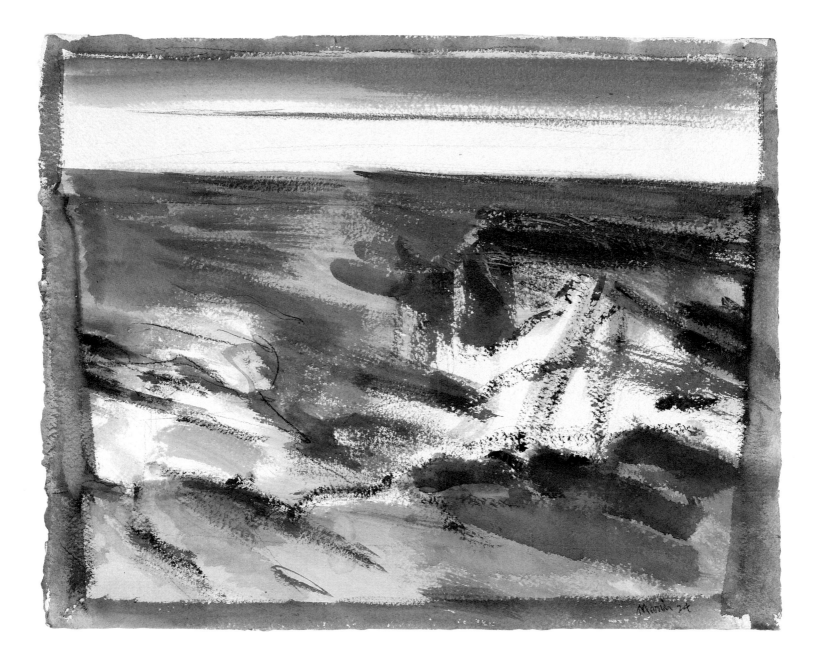

John Marin, *Grey Sea*, 1924, watercolor and black chalk on paper

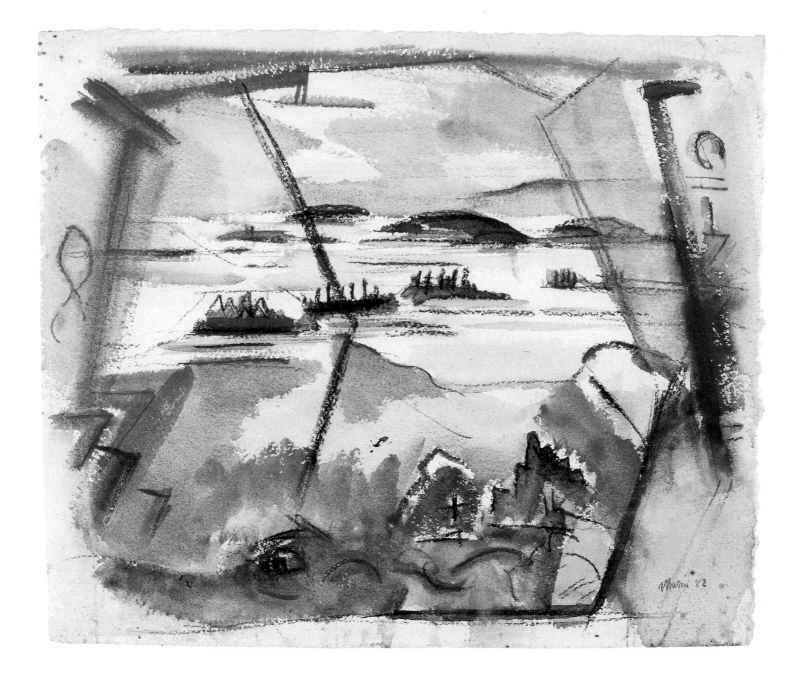

John Marin, *Maine Islands,* 1922, watercolor and charcoal on paper

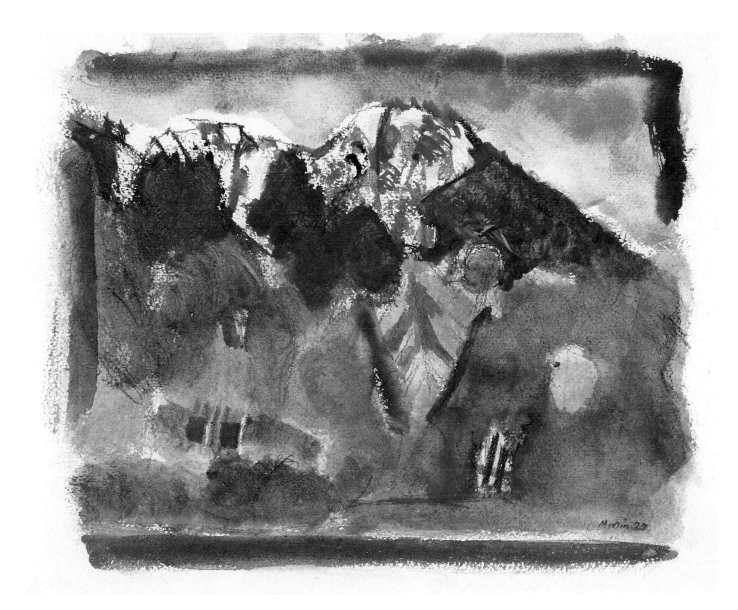

John Marin, *Near Great Barrington,* 1925, watercolor and pencils on paper

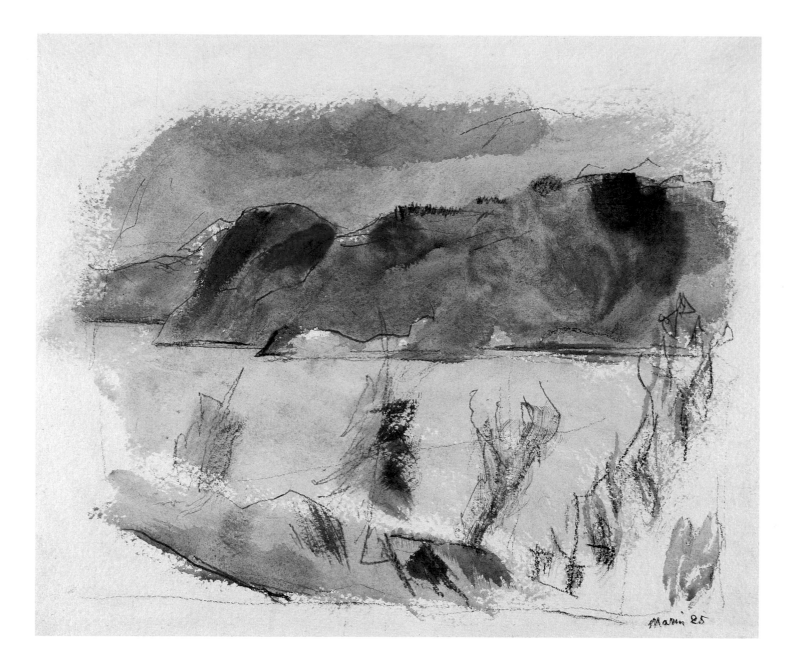

John Marin, *Hudson River Near Bear Mountain,* 1925, watercolor and black chalk on paper

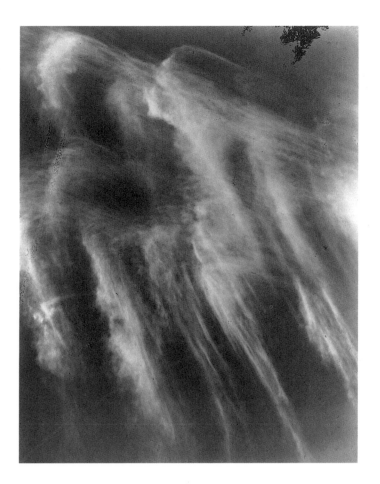

Alfred Stieglitz, *Equivalent* [Bry no. 153B], 1930, gelatin silver print

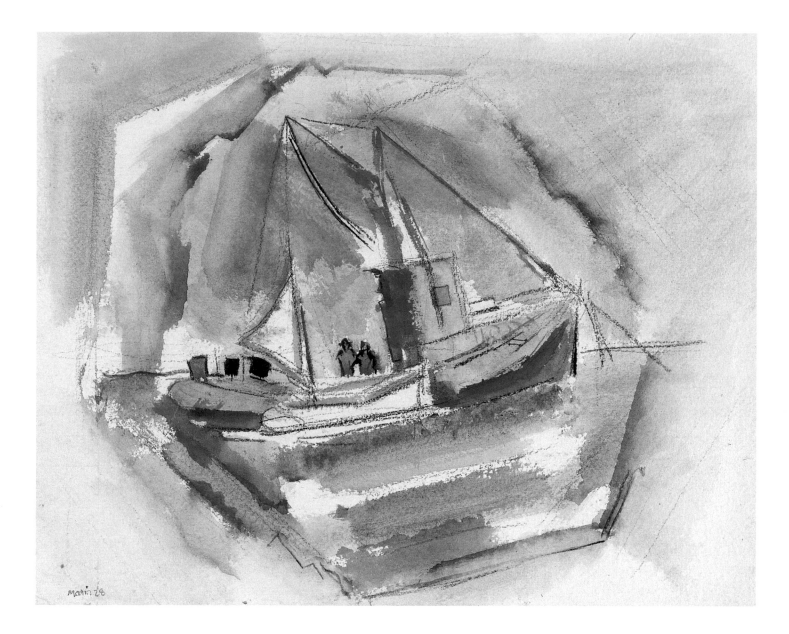

John Marin, *Fishing Smack*, 1928, watercolor, pencils, and black chalk on paper

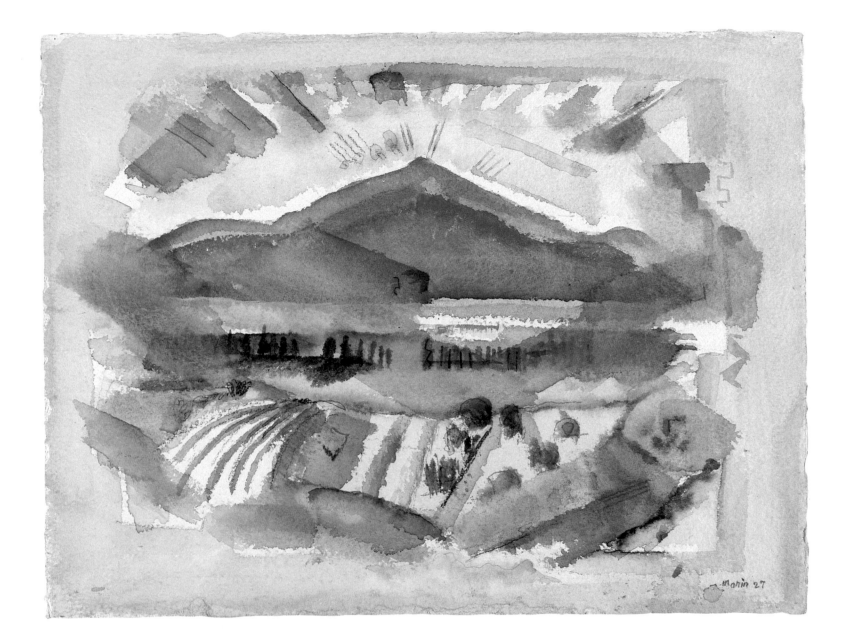

John Marin, *Franconia Range, White Mountains, No. 1*, 1927, watercolor, graphite pencil, and black chalk on paper

John Marin, *Street Crossing, New York*, 1928, watercolor, graphite pencil, and black chalk on paper

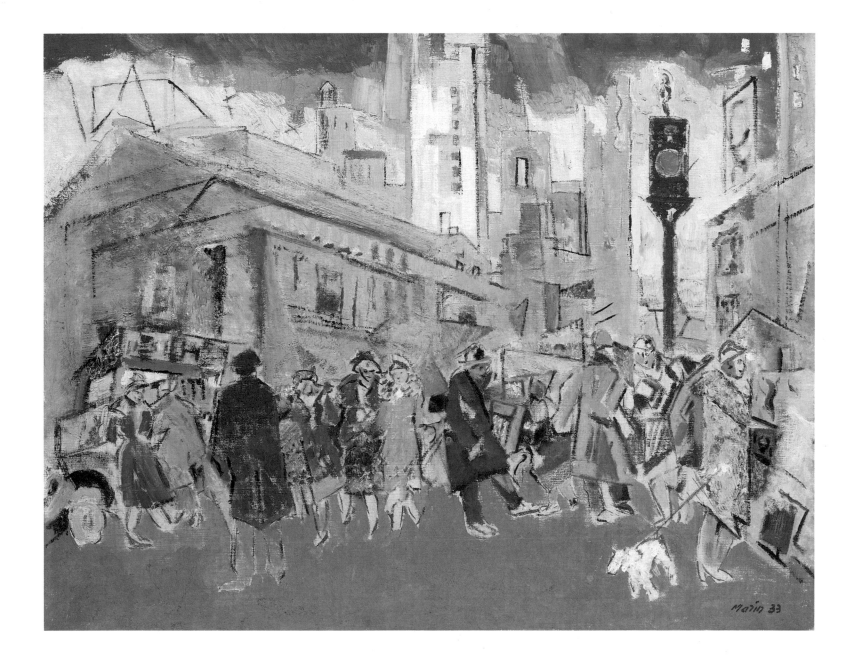

John Marin, *Pertaining to Fifth Avenue and Forty-Second Street,* 1933, oil on canvas

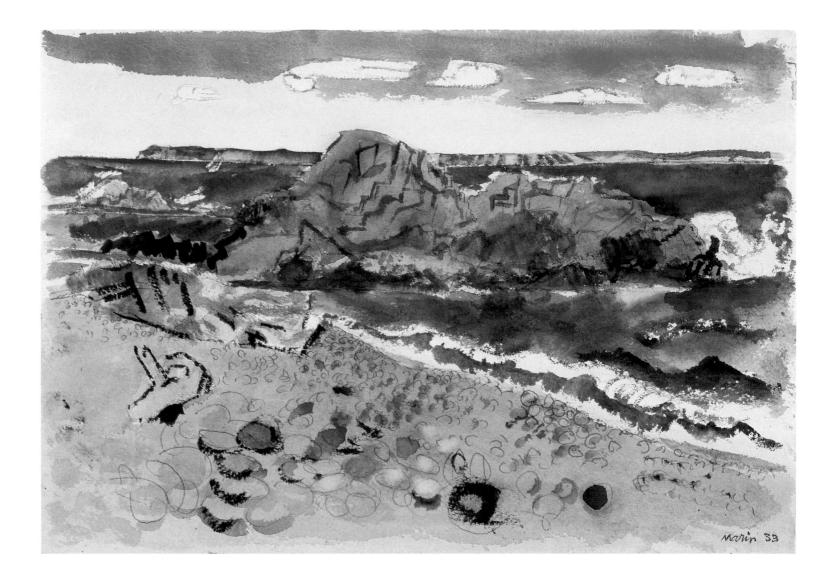

John Marin, *Quoddy Head, Maine Coast*, 1933, watercolor and black chalk on paper

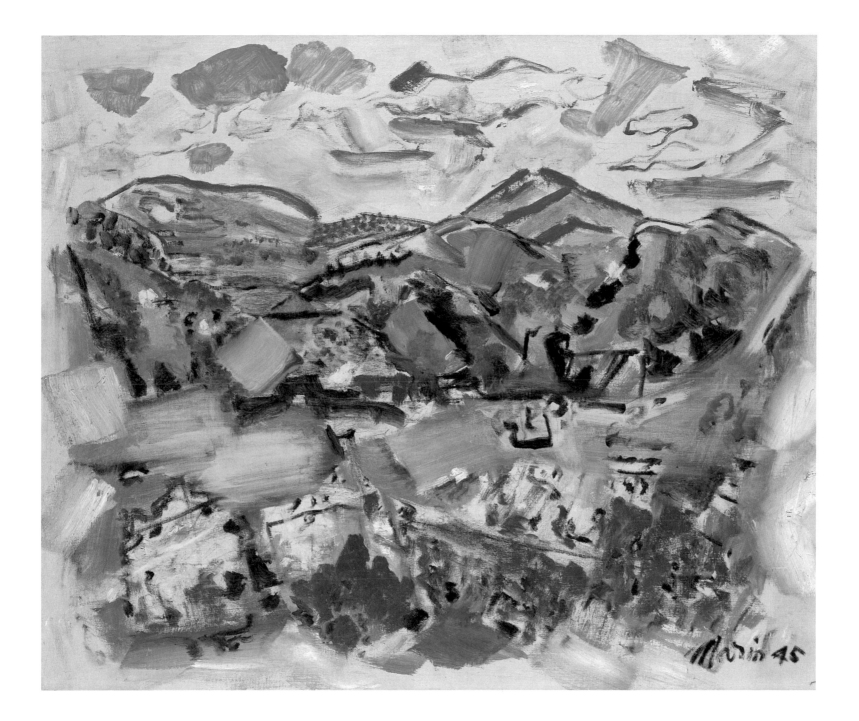

John Marin, *Tunk Mountains, Autumn, Maine*, 1945, oil on canvas

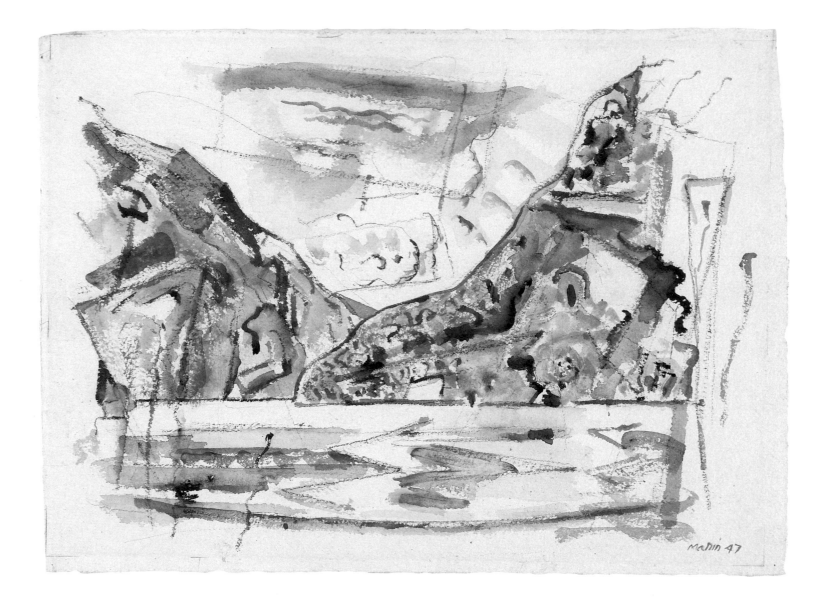

John Marin, *Adirondacks at Lower Ausable Lake,* 1947, watercolor and graphite pencil on paper

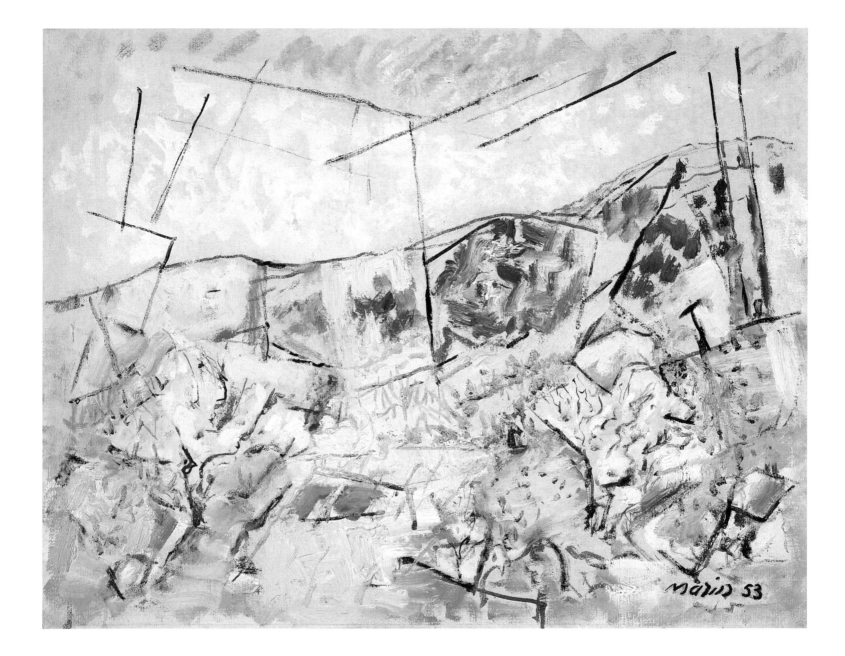

John Marin, *Spring No. 1*, 1953, oil on canvas

*"Before I put brush to canvas, I question, 'Is this mine? Is it all intrinsically of myself?'"*

Georgia O'Keeffe

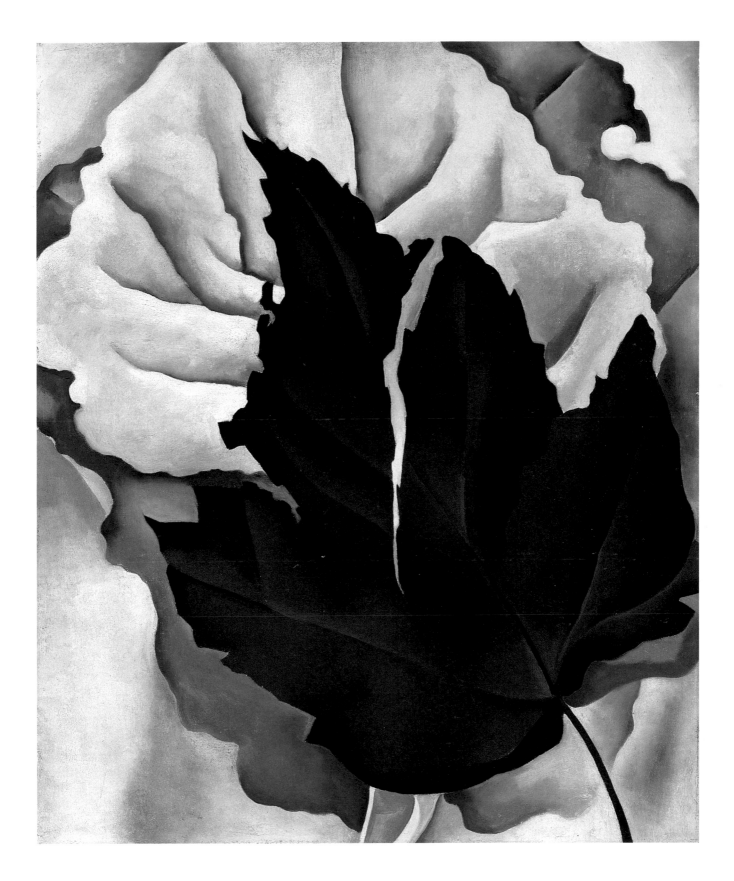

Georgia O'Keeffe, *Pattern of Leaves,* ca. 1923, oil on canvas

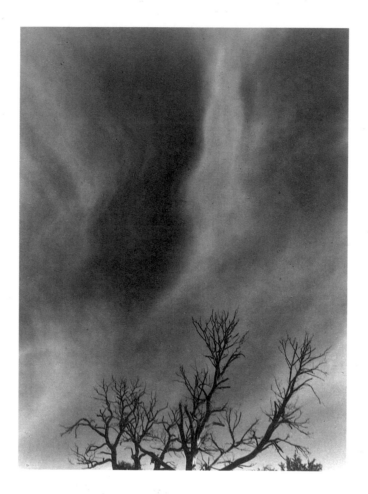

Alfred Stieglitz, *Equivalent* [Bry no. 175B], 1930, gelatin silver print

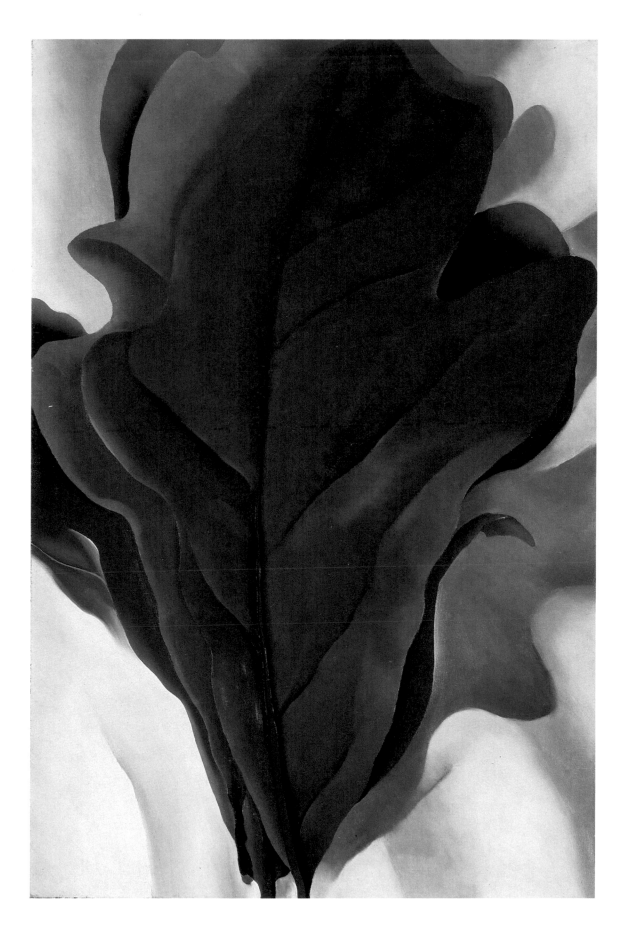

Georgia O'Keeffe, *Large Dark Red Leaves on White,* 1925, oil on canvas

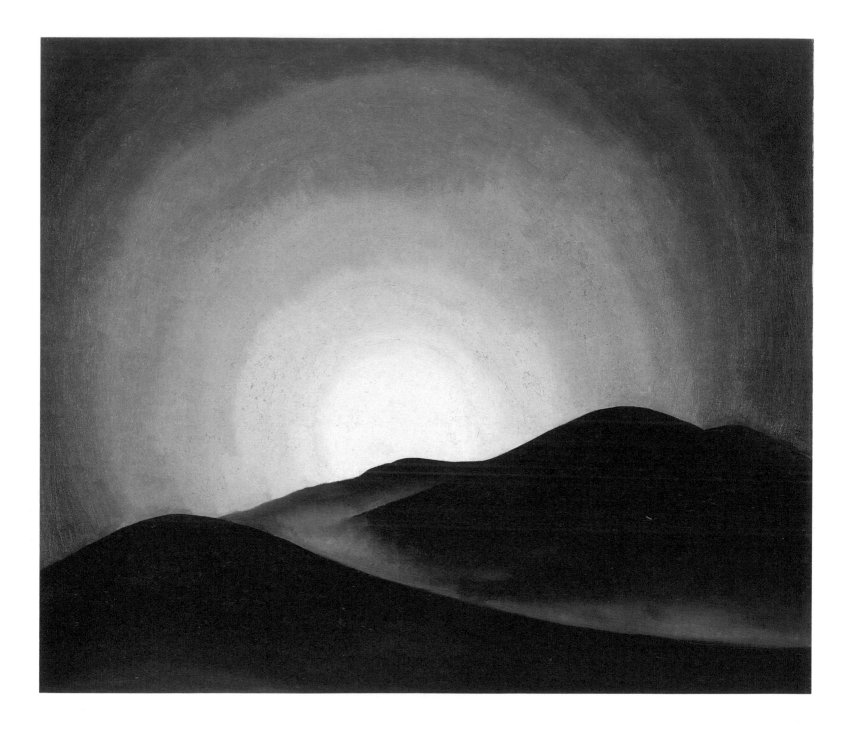

Georgia O'Keeffe, *Red Hills, Lake George*, 1927, oil on canvas

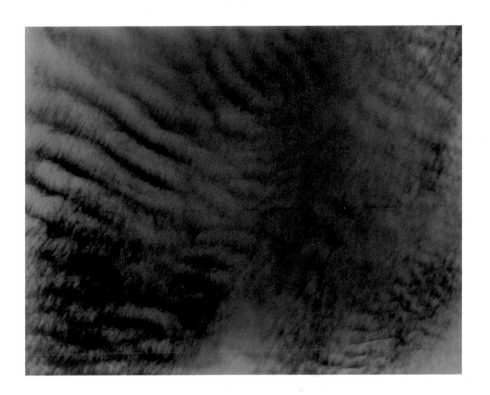

Alfred Stieglitz, *Equivalent* [Bry no. 141D], 1927, gelatin silver print

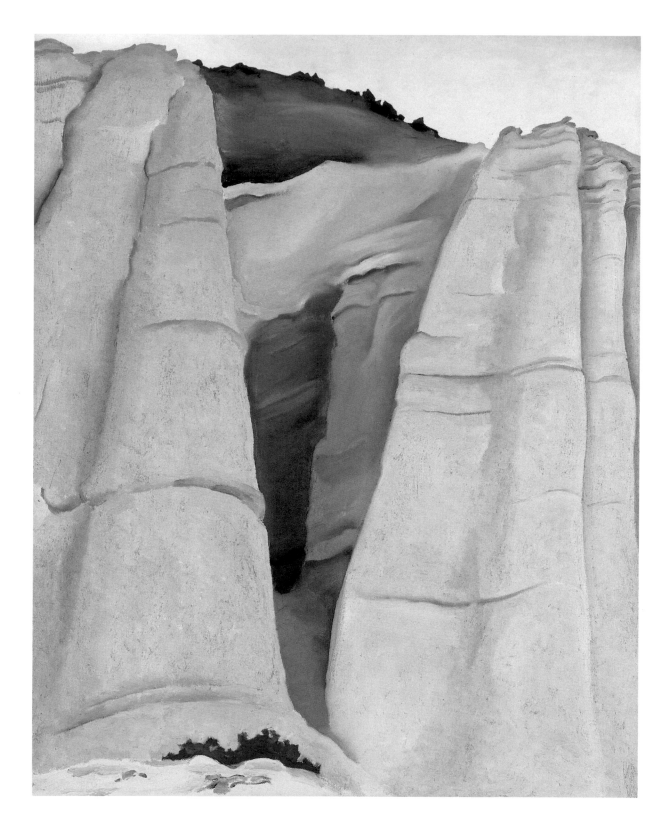

Georgia O'Keeffe, *From the White Place,* 1940, oil on canvas

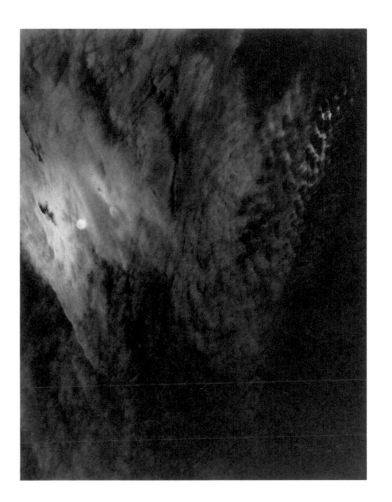

Alfred Stieglitz, *Equivalent* [Bry no. 226B], 1929, gelatin silver print

*"It's a wild glorious morning. Maddeningly beautiful. . . . I ought to be skying."*

*Alfred Stieglitz*

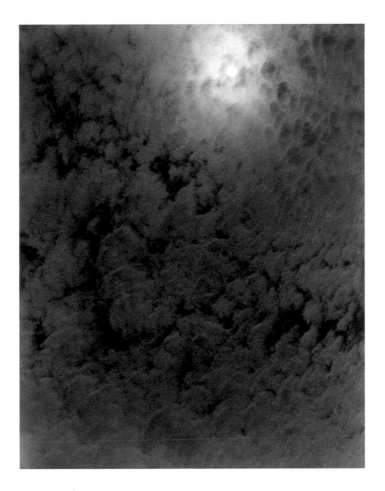

Alfred Stieglitz, *Equivalent* [Bry no. 177E], 1926, gelatin silver print

Georgia O'Keeffe, *Ranchos Church,* 1929, oil on canvas

Arthur Dove, *Snow Thaw,* 1930, oil on canvas

Arthur Dove, *Sand Barge,* 1930, oil on cardboard

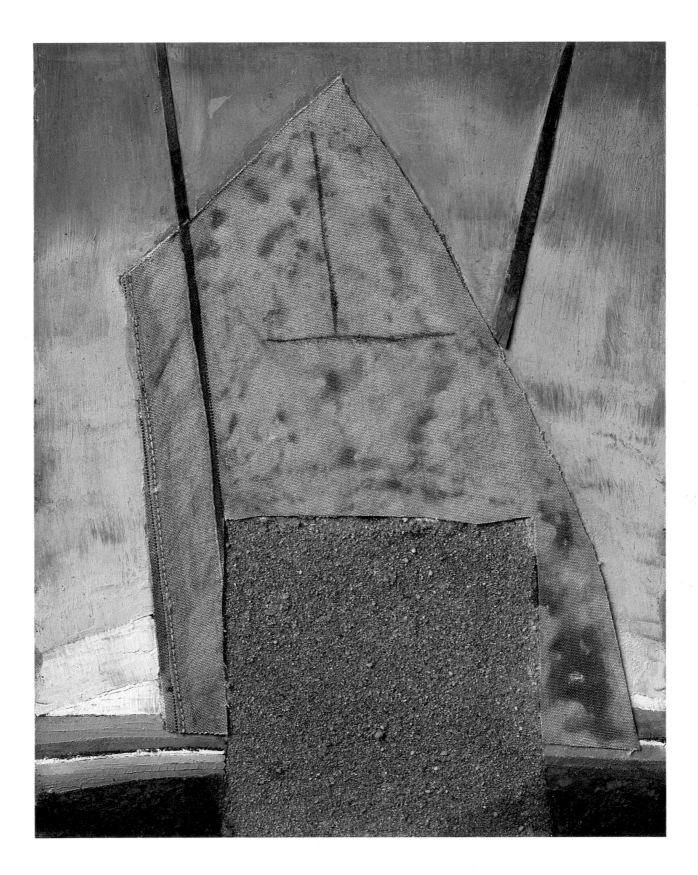

Arthur Dove, *Huntington Harbor I,* 1926, collage on metal panel

*"I am interested in growing ideas into realities."*

*Arthur Dove*

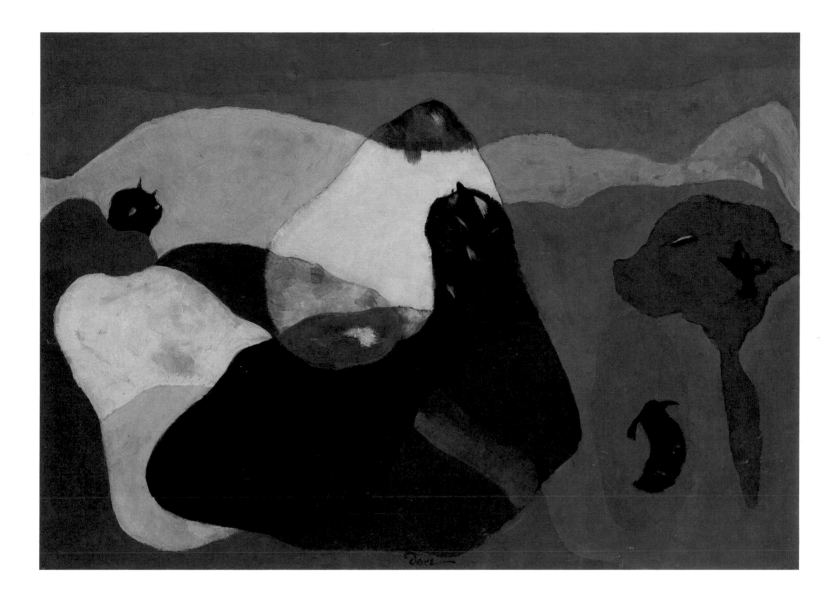

Arthur Dove, *Cows in Pasture,* 1935, wax emulsion on canvas

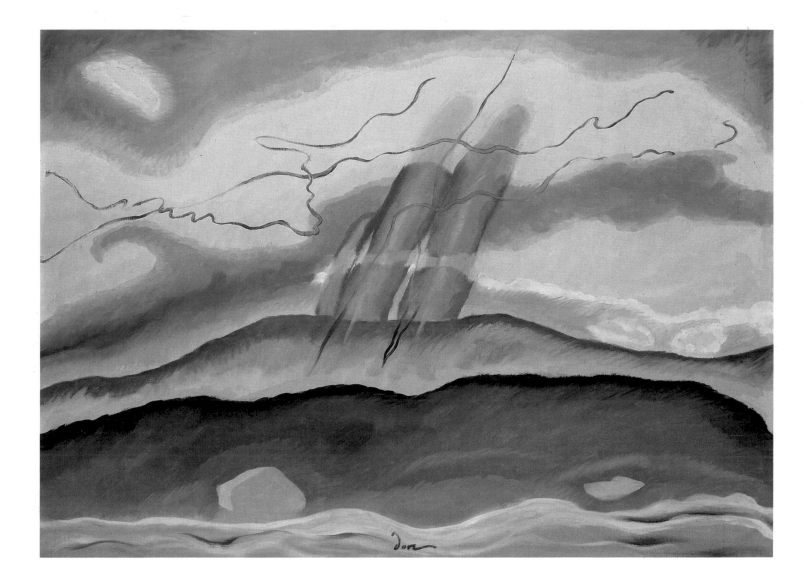

Arthur Dove, *Sun Drawing Water*, 1933, oil on canvas

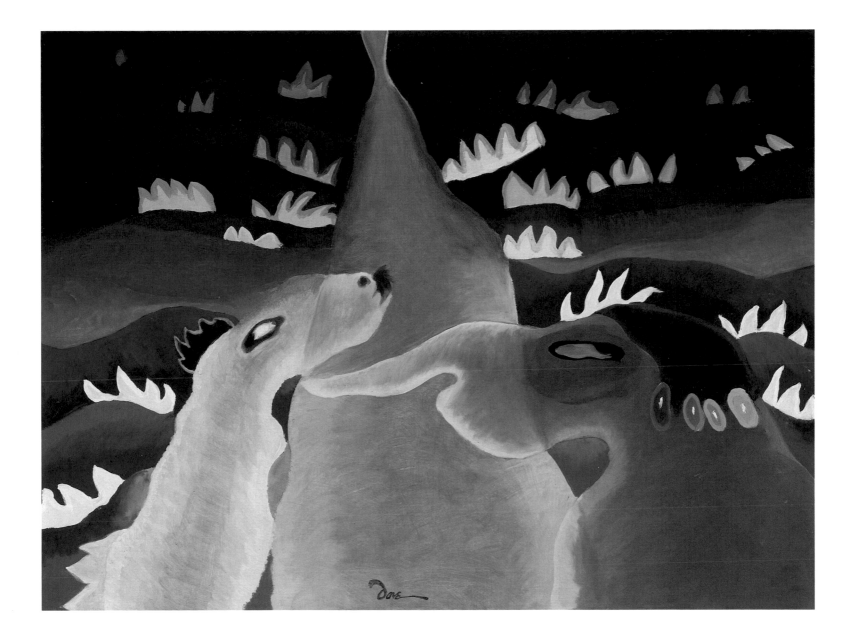

Arthur Dove, *Lake Afternoon*, 1935, wax emulsion on canvas

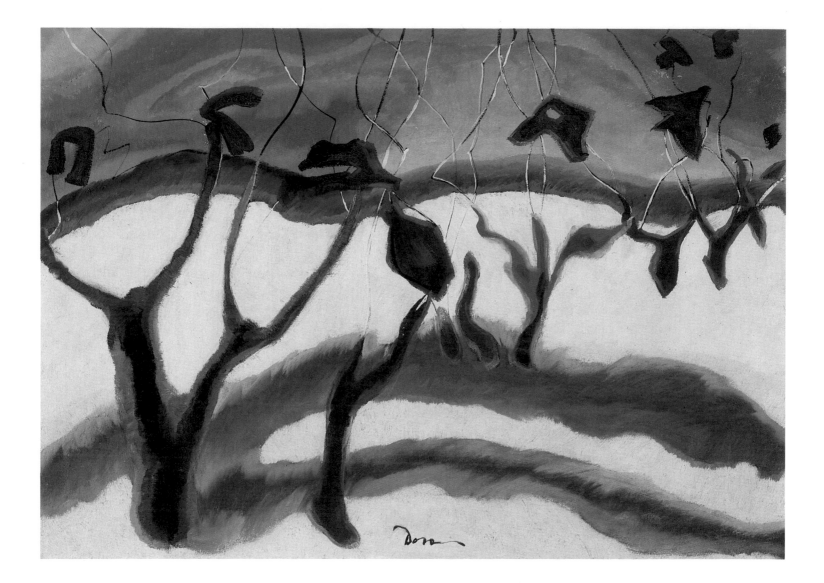

Arthur Dove, *Electric Peach Orchard,* 1935, wax emulsion on canvas

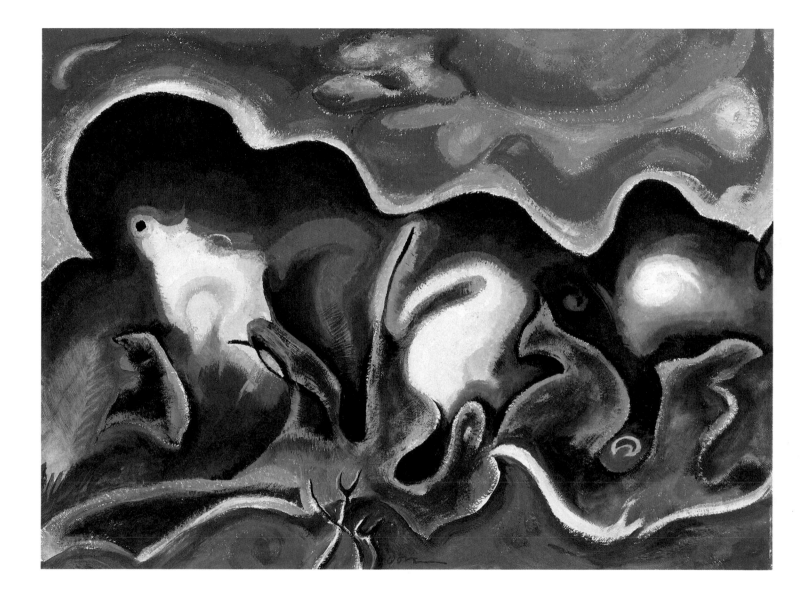

Arthur Dove, *Tree Trunks,* 1934, oil on canvas

Arthur Dove, *Over Seneca Lake,* 1935, watercolor and pencils on paper

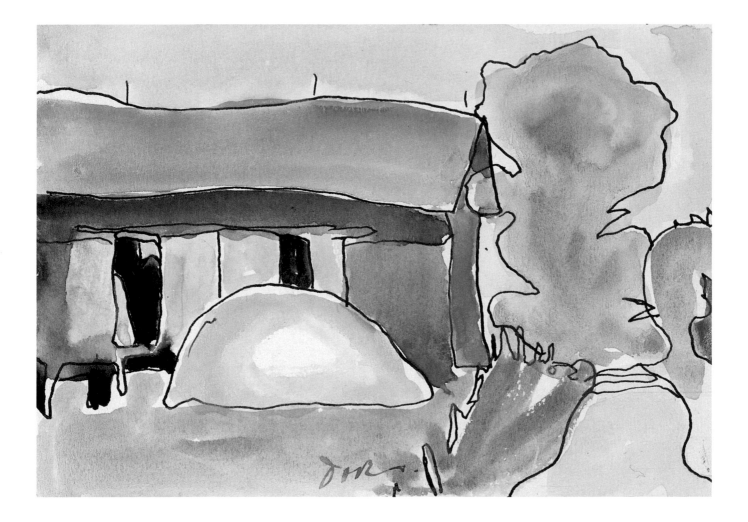

Arthur Dove, *Barn IV*, 1935, watercolor and black ink on paper

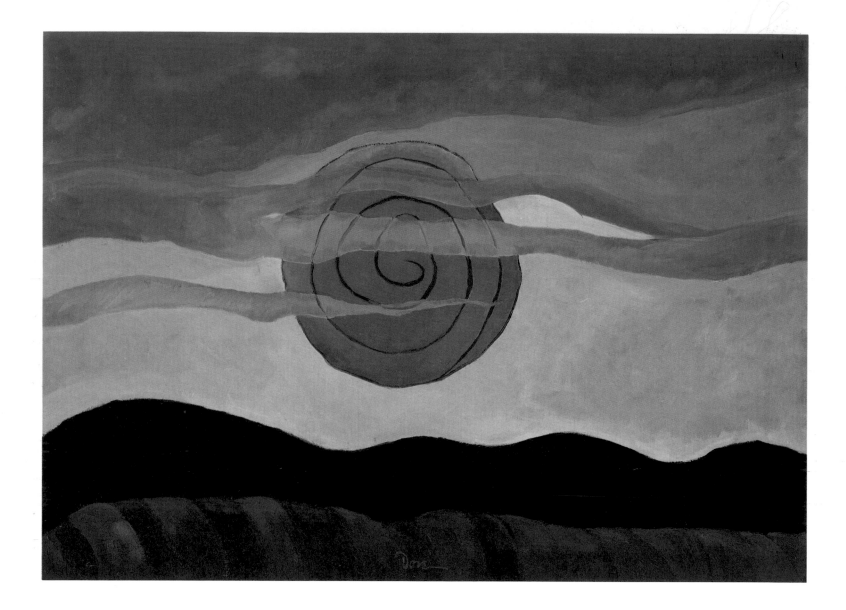

Arthur Dove, *Red Sun*, 1935, oil on canvas

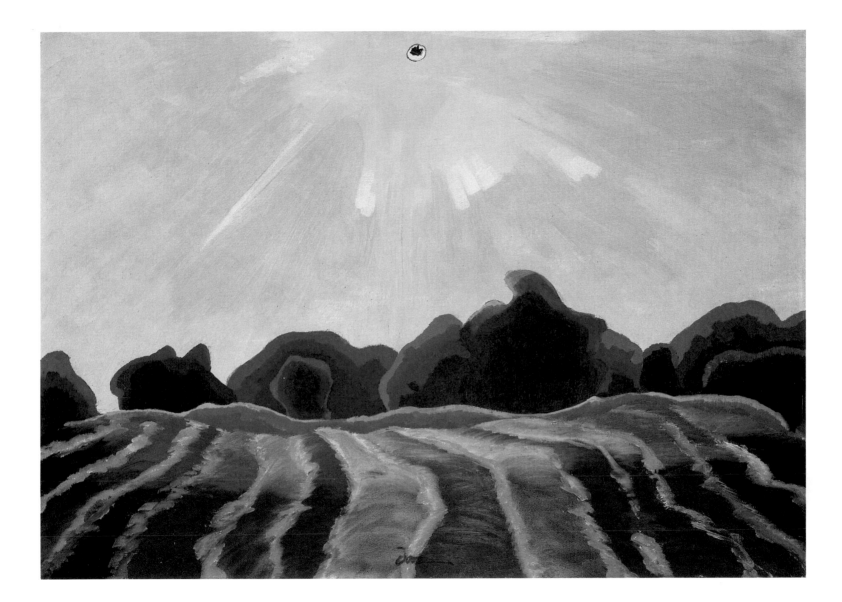

Arthur Dove, *Morning Sun*, 1935, oil on canvas

Alfred Stieglitz, *Equivalent* [Bry no. 171E], 1925, gelatin silver print

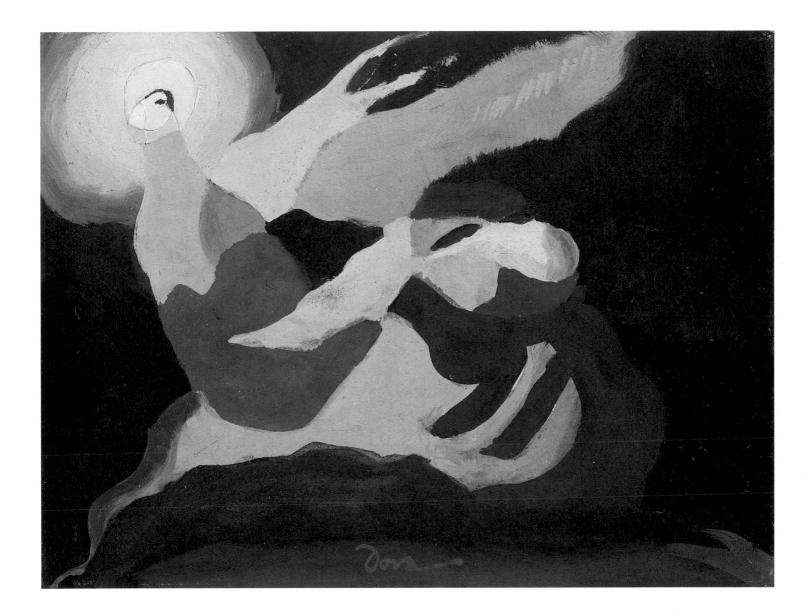

Arthur Dove, *The Moon Was Laughing at Me,* 1937, wax emulsion on canvas

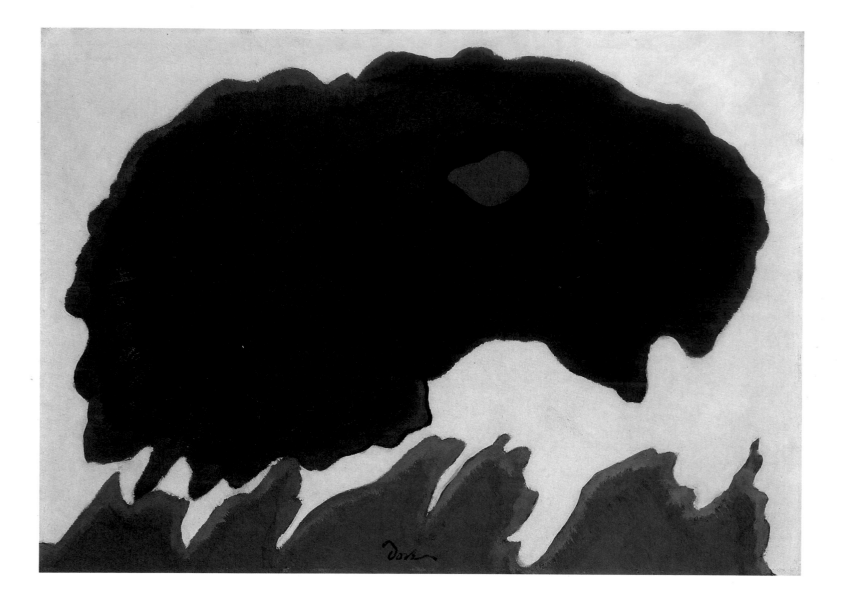

Arthur Dove, *Reminiscence*, 1937, wax emulsion on canvas

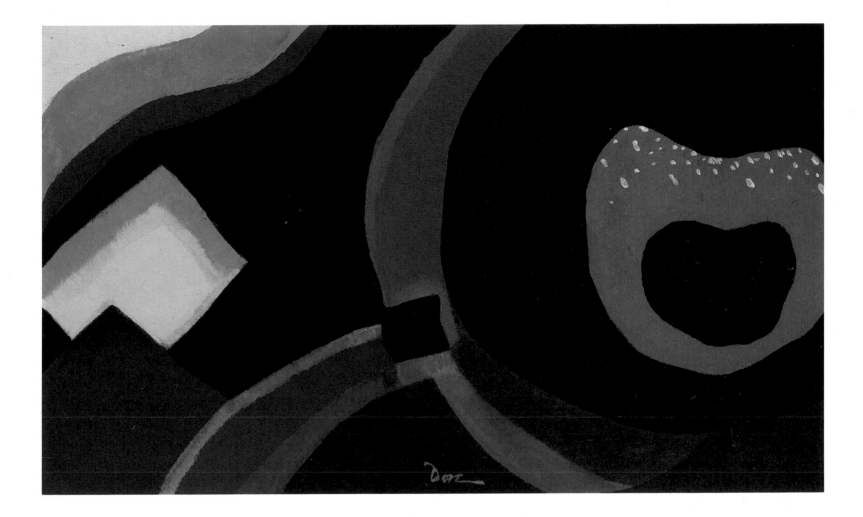

Arthur Dove, *Flight,* 1943, wax emulsion on canvas

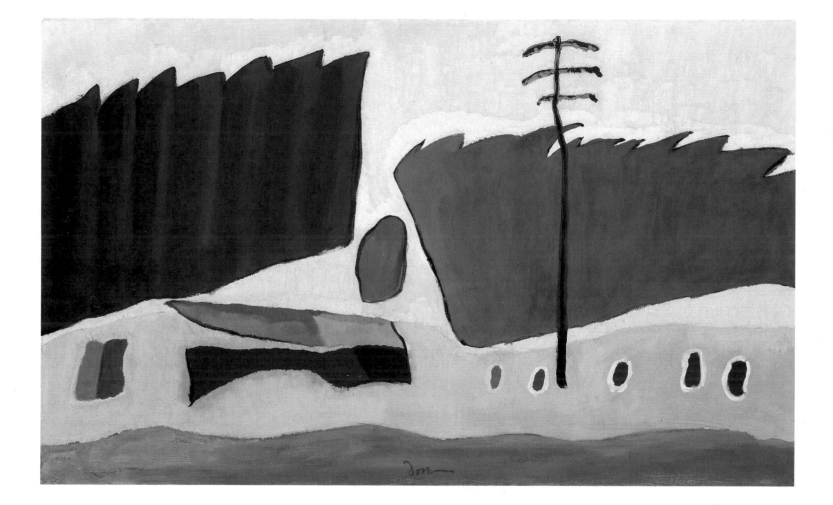

Arthur Dove, *Shore Front,* 1938, wax emulsion on canvas

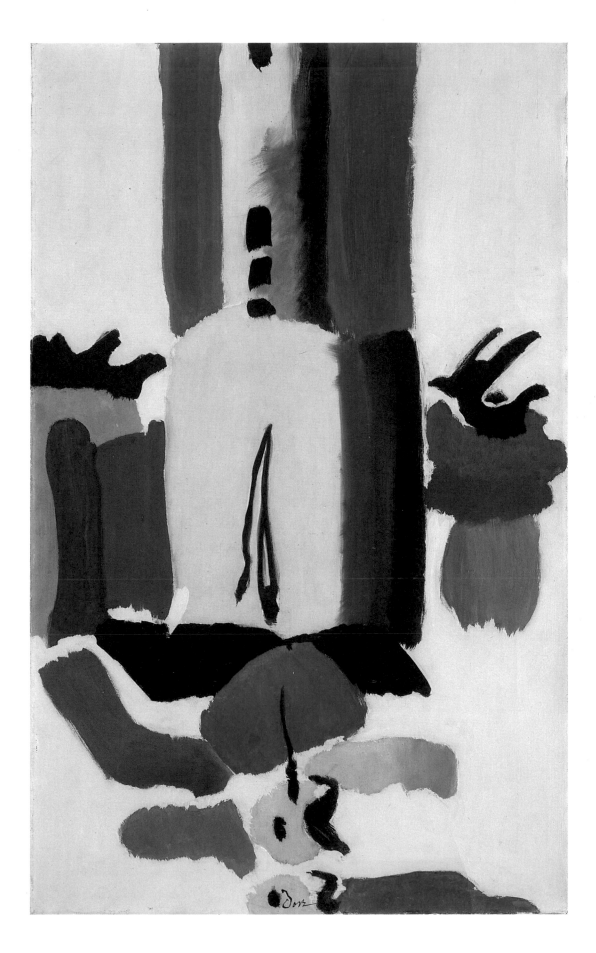

Arthur Dove, *Flour Mill II*, 1938, wax emulsion on canvas

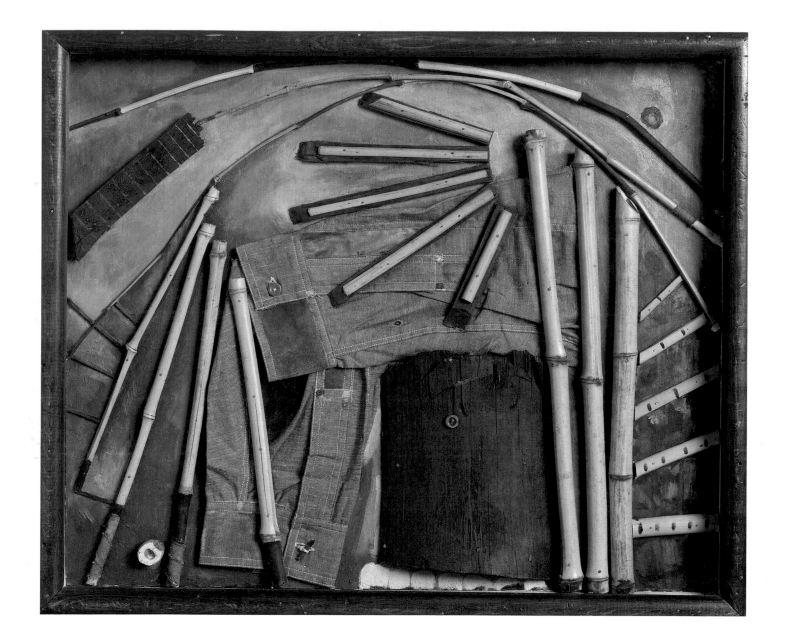

Arthur Dove, *Goin' Fishin'*, 1925, assemblage of bamboo, denim shirtsleeves, buttons, wood, and oil on wood panel

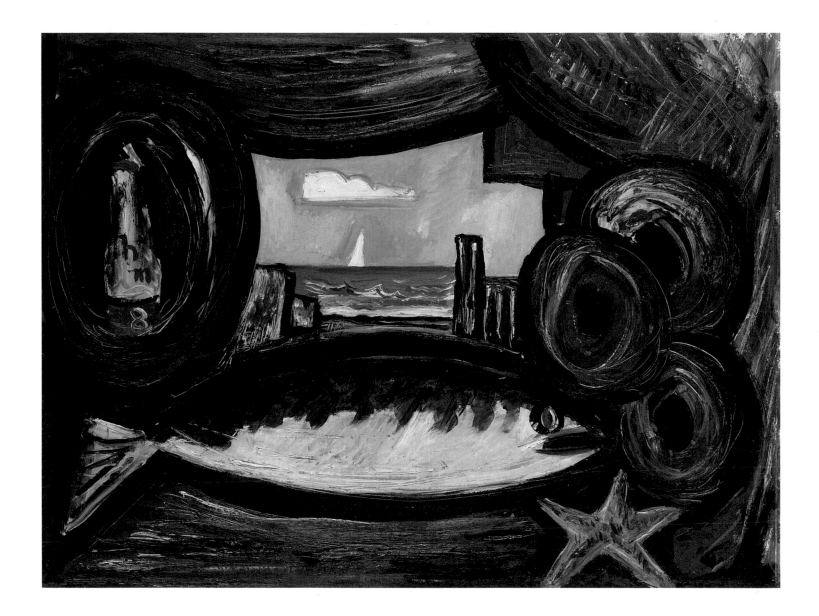

Marsden Hartley, *Sea View——New England,* 1934, oil on academy board

John Marin, *Four-Master off the Cape, Maine Coast, No. 1*, 1933, watercolor and black chalk on paper

Marsden Hartley, *Off to the Banks,* between 1936 and 1938, oil on canvas board

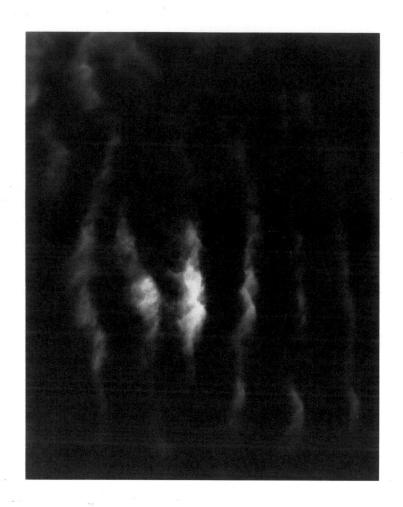

Alfred Stieglitz, *Equivalent* [Bry no. 216E], 1929, gelatin silver print

Marsden Hartley, *Off the Banks at Night,* 1942, oil on hardboard

Marsden Hartley, *After Snow,* ca. 1908, oil on academy board

Marsden Hartley, *Wood Lot, Maine Woods,* 1939, oil on academy board

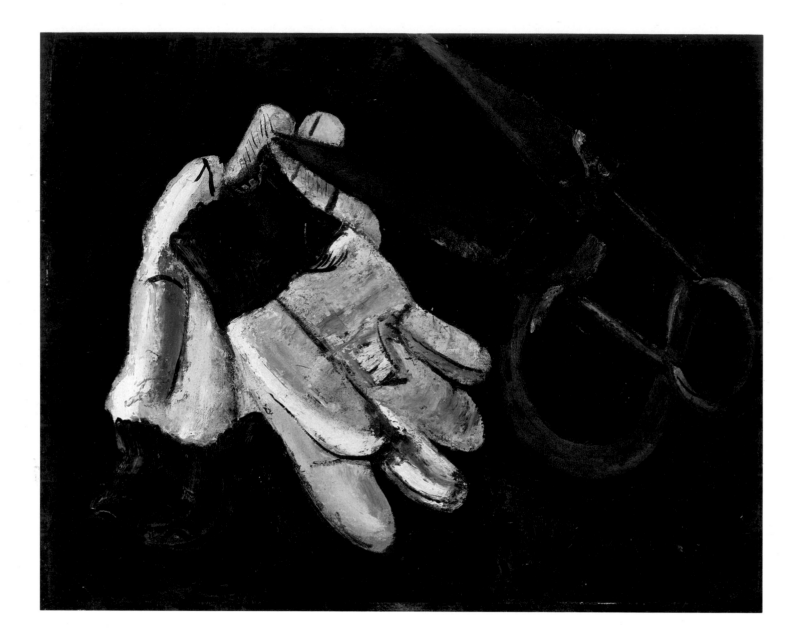

Marsden Hartley, *Gardener's Gloves and Shears,* ca. 1937, oil on canvas board

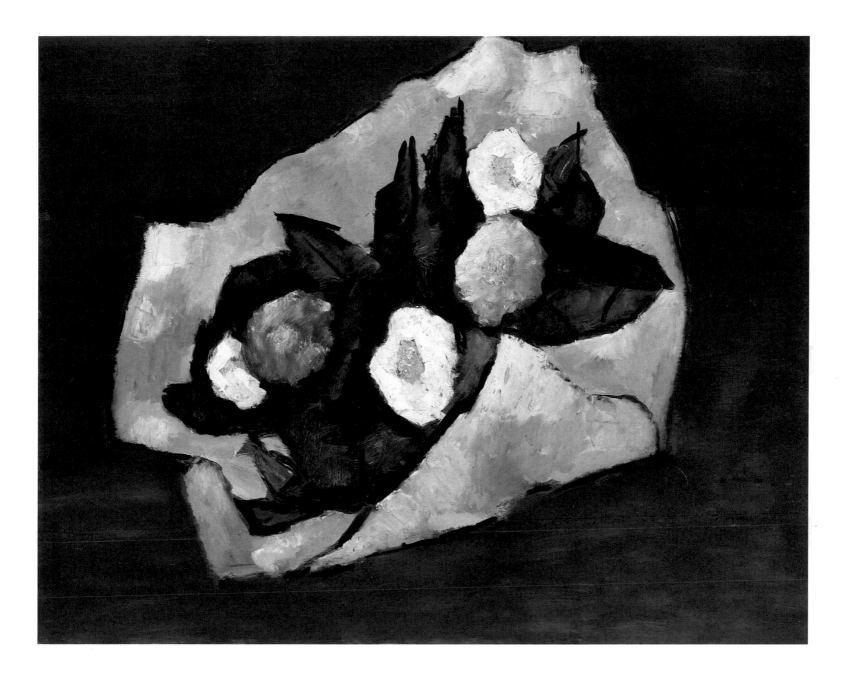

Marsden Hartley, *Wild Roses,* 1942, oil on hardboard

*"When there is a hint of great things going on in the mind of the artist and of his consciousness of the rhythm of the universe, abstract art ceases to be an amusement for the aesthete and becomes a divine activity."*

Duncan Phillips

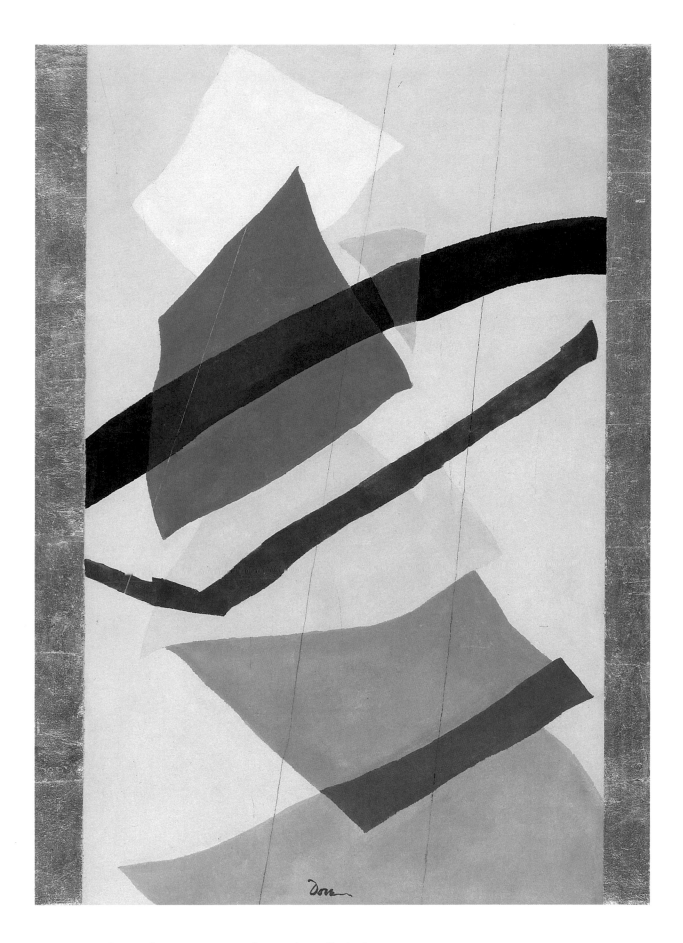

Arthur Dove, *Rain or Snow,* 1943, wax emulsion and metallic leaf on canvas

# Selected Correspondence

EDITED BY ELIZABETH HUTTON TURNER
AND LEIGH BULLARD WEISBLAT

*In the interest of faithfully reproducing the correspondence, the idiosyncratic punctuation, misspellings, and errors of individual letters have been preserved here; the indication* sic *has not been used. Following each letter, the archival location of the document is cited: The Phillips Collection, Washington, D.C. (TPC) or Yale Collection of American Literature, Beinecke Rare Book and Manuscript Library, Yale University, New Haven, Connecticut (YCAL).*

## THE MEETING

*In early January 1926, Duncan Phillips visited The Intimate Gallery (Room 303), which Stieglitz had opened just a month before. It was probably their first meeting, but the two men quickly discovered a shared cause in their support of American modernism.*

*Phillips returned to Washington, D.C., full of enthusiasm for the radical experiments of Stieglitz's artists and eagerly awaiting the arrival of the three works he had purchased at Room 303: Arthur Dove's* Golden Storm *and Georgia O'Keeffe's* My Shanty, Lake George *and* Leaf Motif No. 1. *But Phillips's heart was set on acquiring Dove's* Waterfall, *which Stieglitz had already promised to Paul Rosenfeld, a critic and member of Stieglitz's coterie. The rapid exchange of letters between Stieglitz and Phillips about this purchase are illuminating, for in them the two men define their respective positions in the art world.*

STIEGLITZ TO PHILLIPS
*The Intimate Gallery, New York, January 22, 1926*

My dear Mr. Phillips
Confirming our conversation over the telephone this morning, it is understood that you are assuming full risks for the two O'Keeffes and one Dove which Budworth is to get for you tomorrow morning, Saturday, January 23. It is also understood that the expressage and packing expenses both ways be borne by you. Furthermore, please

understand that in case of purchase, because of the pictures going into an art gallery, Miss O'Keeffe is willing to make a special concession of 25 percent on her prices. These prices are already a concession as the artists themselves are running their own gallery, Room 303, and are keeping their prices as low as they possibly can. Dove, as I have told you, has produced very little and in his case no concessions can be made. His prices are very low because his circumstances force him to this. In my opinion his prices are really ridiculous. But that is his affair.

After this exhibition is over, for your own information, I want to tell you that he is doubling his prices, as he feels this exhibition and the article in the *New Republic* entitle him to this step. Even at the new figures, considering what the Doves really are relatively in American art, the pictures remain low as I see it.

I also wish to tell you that I am perfectly willing to wait six to nine months for the payment of the pictures should you decide to keep them. I will advance the money to the artists knowing that your credit is A plus 1. As soon as you have decided which of the three pictures you wish to keep will you please let me know as there is a steadily growing demand, particularly for the O'Keeffes, and the two pictures sent you are both important ones, one, Leaf Motif No. 1, exceptionally important, one of her finest pictures. And "My Shanty" is hardly less important.

The pictures sent you are "Golden Storm" by Arthur G. Dove, price $200 net; "Leaf Motif No. 1", 1924, by Georgia O'Keeffe, $1000. (less 25 per cent to you); "My Shanty, Lake George," 1922, by Georgia O'Keeffe, $800 (less 25 per cent to you). I have not been able to get in touch with the buyer of the small Dove, Mr. Paul Rosenfeld, whose "Port of New York" you must not fail to read (maybe you'd like me to send it to you at once), so I am sorry that I cannot send that Dove too.

I cannot tell you how much pleasure it was to have you in Room 303 on the three separate occasions and to watch your increasing enthusiasm for what I positively know is exceptionally good. Please remember I am not in the art business. I am not eager to sell anything to anybody but I have a perfect passion in wishing to be instrumental in bringing out the best that is in America and bringing

Ansel Adams, *Alfred Stieglitz at An American Place,* 1939, gelatin silver print, Philadelphia Museum of Art, from the Collection of Dorothy Norman

those who believe in that and are willing to work for that together. It was very wonderful to see you with your wife before the pictures, and have you meet Miss O'Keeffe. I am really looking forward to seeing your wife's work when it is shown at Durand-Ruel's. My greetings to you and to her.

 Sincerely
 Alfred Stieglitz

Did you see the New Republic, Jan 27th. with the essay on Arthur G. Dove by Waldo Frank? It is well worth reading.—
TPC

### TELEGRAM, PHILLIPS TO STIEGLITZ
*Washington, D.C., January 26, 1926*

LETTER RECEIVED   EXPECT THE THREE PICTURES TODAY AND WILL LET YOU KNOW WHICH ONES WE WISH TO KEEP   PLEASE CALL BUDWORTH TO COME AGAIN AND EXPRESS AT ONCE THE SMALL

DOVE WHICH IS LISTED AND REFERRED TO IN CATALOGUE OF EXHIBITION   I TRUST PURCHASER WILL RELINQUISH IT TO OUR MUSEUM
DUNCAN PHILLIPS
YCAL

### STIEGLITZ TO PHILLIPS
*New York, January 26, 1926*

Dear Mr. Phillips: Your telegram which I received at 2:48 P.M. today came to me as a great shock. For it put me into a very unpleasant predicament. I had over the phone given you to understand that I'd try to induce the owner of the Dove to give it up for your Gallery but that I couldn't promise to send it unless consent were given.— Well, I had not been able to get into touch with the owner of the picture so I felt I had no right to send it on to you.

 —And I wrote you to that effect. And then comes your telegram! So as not to ruin your pleasure in your own little show I have taken it upon myself to send you the picture & may make an enemy of one who for years has stood by Marin, Dove, O'Keeffe & Hartley making great sacrifices for them.—

 —I tried to get Budworth at once but failed to get them. So Mr. Seligmann to run over to them & get the picture into their hands at once. So I'm trusting you'll have the picture on time.

 —As for your keeping it I don't know quite how that can be arranged. We'll see what your decision will be. Maybe if the owner of this picture feels that your interest in O'Keeffe & Dove will help them he may feel that he has no choice but to make another sacrifice. We'll see. I know that the picture means a great deal to him & that he will hate to part with it. He loves his pictures.—

 Room 303 certainly misses the little pictures—Many people are coming to see the Doves—important people & there is much real appreciation. There is an ever increasing movement towards his latest works. It is quite remarkable what is happening. Several more pictures have found homes.

 —As for the O'Keeffe Exhibition I know it will be a revelation.
 Cordially
 Alfred Stieglitz

Kindly insure the loaned picture for $400.00.
TPC

---

*Phillips and Stieglitz's discussions on American modernism continued through phone calls and correspondence. Phillips attested to his early interest in abstract painting, citing his acquisition in 1914 of* After Snow *(1908), a Maine landscape by Hartley, as well as paintings by Ryder. He also recounted his purchases of nineteenth-century French*

*masters, who for him represented the sources of modernism. Phillips considered his* Eleven Americans *exhibition, whose concept was derived from Stieglitz's* Seven Americans *show in 1925, a contribution to the support of American modernism. Stieglitz, likewise, emphasized their shared devotion to art, but insisted that the importance of nature and of a uniquely American expression in art was best reflected in the work of these few artists: Marin, Dove, O'Keeffe, and sometimes also Hartley.*

*Phillips's comparison of O'Keeffe's* My Shanty *to the works of the Irish poet and dramatist John Millington Synge showed the enduring influence of his early literary studies at Yale University (1904–08), which had colored the essays in Phillips's first book,* Enchantment of Art *(1914).*

---

## PHILLIPS TO STIEGLITZ
*1218 Connecticut Avenue, Washington, D.C., January 30 [1926]*

Dear Mr. Stieglitz

I am much indebted to you for sending the little picture by Arthur G Dove and for promising to do your best to persuade its present owner to let The Phillips Memorial Gallery add it to its permanent collection. I have seldom been more certain in my life of my deep interest and admiration for a picture and, what is more, the two Doves both appeal to me emotionally. It is no sudden conversion to red blood as you seem to think. I have always loved abstract painting. I bought Albert P. Ryder and Marsden Hartley twelve years ago as well as Daumier and Prendergast. I think that perhaps my purchase of a great Greco three years ago and of a Guys from the Kelekian Sale and the Cezanne-Gauguin and Redon last year may have confirmed my faith and heartened me to live with more of the gallant experiments of the living American "modernists" for whom you have done so much. Going back to the subject of the Doves—and the Exhibition in which they are to hang—I shall be distressed if I hear from you that I cannot keep "Waterfall" as well as "Golden Storm." Your offer to give me time in payment makes it possible to get both these pictures in spite of the fact that I am desperately trying to sell some of the most marketable duplicates I have in order to reduce my staggering load of debt. I want to live with Miss O'Keefe's two canvases longer before deciding which one I would like to purchase. The Leaf Pattern is finer in color and more original in conception but Mrs. Phillips and I feel that perhaps we might find another leaf or flower abstraction at some other time which would give us less disturbing pleasure. It is a hard picture to hang with the work of others and although it is listed in our Exhibition (catalogue of which will be sent to you)— I am not sure that it would look its best in the group when the time comes to hang the pictures, I shall bring it out to show those of

subtle taste and understanding. She is certainly an artist of genius and it is a privilege to have this opportunity of enjoying her work at leisure. Someday I will come to you to arrange a special exhibition of her work in Washington. If I could afford, at the end of a fearfully extravagant season of picture buying, to still add these two Doves and two O'Keefes—I would do so without hesitation. As it is I will say now that we will buy both Doves and probably one O'Keefe. The Shanty is a powerful picture and has the quality I prize in the plays of Synge. I have ordered "Port of New York" but it has not yet arrived.

Thanking you again—and if I get the Waterfall—please thank Mr. Rosenfeld—is that the name? for his sacrifice on behalf of the artist.

Sincerely
Duncan Phillips

I am including a superb Odilon Redon with the eleven Americans. I wish you could see the exhibition. The group includes besides Redon—Dove and O'Keefe—Tack—Kent—Marsden Hartley—Maurer—Max Weber—Canadé—Speicher (an unusual example) and Knaths.
YCAL

## STIEGLITZ TO PHILLIPS
*The Intimate Gallery, New York, February 1, 1926*

My dear Mr. Phillips

That the two Doves give you so much pleasure gratifies me. And I certainly want you to have them for the Phillips Memorial Gallery. It happened that Mr. Rosenfeld called me up this morning and wanted to know when the Dove show would close so that he could get his picture. He was much shocked when I told him that I had just had a letter from you in which you particularly expressed the hope that I could get for the Gallery the picture in question. As I wrote you Mr. Rosenfeld loves his pictures and when once he has purchased one he hates to give it up. As a matter of fact he has never as yet given one up. I told him to think the matter over. That I felt he should make "a sacrifice" for all concerned.

I know you must realise how he feels. For you too seem to know what it means to love a picture. I have given up many pictures—in fact, my whole life—for the "Cause." I wont go into that, though. I do hope that the picture will remain in Washington. Whatever I can do will be done. But I do not want to force Mr. Rosenfeld to give up the picture unless he feels impelled to do so of his own volition. He too has made many sacrifices for the "Cause" so close to me.

I'm afraid you took me a little too seriously about my joshing you a bit as to the sudden conversion to red blood. As a matter of

fact, I realised what had happened to you when you bought the Renoir and the Daumiers and pictures of that type. For these are certainly of red blood if there are any in art. As for the abstract, I also know that anyone who really *sees* true pictures must also see the abstract.

It comes as a surprise to me that you have a Hartley. And that you bought it twelve years ago. I wonder which you have. Hartley, like Marin and Dove and O'Keeffe, is one of my babies. One who has possibly given me the most worry. I wonder have you seen his recent work. I never thought of showing it to you. But there is time.

What naturally interested me most is your growing interest in the "gallant experiments of the living American modernists" in which I am so much interested. You see, I have a passion for America and I feel, and have always felt, that if I could not believe in the worker in this country, not in the imitator of what is European, but in the originator, in the American himself digging from within, pictures for me would have no significance. I prefer the race track and its magnificent thoroughbreds, I prefer athletic games and the billiard table. In short true sport.

To revert to the Dove, it is only fair to say that the purpose of Mr. Rosenfeld's calling me up today was to tell me he was mailing me a check for Dove. In spite of this, in case Mr. Rosenfeld decides to let you have the picture, I am willing to wait for your payment of the Doves for six to nine months. I shall advance the money to Dove as soon as the exhibition is over as I know he is in sore straits. I am writing you this as a friend of yourself as well as a friend of Dove's, as man to man. For my position is such that one is apt to forget the fact that I am in no way a dealer either in art or in anything else. And please remember that I am not forgetting your position and what you told me about your trying to turn some of your duplicates into cash in order to pay for some of your recent purchases.

As for the O'Keeffe canvases I wonder whether you and Mrs. Phillips realise that the leaf canvas you have is really one of O'Keeffe's finest paintings. I am not saying this so as to influence you in keeping it. As a matter of fact offers for it have frequently been refused. That you should find it difficult to hang with the group you mention does not surprise me. Both O'Keeffe and I realised that when you selected it. But it certainly can hang next to her own "Shanty" without either picture suffering, for they are born of one spirit.

As for your not hanging it, in a way it is a pity, for the picture is certainly a most important one. But I do not want to press any condition. You must decide entirely for yourself. Personally I feel that you would make no mistake in keeping both pictures for yourself. If you should at any time wish to exchange them for some other picture or pictures of O'Keeffe's that you might see, I am sure you would find me only too willing to satisfy you. I want you not only

to be satisfied but I want to feel that you have the best for the Gallery because I feel it is only fair to you, fair to American painting and that means fair to the artist.

I know the significance of O'Keeffe's work. There is none more important being done in this country. She is the first real woman painter not only of this country but in the world. That I have scientific proof of. And what is more her work comes from the soil of America. Nothing like it exists in Europe. If I were to take her work to Europe she would create a sensation. Europeans have been trying to persuade me to take it abroad but I propose to stay right here in America and complete my fight in this country. For fight it still continues to be and a very hard one. For I am pretty much alone.

In speaking of O'Keeffe I have no personal interest any more than I have a personal interest in my passion for Greco or for Daumier or Renoir. And as for payment for the O'Keeffes, should you decide to keep them or one of them, I'll gladly extend the time of payment to twelve months or even fifteen months, for she is not in the immediate need that Dove is. As soon as Mr. Rosenfeld will have decide—and I hope it will be within the next day or two so that this matter may be brought to a close—I shall let you know.

My cordial greetings to you and Mrs. Phillips.
Sincerely
Alfred Stieglitz

P.S. Will you kindly let me have a catalogue or two when ready. Of course at any time that you would feel inclined to have an O'Keeffe show, as you seem to be disposed, I would be only too glad to help you bring it about.
TPC

PHILLIPS TO STIEGLITZ
*1218 Connecticut Avenue, Washington, D.C., February 6, 1926*

Dear Mr. Stieglitz
I wish you could see the exhibition. It is beautiful and is making converts to abstract art and "The Cause" for which you have done so much. Have you received the catalogue? I wish I could have delayed writing the Introduction until after I had lived with the new things a little longer. The reproductions of course give no idea of the beauty of color in the paintings by Redon & Tack and the latter is really a superb design altho one would never guess it from the blurred print. The O'Keefes are much admired and we ourselves like them better and better. We surely will keep one and if I were not already so deep in debt I would want them both. The Doves—being less expensive—I can acquire and will send you a check for both as soon as I hear that Mr. Rosenfeld is willing to let the "Waterfall" pass into a very important public collection. I enclose a letter to Mr. Rosenfeld—Please read it and decide whether to for-

ward it to him or not. As you will see I stand ready to *buy* the picture from him so that a profit will partially compensate for his loss. Dove would do his part and see that he got another picture as good or better. If, on the other hand, Mr. R. holds on tight then I wish to commission Dove to paint *on approval* a similar motif for me. But as this might not please me as well I trust that I can keep the little picture here.

Sincerely Duncan Phillips

YCAL

## STIEGLITZ TO PHILLIPS
*New York, February 8, 1926*

Dear Duncan Phillips: I can't tell you how much the spirit with which you have met me means to me—Mr. Rosenfeld wishes me to tell you that you are to keep the Dove "Waterfall." He can't begin to think of any bonus. So my congratulations to you & to him & Dove & all of us of Room 303 & kindred spirits.—

As for the O'Keeffes I feel you should keep the two. And in order to make it a little more easy for you she is ready to let you have both for $1200 which I feel is reasonable enough. In short she makes an allowance of an additional $150 should you keep both—

Her Show is up & it is truly magnificent. It takes one's breath away.—The more you'll live with her work the more you will like it. Demuth was in this morning & remarked again: How she can paint & what a spirit!—He even spoke of Rubens in looking at one you didn't see [but] of course he is an enthusiast—But he speaks truly nevertheless.

—I'm an enthusiast too. But so are you. And we are not criminals. Or are we?—

—Yes, the catalogues came. Thanks—of course I make allowances for reproductions of color in black & white.—Some day I'll see your Tacks—Redon of course I know well—your Show in your little Intimate Gallery will delight many—will cause many too to wonder—& above all will keep the "Cause." I'm glad to know you [are] pulling an oar in its boat.—

—Mr. Rosenfeld says he'll write you. Just at present he is stewing over his first lecture which comes off in Philadelphia. It is on Music.—I'm glad you read his book & I agree with what you say about it.

O'Keeffe joins me in greetings to you & Mrs. Phillips.

Cordially

Alfred Stieglitz

TPC

*O'Keeffe, who was invited by Anita Pollitzer to address the National Woman's Party Convention in Washington, D.C., visited the Phillips*

*Memorial Gallery in late February. Much to the delight of Duncan Phillips, she paid special attention to the part of the collection that for him served as sources of modernism—his Goya, El Greco, Daumiers, and Renoir, among others.*

## PHILLIPS TO STIEGLITZ
*Phillips Memorial Gallery, Washington, D.C., March 4, 1926*

Dear Mr. Stieglitz:

It was a great pleasure to show our treasures to Georgia O'Keefe and to know her better. She is certainly a rare person and my wife and I were delighted to discover in her so sensitive and generous a responce to many different kinds of artistic expression. We were only sorry you were not with her but hope you can see the Collection very soon.

I enclose a check for $400 for the two paintings by Dove. I will take advantage of your permission to postpone payment on the O'Keefe "Shanty" until I have had a chance to see a great many of her best canvasses representing a period of five years. I would like to have a private view without either you or the artist herself present and you will understand the reason. Magnetic personality affects one's judgement. We must catch up with O'Keefe as we have missed her work in past years. We are going to New York about the 12th of March for my wife's exhibition at Durand-Ruel's which opens on the 15th. Perhaps after the opening we could see a number of canvasses in some room not open to the public, Lake George landscapes, lillies, petunias, still lifes etc., and defer a decision as to what example we want until after that. I can remember the "Shanty" but I think I will send the "Leaf Motif" in order to compare it with the other canvasses. After living with this fascinating composition for a month I have decided that, although the color is of extraordinary beauty, I believe I could find a design which would give me more unqualified pleasure. With best regards to you and hoping to see you soon.

Sincerely yours

[Duncan Phillips]

TPC

## STIEGLITZ TO PHILLIPS
*New York, March 4, 1926*

My dear Mr. Phillips: Dove has received the check. He requests me to thank you in his name—O'Keeffe tells me how beautiful the two Doves look in your home. She returned from Washington full of rare enthusiasm. She thoroughly enjoyed every moment with you & Mrs. Phillips & the pictures—She tells every one worth while what a splendid work you are doing.—Your Courbets & Daumiers,

the Renoir, & Greco she tells me about. Is full of them. She is painting & doing incredible work.—

When you come to Room 303 I'll see to it that you are undisturbed. Her exhibition continues to attract in a very deep sense.—Weyhe came today & I never saw him so excited. Says: O'Keeffe is in a class by herself here in America. Brancusi told me he felt she was the only *true American* painter he had seen. I didn't show him Marin who I feel is also very American.—Of course I listen & discount enthusiasm.—Yet I feel (& know) O'Keeffe is a very great person—a rare artist.—And American.—

> You'll see for yourself
> Our cordial greetings
> Alfred Stieglitz

TPC

---

*As promised in his correspondence, Phillips paid another visit to Room 303 in mid-March and examined more of O'Keeffe's work. He committed himself to* My Shanty, *exchanged* Leaf Motif No. 1 *for* Pattern of Leaves, *and purchased a new work,* Flame-Colored Canna.

*Stieglitz, continuing to woo Phillips, must have visited Marjorie Phillips's show at Durand-Ruel, because Phillips thanked him for his warm comments on her paintings. A common bond was established in their marriages to committed artists.*

*Phillips at this time discovered Marin. He must have visited Daniel Gallery, where he purchased his first example, a 1913 watercolor,* Black River Valley. *Upon his return to Washington, Phillips recalled the two more recent Marins he had seen at Stieglitz's gallery,* Maine Islands *and* Grey Sea, *and he purchased them later that month. Thus began Phillips's year of greatest passion for Marin, a devotion that, despite periods of no new acquisitions and consistently high prices, remained steadfast throughout Marin's lifetime.*

---

PHILLIPS TO STIEGLITZ
*1218 Connecticut Avenue, Washington, D.C., April 15, 1926*

Dear Mr. Stieglitz

Recently I secured my first Marin watercolor by trading another artist's oil painting for it. It was not a particularly original or powerful Marin but a thoroughly characteristic one in color and I wanted to live with it. The result has been astonishing! I am not only ready for Marin but distressed at the idea of being unable to acquire others *at once*! I would so like to have as important a Marin as *we* have an O'Keefe and my mind keeps turning wistfully to two of the finest—both of which Mrs. P. and I saw in your Room. Best of all was the superb weighty gray ocean with a bar of blue at the top and next best was a design of islands in a Bay with a frame of lines in

the foreground. If one or both of these Marins are unsold I should be terribly tempted—especially if you could pay the artist and let me wait a year and then pay in two installments. By the way I hope to send you the first $1000 check for the O'Keefes very soon. The "Oak Leaves" looks very beautiful against the oak panelling in our Library—opposite the Golden Storm of Dove which is also wonderful against a background of dark wood. The "Canna" in its dazzling brilliancy is a more difficult picture to hang and must wait for an O'Keefe exhibition in our Little Gallery.

Mrs. Phillips is delighted that you find something appealing in her work. It is very sincere and personal and spontaneous and lovely in color and there is no trace of either affectation or commonplace vision. I am sure all good judges of art—even though they might incline to more daring & abstract expression—would respect these qualities & realize their promise. Wish I could see the new Demuths. If you can send one or both of the Marins which I have so vaguely tried to identify without titles and from brief acquaintance—I can make up my mind what can be done. If I could only *sell* a valuable picture or a lot of less valuable ones—I would be able to stagger out of my load of debt and fill some gaps in the collection of which I am very conscious now that my catalogue is about to go to the printer. Is it too late to sell at auction this year? I must ask Chapman.

> With best regards to you both
> Sincerely
> Duncan Phillips

YCAL

---

STIEGLITZ TO PHILLIPS
*The Intimate Gallery, New York, April 16, 1926*

My dear Mr. Phillips

I don't know whether I should commiserate with you or not. I know what it means to become infected with Marinitis. Those who have once achieved it I fear are forever incurable. Such has been my experience this past seventeen years. So I don't know whether I should be glad or sorry for you.

Joking aside I am really delighted that you finally feel impelled to have Marins near you. They are ever a wonderful tonic. As for the Marins you mention I have been holding them for some museum to come along and give them a place. So you are not out of order. You will remember that when you asked the price of that Marin sea piece I refused to give it to you, first of all because you had told me you had "no money" and, secondly, because I wanted you to remember Marin and not a price which might have staggered you at the time. These two Marins have been much sought for. All sorts of offers have been made for the sea piece. Now, as long as you seem to really want that picture and the other one too—the Maine

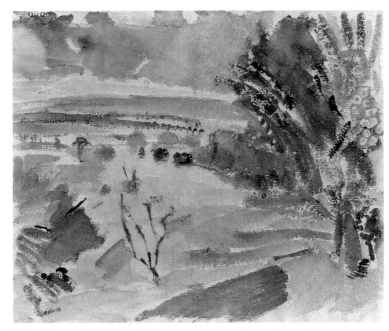

John Marin, *Black River Valley*, 1913, watercolor and graphite pencil on paper

islands—I have the following suggestions to make:

The price of the Maine Islands is $1400. I could let you have it—you represent a museum—for the special price of $1100. The price of the ocean is $2500. On this I could make you an allowance of $400. Should you desire to become possessor of both water colors I could let you have the two for $3000. As for payments I would suggest a payment of $1000. within six months, another $1000. within six months thereafter and the last $1000. within nine months after that. Should you decide for the sea piece I suggest the payment of $1000. within six months and the balance within six months thereafter. Should you decide only for the islands I should suggest the payment of $500. within three months and the balance of $600 within six months thereafter.

I again repeat that you must remember I have no business interest whatsoever directly or indirectly in this matter. And that I am considering you quite as much as Marin. All I know is that should you get those two Marins I know that your gallery will be tremendously enriched. I hope that in time you will have quite a collection of Marins. There are quite a few beautiful Marins which I can let you have for sums much lower than the amount involved in the purchase of these two very important pictures. As soon as I hear from you I'll be ready to ship you the Marin or Marins you want.

My kindest greetings to Mrs. Phillips and to yourself.

Sincerely

Alfred Stieglitz

N.B. As there is a party wanting the sea piece very badly I think you had better telegraph me your decision as soon as you receive this. It is for this reason I am sending you this by special delivery.

As for Marin, I intend to advance him the moneys he needs at present.

TPC

## TELEGRAM, PHILLIPS TO STIEGLITZ
*New York, April 16, 1926*

PLEASE SEND BOTH SEA PIECE AND MAINE ISLANDS BY MARIN AT YOUR EARLIEST CONVENIENCE     I SHOULD HAVE TIME TO CONSIDER SUCH SERIOUS ADDITIONAL INVOLVEMENT AND I HARDLY KNOW THE PICTURES WELL ENOUGH TO GIVE YOU AN ANSWER IMMEDIATELY CAN ASSURE YOU HOWEVER WE WILL TAKE AT LEAST ONE OF THEM ON CONDITIONS OFFERED
DUNCAN PHILLIPS
TPC

## STIEGLITZ TO PHILLIPS
*New York, April 17, 1926*

My dear Mr. Phillips: Your telegram received. And Budworth has been notified to ship you the two Marins fully insured for $3900 against all risks.—

—I am sure you are in for a real experience—a lasting thrill. Every time I take those pictures out I am amazed afresh at their wonder. Both are masterpieces—I know how you hate to become more involved—but I know once you have those two pictures in your possession you'll hate to give up either. It is understood you keep one at least.

My congratulations whatever your decision. And once more my heartiest greetings to you & Mrs. Phillips.

Cordially

Alfred Stieglitz

TPC

## TELEGRAM, PHILLIPS TO STIEGLITZ
*New York, May 5, 1926*

SO SORRY I HAVE NOT WRITTEN OF SAFE ARRIVAL OF THE MARINS HAVE BEEN OUT OF TOWN AND VERY BUSY SINCE RETURN     THE MARINS HANG IN OUR ROOM AND GIVE CONSTANT DELIGHT     WE WILL KEEP BOTH AT ONE THOUSAND EACH YEAR SENT WITH CHECKS FOR O'KEEFFES     HOPE YOU WILL TAKE NEEDED VACATION AT ONCE
DUNCAN PHILLIPS
TPC

## STIEGLITZ TO PHILLIPS
*New York, May 9, 1926*

My dear Mr. Phillips: Just as a very wonderful unknown Lady from Brooklyn walked into Room 303 & had bought a beautiful New

Ansel Adams, *Alfred Stieglitz at An American Place*, 1939, gelatin silver print, Philadelphia Museum of Art, from the Collection of Dorothy Norman

York Marin your more than welcome telegram came! Naturally I was elated for the sakes of all concerned. I am so glad to know those very beautiful Marins housed with you where I know they will ever be a source of pleasure. What greater comfort can there be to an artist—or to his friend?—

—The week has been a terrific one. Amazing beautiful without a flaw. So I'm feeling less tired—but am trying to husband what strength is left.—

I'm hoping you will have a fine summer—you & Mrs. P. & the children.—It will be impossible to get to Washington this Spring—I haven't the strength & Room 303 needs me. We plan to go to Lake George on June 1st.—Our heartiest greetings to you & Mrs. Phillips.—

ever cordially Alfred Stieglitz

TPC

## THE FIGHT

*From their summer retreats—Stieglitz in Lake George, New York, and Phillips in Ebensburg, Pennsylvania—the two men resumed their correspondence and discussed their plans for the coming season. At this point, before his visit to Marin's show in December, Phillips's focus was on Dove. He began what became a continual plea—to see the artist's earliest work, his abstractions, as well as to meet the artist. But Stieglitz discouraged him from such a meeting. He wanted Phillips to look more closely at Marin. Stieglitz was setting the scene for Phillips's encounter with Marin. And setting a new price—two watercolors priced at six thousand dollars.*

PHILLIPS TO STIEGLITZ
*Ebensburg, Cambria County, Pennsylvania, October 16, 1926*

Dear Mr. Stieglitz

Thank you so much for your letter. We are distressed to hear that you have been ill and trust that you will not resume your exacting and taxing work "on the firing line" unless you are entirely fit and feeling fine. This is just a line to ask you if I could see all there is to see of Arthur G Dove's paintings at some appointed place next week. I cannot stay in New York more than two or three days but must be there on Saturday the 23rd and would like to have a private view of his best work not only with the idea of acquiring another example of his art but also of planning for a one man show in our "Little Gallery". You write that you do not expect to be in New York until November so I fear I must miss you on my first trip to N.Y. Later I want to see the Marins and perhaps I can ask you to help me get together a Marin exhibition. But I thought I would like to show Dove's things early in the season and if possible would like to select the works available for my purpose on the occasion of my days in New York Oct. 26th–27th–28th. November will be a very busy time for me in Washington and I am not even certain that I can leave at all. Could you wire to Dove to meet me somewhere in New York on the 26th of this month and to have a lot of his *painted* work for me to see. Then a line to me saying that it is arranged will be deeply appreciated. We are looking forward eagerly to your season and especially to the new work of the wonderful Georgia O'Keefe. Please remember us both to her and accept our thanks for your kind thought of us. My wife has painted many charming pictures this summer and made a marked advance in technical breadth and in selfexpression.

Sincerely
Duncan Phillips

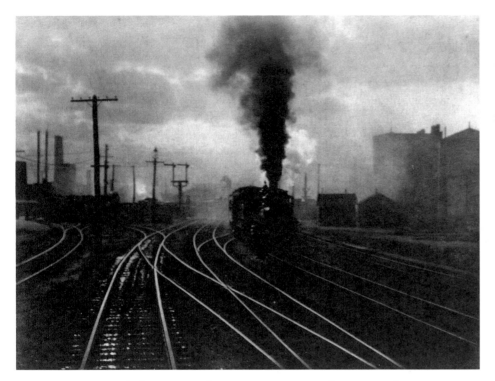

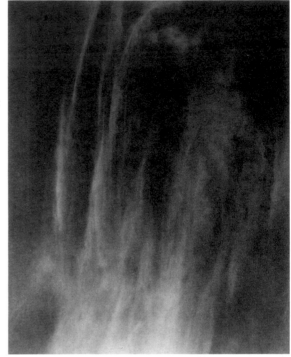

Alfred Stieglitz, *Hand of Man,* 1902, photogravure, private collection, Washington, D.C.

Alfred Stieglitz, *Equivalent* [Bry no. 220A], 1925, gelatin silver print

P.S. As there will be no time for your answer to reach me at Ebensburg before I leave for Pittsburgh and New York next Wednesday—would you drop me a line to the Hotel Gotham New York—55th St. and Fifth Avenue.
YCAL

### STIEGLITZ TO PHILLIPS
*Lake George, October 20, 1926*

My dear Mr. Phillips: It's too bad I'm to miss you. We return to N.Y. a week later.—As for the Doves—quite a few have found owners. The unsold ones are at the Room. Mine—I have about 8–10 [that] are in storage. You virtually saw all the Doves there are. You see he has had very, very little opportunity to paint. I don't know what he may have done this summer. I know he has been forced to keep at illustrating to make a living not only for himself & wife but for his boy.—So I don't believe there are many if any new things. I'd be surprised if there were. And if there are any they'll be shown at the Room first. That's virtually an agreement amongst ourselves.—I think you can see the reason for that—of course I'm eager to support you fully in your interest for Dove—He is one of the very few original workers in America—He is American.—So can't you wait till later to arrange a very fine Dove show. I'll help you. That's my

life.—Three of his things, including "the Nigger goes a Fishin," will be in the coming International show of Abstract art to be held in the Brooklyn Museum.—It is being arranged by the Société Anonyme. There will be three Doves, 4 Marins, two O'Keeffes (very wonderful ones), 2 Hartleys & 8 of my photographs coming from Room 303—a very fine showing it will be.—

—Of course I'll also help you to a Marin Show when you are ready. I believe in what you are trying to do.—

Of course my great problem is to keep these workers alive. And that is a problem.—To preserve their integrity—to keep them free—& to find a few appreciative people who can be entrusted with their work—for I jealously guard it *knowing what it is*—& who are willing at the same time to give these rare souls some actual money so as to let them work.—And as I wrote you I'm far from well—even now.—But I have no choice. I'll see these Americans thro' as long as I live. If nothing more it is an object lesson on *Concentration*—

—And by the way I wonder if you couldn't manage to let me have a check for Marin's first payment—I believe I wrote you that you were to pay $1000 in 6 months—another thousand 6 months later—& the last thousand six months after that. And I have advanced Marin the first payment, which is actually due Nov. 7. And as I have told you I am a man of no means—and the Room has to be paid for with cash—& my own blood. I believe the first 6 months are nearly up.—The first O'Keeffe payment is due about February

15th.—I hate to talk money at all—I think I realize your position & I want to accommodate you as much as the men (& woman) can possibly afford. You have two grand Marins. And as to the O'Keeffes—well, I don't know what adjectives to use. They are wonderful pictures. She has been hampered by my illness—but she has some great pictures to show.—

I expect to open the Room about November 11th. with new Marins—pictures I haven't seen.—I'll keep them up about two months.—

—I'm glad to hear about your wife's work.—I must come to Washington as soon as I can arrange [it] & not risk my health. And that's a question how to do that.—But I'll manage—

—O'Keeffe joins me in sending you greetings

Sincerely

Alfred Stieglitz

In making out check will you please make it out to The Intimate Gallery—& send it to me.—I forgot to say that I haven't written to Dove to meet you as I feel nothing could come of the meeting now in view of what I told you about his pictures & him. Later in the season when I can show you what is to be seen I can arrange that Dove be present. You see he lives on a boat & rarely comes to town—it is a long very inconvenient trip. Of course he knows your interest in him & it means a great deal. I am doing what I believe is wisest for you as well as him.

Once more greetings.

A.S.

TPC

## PHILLIPS TO STIEGLITZ
*Phillips Memorial Gallery, Washington, D.C., November 5, 1926*

Dear Mr. Stieglitz:

Many thanks for good letter of recent date. I have been travelling and have not had opportunity to answer more promptly. I would like to have an exhibition of your group, or else of Marin, in April and there will be plenty of time to arrange it later. Next time I am in New York I will certainly wish to see Arthur Dove's complete output with a view of adding another example to our group and also of seeing the possibility of an exhibition next year if not this year. The same will apply to O'Keeffe. At the earliest possible moment I want to look over all the Marins that you have and especially the earlier ones. Curiously enough, I know his later work better than his earlier work and would like to get one or two examples of his water colors of ten years back or even earlier.

I enclose check for $2000, made out to the Intimate Gallery, which is first payment on the O'Keeffes and the Marins. I dont

know whether this is exactly as you wished but it is more convenient for us to do it this way than to separate the first payment on the two artists. Mrs. Phillips and I hope to see you and your wife on the occasion of our next visit to New York and that may be in November during the Marin exhibition. With best regards,

Sincerely yours

Duncan Phillips

TPC

---

*Phillips did not attend Marin's solo show right away. As an inducement, Stieglitz sent him the reviews, along with an urgent plea that he should not miss the new work. Phillips, planning units of works by Stieglitz's artists, became interested. He began to consider Marin for further exhibition plans, and Stieglitz was ready to offer assurances about the show he could deliver.*

---

## PHILLIPS TO STIEGLITZ
*Phillips Memorial Gallery, Washington, D.C., November 20, 1926*

Dear Mr. Stieglitz:

Thank you for the many interesting inclosures which you have sent to me, all of which I have read with keen interest and satisfaction because I share the views expressed by the critics. I particularly enjoyed what Murdock Pemberton wrote about his unexpected long and exciting visit in your Room since it corresponds so much with my own experience and that of Mrs. Phillips. McBride is certainly an enthusiast about the genius of Marin and he has reason to feel that he is on safe ground for whether one likes him or not, according to one's love of suggestion or complete statement, yet the genius seems beyond dispute. I had expected to go to New York before this time but have had guests in my house and a lot of matters requiring my attention. I can hardly get to New York now before Friday of next week and possibly not until the end of the month. It is particularly important that I should see the Marins because I am not only interested in a possible purchase of another example from his early work, but hopeful that I can arrange with you for an exhibition of his work in our Little Gallery a bit sooner than I intended. During the months of January and February I am planning an exhibition of American motifs by American artists in our Main Gallery and a group of extremely fine and original Marins in the Little Gallery. We can only hang about ten or twelve pictures and space them properly. In fact, two or three would have to be smaller than the Marins I have seen. I am writing to ask you if you would pick out from Marin's early work a few landscapes, rather easy of

comprehension and lyrical in color and light, which we could count upon as available for purchase, and if you would also reserve from the exhibition of new work a number of the best which remain unsold so that if the exhibition is over and the pictures scattered by the time I should reach New York I can still see these at the Room. Of course I hope and expect to be there before the end of the show and to make my own choice from what is available. Meanwhile, I would like to have your assurance that you have me in mind and that you will be able to send a dozen Marins for January and February. We would, of course, pay the insurance and would make every effort to sell the pictures while here. When I am in New York I also hope to see more of the work of Arthur Dove but, since you think he has done nothing new and that I have already seen most of his pictures, I doubt whether we could arrange an exhibition of his work this season.

Sincerely yours

[Duncan Phillips]

TPC

STIEGLITZ TO PHILLIPS

*The Intimate Gallery, New York, November 23, 1926*

My dear Mr. Phillips

I have your letter of the 20th. You have no idea what is in store for you when you see the new Marins. The excitement in the Room is running at fever heat. I can say that Marin has jumped into the class with Ryder. You'll see.

I am naturally glad that you intend holding a little Marin show in your gallery and I shall do my best to follow your suggestions. I think I understand.

The present Marin show will last until January 15. It has only begun. But you have my assurance that you can have a dozen fine Marins for January and February and all of these purchasable. I also understand that you will bear the full responsibility while these things are en route and in your gallery: responsibility for loss or damage.

We'll talk about the Dove situation and anything else that you may be interested in. Looking forward to seeing you and with kindest regards to both you and Mrs. Phillips from Georgia O'Keeffe and myself,

Sincerely

Alfred Stieglitz

TPC

---

*Phillips finally saw the Marin exhibition and was as excited as Stieglitz had wished. Stieglitz hoped that if Phillips purchased one of the two watercolors priced at six thousand dollars, the publicity of such a* *sale would boost Marin's popularity. Phillips was wary of such a high price but finally agreed to buy* Back of Bear Mountain *with the proviso that the transaction remain secret. What followed was a struggle that lasted until the end of 1927 and indeed was never fully resolved. For the two men, the disagreement centered upon how the "event" developed at Room 303: whether Phillips agreed to the six-thousand-dollar price tag before or after Stieglitz gave one work to Marjorie Phillips and halved the price of the other.*

*The dispute highlighted the fundamental differences between the two men. Phillips envisioned a museum filled with European and American modernism that included, but was not exclusive to, the Stieglitz circle—Dove, Marin, O'Keeffe, and Hartley. Stieglitz, on the other hand, focused solely on this small group, who for him represented the best and indeed the only viable proponents of American modernism. Even more fundamentally, Stieglitz saw Phillips not as a museum director but as a collector who should take personal responsibility for the well-being of these artists' lives. That included believing in Marin's work, even in the watercolors, and buying them at prices on a par with those for works by well-established artists. But although Phillips agreed with Stieglitz about the importance of this circle, his goals and resources encompassed a much larger worldview of the modernism his museum should represent. His emphasis, ultimately, was on the quality of his collection—both European and American.*

---

STIEGLITZ TO PHILLIPS

*The Intimate Gallery, New York, December 5, 1926*

My dear Mr. Phillips

This is Sunday and there is a blizzard raging outside. I am at the Room and in a way I hope nobody will come. The Marins become more and more wonderful with every hour. They are incredibly beautiful. Even more so than you can possibly realise. Yesterday I had to deliver myself of a promised lecture in the Brooklyn Museum, re the ultra modern International Art Exhibition which is going on there. While there I took a good look at the Sargent collection of water colors together with the section of American water colors on which the Brooklyn Museum particularly prides itself. Incidentally, everybody is there but Marin. Most amusing. The lecture was an intense success!

So when I am here with the Marins and think of the Sargents and the other water colors I must smile. Sargent without doubt is terrifically clever and at moments reaches sometimes beyond cleverness. But these Marins seem because of Sargent even more terrifically wonderful than ever. I want to congratulate you and your wife on what at first seemed like a mad plunge on your part when you decided to take *that* big Marin in spite of what seemed to you a whistling price.

But you must realise what your courage really has brought you because of my appreciation of that courage. As a matter of fact, the three pictures that now can be called yours and your wife's are all truly masterpieces. That I know, and you will realise it more and more as time goes on. As for prices, considering what is being paid today for names that in time will become as meaningless as Bouguereau and Meissonier, etc., these figures that now seem so whistlingly large will seem as ridiculous as the figures that Henri Rousseau received for his paintings. I feel that you have gotten a glimpse of the real spirit on which 291 has been fighting and struggling for upwards of 36 years in this country. Every minute of those 36 years. You have no idea what intrigue is going on to destroy not only me but Marin, O'Keeffe, Hartley, Dove, and whatever I fight for. I don't know why it should be so, but it is. But maybe it is that very fact that keeps me fairly fit when I am on the firing line. And now to the arrangement about payments.

I have considered the matter carefully. I have told Marin what I did and how. And he seemed more than pleased and satisfied. Particularly when he heard that I had presented your Lady with the picture that both of you seemed to come together on from the beginning. As for payment, I feel that you ought to be ready to pay $1500 by January 1, 1927. That $2000 be paid six months later, that is by July 1, 1927, $2000 six months after that and the balance of $1500 six months after that. This arrangement has of course nothing to do with the arrangement for payment on the agreement of last your re Marin and O'Keeffe. I am enclosing what I call a "document of understanding". One of these you can keep and the other if you will sign it I will keep it on file. I feel that this is necessary because of the possibility of something happening to you or to me and it would not do to have Marin pay the penalty. I furthermore enclose memoranda for the O'Keeffe and Marin transaction of last Spring for the same reason. It worried me greatly when I was so sick that I had been so lax as to these matters, never having thought of the possibility of your and my not living forever.

I want to assure you furthermore that if anyone should want the two Marins you still are "itching" for, I'll telegraph to you and give you the first chance. I might as well tell you right here what the terms will be so that you can wire back your decision should it be necessary. The big green one is catalogued at $2700 and the "Near Sparkill, N.Y." at $1800. If you should decide to take the two I'd allow you a concession of $700, not more. As the prices of those pictures are really very low as far as Marin values go.

I am certainly looking forward to the early Spring when I expect to get to Washington with O'Keeffe for a few days, which will mean that I'll get a chance to see some of the wonderful things you have and share your enthusiasm as here you share mine.

My greetings and congratulations to you and the Lady.
Alfred Stieglitz

Note: In the memorandum of the understanding enclosed, you will notice that the presentation Marin to the Lady is not specified.
TPC

## "MEMORANDUM OF UNDERSTANDING," SIGNED BY DUNCAN PHILLIPS
*The Intimate Gallery, New York, December 5, 1926*

Memorandum of Understanding
Between Duncan Phillips and Alfred Stieglitz (for John Marin) in the matter of Marin water colors selected by Duncan Phillips, the pictures being:

No. 12, catalogue of John Marin Exhibition, Nov. 9, 1925 to Jan. 15, 1927, Room 303, Anderson Galleries, 489 Park Avenue, New York City

"Back of Bear Mountain, New York"          $6000.
No. 10, catalogue, as above,

"Hudson River Near Bear Mountain" Special price because of selection of number 12, at $6000.          $1000.
                                                              $7000.

It is understood that payments are to be made as follows: the dates representing in each case the latest date permissible:

| Jan. 1, 1927 | $1500. |
| July 1, 1927 | 2000. |
| Jan. 1, 1928 | 2000. |
| July 1, 1928 | 1500. |
| | $7000 |

Checks to be made payable to Alfred Stieglitz (John Marin Fund). Please sign & date & return to Alfred Stieglitz
    [Signed] Duncan Phillips
    Dec. 7th 1926.
YCAL and TPC

---

*Once Phillips had returned to Washington, he still desired* Near Great Barrington. *He also followed his letter with a telegram, the wording of which merely complicated the upcoming struggle. The telegram seemed to give Stieglitz permission to publish Phillips's purchase price. But even though Stieglitz later used this telegram as justification for his actions, after promising to keep quiet, he had already broken his word by sharing the details of Phillips's purchase price with the "inner circle."*

---

PHILLIPS TO STIEGLITZ
*Phillips Memorial Gallery, Washington, D.C., December 7, 1926*

Dear Mr. Stieglitz:

We are delighted at the prospect of adding the three soul-stirring Marins to our Collection and feel that the terms you make us for the three come to a reasonable total. However I cannot honestly say, much as I admire "Back of Bear Mountain," that it is worth $6,000 and would not wish to have you announce to the world that I was ready to pay that price. In other words, the proposition you made was not only acceptable but attractive and we are grateful to you for making it possible for us to secure the pictures, but it would not be fair to me to tell of my paying the full price for the one picture without also telling of your generosity in regard to the other two. It would mis-represent my own judgment in regard to values and would lay me open to a charge of paying anything for a picture I like, which of course is an impression I cannot afford to create in the minds of the other dealers. I agree to the terms of our Memorandum of Understanding on condition that you will keep them confidential. Surely there will be enough mutual advantage to Marin and to the Phillips Memorial Gallery in the fact that we have bought five of his water colors in two years.

You do not say in this letter of December 5th just when you are sending them and I would like to know so that if you are keeping our pictures until the middle of January we can place insurance on them. I would like to receive them at once and hope you can spare them from the exhibition. The choice of those subjects was very difficult and the two other green Marins linger in my memory with a devastating insistence. However I am afraid I cannot afford them at the prices you name. The best I could do would be to offer the "Maine Islands" as an even trade for either of them and that would not be to Marin's advantage as the Islands are more difficult to understand and would be harder to sell. Do not forget to pick out for us a half dozen early Marins of the best quality for our exhibition opening December 27, and at the close of your Marin exhibition we would like to receive the others marked with my initials, over and above our own selection. That included the Great Barrington mountain scene, the "Near Sparkill, New York", the River scene surrounded with reddish trees against blue and violet hills, and the one call[ed] "Passing Song" with the sailboat. I will turn over the two Memoranda to our Treasurer and it will probably be best to add one thousand dollars from our agreement of last year to each payment of the new agreement until the whole amount has been settled.

 With best regards and best wishes,
 Sincerely yours
 Duncan Phillips
TPC

TELEGRAM, PHILLIPS TO STIEGLITZ
*Washington, D.C., December 8, 1926*

SAY AS MUCH OR AS LITTLE AS YOU PLEASE ABOUT OUR AGREEMENT
ALL THAT MATTERS IS OUR HAVING THE MARINS ESPECIALLY THE BIG
ONE
PHILLIPS
TPC

STIEGLITZ TO PHILLIPS
*New York, December 8, 1926*

My dear Mr. Phillips: I have your letter of the 7th also the "understanding" signed. I regret that you feel your new big Marin not worth $6000. I know it worth considerably more—much more.— If you lived in Room 303 as I do—& had lived with Marins for 17 years as I have—& knew what artists say—& have said—about him you could not but agree with me. You'll realize in time how reasonably you bought and you have helped Marin. It won't turn his head. I found it advisable to let the very small "inner circle" know what had happened—chiefly because of its beauty—its unusualness in the—happenings. And the little circle understood. Money was not in their minds.—Otherwise it is no one's affair. As for the arrangement for payments that is confidential—only Marin knowing— outside of ourselves.—

I am a bit amused that you class me amongst the dealers! I have to bear it. I often wish I could be a dealer—but dealing in human souls is just a bit beyond—or short—
of my make up.

I am busy selecting early Marins for your Show in January.—

 As several Museum Directors are to be brought to the Room to see the Marins I find it advisable to keep the Room in tact. It is important for Marin & for America. I'll send the pictures as soon as the right moment arrives. So you had better insure if at all nervous.

 —There were several nibbles to-day at the Green Mountain (it looks particularly magnificent in to-day's cool gray light). There was a nibble too at the other. It needs brighter light to look its best.

 —I'm sorry you find $3700 too much (or beyond your means) for the two green ones. May be when the Show is over & they are still to be had I might be able to have another $700 off the figures quoted to you.—It would be too grand to know all those Marins in one Gallery. What an array. The money involved is really not much. Twenty-five years ago or more Sargent received $50000 at Knoedlers for 20 watercolors.—(The dollar then was worth more than twice its value now.)—There in the Brooklyn Museum. Think of 20 real Marins in a Museum.—

—But I won't let my imagination get hold of me
Greetings
Alfred Stieglitz

Later: Your telegram has come. I can't make out what prompted it. Yet I'm glad it came as it assures me of your confidence in me. I am mailing you something that might interest you.—
    A.S.
TPC

## PHILLIPS TO STIEGLITZ

*Phillips Memorial Gallery, Washington, D.C., December 10, 1926*

Dear Mr. Stieglitz:

Of course you must know that you are not a dealer. It was the careless use of one word which gave you that wrong impression. I do not question that a great Marin will eventually be worth even more than $6,000 and therefore I was wrong to stress the point that I would not have paid that much for that reason. My real reason is, that if I am to buy the large group of Marins which I am already planning, I count upon your giving me reduced prices, not merely museum prices but even lower than that, to encourage me to go on with the collection of his work in all periods. For instance, in the matter of that Sunlit Woods and Snow Mountain painted near Great Barrington, I hate to let that picture go for it is a grand one but I have absolutely reached the limit because the reduction you offer does not make much difference. If I could feel that you would let me have the picture for one thousand dollars, I would be able to acquire a few early examples and thus round out the collection. Already I can see that with the publication of my catalogue I have reached the end of the first period in the life of the Phillips Memorial Gallery, a period of exploration and broad tolerance. Inevitably there will be a tendency in the future to eliminate what is not of permanent value and to specialize on the artists who seem to grow bigger as time goes on. In America Marin is certainly one of these and I would like to have a group of his, as well as groups of Homer, Twachtman and Ryder. Please reserve the green Mountain by Marin and mark it as mine, on the understanding that the price is to be settled by new negotiations after seeing the early Marins which you will send for our exhibition. Greetings to you and Georgia O'Keeffe from us both,

    Sincerely yours,
    [Duncan Phillips]
TPC

## STIEGLITZ TO PHILLIPS

*The Intimate Gallery, New York, December 11, 1926*

My dear Mr. Phillips

Lying before me is your letter of the tenth. Also your answer to my telegram. I hasten to write you.

You see I am writing so frequently and completely because I want to bring about a perfect clarity between us. Because I feel that you will not only have to have a large group of Marins but undoubtedly groups of Dove and O'Keeffe, maybe Hartley even, not to speak of my own photographs if you really want your gallery to reflect a growth of something which is typically American and not a reflection of France or Europe.

I agree with you that Homer, Twachtman and Ryder are three American giants. Of course I place Ryder above Homer and Twachtman. A colossal figure. And before Marin gets through he'll prove that he is equally colossal. But that is all aside from what I really want to say.

I reiterate that I am giving you all the benefits that I can as far as prices are concerned. I reiterate that I am considering you maybe more than Marin. Certainly not less. For I feel that it is essential for all of us that Marin be represented in your gallery as completely as possible. Now, I telegraphed you this morning that I was willing to let you have the Green Mountain for $1510. In view of the offers I had received on that particular picture I had to have an immediate reply. You see I have cut the $3000 offer for two Marins virtually in two.

I hope that your passion for Marin has been because of this addition at least temporarily satisfied.

I enclose a memorandum for the payments for this picture. I think the arrangement will satisfy you.

It will interest you to hear that Pierre Matisse spent an hour here this morning and was more than enthusiastic about Marin, saying he was one of the few really great artists that America has produced. But of course one does not need what Pierre Matisse has to say.

By a curious coincidence a woman with whom O'Keeffe and I lived eight years ago just came in and has gone. Her father was a sculptor and the intimate friend of Ryder. Ryder used to play with this woman when she was a kid and she has told me many stories about Ryder, most interesting, when we were living with her.

There is an ever increasing excitement about the exhibition even though the visitors are relatively few. There is much intrigue going on against this Room owing to increasing jealously. Why there should be this jealousy I can't quite understand. But the human being is certainly a queer sort.

    With kindest greetings
    Sincerely
    [Alfred Stieglitz]
YCAL

Alfred Stieglitz, *Equivalent* [Bry no. 217B], between 1924 and 1931, gelatin silver print

until February and by that time I will be able to get all the Marins at once and alternate them on the walls, continuing the show for two months so that they will all be seen, somewhat in the way you show them in Room 303, with that same sense of overflowing of beauty and embarrassment of aesthetic wealth creating in the mind a terrific impact of new ideas and new inspiration. The book on 291 is fascinating reading. My wife and I were particularly interested in reading the contribution of our dear friend Katherine Rhoades. By the way, we have no record of her New York address and wish to put her on our mailing list. All I have heard is that she has an apartment in New York this winter and is going to paint. We miss her very much in Washington. What an extraordinary poem for a young girl to have written, full of fire and depth and prescience and genuine exaltation. I would like to write you more as to my own views about what you are doing, and what Room 303 means to me and to Marjorie Phillips, but I am very busy and will write you again.

Sincerely yours

Duncan Phillips

TPC

### STIEGLITZ TO PHILLIPS

*The Intimate Gallery, New York, December 15, 1926*

My dear Mr. Phillips

I would have acknowledged the receipt of your letter of the eleventh before this if I had not been rushed to the limit. You have no idea what is happening in the Room. Mad moments. No two alike. One madder than the other. The latest event is the editor and art editor of a magazine with a million and a half circulation storming the Room and within 10 minutes leaving it with a Marin and an O'Keeffe to be reproduced in color. They bought the pictures outright and found the prices absurdly low!! This certainly staggered me. After everything I've had to hear for years about "high prices". Of course I am glad for Marin's sake and O'Keeffe's. They wanted the Green Mountain and were ready to pay a big price for it. But I did not let them have it because I felt you had your heart set on it. Curiously enough there have been four people after it within the week.

Now I wonder why you have not returned the memorandum I sent you for signature. I must keep these matters straight otherwise there will be a mess for all concerned. And I cannot afford a mess. So please send me the paper so that I can put it on file. I made you the absolutely lowest price possible. Even though I am willing to make every concession to you which I feel is more than fair, I dare not lose sight of the fact that now is Marin's chance to release the pressure on his wife. If she breaks down it would be a calamity for Marin which means for all of us who are interested in his working freely.

### PHILLIPS TO STIEGLITZ

*Phillips Memorial Gallery, Washington, D.C., December 11, 1926*

Dear Mr. Stieglitz:

I seem to be communicating with you at the rate of twice a day! My secretary read me your telegram over the phone this morning while my mind was full of other matters. I was rearranging the hanging of the Gallery which is always an engrossing and perplexing problem. Instead of grasping the fine spirit and perfectly clear intention of your suggestion that I offer fifty cents to bind my reservation of the Green Marin, I assumed that you were making a new proposition on the actual payment on the picture and that the telegram was not clear. This impression was increased by the fact that your name was inaccurately spelled. However I caught the note of generosity and desire to protect our interests in your telegram and I am glad that I accepted your proposition without knowing what it was for it shows you again how much I trust you. Please take your time about the selection of the early Marins for our exhibition for it might mean selecting for the Collection and not merely for the show. All things considered, I will postpone the Marin exhibition

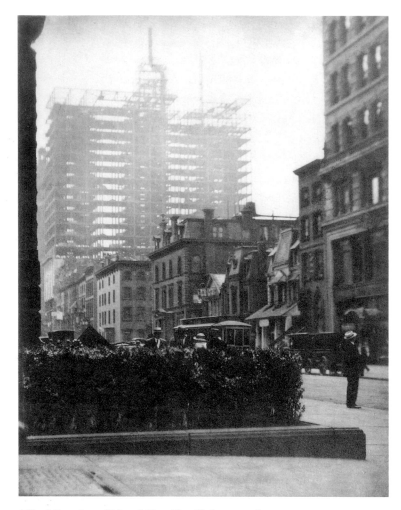

Alfred Stieglitz, *Old and New New York,* 1910, photogravure, private collection, Washington, D.C.

But I don't want you to do anything against your free will. I know you are probably possibly even more busy than I am and so have possibly overlooked sending this paper.

The more that happens here the more I realise that the prices I have asked for the Marins are really low—much too low. Still, he is satisfied and I feel I am doing the right thing for all concerned. The more I think of Marin and O'Keeffe the more I know they loom up as giants.

I am glad you enjoyed "What is 291?" and enjoyed particularly the contribution of our mutual friend, Rhoades. Her address is 1435 Lexington Avenue. She is painting. I am wondering what her painting will look like. My most cordial greetings to Marjorie Phillips. I wonder when your book will be out. Would you send me one inscribed? I'd appreciate it. I am ordering a few copies for the Room from Weyhe.

Sincerely yours,

[Alfred Stieglitz]

YCAL

*Stieglitz purchased copies of Phillips's* A Collection in the Making, *published in mid-December of that year. Phillips saw it as both a summary of his collecting history thus far and a statement of intent for the future. He followed this book with two articles and one essay, all entitled "A Collection Still in the Making." Phillips was proud of his tome, reusing parts of the text in later publications throughout his life, but he always intended to follow it up with a second volume that would more strongly reflect his adherence to modernist, abstract art. As it happened he published only a handbook of his collection in 1952.*

*The Egyptian head that Phillips purchased from the Kahn auction served as an example of his sources of modernism even more strongly than the eighteenth- and nineteenth-century art that he had already collected (such as Chardin and Daumier). The head appeared on the cover of his 1927* Bulletin, *which was published in conjunction with the first of his "Tri-Unit" exhibitions. Phillips created these three-part exhibitions to show the interrelationships of art of all ages and nationalities.*

PHILLIPS TO STIEGLITZ
*Phillips Memorial Gallery, Washington, D.C., December 27, 1926*

My dear Stieglitz:

It was so kind of you to write me at once upon reading the book on the Collection. I am not surprised but deeply gratified that you are able with perfect sincerity to speak of it as highly as you do even though so much that is written about and illustrated is not at all up to your taste. You have a broad and kindly understanding and can recognize in it the rare sort of consecration which you have yourself to a Cause and a special mission. Mine is different from yours. This first catalogue is, as I told you, a report of the first stage of our development, the stage of exploration based on a principle of open minded interest in everything that is vital and sincere and aesthetically distinguished. I will continue to broaden the field but all the time crystallize my own convictions as to what is of permanent value. The next edition will probably report a radical change with significant eliminations and even more significant selections of artists chosen for Exhibition Units. My plan is to keep the public informed of my growth and development, to let them participate in the adventure of forming a collection. But why go on? You understand exactly what I am doing and realize that I take my time to make up my mind about whatever interests me and I am embarrassed always by the extent of my interests.

So sorry that O'Keeffe is ill, please remember us to her and extend our best wishes for the New Year. I may dash on the end of

this week just for a day or two to see an Egyptian setne head of the 18th Dynasty in the Kann Catalogue. If it is possible to get it within our very limited resources I may do so, and you will understand my feeling about the relationship of Egyptian sculpture to so much that is important in modern painting.

Instead of revising the previous schedule of payments by adding the last item namely, what we call the Green Mountain Marin, I shall send you a separate check in full payment for that picture, leaving the other payments as before. So on receipt of the check you will send me a receipt of the same and tear up the memorandum I sent you. I would have written about this instead of sending back the signed agreement but I was ill in bed with a bad cold which I have had for two weeks. I may have to go away to shake it off. I hope you can send the Marins before I do go away so that I can see them and study them and arrange my exhibition and write a thoughtful introduction for the catalogue. While the pictures are here, and I hope there will be at least a half dozen "Class A" early Marins, wouldn't it be a good idea for me to have them all photographed and prepare a little Brochure on Marin taking my own appreciation and quotations from those papers you sent me. I will try to sell the ones which we do not keep and I believe that I can do so if, with the help of an illustrated catalogue and tributes from the authorities, I can impress the Washington public with the importance of the man to whom they are being introduced. I have already given preliminary announcements of the Marin Exhibition to the papers here, stating that Washington is to see one of the greatest living artists and one of the biggest men America has produced in painting. I must bring this long letter to a close,

Sincerely

[Duncan Phillips]

P.S. I am sending you an autographed copy of "A Collection in the Making."
TPC

STIEGLITZ TO PHILLIPS
*New York, December 29, 1926*

My dear Duncan Phillips: The book has come Yes I know I have found a friend—And I feel you know you have found one likewise.—

—I have been looking much at your book & every day it is discussed by people coming. Many criticize! I laugh & ask them what they find good. That flusters them. And then I point out many of the "good" things & I ask them whether they wouldn't like to help them live—That thought seems to strike the fewest until pointed out to them.—

Once more my congratulations—

—Your Marins will go to you early next week altho' the Show continues a week longer.—

To-day I was in storage to pick out some early Marins to replace some I had chosen for you the other day. George F. Of has all to clean up frames, etc.—I'm surprised how few A1 early Marins are left. But all you are to receive are of that class. Of course it will be fine to have you interest people in Washington. But what I am enjoying most is the thought of the real joy you & your wife will have living with the Marins.—For real joy it will be.

I have begun "rehearsing" the O'Keeffes. There are some grand canvases. Incredible performances.

—I hope the Egyptian head will materialize. I have a great leaning towards the Egyptian. Always had. Once more thanks & our cordial greetings.—

Alfred Stieglitz

It's a great idea to have the Marins photographed.—In looking at the book with the people many are very much attracted to Marin's Maine Islands.—It stands right out in a surprisingly fine manner.
TPC

*Stieglitz now directed Phillips's attention to O'Keeffe, as he had done the previous year with Marin. His next letters anticipated the impending show of her recent work, which would feature many of her New York paintings. He and Phillips also discussed the mechanics of having Marin watercolors shipped to Washington for Phillips's upcoming Tri-Unit show. Although originally intended to be a solo installation, the show ended up being a "wall of Marins" hung alongside European artists, particularly Bonnard, with whom Phillips thought Marin had affinities.*

STIEGLITZ TO PHILLIPS
*New York, January 23, 1927*

My dear Mr. Phillips: I have been hesitating. Hesitating to make the suggestion. For I am fully conscious how terrifically busy you are—under what constant pressure you live. Furthermore you are preparing the Marin Exhibition.—But wonderful things are happening in The Room. Unbelievable—a real pilgrimage to the O'Keeffes. Artists—& art connoisseurs—authors—art directors from distant parts & lands—even "classy society" are rushing in & all seem overwhelmed. It is acclaimed that O'Keeffe has brought a new world to us all. It is universally conceded that she has made a gigantic step forward as a painter. Demuth arrived & after carefully

looking about for awhile exclaimed: Grand! The favorite seems to be The Shelton—Sun Spots! But he is still to see the Show in daylight. I discount all enthusiasms. But I know you ought to see the Room—& as soon as possible. If only for an hour. (I feel that O'Keeffe even tho' developing along particular lines may never be seen again as in *this* Show—so fully—so varied—so inventive.) It is with the inconvenience of a rush trip. That is the suggestion. It is not with the idea of your buying but because *you should see—You must know.* It is important for you & what you are doing & intend to do even more fully. It is important for America & for all its true artists. Those are the ones we are seeking.

—I have hesitated. But after what I have witnessed the last few days I have no right any longer to "spare" you. I don't expect you'll be able to come but you at least know what I feel.

—Seeing the O'Keeffes later when no longer hung & many distributed will not give you what you'd get now—& which is the essential thing. My greetings to you & Mrs. Phillips.—

Cordially

Alfred Stieglitz

There were 800 visitors in The Room yesterday!
TPC

PHILLIPS TO STIEGLITZ
*Phillips Memorial Gallery, Washington, D.C., January 27, 1927*

Dear Mr. Stieglitz:

We have been planning right along to go to New York to see our great Daumier and Courbet in the Reinhardt exhibition alongside of great masters of all ages. I hear that our pictures are the most admired by those best qualified to speak. Please stop in and see these masterpieces. The Daumier was never before shown in this country and it is the greatest thing he ever did, a work of towering genius. The Courbet also is magnificent. Of course we also wanted to see the O'Keefe exhibition though I admit we were a little afraid of it, afraid to be tempted to buy any more when our funds are all gone. But we have O'Keeffe represented in three different aspects and must be content to wait for another year to add to the group. I have not yet told you that the reasons why we are now prevented from going to New York are (1) Mrs. Phillips has not been well, (2) I am working with intense concentration on a group of exhibitions in three different galleries and am trying to get a booklet under way which will be illustrated with pictures from this exhibition and commentary upon it. The three units together, two large and one small, will give a comprehensive picture of what we are doing and the way we want to do it even when we have a big building. The

Marins hang on one wall of the Main Gallery where there is daylight and where they can be seen at a proper distance and in comfort, a sofa placed at exactly the right range will enable the serious student who desires to know Marin can look long and intimately at each picture without rising, referring, if he wishes, to the Notes which I have written and the Press comments on Marins genius. In the same Main Gallery modern French paintings will be shown, Matisse, Bonnard, Segonzac and others. And in the midst of all this vitality of the modern mind, expressing itself so diversely in color and form, I will show our Stone Head of the 18th Dynasty in Egypt with its glimpse of a happy moment when the sun came out and the individual was prized, all the spirit of modern artists anticipated. Downstairs in the Lower Gallery there will be contrasts of old and new combinations that will make people think, not just miscellaneous arrangement of things. I wish you could come to see the Collection during February and March while these shows are on view. In fact, you must come and Georgia O'Keeffe too, and you must tell your friends about it. I would like to have Murdock Pemberton and Virgil Barker come down here during this show and write up their impressions, and I may try to arrange that later on when I finish my catalogue. You see that I am too busy to leave town and would rather see whatever the O'Keeffees that remain unsold after all the excitement in your Room has subsided. I will need rest not excitement after the climax of my own art season. By the way, I may have to have one more early Marin, the smaller one of the Tyrol, it is very luminous and lovely and would fill a gap in the Marin Unit. As they seem to be getting scarce, perhaps I should grab a good one of that period as a mere matter of policy but I hope you will let the payment go over for a long time as we are absolutely unable to add to our previous indebtedness. It is priced at a thousand but eight hundred would be as much as I could pay for it and that not for some time. I think you will like the little notes I am writing for the catalogue on each Marin of our own group, they are meant to help people to see emotionally and musically instead of with the usual solicitude for literal fact.

Again our regrets for not coming at this time but you will understand.

Sincerely yours

Duncan Phillips

TPC

---

*Stieglitz's mixed response showed his annoyance with Phillips's continued discussion of his nineteenth-century Europeans and with his attempts to usurp Stieglitz's own critics and supporters to promote European shows, while impertinently advising Stieglitz to expand his*

*view of art. But he still needed to court Phillips, so while he criticized the quality and installation of the show in New York, he nevertheless praised the works there that Phillips owned.*

*In this letter Stieglitz admitted to telling Henry McBride, a critic and supporter of Room 303, the story of the six-thousand-dollar purchase. McBride's article, published a few days later in* The Dial, *was followed by Murdock Pemberton's in* The New Yorker. *Phillips was stunned to find the critics interested only in what they considered an excessive price for a Marin watercolor.*

---

STIEGLITZ TO PHILLIPS
*The Intimate Gallery, New York, January 29, 1927*

Dear Mr. Phillips

I received your letter of the 27th just after having come from the Reinhardt Gallery, having had to go to my dentist in that building before coming to Room 303. A tooth of mine having been raising merry hell with me for over a week. So I saw your Daumier and your Courbet. The exhibition itself rather annoyed me as the pictures are miserably lighted and shown without a trace of "feeling". Still, I did take as good a look at the Daumier as the atmosphere permitted and also at the Courbet. I could enjoy nothing under such conditions but I realise that the Daumier is a magnificent one and the Courbet equally so. Some day I hope to see them in your own place where such pictures undoubtedly breathe their own life and one can breathe with them.

I am amused that you should be afraid to see the O'Keeffe Show. Remember, I would protect you against all temptation. I think I understand your temperament and know a little about your temptations. So don't be afraid. Just come and see for yourself. I guarantee you against any "fall".

Of course I'm sorry that Mrs. Phillips is not well. That you are working with intense "concentration" on your various exhibitions, I know. I also know what that means. The exhibitions will certainly be very wonderful including that of the Egyptian stone head. I'm afraid that I won't be able to get away in a hurry from the Room. If what happened there last year was important what is happening this year is more than important. You can have no idea. It is incredible. And everything is moving wonderfully and in the right direction. It all has nothing to do with money.

What amazes me most is the class of people coming. All ages. The youngsters are most magnificent. A new kind of human being. Don't fear, I'll be telling everybody about your shows. You are often mentioned. And before I get through with you you will have become quite a Lohengrin in the art world.

Murdock Pemberton I'm afraid is so rushed on his job that I doubt his being able to get away to Washington; and still I'll see

about it. As for Virgil Barker he is in the West *digesting* and hoping to start writing a book. He won't be back in the East for a year.

I don't want you to see the O'Keeffes that remain unsold. I want you to see what is there now. And if you should come I'll see to it that there will be one hour at least without excitement.

Yes, the Marins, the early Marins, are getting to be very scarce. The $800 you speak of as being willing to pay will be all right although the $1000 was already a concession to you. And as for payment I suppose you could pay that by January 1, 1928. If that is satisfactory I will send you a memorandum. So let me know.

I'm sure that the little notes you are writing for the catalogue on each Marin of your group will delight me. I hope you will find people sharing your enthusiasm. If a few get to understand everything will be all right. The many will never be able to. I am enclosing a clipping which undoubtedly will interest you. Maybe you will have seen it. Your book lies conspicuously on a chair in the Room and many people look at it. There are many discussions.

McBride spent the evening with O'Keeffe and me last evening and amongst other things we spoke about you. I told him the story about your purchase. All the detail. He got the spirit. Again I say it is the spirit which means everything to me. We also spoke of your book and the work you are doing and McBride feels as we do about it. And about you. We all think you are doing something that no one else in your position is doing. Real constructive work. The museums are pathetic even if they make heroic efforts to be otherwise.

With kindest regards to Mrs. Phillips and yourself and hoping that she is all right again,

Cordially
Alfred Stieglitz

N.B. The chief reason that I'd like to have you see the O'Keeffes is not that I'd like to have you buy any but as long as you are interested in O'Keeffe—and I know she is one of the most important workers in America and maybe in the world today and not only according to my idea but the ideas of many who come to the Room, and many who really know come—I feel that you as a student of the art situation and of the artists owe it to yourself to see the whole evolution of so important a worker. Just as I feel that you are entitled and should see the whole evolution of a worker like Marin. For the same reason. This is not so important with most workers. Very few need this close study particularly in America. By this I mean most workers repeat themselves. These two workers do not. At least as yet not.
TPC

*Phillips Memorial Gallery, Washington, D.C., February 4, 1927*

My dear Mr. Stieglitz:

McBride's "stupefaction and numbness of mind" about my paying $6000 for a Marin as publicly expressed in the Dial following upon a similar announcement by Pemberton in the New Yorker has annoyed me considerably. As you remember, I asked you to keep our arrangements confidential since I was not prepared to spend that amount for one picture, and only agreed to your plan because the three pictures averaged $2000 each. In a later telegram I may have given you the idea that I was ready to give publicity to the wrong impression but this was only because you had said that you would keep the matter confidential within your immediate circle. I think it is only fair that the same men who have given publicity to the "$6000 for one picture["] news item should contradict this in the public press.

The Tri-Unit Exhibition does not open until the 5th and the illustrated catalogues will not be ready for ten days later owing to the fact that I am making the booklet a publication which will supplement my book "A Collection in the Making", as a work of equal quality. Nevertheless I will send you the paper backed catalogue which will be ready Saturday and which will contain all the text. The two Washington art critics have already come and of course neither of them could see Marin. As you say there will be only a handful of people really able to understand and appreciate but I hope to make a few converts and, possibly, one or two sales. I have not told you that I will accept the Tyrol, 1910, by Marin for $800.00 payable January 1928, and you can send me a memorandum to that effect.

Still hoping to see the O'Keeffe show, perhaps just before going South the end of February.

Sincerely yours

[Duncan Phillips]

TPC

---

*Phillips accompanied his Tri-Unit exhibition with a "makeshift catalogue." He followed it with his* Bulletin, *a special publication with essays that laid out his emerging aesthetic.*

---

*Phillips Memorial Gallery, Washington, D.C., February 8, 1927*

Dear Mr. Stieglitz:

The illustrated catalogue fell through at the last moment because I realized that it would either have been done badly or that it would not have been out in time for the opening day. We compromised on a makeshift catalogue which included all the text but only one picture. And that turned out to be a bad reproduction. As this Tri-Unit Exhibition is really such an important event in our history and in the art life of Washington, I am planning to commemorate it with a handsomely printed book by Nunder which should be ready the second or third week in February. I really hate to send you the inadequate catalogue but knowing that you would be impatient to see just how I am presenting Marin with Press Comments, Notes of Interpretation, etc., I will send you a copy as soon as a few more hundred are printed. We had over two hundred people the first two days and all the catalogues were carried away. Sunday afternoon was a very exciting time and I was surprised and gratified at the amount of enthusiasm created by the exhibition which is quite daring. The critics were impressed in spite of themselves by Marin with his tremendous force, and also by the beautiful flower garden of a wall on which Matisse and Bonnard were the chief attractions. The two other units were a striking contrast to the excitement of the Main Gallery. But the same idea prevailed in all, namely, that art can only be interpreted through suggestive settings and combinations. The Stone Head looks marvelous against Tack's "Voice of Many Waters" which suggests geological time in colors that are almost like an Egyptian fresco, but with Twachtmanesque atmosphere and Chinese delicacy of pattern instead of mere arabesque in one plane. The Head is more beautiful than I had thought. It is one of the most beautiful things that has ever been found in Egypt. The expression around the mouth and eyes is disturbing, it is so revealing of the very soul of the young King portrayed. I call the whole exhibition "Sensibility and Simplification" and it is just as true of this ancient source as of the latest development in painting. All this genuine enthusiasm for the beauty that I have created on these walls leads me to insist that you and such men as McBride and Pemberton and, if possible, Barker should come down at your very earliest convenience. New York has seen no such exhibition as this. Art has never been thought of quite in this way.

By the way, we have more Marins than we can show and as I want every one of them to be of first importance I have left out a few of the early ones. Shall I return these or keep them with the possibility of making a sale? I believe that I will make converts. Do you remember Mr. and Mrs. Gerrit Miller? He is a scientist and a music lover and is an admirer of Marin and O'Keeffe. He was simply spellbound by our wall of Marin and spent the whole afternoon studying and thrilling to the artist's genius. I will take the early Marin entitled "The Tyrol", for $800.00, payable January 1928, so you can send me a memorandum to that effect. I must say in all friendliness, but with a frankness with which friends should meet one another, that I am annoyed by all the publicity given in the press to what I had thought was to be a confidential arrangement between us. You see my own

position in the matter is misrepresented. In reporting the affair it is stated that I paid $6000 for one picture and that I bought four of them, presumably for the top price in each case. Is it fair to me, even in the interest of Marin, to let it appear that I am so easy a mark and that I have such unlimited resources? Nor do I think that it will help Marin to boost his prices in this unnatural way. It may frighten off people who would be about ready to buy but who could not rise to such figures. I, myself, would like to feel that I could continue to buy Marin but I certainly cannot if that scale of prices prevails in the future. And it is a shock to hear that an O'Keeffe has gone for $6000 also. Do be careful not to overdo this boom. I have seen the work of artists come to a standstill, so far as sales are concerned, through being rushed too high prices too soon. Pemberton in the New Yorker and McBride in the Sun and Dial should really be made to give the whole truth of our arrangement, retracting what they have written, but I dislike a continuation of the publicity and must merely ask you to please put an end to it and to tell these men and all others the strict truth, in the interest of Marin as well as of myself. In conclusion let me repeat how high a value I place upon the very Marin in question. The fact remains however that I could not have had it, could not have brought myself to consider it at that figure if you had not presented the other pictures and thus made me see the matter from a practical standpoint, as an investment which the Gallery could not afford to miss. Hoping that you will understand how sensitive I am to being misrepresented but thanking you always for your genuine and highly valued assistance to the cause which I have at heart, namely, the building up of a great Collection. With best regards to you and O'Keeffe,

Sincerely yours
[Duncan Phillips]

P.S. We shall surely see the O'Keeffes before the end of the exhibition but just when I cannot say.
TPC

---

*The correspondence between Phillips and Stieglitz became consumed by a growing defensiveness regarding the "event" and how it should be viewed, couched in discussions of the importance of their own work.*

---

STIEGLITZ TO PHILLIPS
*The Intimate Gallery, New York, February 13, 1927*

My dear Mr. Phillips
I have your letter of the eighth before me. I hasten to write to you because your letter has really stunned me. I do not resent it because

I feel that you are frank in letting me know about your resentment re the Marin publicity in connection with what you call your "soul-stirring Marin". You thus give me a chance to clarify a few things to you. A few erroneous ideas you somehow have gotten into your head not only about this Marin publicity but about O'Keeffe and what has happened to her as far as "remuneration" for her work is concerned.

First, as for the publicity given to your purchase of the Marins please dont forget that you telegraphed me to use my own judgment in how to make public what I considered at the time your wonderful sportsmanship. Please remember that you had virtually bought three Marins for $5000 before you decided to take the Marin you really wanted for $6000. If you will remember, a remark of Mrs. Phillips decided you. You may not have been conscious of that. But it was this fact which moved me on the spur of the moment, in commemoration of your sportsmanship as I called your act at the time, to present Mrs. Phillips the Marin which both you and she had chosen as one of the three originally selected in the $5000 arrangement. This particular Marin was priced to you at $2000. You will remember that both of you, when I acted as I did so spontaneously, said: "Why, we cannot accept this gift. You have no right to give us that Marin." My answer was: If I have a right to sell Marins I have a right to give them away. I furthermore said that if Marin could not trust me to do what was right by him in the spirit of the Room, he would have to find another friend. Furthermore, you in your enthusiasm wanted the little gray "Hudson at Bear Mountain". And I told you that owing to your having paid $6000 for the great Marin I would cut the $2000 price in two. You then spoke something about the "Green Mountain". And I told you I thought you had done your share and that you should not spend more money that morning in the Room. You thereupon requested me not to sell that Green Marin to anyone until I had given you a chance. As you know I lived up to your request. You finally were allowed a concession of $1190. on that picture which I would never have given you had you not led me to believe that you were perfectly satisfied with having paid $6000 for the "$6000 Marin".

And please dont forget that the "$6000 Marin", as I told you, would not have been bought by anyone for one dollar less than $6000. (Incidentally right here I might tell you that the other "$6000 Marin" has been withdrawn from the market and cannot be had at any price.) At the time I agreed that no publicity should be given to what happened except to Marin and to two or three of the immediate coworkers in the Room. I lived up to the promise until you sent me a telegram releasing me and giving me permission to use my judgement—I assuming that you felt that it was only fair to let me act not only in the interest of yourself but in the interest of the spirit of Marin and the spirit of the Room, which I believed were synonymous.

It happened that Louis Kalonyme came in at the time. Kalonyme is one of the most brilliant young men in America, the intimate friend of Eugene O'Neill. Kalonyme is writing brilliant articles on art and on the theatre for *Arts and Decoration.* Furthermore he writes on art for the New York Times. He also writes for Europe. I told him as well as Pemberton the *exact* course of events in the Room. I told these men the story with no idea of publicity but because they are two unusual fellows and truly interested in the living side of the art movement of today. Both were elated at what you had done. Were elated at your sportsmanship, at your courage. At the fineness of both yourself and Mrs. Phillips. It was not money that was in their minds.

As for McBride, I said nothing to him until I had seen what he had written in the Dial and what he wrote in the Dial rather staggered me. I was horrified. But it so happened that the very next evening McBride came to see O'Keeffe and myself. As soon as I saw him I told him that I regretted greatly that he had written as he did. McBride said nothing. But I could see that he was deeply impressed—impressed as any person of sensibility would have to be impressed. Because the story is truly a magnificent one. Finally McBride smiled and said something to the effect: I can't believe that anybody should be affected by many of the things I say.

As a matter of fact he resents it that people take him literally in matters like this when he is having his little "Artist's joke". For McBride is an artist and an underpaid one like so may others who are really artists in this country. This is not the first time that McBride has put me in a false position. Yet I'm fond of McBride. He's a rare person and I believe he is a friend. Without his little pranks I dont think he'd care to live. And I understand.

When anybody came to the Room to inquire about your purchase—as many did even dealers—and I felt that it was in the interest of the "Cause", I gave them the same facts. All felt that you had done a magnificent thing. But all also felt that you got a great Marin at a more than reasonable figure. Now of course, My dear Mr. Phillips, I cannot help what people will take out into the world. You know very well that even one's closest friends when desirous of helping one are apt not entirely to reflect the actual spirit of a conversation or a fact. Silence is apt to be misconstrued as well as a true picture in words of any event. If one knows life one doesn't resent that. One accepts it as part of life.

So why did I not have the right to assume that you would give me the benefit of the doubt instead of virtually accusing me of misrepresentation? My life relatively is much simpler than yours. Every moment of my life is correlated and focussed on one idea. That is one reason why I have a memory. Your life is not quite of the same concentration. This is not criticism. It is merely something I believe. Maybe can prove. I am truly sorry that you have permitted anything to becloud the extraordinarily beautiful happening that morning in

the Room when you chose your Marins. Nothing can rob me of what I received in spirit. And I am forced to reiterate for the Nth time that you must never forget that for myself money does not exist.

It is too bad that I am forced, owing to the needs of even as simple a man as Marin and a more than simple woman like O'Keeffe to be compelled to be the go between them and people who are willing to exchange some of their dollars for the concrete materialisation of their spirit. But I am willing to be misquoted, misrepresented, suspected and God knows what not, as long as I know that everything I do is done in broad daylight and I have nothing to hide from anybody. The door open as you know.

You warn me about what you call the pricking of a boom. I'm amused. There is no boom either in Marin or in O'Keeffe. As little boom as there ever can be is the spirit of the Phillips Memorial Gallery. I wonder did you object to Durand Ruel for publishing the fact in the newspapers that you had paid $125,000 for your Renoir. I doubt it. I cannot for the world of me understand what you should be ashamed of or what you have to hide. You may believe the dealers and artists may try to make you pay a penalty for having so generously given $6000 for a Marin! I cannot believe that. You may not know that dealers go about and so do the artists telling what you and other people have paid for your purchases. There seem to be no secrets. Certainly not in the art world. There is hardly a single thing that you or others interested in modern art have bought that is not reported to me and what you and they paid for it. And this for years before I knew you. Why I should be told or should ever have been told I don't know because it certainly does not interest me and I pay no attention to it for it has absolutely nothing to do with me.

As long as you mention the "$6000 O'Keeffe" I will tell you what happened. A woman seeing the O'Keeffe Show became so excited about what she saw that it seemed to change her life, as she put it to me. She insisted in procuring the "Shelton—Sunspots". And she offered to pay anything that was asked, saying that she had complete trust in me to do the right thing by her and O'Keeffe. She is a woman who had been giving O'Keeffe an annuity for three years of $1000 a year. For this she had been receiving a picture every year. When I suggested that Marin for his water color had received $6000 from you and that I felt the "Shelton–Sunspots" was an equally great picture, I thought that if she would give O'Keeffe $1200 ($100 a month) for five years, she would be doing what I considered fair. She felt that that was more than fair, positively generous. When the world was told many who know and understand considered that O'Keeffe should have received considerably more and that I was unfair to O'Keeffe. From a business point of view, if I could take such a view, I certainly would not have let this woman or anyone else have this picture under $10,000.

It must not be forgotten that all the moneys that I really would be entitled to if I were in business, I divide between the so-called buyer and the artist. Oftentimes allowing all to the buyer. On some occasions all to the artist. Let me tell you furthermore that other O'Keeffes have been placed. Also on an annuity basis as you yourself are giving her an annuity for your three O'Keeffes but that the people have been making the offers. New people. Not acquaintances. That the O'Keeffes placed outside of the $6000 one have brought $3000, $2200, $1000 as well as $75 etc. Now dont for one moment believe that O'Keeffe is having her head turned. All this is not affecting her any more than Marin. And it is certainly not affecting the Room.

What is happening is that Marin and O'Keeffe both can work quietly for a couple of years without having to worry about exhibitions or money. Which furthermore means that I can get a let-up and take care of my health which is my dividend.

I can assure you that next year's exhibition of Marin which is virtually ready, will be even greater than this year's. I can also assure you that the prices will not be exorbitant. I dont believe in high prices. But it is good to occasionally establish a real figure for a masterpiece. It seems absolutely necessary in America.

You certainly cannot complain about the prices you have paid for your magnificent collection of Marins. Nor can you complain what you paid O'Keeffe. Or let me say the annuity that you have given her for three years. After all, I think you will agree with me that the main thing is that both Marin and O'Keeffe go on singing their grand songs. Wait till you see the O'Keeffe Show.

Incidentally it may interest you that the Metropolitan Museum is after my photographs. But I have not time for anything like that at present. Somehow or other I am indifferent to all that as far as my own work is concerned.

As for your Tri Unit Exhibition, undoubtedly it must be a magnificent exposition. But for the world of me I dont see how I can get away from the Room. I am needed there every moment. The world is moving fast and there are greater things happening in the Room than the procuring of either Marins or O'Keeffes, things entirely unrelated to money. As for McBride and Pemberton coming down, I dont see my way clear in suggesting any such thing to them. I never suggest anything to McBride or Pemberton. I feel that they would have a right to resent it. I also feel that it would be robbing them of their liberty. I rarely suggest anything to anybody unless I am asked for suggestions and then I am more than careful. As for Virgil Barker I wrote you some time ago that he was in the West taking care of his health and also writing a book and does not want to be interfered with.

As for the Marins you have and which could not be hung, of course it would be fine if you could find a home for them in Washington. I suppose your Exhibition wont last longer than a month or so. And if no home has been found for any of the Marins, why you could then ship them back to me with those shown and not kept by you. As for your new Marin you wish to keep, I'll send you a memorandum within a few days.

I never doubted that the Marins would attract great attention. For you have a most magnificent lot and I cant believe that all of Washington is asleep.

With the assurance that I am more than delighted that your Exhibition satisfies you and gives others so much pleasure, and regret that for the present at least there is no thought of my being able to come to Washington and with greetings to you and Mrs. Phillips,
   Sincerely
   Alfred Stieglitz
TPC

---

*Phillips in his next letter haggled openly for a discounted price on a Marin work,* Pearl River Near Suffern, *signaling his awareness of Stieglitz's plan to raise Marin's (and O'Keeffe's) market value.*

---

PHILLIPS TO STIEGLITZ
*Phillips Memorial Gallery, Washington, D.C., March 8, 1927*

Dear Mr. Stieglitz:
Since I last wrote to you I have sold one or two pictures and I now feel that I might spend the proceeds for one more Marin. I am becoming fond of "Pearl River—Near Suffern" and I wonder if, in consideration of my much advertised purchase of so many of his works, you would let it remain here in the Marin Unit for a price considerably lower than the $1250 asked for it. I certainly could not pay a cent more than one thousand and am asking for better terms which I could accept without delay. I am also writing about O'Keeffee's "The Shelton at Night"—the one with the lighted windows reproduced in Arts and Decoration. It looks very fine and now that the Show is over, if unsold I should like to have you send it on approval. It is only fair however to say that I could not consider it if the price is over $2500, and that in any case I would have to give up one of our others—probably the Canna which is impossible to exhibit with other pictures—in part payment.

I hope to send you the published brochure of the Tri-Unit Exhibition this week. We have had a catalogue with Notes of interpretation ever since the show began to help our visitors —especially with Marin. But it was unillustrated and printed inaccurately so I have not sent it through the mails. The exhibition has been extended through April but at the end of March I will return all the Marins we do not own. I want to be able to keep Pearl

River. Hoping to see you and O'Keeffe at our Gallery before the end of April,

Sincerely

[Duncan Phillips]

TPC

---

*Stieglitz, unhappy that Phillips had not visited O'Keeffe's show, became unwilling to sell one of her paintings to him. But rather than openly refuse, he undermined Phillips's aesthetic judgment by deeming the picture unworthy. Then there was Phillips's stated intention to return* Red Canna. *The battle lines were drawn.*

---

STIEGLITZ TO PHILLIPS

*The Intimate Gallery, New York, March 11, 1927*

My dear Mr. Phillips

I have your communication of the 8th. I had been fearing that you might be ill not having heard from you in such a long time. Not having received a catalogue of your Tri-Unit Show, you having promised to send one weeks ago.

In regard to your offer for the Marin "Pearl River Near Suffern," that is $1000, you put me into a position which compels me to say, all right provided you pay the $1000 at once. If so, please make out a check to John Marin and send it care of me. You might as well know that the price of that Marin was $1800 and that I had already made a concession to you of $550 when giving you the quotation of $1250. But I am not going to make it a question of money. I am rather tired of being put in a false position. I see you have not grasped my spirit nor the spirit of the Room. I am sorry, but we'll let it go at that. I am glad you like Marin's work. That is the chief thing.

As for the O'Keeffe "Shelton at Night", the reproduction of which you saw in *Arts and Decoration,* let me tell you that she is repainting that canvas not being satisfied with it. The only canvas shown in the Exhibition with which she was not completely satisfied. True, it was admired and was very effective. But that is not sufficient for her nor for me. As for your Red Canna and your not being able to hang it with other pictures, I told you at the time when you bought it that it would cause you trouble if you did not understand the modern way of hanging pictures. If you had seen how O'Keeffe's Show was hung, you probably would have learned something which would have enabled you to hang this Red Canna of hers without disturbing anything around it. But it is too late now.

As for the brochure you speak of, naturally I'll be glad to see it. Since November 1, I've been in the Room daily without a break. It

has been a marvellous experience but a trying one. O'Keeffe has been ill again.

The Lachaise Show is very beautiful—very perfect. Whether we can come to Washington or not remains to be seen. I must do something for myself. Very soon. And O'Keeffe must paint.

Sincerely

[Alfred Stieglitz]

YCAL

---

*When Phillips finally sent Stieglitz his* Bulletin, *Stieglitz gleefully issued a terse note informing him of an error ("Pierre Matisse"), even as he praised its contents. Phillips responded in an embarrassed manner. Phillips then became furious at the new turn the publicity had taken, primarily because it cast him in the role of a conservative collector who trusted only artists in academic organizations. He escalated the fight by complaining to editors directly.*

---

PHILLIPS TO STIEGLITZ

*Phillips Memorial Gallery, Washington, D.C., March 19, 1927*

Dear Mr. Stieglitz:

I will send you a check for the Pearl River of Marin just as soon as my treasurer says the funds are available. I was counting on a sale which didn't come off but I want that Marin just the same. It has grown on me until I now like it one of the best.

I am glad you like the Bulletin. I could have made it much better if I had not dashed it off rather hastily, as the terrible slip about Matisse indicates. It was even worse for me to be so careless in the proof reading not to notice the Pierre in place of the Henri. We always refer to the great masters by their last name so that in many cases we are really not familiar with the sound of the full name. That must account for the fact I allowed the slip to pass unnoticed in a quick correction of the proof. It was not worth recalling the edition on that account as it had been delayed so long.

I am returning all the Marins not in our Collection except "The Palisades" which I need on the Marin wall for the balance of the exhibition. Can you let me keep it through April? Several people have been interested in this one water color and I want to see if I can not sell it to Mrs. Eugene Meyer who likes Marin greatly. The wider spacing makes the Marin wall look finer than ever and the corresponding elimination of non-essentials from the other walls has improved the look of the entire exhibition. I have added two new Bonnards, making a whole wall of this artist and his greatness as a colorist is undeniable by anyone at all sensitive to quality in paint. I really wish you would come during April to see this unique

John Marin, *Mt. Chocorua—White Mountains,* 1926, watercolor
and graphite pencil on paper

exhibition of Sensibility in Sculpture and Painting. The paintings
are being sent today to George F. Of with instructions to deliver to
you, and we are paying the express charges.

I was really angry at the last article of Pemberton's in the New
Yorker repeating the $6000 item again, in spite of my appealing to
you to soft pedal on that since it misrepresents me, and proceeding
to refer to the Phillips Memorial Gallery as a reactionary institution
which hitherto "had bowed only to Academicians". This is such a
distortion of the truth that it is really not worth a reply but I did
send a tempered one to Pemberton and the contents of it also to
Watson, McBride and one or two others. My anti-Academic prin-
ciples have been so freely expressed for many years that this critic
only exposed his own ignorance of what he was talking about. I have
far more artists outside than inside the Academy in my Collection.
And the initials N.A. or A.N.A., are considered too unimportant to
appear on any pages of my book "A Collection in the Making". I am
not in favor of destroying the museums but I would like to see the
Academy go out of existence forever in every country, as it seems
to me a blight and a contagious influence for its off-shoots are as
bad as the main trunk, all rooted in the idea of complacent "cliqui-
iness". I know you will understand that in the expression of my own
principles and views, which may not always be in alliance with your
own, I have no feeling against individuals and I am only being myself
as you are yourself and as we all must be ourselves if art is to be
worth anything.

Sincerely yours

[Duncan Phillips]

TPC

PHILLIPS TO DEOCH FULTON, EDITOR, *THE ART NEWS*
*Phillips Memorial Gallery, Washington, D.C., March 22, 1927*

Dear Mr. Fulton:

I wish to correct a statement made in The New Yorker to the effect
I paid $6000 for one Marin, a story which has become one of the
things gossiped about all over town, or at least that part of town
which is in any way interested in pictures. The statement has been
printed in The New Yorker in two different issues and by Mr.
McBride in The Dial. Unfortunately I had to allow the item to pass
uncontradicted because it is, so far as it goes, correct. But it is only
a half truth and the other half should be known. Field Marshal
Stieglitz maneuvered negotiations so that I paid his record price for
the Marin I liked best, receiving as compensation two others of the
very finest of Marin's 1925 vintage *as gifts.* Thus I secured for $6000
three of the best Marins in existence at an average of $2000 each.
No doubt the misleading statement that I bought a single Marin for
$6000 helped the cause of modern art in general and Marin in par-
ticular. I must say however that I would have been unable to con-
sider any one Marin this year, no matter how wonderful, for such a
price, and it was only the opportunity to get three A-1 water colors
by this great artist at a price below their value which tempted me.
I realized well enough the news value of my bargain for propaganda,
but, as it was in a worthy cause and on behalf of America's finest
painter, I not only understood but cooperated. So of that mis-
statement I have nothing further to say, except that I am tired of its
endless repetition. There are better things to write about Marin
than his market value.

I cannot be so complacent with another mis-statement in a late
article in The New Yorker. It is suggested that my purchase of the
Marin at the sensational price was probably a cause for the National
Academy's less scornful attitude towards the Modernists since hith-
erto the Phillips Memorial Gallery "had bowed only to Academi-
cians." This is so fantastic in its distortion of my whole record that
it is not necessary to issue any denial. To be sure it is quoting some
unknown radical and therefore it is to him that I must lay the charge
either of ignorance or malice. I have been a free lance at war with
the Academy and all it stands for these many years, and have ex-
pressed myself in print with too little equivocation, as to the mean-
inglessness of Academic standards and awards, for this anonymous
person to succeed in misleading readers. It is well known that I have
more paintings by painters outside than inside the Academy, al-
though it never occurs to me even to look for, or care about, the
tag or lack of tag after an artist's name. In my Estimates of the Art-
ists in the Phillips Memorial gallery as published in my book "A
Collection in the Making", a copy of which was sent to you, no
mention is made of any organizations belonged to, offices held and
prizes won. I am not at all interested in such things nor influenced

by these inconsequential results of political wire-pulling in the painter's profession. I wish to be more independent than the leaders of the Modernist factions for I am opposed to all cliques and to politics outside as well as inside the Academy. I could confront Mr. Pemberton with lists of painters in my Collection which would show that from Ryder and Twachtman to Prendergast, Davies, Tack, Luks, Sloan, Tucker, Miller, Sterne, Kent, Marin, Demuth, Karfiol and Hopper, the men I particularly stand for are, with a few unacademic exceptions such as Lawson, Myers, Speicher, Spencer, and Beal, outsiders from Academic free passes. I am more inclined to buy from unheard of radicals, especially if no clique or club is busy boosting them, than from prize-winning members of the Academy or its annex the New Society. Pictures, it seems to me, should be judged from a sufficient distance, so that the judgment is not the result of bias, or too much knowledge of which painters are considered "regular fellows in good standing" and which ones are either black-listed for being too much of the Old Guard, or too free and untrammeled by professional politics.

I wish you could see our Tri-Unit Exhibition. I am sending under separate cover a copy of our Bulletin which is illustrated with our new acquisitions. This supplements "A Collection in the Making" and I hope you will consider the two publications as a record of that [which] is being tried down here as a demonstration of the Intimate Museum and Experiment Station Idea in Art.

Sincerely yours,

[Duncan Phillips]

TPC

## STIEGLITZ TO PHILLIPS
*The Intimate Gallery, New York, March 24, 1927*

Dear Duncan Phillips

I have your long letter of the 19th and I have read it and reread it I dont know how often. And I dont know exactly why I have read it so often. But somehow or other I feel that you have some things frightfully twisted in your mind which things should not affect you even if they existed in reality. And I know that many of them do not.

As for the check for the Pearl River Marin, have it sent along as soon as your treasurer finds the funds available. Which I hope will be soon as the price you made for yourself was based upon a cash payment. Marin needs the funds. I am glad you like the Pearl River. You did when you were here. It is an important piece in relationship to the abstract Marin which you have and still more abstract Marins which you as yet have not arrived at. But will in time, I am sure.

As for the Palisades, which you are keeping for the Marin wall, to balance the Exhibition, of course you can keep it through April. Maybe you will finally be able to dispose of it. As for Mrs. Eugene

Meyer, I wonder do you know that she was a great Marin fan as long as 18 years ago and she has some dozen Marins I believe which she got at 291 in the course of the years when she was so intimately identified with me. Thanks for returning the Marins you no longer need. Undoubtedly I'll hear from George F. Of in due time.

So you have bought two more Bonnards. It is always good to be able to satisfy a passion. I like Bonnard well enough but he never could become a passion of mine.

I am terribly sorry that you should permit yourself to be made upset by reference to that "$6000 item" whenever it appears. I have spoken to the people about your feeling and your requests. They know the exact story from me and that is all I can do. I cannot dictate to anyone. As a matter of fact I refuse to. I dont believe in it. You ascribe to me powers that I haven't got or which if I did have them I would not use. I have no idea what you are referring to when you say that Pemberton had written of your gallery as a reactionary institution, etc. I do not watch the press very carefully. Unless something is specially called to my attention I am very apt not to see it. I hope your letter to Pemberton, Watson, McBride and Co., will be effective in the way in which you want it to be. I somehow suspect that when these men speak of academic they dont necessarily mean the National Academy but really mean conservative or ultra-conservative.

As for the museums I personally feel that many of them are even worse than the Academy. One knows what the Academy is and what it stands for but heaven knows what most museums stand for. There is as much "cliquiness" in most of the museums of this country as there is in the Academy.

Your museum is your personal expression. It cannot be considered a museum in the usual sense even though it may be one.

It will undoubtedly amuse you to hear that last week an artist who is represented in your collection as one of the "moderns" (I consider him an academician) came to me and told me that he had understood from you that you had received for your $6000 the so-called $6000 Marin and four Marins presented to you as a bonus. I told this friend of yours and mine that I absolutely refused to believe that any such thing had come from you. I told him the facts as I had told them so often. And when I was through he said: "So there are two stories." If I had not full control over myself I think I would have hit this man. But he did not even realise what he had said or what he had done. But I know why his pictures have never meant anything to me and why at 291 I refused to show them even though I helped him personally in many ways. Its a queer world. I have taken the trouble, my dear Mr. Phillips, to look up the "Memorandum of Understanding" re this $6000 Marin which I have signed by you and a copy of which you have. And I find that my "memory" is 100 per cent straight. I hope this will be the last time that this unfortunate $6000 business will have to be referred to by me per

letter. When I see you personally I will tell you exactly what I have been telling people when they forced me into saying anything and then I am sure you will say that I have not said anything which did not happen exactly as I related. Of course I know that you feel the story as told in the papers does not tally with the spirit of the transaction. In this I agree with you. But somehow or other editors and publishers seem little interested in spirit.

If we can come to Washington we'll certainly do so. But just for the present I have but one thought. To get at my own work. As soon as I can and as long as I can.

With kindest greetings,
Sincerely Alfred Stieglitz
TPC

## PHILLIPS TO STIEGLITZ
*Phillips Memorial Gallery, Washington, D.C., March 26, 1927*

Dear Mr. Stieglitz:
I am glad that we are to have no more occasion to write about the Marin affair, one to the other and back again. Stories about prices in the papers always get garbled and the spirit of an agreement is, as you know, of no interest to the "headline hounds." The real story is getting more and more garbled and that is why I wrote my letter to several editors telling the straight truth as you tell it to anyone who asks you about it in your gallery. The unnamed painter who quoted me to you as saying that I had received four pictures as a bonus for paying the $6000 as a peak and a record price for Marin was guilty of a malicious misstatement of what I told him. If he got the figure 4 it was merely that I state I secured four Marins all at approximately one time, the Bear Mountain abstraction at $6000, the two pictures given by you to Mrs. Phillips and myself, and the "Green Mountain" which I paid for a little later as a separate transaction. As I wrote to Mr. Pemberton, he must have better things to write about Marin than his market value. It serves the cause of this great artist ultimate renown far better to publish attributions to his art and what it means to the best critics of the country than to "boom" his prices and make him, as you say, the victim of jealousy. I can understand why Marin's greatest admirer outside of your Room, Henry McBride, was not at all pleased to hear the story. For Marin's sake as well as for us I know that you will continue to correct the impression which has been broadcast.

By this time Of has delivered the Marins which we are returning. It was a pleasure the other day to show them to Katherine Rhoades who came to Washington for a few days. She was of course thrilled by the Marin wall as she had not seen his recent work. She saw the relation between him and Bonnard as two great temperaments and two colorists of genius. It is possible indeed to have a passion for both men, for they belong to the same family of artists, men who trust their senses and invent beauties which are at the essence of life with paint as beautiful as it can be, each in his separate medium. Marin is bigger and more elemental and has more emotion to convey but Bonnard in his more playful way is a poet no less endowed with the Divine fire.

Sincerely yours,
[Duncan Phillips]
TPC

## STIEGLITZ TO PHILLIPS
*The Intimate Gallery, New York, March 30, 1927*

My dear Mr. Phillips
I had hoped the "Marin affair" need never again be referred to in our correspondence. But your letter of March 26 shows that your recollection of what happened in Room 303 is badly twisted. In your letter, lines 11 and 12, you say: ". . . the Bear Mountain abstraction at $6000, the two pictures given by you to Mrs. Phillips and myself," etc.

Two pictures were not given to you and Mrs. Phillips. I enclose copy of Memorandum of Understanding of December 5, 1926, of which the original is signed by yourself. This will recall to you that you paid $6000 for the Bear Mountain abstraction and that you paid $1000 for the picture, Hudson River near Bear Mountain, "special price because of selection of number 12 at $6000." Obviously this picture was not presented to you as you seem to believe.

I wonder [how] can you possibly have done Marin and Room 303 the injustice of sending this gross misstatement into the world in your letters; leading people to believe that you had paid $6000 for a Marin with the understanding you and Mrs. Phillips were to receive two Marins as a bonus.

Please never forget that Mrs. Phillips received the Marin presented to her *after* you had decided to take the "$6000 Marin"; and that neither you nor I nor she had any idea beforehand this would happen. It was my spontaneous and generous impulse to present Mrs. Phillips with a Marin she had admired and so commemorate what seemed at the time your act of sportsmanship. I wonder was not this generous impulse of mine the source of all the subsequent trouble.

[Alfred Stieglitz]
YCAL

## STIEGLITZ TO PHILLIPS
*New York, April 2, 1927*

My dear Mr. Phillips: Enclosed was sent to me I wonder is this your

version of what happened in Room 303.—If yes, kindly let me know. If not please write to the Art News,

Alfred Stieglitz

Enclosed Art News Apr. 2/27 (re "$6000 Marin & others"—also Editorial Field Marshall Alfred Stieglitz—)
TPC

## PHILLIPS TO STIEGLITZ
*Charleston, S.C., March [April] 4, 1927*

Dear Mr. Stieglitz:

I am tired and ill and have come here for a rest, but I must try once again to clear the fog of embarrassment between us.

Mrs. Phillips and I are very certain of what happened when you called us into the hall outside of room 303. I was planning to purchase two of the less costly Marins and had no intention of getting the expensive one, the price of which seemed fantastic. You said in effect "Don't miss the great Marin, which you like best. If you say you will take it at Six Thousand, and I will not take a cent less, then I will *give* you the Hudson River at Bear Mountain and I will give Mrs. Phillips the Rockland County." The inducement made me agree, otherwise I would not have even considered paying Six Thousand for any one picture. I was in full possession of my faculties and what you offered was an inducement.

Emphatically and for the last time I must deny that I ever said I would take the Bear Mountain for your record price *until* you had named the compensation. If the memorandum gives the figures as you now show them, then I must have been careless in failing to notice that instead of *giving* the Hudson River as you said you were doing you were making a greatly reduced charge for it. Even at One Thousand the reduction was in the nature of an inducement and this, together with the gift to Mrs. Phillips, convince us that you were really making it worth while. You *called it a gift at the time* and I took you at your word. In any case the matter is closed. At least I hope so.

To my great annoyance I have just received a letter forwarded from my office in Washington, written by Mr. Fulton, Editor of Art News. He tells me that he is using the contents of my letter to Mr. Pemberton as a news story for the current issue of his paper. This I emphatically *did not authorize,* and I am trying to suppress it by wiring to him, but I fear I am too late. The gist of my letter was simply this: I did pay the Six Thousand for the Marin picture of Bear Mountain, but under circumstances which explained my action and which have never been told to the public. There were compensations and inducements offered which made the transaction of practical benefit to the Phillips Memorial Gallery. I hope that no matter what is published and no matter how many inaccuracies may

arise in the news story you will refrain from prolonging the controversy, which must be a burden to the public by this time.

If the publicity continues it will spoil what has been one of the most intense pleasures of the year for me, my joy in John Marin and my chance to live in daily contact with his exhilarating art.

Sincerely yours,
Duncan Phillips

I am really heartsick over this Art News publicity. I had to correct the wrong impression which had been broadcast but only in order to prevent its further repetition. My aim has been to stop the controversy instead of prolonging it—And if you are indifferent to my feelings & myself in the matter—I beg you for Marin's sake to let the matter drop. All this is not a boost—but a boomerang for Marin. And it spoils my Marin season which had done so much for the Cause which we both are working for. I wanted more Marins—wanted to keep in step with so splendid an adventurer. Money and publicity between them can spoil anything. In future I shall never buy anything unless the price is withheld from the public.

DP
YCAL

---

*Stieglitz now took offense at Phillips's description of the Marin acquisition as a bargain struck through a series of gifts, options, and discounts. He had in fact always intended that the six-thousand-dollar event be publicized, but had never intended that his own role be known. Stieglitz had told the critics that he was to be left out, that he was of no importance. Now that Phillips's version was published, however, Stieglitz felt personally attacked and believed that he was compelled to publish his own account. He did so, with a pamphlet that he continued to distribute until December.*

---

## STIEGLITZ TO PHILLIPS
*Room 303 [The Intimate Gallery], New York, April 7, 1927*

My dear Mr. Phillips

I have your letter from Charleston, S.C., dated March 4th, 1927—(it should read April) and I had to write to you. First of all I cant tell you how sorry I am that you are ill and tired. Secondly I more than wish to assure you that in all this unfortunate affair I have been considering you and Mrs. Phillips more than anyone else. I have never considered myself. I do not today. Your letter shows clearly that you are ill and tired.

You see your innocent letters to the art critics and the press, how they have been garbled. Do you think you can ever undo what this

garbling of the press has already done? Of course your aim was to stop a controversy but it was you who introduced the controversy. As for Marin I am truly sorry. He knows nothing of all this which is going on. I spare him that.

I dont think in terms of "boosts" or "boomerangs." Marin cannot be harmed, somehow or other, as long as Marin and I are friends. I am sorry if your Marin season has been spoiled. It is certainly through no fault of mine. I have done more than my share. Remember, you have the Marins. If you let the controversy spoil them for you, then that shows a weakness in yourself. Nothing can spoil a pure thing for me. A work of art is always that.

When you say that "in future I shall never buy anything unless the price is withheld from the public," I wonder why you should worry so much about so trifling a matter. You will never be able to keep it secret. Artists will tell each other what they have received for their pictures. And they will tell their friends no matter what conditions you make that the price paid should be kept secret. Within the last four weeks artists have been telling me what they have received not only from you but from others. Sometimes proud of the amount, sometimes crestfallen. I dont ask. They simply tell. It is natural. I've written you a similar thing before.

As for what you say happened in the hall, that you and your wife remember, it came about as follows: After you had decided to take three Marins—Sunset Rockland Country, The Hudson, and the Green (Great Barrington)—not including the "Back of Bear Mountain," you exclaimed you were not getting the picture you really wanted and turned to your wife and said to her: "But Margery you dont tell me what you like best." She informed you that she liked best two pictures hanging on the wall to the left of the door as you came in, and you remarked, but you liked best the "Bear Mountain." I took the trouble to tell you at the time that Mrs. Phillips undoubtedly was looking at the Marins from a painter's point of view and you were looking at them from a collector's point of view and that all three Marins were virtually equally wonderful. Your wife then said to you to my great surprise and amazement and very quietly: "Why, Duncan, if I felt about that picture as you do, I'd buy it." After she had said that you said: "You would?", much surprised and she answered again, "yes."

I then saw your predicament and wishing to relieve your constraint asked you and your wife to come into the hallway because there were too many people moving about the Room; and telling you I thought I could simplify matters. What was said in the hall where we were only a minute or two was as follows: You informed me that you could not pay $6000 for the Marin because of the false position it would put you into because of the dealers and artists. I said I understood and told you there was no use of being bothered about that, that if you paid $6000 it would be kept quiet, that I would only tell a few insiders and request them to keep it to them-

John Marin, *Self-Portrait*, late 1940s or early 1950s, graphite pencil on paper

selves. It was nobody's business and I said everything would be all right.

We then came into the Room and to my great surprise, for I really had not expected it, you said: "I'll take the Marin for $6000." I still feel the chill that went down my spinal column when you said it—for I had absolutely refused to make a penny's reduction of this and one other Marin, "The Mountain." I remarked: "A miracle has happened. An American has the courage to be a sportsman before a wonderful picture." And I added that as one miracle begets another I would take the privilege of commemorating the wonderful moment for American art and artists in being permitted to present Mrs. Phillips with the Marin, Sunset Rockland County, which both you and she admired so intensely upon first entering the Room and which was one of the three Marins you originally decided to purchase. You had agreed to the three for $5000 having asked for a reduction because of your museum. The reduction to you was $1500 on those three pictures, valued respectively $1800, $2000 and $2700.

Both you and Mrs. Phillips refused to permit me to present this Marin to Mrs. Phillips saying that you could not accept an $1800 gift from Marin. Whereupon I told you that you need have no qualms because if Marin permitted me as his friend to accept $6000 for one of his pictures he would have to give me the privilege of giving one away, and that if he did not like the way I did things for him he would have to find another friend to take care of his pictures. I told you to remember that the picture was not given to you but to your wife in commemoration of this act of sportsmanship on your part. I called your attention for the Nth time not only that day but as I had called it before when we met, that all this question of moneys and pictures was hateful to me, and that I had not and never have had any personal interest in it. That unfortunately Marin's family as well as himself seemed to have to pay bills as other people do. That meant he was called upon for cash. You and Mrs. Phillips seemed to understand and were delighted as was I.

Then you followed this with the question: "For how much can I have the little Hudson River?" And I said to you: "Mr. Phillips, as you have not received anything in token of commemorating this wonderful moment, you can have the $2000 Marin["] (this was also included in the original purchase of three which purchase was cancelled, naturally, after you had decided to take the $6000 picture) ["]for $1000.["] You did not know that $1200 had actually been offered by someone else. You said at the time this was more than generous. I wanted it to be more than generous for I felt that after you had expressed your willingness to pay $6000 for a Marin, as Marin and I neither of us believed in "high prices" for anybody's pictures, I wanted you to feel that I appreciated your sportsmanship—your spirit. The only way I could, was to act as I did.

Then you wanted to know about the Green picture, which was the third of the original three you had bought and I said: "Mr. Phillips, you cannot have another Marin this morning, you have done more than your share. You have assured Marin a year's livelihood and you have made possible the continuation of the Room." I had explained to you on what basis the Room was run, that is that the artists were running it, I was merely their voice without remuneration giving my services and my time. I then said: "you had better go to Washington and think over what has happened." But you asked me not to let anyone have the Green picture until you had had your opportunity. I promised you this. And as you know later on I wired you that an offer of $1500 was made on the picture and you took it for $1510. This picture was originally valued at $2700.

Please remember the sequence of these events. It is the sequence which gives you the picture of the spirit of what happened in the room that morning. The way you interpret and remember, the whole business would have been a very shady transaction not only on my part but on the part of yourself and your wife. In that case what would there have been to keep secret; because on the face of

it you would not have been paying $6000. And I for one know that there was nothing but wonder in everything that happened that morning in the Room. And if I am not mistaken the session lasted at least two hours and it ended with my saying to you: "Now Mr. Phillips, the great thing that has happened this morning is that the spirit of 291 and your spirit have become one. That there is a working together in understanding of Room 303 and the Phillips Memorial Gallery." You then said to me: "Yes, it is very wonderful. I'm ashamed of the book which is about to appear and which I have written." Whereupon I said: "There is nothing to be ashamed of if you have written your own experience. There is always time in a future book to confess your mistakes."

Now I am sure that in reading this you will feel very much better. I know you will. For you will realise the truth of what I have written. And please remember that the whole root of this trouble, I believe, has been in the fact that you feared the dealers and artists not understanding your purchase of the $6000 Marin. That is, your paying $6000 for one of his water colors. There is still asinine stupidity and superstition about a water color not being worth as much as an oil painting. This is one of the reasons why I insisted on sticking to the figure of $6000 for this very great Marin and one other equally great, the one your wife preferred, if she really had any preference. The value was arrived at by art critics, an art dealer, myself and several connoisseurs of Marin, on the first day the Marins were hung, which was nearly three weeks before you came.

I hope you will get your health back and please remember that I have no feeling whatsoever against you or even the Art News. Furthermore please dont forget that I still feel that it is unfortunate that the so-called news item of your achieving the $6000 Marin should find its way into print. Particularly in the way it did. But once it was in print I could say nothing unless I related the facts as above stated and you know very well that there is not a magazine, not to say a newspaper, that would have been interested in the facts at the time. And please dont forget a very important thing, which is that you telegraphed me releasing me from secrecy and telling me to use my judgment, that you trusted me.

Sincerely

Alfred Stieglitz

P.S. In reading this letter and realising the position you put me into before the world as a dishonest man, my dear Mr. Phillips, I feel that there is not another human being who would be as mild as I have been. Please remember I have a life-long record which bears the closest scrutiny. And a record that I have not received one cent directly or indirectly for thirty-seven years of service in this country. And it might interest you to know that until this day I have never accepted even as much as a Marin water color from him without paying for it, although he was frequently ready to

give me some. You say in your letter we are both working for the same cause. I wonder whether we are.

TPC

Stieglitz to Phillips
*Room 303 [The Intimate Gallery], New York, April 7, 1927*

My dear Mr. Phillips

I have just received by special delivery, at ten minutes to 6 P.M. copy of open letter sent to the Art News by yourself on the sixth instant. I appreciate your desire to get the truth before the public. I see that you still insist that you received two Marins virtually as a gift before you decided to pay $6000 for the so-called great Marin. Enclosed letter which was ready to be mailed to you before this one of yours arrived will give you the *facts* in sequence *as they actually happened* and I do not doubt that you will see in reading my letter very carefully, maybe twice or three times that on the face of all that has happened my letter states the facts literally.

As you put the "transaction" before the public I still hold that it remains a more than shady one as far as you and your wife and myself are concerned. Of course you may deny that the sequence of my story is the correct one. You have a wife as a witness to your story. If you insist that what I have said is not true you give me no choice but to print in pamphlet form the two stories and let the world decide for itself which it wishes to believe. I am willing to let it go at that. But I feel that you do not want any such thing to happen. I certainly dont want it.

It was I who was very foolish to act as I did at the time. I realised how foolishly I had acted after you had left and I felt that you might get events garbled in your mind, knowing that you resented having to pay $6000 for a Marin on which not a penny's reduction would be made to anybody. And it was for that reason that for the first time in my life I sent anyone a document of agreement to be signed. I hold that document. In that document over your signature it is stated clearly that you paid $1000 for a Marin *because* of your having bought a Marin for $6000. I wonder if you understand that English. Incidentally your letter to the Art News makes it appear you received an expensive Marin as a gift whereas the one for which you paid $1000 had been valued at $2000.

If the other thing had happened I would have had to send you a document of agreement saying that because of your having received two gifts you paid $6000 for a Marin. That is the way I have learned mathematics. I repeat that what happened in your mind was that you received three Marins and that they cost $7000. You like to believe that you got your Marins for less than you actually wanted to pay. Furthermore I wish to emphasize that when *Mrs. Phillips* was presented with a Marin I stated several times clearly to you and to her that the picture was not given to you but was given to her in commemoration of your sportsmanlike act in buying a Marin for $6000, and she having been the cause and having given you the courage. Now will you please tell me why I should have given Mrs. Phillips a Marin, and when in your letter do you state that it was given to her. I dont care to believe that neither you nor she will remember that that Marin was given to her.

The more one analyses the facts the more obvious it becomes that both you and she had simply forgotten what seemed to me the spiritual significance of the whole morning which culminated in your purchase of a Marin for $6000. Without any inducement of any kind. That you should feel as you do about the $90,000 Sargent and that you should feel about me as you do I well understand. I know that in reality you respect me. I know that you would give anything if this had not happened. And I know that as late as yesterday I said to O'Keeffe again, the one thing I'm sorry for is Phillips. Now I feel that if you will accept my story as the true one, I will not say a word to another soul and I will let the world think whatever it pleases about me and about your story if you wish to let it stand as it does. But I shall reserve myself the privilege to print for myself to put in my safe box your letters and my letters, all the printed matter relating to the story so that the book can be found with the Marins when I am no longer there. My friends either know me or they dont. That's all I've got to say.

Hoping that your health is being restored and that Mrs. Phillips is not being upset too much by this unfortunate mess, and hoping that you will not charge up against Marin and the other artists my idiosyncracies,

Sincerely

Alfred Stieglitz

TPC

Phillips to Fulton, "Copy of Open Letter to The Art News—Just sent 4/6/27" [to Stieglitz]
*April 5, 1927*

Dear Mr. Fulton:

I was shocked to hear from you, (in your note of April 1st, forwarded from my office in Washington and received yesterday), that a private letter, a copy of which had been sent to you, and to several other Editors, *to prevent further misstatements about the $6000. Marin,* was being used as a news story in your issue of April 2nd. Although I realized I was too late to suppress this unauthorized item, I nevertheless wired immediately my disapproval and displeasure. My purpose in writing the letter, from which your "story" was taken, was not to prolong the discussion but rather to clamp the lid on further publicity by letting the truth become known to Editors so that they would not permit continued references to the

garbled account in their periodicals as to an uncontradicted fact. Evidently my distaste for the whole affair and desire to be quit of it was not understood or it would have been more respected. To my grief you publish not only your news story but an editorial under an irritating caption "Field Marshall Stieglitz". Now I have a great deal of admiration for Mr. Alfred Stieglitz who may be a Field Marshall but who is also a great artist and a consecrated soul with a passion for beauty which I understand and value very highly. His policy in regard to Marin and his market value may or may not be justified by his altogether admirable desire to serve Marin's interests in a world which likes to scoff and is only moved to grant recognition to those for whose works big prices are paid.

That I was misrepresented in the press for Marin's benefit—did not arouse me earlier because I knew that in reality I had not been charged too much. Even if I *had* actually paid $6000 for one Marin masterpiece I would have made a far wiser investment than the Metropolitan Museum has made in spending $90,000 for a Sargent! It is commonly assumed that a water color is of less value than a painting in oil. There is no more sense in such a theory than in the other fallacy which measures monetary worth in a picture according to its size! And no matter how slight the medium, or no matter how little time a picture may have cost its creator, the true worth is in the inherent depth and power of the emotional expression and the mastery of the means employed to that end.

It is therefore my conviction that if I *had* paid $6000. for one great water color by John Marin I would have been wiser than most people as yet realize. As a matter of fact I was unable this year to pay that price for any one Marin. I was on the point of deciding to take several of the less costly pictures of the 1925 vintage when Mr. Stieglitz persuaded me to pay the record price for it on consideration of two other Marins, almost equally fine, which go to the Phillips Memorial Gallery and its Marin Unit as extra dividends on the investment. To my embarrassment I am now told that if I had referred to our so-called memorandum of agreement I would have noticed that one of the two was entered on the bill at a greatly reduced figure which evidently was regarded as a gift without actually being one. It has always been referred to as a gift but evidently I did not understand the relativity of the phrase.

Now my dear Mr. Fulton I ask you to publish this letter in full over my name and without editorial comments other than a postscript to the effect that the matter is closed and no further letters or comments will be printed. You could say that I would be obliged to everyone for less curiosity and gossip as to what is my own business and that of no one else. If the prices I pay for pictures cannot be kept confidential I shall be careful to purchase indirectly a practice contrary to my inclinations. Money and publicity can spoil anything, even my pleasure in the immaterial art of John Marin. I hope Mr. Stieglitz will think on these things in his future endeavors to hasten the coming of fame and fortune to those artists who trust themselves to his care.

Sincerely yours,
Duncan Phillips
YCAL

---

*Stieglitz enclosed in the following letter all the supporting documentation he could find, including the infamous "memorandum" and telegram from Phillips.*

---

STIEGLITZ TO PHILLIPS
*Room 303 [The Intimate Gallery], New York, April 8, 1927*

My dear Mr. Phillips

I am sorry to have to bombard you with some more matter but it is absolutely important for all concerned that this question we are trying to bring to a clear solution should be settled once and for all.

Last night after having written you two letters dated April 7, which were mailed today by special delivery, I made a hunt through my letter file to find what letter I had written to you on December 5 in connection with the document of understanding I had sent you for signature. In looking for the letter I ran across your telegram of December 8 which I've been alluding to at various times but the wording of which I did not remember. I merely remembered the spirit. Enclosed is copy of the telegram. It will show you that you gave me privileges which I have not used. The telegram proves I have betrayed no confidences.

I also found the letter I looked for and I am enclosing a copy. I think its contents will enlighten you and show you once and for all what the spirit of the memorable morning was to me and what I believed it was to you and your wife. It will also show you that the picture which you claimed was given to you as a gift was given to Mrs. Phillips. It does not state *when* the picture was given but I think that from all the material I have now sent you you will see that it is impossible that I should have given her a Marin *before* you bought the $6000 Marin. Secondly it is impossible from the fact that you paid $1000 for the $2000 Marin which you had looked upon erroneously as a gift, that that had been given to you before you paid $6000 for a Marin.

I feel I need not dwell on this matter any further. It is too bad that both you and I have had to waste such time and energy for over three months to come to this clearing up of what I feel should have been understood on your part from the beginning. I repeat, I have nothing but the best feelings for you and your wife and that I bear no resentments towards anybody or anything. I've grown too old in service not to be impersonal.

With the best of wishes and greetings,
Sincerely
Alfred Stieglitz

Impersonal Summary

The question between Mr. Phillips and Mr. Stieglitz resolves itself into: Did Mr. Phillips have any idea that Mr. Stieglitz would give his wife a gift of a Marin or him a special discount on another Marin *before* he had purchased the $6000 Marin. Mr. Stieglitz claims that Mr. Phillips did not and that Mr. Stieglitz himself did not know that he Mr. Stieglitz would act as he did until Mr. Phillips *had* finally acquired the Marin at his wife's suggestion. With the evidence in the question answers itself.

A.S.
TPC

STIEGLITZ, PAMPHLET
*[The Intimate Gallery]*, New York, April 17, 1927
*[published April 27, 1927]*

Here is the Marin story—how $6,000 happened to be given for one of his pictures.

In the first days of December, 1926, one forenoon, Mr. Duncan Phillips came to Room 303 (known as The Intimate Gallery) Anderson Galleries Building, 489 Park Avenue, New York City, to see the new Marins which had been on view since November 7. As Mr. Phillips looked around, he exclaimed: "What a magnificent Show! How exciting! Where is the great Marin that McBride wrote about in his enthusiastic review?" I pointed out the particular Marin. Mr. Phillips immediately asked: "How much is it?" I hesitated to tell him its valuation. I laughed and said: "Mr. Phillips, what I am going to tell you strikes me as funny as if I said a billion dollars. But before telling you its valuation I want you to know that an informal committee consisting of Marin connoisseurs, an art critic, an art dealer, myself and others, individually arrived at the valuation not only of this particular picture but of several of the other Marins, the valuation on this one being $6,000." Mr. Phillips actually gasped and said that of course he could not pay any such ridiculous figure. My answer was that on two pictures in the Room not a penny's allowance would be made to anybody even if Marin had to starve. And that this was one of the two pictures. On the others concessions could be made to museums and to people who already owned Marins. When Mr. Phillips saw that there was no use arguing with me I told him that if a first class Matisse brought $12,000 at a dealer's I felt that this particular Marin was certainly worth $6,000; that if the same Matisse could be had for $6,000 then this Marin could be had for $3,000; that if the particular Matisse could be had for $3,000,

then this Marin could be had for $1,500. And if the particular Matisse would be given away then this particular Marin could be given away.

Whether Mr. Phillips understood or not I do not know. It is immaterial. Furthermore Mr. Phillips was told that it was neccesary, once and for all, to establish a "price" on a water color done by Marin. That this one was universally conceded to be an exceptionally great picture and its valuation had really nothing to do with medium. Moreover a stand had to be made for the modern living American in view of the flood of French art. I told Mr. Phillips for the Nth time as I had told him in former meetings that I felt and knew that art and money had nothing in common. That I was not in business. That I had no financial interest in art, directly or indirectly. Never had. Never would have. That dealing in human souls, in the blood of living artists, was ever hateful to me. But that somehow or other Marin needed a modest sum of money for his family. That he had to help pay rent for this Room (for Room 303 belongs to the artist, they pay the expenses, I give all my time without remuneration of any kind). That the Room represents primarily an idea—that it was a continuation of a demonstration that began many, many years ago, one of its forms being 291. Mr. Phillips in the meantime inquired the prices of some of the other Marins he particularly liked. I gave him the catalogue, marking their prices in it. He said he unfortunately had to go and would be back later, or the next day, with Mrs. Phillips. After he had gone I noticed that in his haste he had forgotten the catalogue.

The next morning Mr. and Mrs. Phillips came in together and both of them were very full of enthusiasm as they looked around and said: "Isn't the Room glorious!" Mr. Phillips pointed out to Mrs. Phillips "the great Marin" and said: "It's impossible for me to pay the price asked for the picture, $6,000." I again repeated the essentials of what I had told Mr. Phillips the day before. Mr. Phillips and Mrs. Phillips then chose three other Marins individually valued at $1,800, $2,000 and $2,700 and catalogued as, respectively: "Sunset Rockland County," "Hudson Opposite Bear Mountain," and "Near Great Barrington." Mr. Phillips asked if I would make a concession to his museum on these and I told him he could have them for the lump sum of $5,000, a concession of $1,500. Mr. Phillips at once accepted the offer and he had hardly accepted it when he exclaimed, looking at the "great Marin": "But I haven't got the Marin I want." And he turned around to his wife and said: "Marjorie, you don't say which you like best." She pointed to two large Marins on the South wall ("Mountain Overlooking Haverstraw" and large "Sun Disc") not knowing that the valuations on these pictures were $6,000 and $5,000 respectively. Her husband impatiently remarked that he did not want those but wanted the one he was looking at, the "great one" (also a "large" picture. Mrs. Phillips very quietly said: "I like that as well as the others." And I remarked

to Mr. Phillips that Mrs. Phillips as a painter chose those pictures and that he chose his as a collector. That I felt there was really no difference in the importance of these pictures as the two Mrs. Phillips picked out were the two that I liked particularly and that the one he picked out was O'Keeffe's favorite as well as McBride's and as a matter of fact was the popular favorite among the cognoscenti.

Mr. Phillips then remarked that under no conditions would he pay $6,000. Mrs. Phillips quietly said: "Why, Duncan, if I felt as you do about the picture I'd buy it." He, much surprised, exclaimed: "You would?" As I realized the embarrassment of Mr. Phillips, there being other visitors, strangers, moving in and out of the Room, I asked Mr. and Mrs. Phillips to come into the public hallway where there were no people and where I felt something might be cleared up. I asked Mr. Phillips why he hesitated. He frankly confessed that his position with dealers and artists would become very difficult if they heard that he had paid $6,000 for a Marin water color—particularly a water color. Whereupon I assured him that there was no reason why anyone should be told outside of Marin himself and a few insiders, as it was nobody's business. With that we came back into the Room and to my greatest surprise Mr. Phillips standing before the picture quickly said: "I'll take it." I still remember the chill that ran down my spinal column. A miracle had happened. For me it had nothing whatsoever to do with money. I turned to Mr. Phillips and said to him: "I congratulate you. A miracle has happened. An American has become a sportsman before an American picture. For years I've waited for that miracle." I added, thinking of Mrs. Phillips as the unconscious cause of this miracle: "One miracle begets another. Mrs. Phillips, let me present to you in commemoration of this act of sportsmanship of Mr. Phillips, that Marin" (the small "Sunset Rockland County") pointing to the one she and her husband ran to first with greatest enthusiasm when entering the Room and which was one of the three in the original purchase for $5,000—which purchase of course was automatically cancelled when the $6,000 Marin was acquired.

Mr. and Mrs. Phillips in unison exclaimed: "We cannot accept any such gift from Marin." I said: "Please remember it is not a question of 'we.' But this is a present to *Mrs.* Phillips and not to you, Mr. Phillips. As for Marin let me say that if I am permitted to accept $6,000 for a Marin I must be permitted to give away an $1,800 Marin if I see fit. And if Marin does not like the manner in which I protect him he'll have to seek another friend." With that Mrs. Phillips accepted the gift and I felt she and Mr. Phillips understood the spirit which underlay the action—the moment.

It was a spontaneous impulse on my part. Neither Mr. and Mrs. Phillips nor I had the slightest idea before Mr. Phillips acquired the Marin for $6,000 that anything like this gift would take place. Mr. Phillips then exclaimed: "How about the little Marin in the corner?" pointing to "Hudson Opposite Bear Mountain," a picture for

which I had refused $1,200 the day before, which was valued at $2,000, and which was the second one of the three Mr. Phillips had acquired in the original $5,000 purchase. I said: "Mr. Phillips, as you have received nothing to commemorate this morning of miracle, you can have that Marin for $1,000." He remarked, "That's too generous." My answer was: "Never mind, let me take care of that." He then pointed to the third of the three he had originally purchased and wanted to know what he could have that one for. My answer was: "Mr. Phillips, you have done your share for Marin this morning. Marin is assured another year's freedom and the Room is assured another year. You had better go to Washington and think over what has happened." He insisted that before anyone else got the picture that he be telegraphed to so that he might have prior rights. I promised him that. (About ten days later he acquired this picture by telegraph for $1,510—ten dollars more than he had been offered.) Before he went I told him that I felt that he had finally gotten a glimpse of the spirit of Room 303, that he had become part of it and that Room 303 had become part of the spirit of the Phillips Memorial Gallery. That it all, as far as I was concerned, had nothing whatsoever to do with money. Furthermore I emphasized the fact that he should not forget that the one picture belonged to *Mrs.* Phillips as he had again referred to it as one of the three pictures which had become his that morning. Then out of the clear sky and rather abashed, Mr. Phillips said: "A book of mine is coming out in a couple of weeks and I am thoroughly ashamed of much in it." I had no idea what he had in his mind but said: "Mr. Phillips if it contains mistakes and they are your own, you have nothing to be ashamed of. You will always have a chance in a future book to confess to your mistakes. That is the road of growth." Mr. Phillips asked whether I really believed that and my answer was: "I know it." Mr. and Mrs. Phillips left and I assured him once more as he was leaving that a miracle had happened and that I promised him to say nothing to anybody outside of the few I had mentioned to him and that I would ask them to be quiet.

The same day, in thinking over what had happened and after having told Marin who happened in, and O'Keeffe and two or three others, insiders, the above facts, something made me feel that maybe Mr. Phillips in view of the exciting hours, might get the "transaction" somewhat muddled for it was most unusual and "unbusinesslike." So I did something I have never done in my life before and I am 63. I sent Mr. Phillips what I called a "document of agreement," clearly specifying that Mr. Phillips had paid $6,000 for the Marin "Back of Bear Mountain"; that because he had done so he was receiving another Marin at a special price of $1,000 (a reduction of $1,000), dates of payment being specified in the document; and asked Mr. Phillips to keep one copy and return the other signed and dated, which he did. Furthermore an informal letter accompanied this document in which I specifically stated that the Marin pre-

sented to Mrs. Phillips was not mentioned in the document of agreement.

All the "inner circle" including Marin himself, were elated at the spirit and the fineness of what had happened. Mr. Phillips when returning me the signed agreement told me frankly that much as he admired the "great Marin", he did not think it worth $6,000, requesting me again please not to say anything to the outside world. I had just finished reading the letter when a telegram was handed me which read as follows: "Say as much or as little as you please about our agreement. All that matters is our having the Marins especially the big one. (signed) Phillips." To this day I have no idea what prompted Mr. Phillips to send that telegram. And although I was thereby released as to any promise, I kept the word I had originally given.

Unfortunately, without my knowledge or desire a friend of the Room did go out and tell dealers and the New York Times that a Marin had been acquired for $6,000. When I heard this I was shocked. But I had Mr. Phillips's telegram and that in a way quieted me. People came to inquire whether what they had heard was true. In every instance, and there have been hundreds, I related what I have related above. I gave the facts. And that is all I could do. And I believed the people understood the spirit of both Mr. and Mrs. Phillips and the Room. A well-known magazine writer on art matters appeared on the scene and asked me for particulars, saying: "It's too good to be true. Is it?" I asked him whether he had fifteen minutes time to listen. He listened. I told him what has been told above literally as I have told everyone inquiring literally, to this day. There was nothing else to tell. He asked me whether he could use the story and I told him as Mr. Phillips had released me and the story had gotten out I did not see why he should not use it. I requested him to leave out mention of The Intimate Gallery or myself and to emphasise Marin and above all the sportsmanship of Mr. Phillips.

After all this I was utterly surprised when Mr. Phillips sent me letters requesting me to correct the "misstatements" being broadcast that he had paid $6,000 for a Marin, as he was being "misrepresented." I did not understand him although a long correspondence covering months ensued. I did not see what I could do except to send out verbally a statement similar to the one being sent out at present. But until a week ago I had no idea that Mr. Phillips did not understand the *sequence,* the *spirit* of what happened that morning in the Room. But now that Mr. Phillips has given the world the impression that I had given him two important Marins *before* he was willing to give Marin $6,000 for the "great Marin" I feel I have no choice but to send this out into the world.

Alfred Stieglitz
YCAL

*Bombarded by the press and by Stieglitz, Phillips made his plans to leave for the summer. He decided to cut off all personal communication, leaving his treasurer, Dwight Clark, to handle the outstanding payments on the works purchased. Stieglitz took offense, refusing to correspond directly with the museum staff, and at one point even insisting that he thought Phillips had bought the works for his personal collection and not necessarily the museum. In the end, Stieglitz was forced to correspond with Clark, but he never addressed him by name.*

PHILLIPS TO STIEGLITZ
*Phillips Memorial Gallery, Washington, D.C., April 11, 1927*

Dear Mr. Stieglitz:

Upon my return I find your two long letters written upon receipt of my two rather excitable communications from Charleston. I am sick of the whole matter and feel that all of us, and in this I include the press and public, have made a mountain out of a mole hill. As you say, I paid $7000 for three fine Marins and the average of $2000-plus is considerably less than the $6000 for one picture so much advertised to the public. My annoyance has been out of all proportion to the importance of the affair and this was no doubt aggravated and brought to a climax by the reference in The New Yorker to the Phillips Memorial Gallery as having hitherto bowed only to the Academy. My last letter to the Art News states my real feeling in regard to the whole affair, including my respect for you and my belief that Marin is a great artist who does not need all this propaganda to boost his fame. I can not understand what you mean when you say I make out our agreement to be "shady". This is hysterical and ridiculous but as my first letter from Charleston was but little better in that respect it simply proves that the matter should end here and now, and if it can end in mutual respect and with an expression from us both of our regret that the controversy had to be, so much the better all around. I will positively say nothing more about it either verbally or in writing. Your version of the matter and mine have only an infinitesimal difference and the little points you raise are so trifling that I do not consider them worth talking about any longer. I enclose check for the last Marin purchased and if we are to go on in future years working together on behalf of Marin, O'Keeffe and other important artists in whom we both believe than I feel sure you will have the wisdom not to exaggerate this matter by having our letters printed for the files. It would all appear ridiculous to posterity, such squabbling about nothing at all. Marin's greatness is not in dispute between us and I think that my purchase of nine Marins in two years shows plainly enough that I have finally

realized the importance of this artist and invested in him, not only with enthusiasm but with sagacity.

Sincerely yours

[Duncan Phillips]

P.S. I am attending to a few matters such as this and then closing the books on art until next fall. I will probably not answer any letters or other communications and I doubt if they will even be referred to me. It is important that I should take a real vacation as I was ill in Charleston and may have to leave again in order to get away from the activities and constant social contacts in our Gallery.

TPC

STIEGLITZ TO PHILLIPS MEMORIAL GALLERY
*The Intimate Gallery, New York, May 4 [April bill resubmitted in May], 1927*

Attention Mr. Dwight Clark

Gentlemen:

I have your letter of April 28 and note your statement that the items in the memorandum which I had sent Mr. Phillips and which you returned to me are not for Mr. Phillips personally, but for the Gallery. This is the first time in my long dealings with Mr. Phillips that any such distinction has been brought to my attention. Those dealings throughout have been with Mr. Phillips individually, as can be readily seen from our correspondence. In particular, this is true of the written memorandum which Mr. Phillips signed last December regarding his last Marin purchase. I have always looked to Mr. Phillips for payment, as I know nothing about the Gallery or its resources. You will, therefore, pardon me if I do not comply with your request to make out a bill to the Gallery. If the relations between Mr. Phillips and the Gallery are such that the Gallery ought to pay, they can readily adjust that between themselves without asking me to change what I consider a well established relation between Mr. Phillips and myself. I do not wish to seem disobliging. But if the change which you request me to make is in any sense important, that fact would furnish a very potent reason why I should not be asked to make it.

Very truly yours

Alfred Stieglitz

YCAL

STIEGLITZ TO PHILLIPS [ENCLOSED WITH ABOVE LETTER]
*April 4, 1927*

My dear Mr. Phillips

Will you please see to it that you send check of $1000. made out to

John Marin, to me at once. You purchased your latest Marin at your own price and your own conditions which were $1000 to be paid at once. This was three weeks ago.

Sincerely

Alfred Stieglitz

(for John Marin)

YCAL

DWIGHT CLARK, TREASURER, TO STIEGLITZ
*Phillips Memorial Gallery, Washington, D.C., May 5, 1927*

Dear Mr. Stieglitz:

Your letter of May 4th has just been received. The purchases that Mr. Phillips has made from you were for the Phillips Memorial Gallery, just as any other purchase that Mr. Phillips would make from any of the dealers or artists are for the Phillips Collection, and are paid for by the Phillips Memorial Gallery which is the incorporated name of the Collection. On April 11th the Phillips Memorial Gallery sent you a check payable to John Marin for $1000. You turned that check over to Mr. Marin and he endorsed it, on January 10th the Phillips Memorial Gallery sent you a check for $3010 and you made your various endorsements of it. When the recent bill came in made out to Duncan Phillips it was very properly returned to you [so] that you might make it out to the Phillips Memorial Gallery and receive the check for the same as has heretofore been sent you.

The Phillips Memorial Gallery is a public educational institution and incorporated as such. Mr. Phillips personally does all of the buying for that corporation and his purchases are for that corporation consequently we ask that all bills be rendered in the name of the Phillips Memorial Gallery and not in the name of Duncan Phillips.

I hope that this statement of the facts makes the matter clear to you and that you will send a bill to the Phillips Memorial Gallery for whatever may be due you so that the matter can be attended to in the usual course of business.

Very truly yours

[Dwight Clark]

TPC

DWIGHT CLARK, TREASURER, TO STIEGLITZ
*Phillips Memorial Gallery, Washington, D.C., May 10, 1927*

Dear Mr. Stieglitz:

I have your letter of May 9, 1927. The point that you raise, namely, that your dealings in the past have always been with Mr. Phillips personally is perfectly true and there is no attempt made to dispute it. Mr. Duncan Phillips is president of the Phillips Memorial Gallery

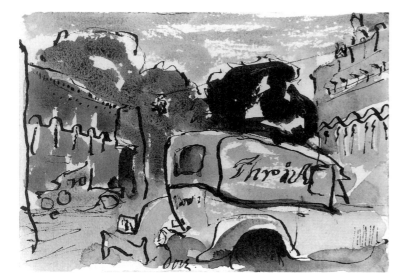

Arthur Dove, *Phelps, New York*, 1937, watercolor and black ink
on paper

corporation. He does all of the buying for the Phillips collection
unless in some special case he delegates me or some other friend to
make some special purchase for him. Even in those cases, however,
the purchases are for the Phillips Memorial Gallery. The bills are
made out to the Phillips Memorial Gallery and payments are made
with a check of the Phillips Memorial Gallery. Mr. Phillips almost
always conducts his correspondence on the letterheads of the Phil-
lips Memorial Gallery. All that I am asking you to do is to submit
your bills to the Phillips Memorial Gallery so that in due course a
check of the Phillips Memorial Gallery can be sent in payment of
the amounts due you.

It is so generally understood by artists and dealers that when Mr.
Phillips makes a purchase, he makes it for the Phillips Memorial
Gallery, that we have all become accustomed to the fact, and you
are the first one to raise this point. As I reminded you in my pre-
vious letter, you have always received Phillips Memorial Gallery
checks in payment of Mr. Phillips' purchases for the Gallery, and
why you now raise this point, I do not quite understand.

Very truly yours,
[Dwight Clark]
TPC

---

*After the long silence of the summer and fall, it took Arthur Dove,
who realized that Phillips was his only consistent patron, to mend the
rift. He asked Phillips to visit his show and, when Phillips hesitated,
got Stieglitz himself to apologize. It took Stieglitz five drafts to purge
his bitterness, but he finally produced a distilled and terse apology.*

---

## DOVE TO PHILLIPS
*[Halesite, N.Y.], [after December 12, 1927]*

Dear Mr. Phillips,

Your interest in my paintings leaves me free to tell you that I think
a vital step has been taken in modern expression in the later ones.

Yesterday on seeing the new paintings hung together for the first
time I felt that there was beauty there that has gone much farther
toward a new reality of my own.

I feel that you should and will go to see them.

Very truly

Arthur G. Dove

TPC

## PHILLIPS TO DOVE
*Phillips Memorial Gallery, Washington, D.C., December 19, 1927*

Dear Mr. Dove:

I wish that it were possible for me to visit your exhibition but for
two or three reasons it seems to be out of the question. In the first
place I cannot leave Washington as I am deep in engagements which
keep me here and I am distinctly behind in my work because of a
recent illness. Then, too, as you probably know, Mr. Stieglitz and I
had a serious misunderstanding last year and he treated me in a way
which I cannot easily forgive. It would be impossible for me to visit
his Intimate Gallery without stirring up something that is past his-
tory and which I do not wish to keep actively in mind. Perhaps in
time he will feel like telling me how sorry he is and if that time
comes I shall be able to resume my active and wholehearted interest
in the work of the artists who exhibit under his patronage. Believe
me, I am greatly interested in your work, and if, after the exhibition,
you care to send down one or two little things which are particu-
larly fine in color and design and not "too difficult", I shall be glad
to study them and enjoy them for a while. I would not promise to
purchase any because I have spent so much already that there are
no funds available for a long time to come. But I do want to keep
up with your work. You are one of the few modernists thoroughly
original and American and free from any confinement within a te-
dious formula.

Sincerely yours

[Duncan Phillips]

TPC

## DOVE TO PHILLIPS
*[Halesite, N.Y.], [after December 19, 1927]*

Dear Mr. Phillips,
Thank you for your answer.

In so far as your difficulty with Stieglitz goes, I think that the thing you are both interested in is bigger than that, and I know that he would let nothing come between you and an idea.

I am absolutely certain that you can feel more free than ever as far as he is concerned.

I am sorry if any one feels that anyone has to be sorry. Has that anything to do with painting?

I am glad if anyone feels glad.

That certainly has something to do with painting.

Am thinking of your freedom of thought.

I do believe in the twenty years that I have known Stieglitz just as you probably believe in the time you have been interested in the thing we are all trying for.

If you do not feel like coming to see my things, that should not keep you away.

That you should be interested in buying them does not interest me except in the remote future of the development of an idea. I have earned the privilege of saying this. They are placed now perhaps better than they ever will be again. That is the thing I wanted you to see.

Sincerely
Arthur Dove

Am sending you a book by Toch that speaks of the "mat" varnishes you spoke of in our former correspondence.
TPC

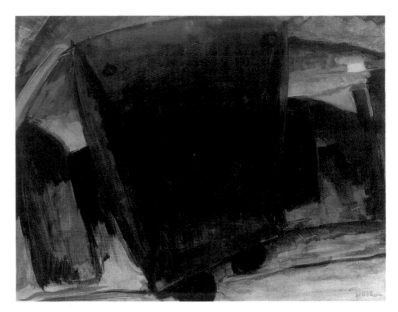

Arthur Dove, *Coal Carrier*, 1929 or 1930, oil on canvas

Wishing you health & quiet for the coming year—
Yours truly Alfred Stieglitz
TPC

---

*Phillips sent a handwritten acceptance of Stieglitz's apology, keeping a typed copy for his own records.*

---

STIEGLITZ TO PHILLIPS
*New York, Xmas morning 1927*

My dear Mr. Phillips: Arthur Dove has seen fit to send me your letter to him. I hope you will not consider this a breach of confidence on his part. I can assure that I regret exceedingly that I appear to be the cause of your not being able to see his work in The Room.—Your letter says that I treated you in a way which you cannot easily forgive. If you will let me know what I have done which is to be forgiven I will certainly ask you your forgiveness. To this day I have failed to understand what has come between us. You may rest assured that I have not spared myself in trying to understand.—must be either a very big fool, dense, or incurably innocent.

I can assure you also that I have no desire to stir up the past, for my own sake as well as yours & that whenever you should feel like coming to Room 303 you will find yourself completely at ease. I feel you will be even more free than you & Mrs. Phillips were that memorable morning because you will be there, as far as I am concerned, as a student & not as a potential buyer.

PHILLIPS TO STIEGLITZ
*1218 Connecticut Avenue, Washington, D.C., December 29, 1927*

Dear Mr. Stieglitz:
I prefer not to revive in any way, by correspondence or in conversation, our unwise and unfortunate controversy of last season. I have never seen and I have no intention of reading the publication which you issued about the affair—even although I am told you are still having it handed to visitors in your gallery. For me however the matter is closed. Since you assure me that the disagreement will not be discussed or even mentioned and since you and I both regret what has come between us, then Mrs. Phillips and I will be glad to visit the Arthur G. Dove Exhibition some morning next week. As you say we must come quietly, as serious students of the works of art, separately and as a group. Your artists are free spirits, very much alive in their thoughts and sensations. It is not only a pleasure but a duty for a patron of living art to watch their developments from year to year.

Sincerely yours
Duncan Phillips
Original at YCAL and copy at TPC

My dear Mr. Phillips: I am very glad. Doubly glad to-day because your letter with its fine & generous message—was handed to me as I came to The Room at noon from the Hospital where O'Keeffe was under the surgeon's knife this morning. It was an agonizing time.—But when finally the doctors reported favorably the world seemed born anew. This rebirth was reenforced when reading your letter.—I know every one will be happy for it was regretted generally [that] men like you & myself should be kept apart—not working together—through an unfortunate misunderstanding. But we agree that is now a closed chapter.

—The Statement you refer to I withdrew the moment Dove sent me your letter. As it was, since June 1st but twenty copies of the Statement were circulated, And not so very many before.—

The Room awaits the coming of you & Mrs. Phillips. There is much certain enjoyment for you both.

Sincerely yours
Alfred Stieglitz
TPC

## AN IMPERTINENT SUGGESTION

*After purchasing* Huntington Harbor *at Dove's 1928 exhibition, Phillips became Dove's most reliable supporter, visiting nearly every solo exhibition that Stieglitz gave him and purchasing works nearly every year. But the trust that Phillips and Stieglitz formerly enjoyed was now lacking, and although both Dove's and Stieglitz's letters to Phillips were friendly and neutral, their letters to each other retained harsh criticism.*

*Stieglitz felt that Phillips should financially support his artists— buying new works and sending subsidies—rather than support European artists such as Matisse and Bonnard. When Phillips began to concern himself with Dove's career, holding exhibitions and writing essays on him, Stieglitz felt that his own role was being usurped. He preferred to cast Phillips in the role of an affluent collector, a characterization that Phillips fought. Like Stieglitz, he saw himself as a director and educator: through his writings and exhibitions he would help define and nurture American modernism. He considered himself an adviser to and promoter of worthy young artists.*

*In one particular case, Phillips flexed his aesthetic and artistic judgment, citing formalist criteria in his suggestion that the canvas of Dove's* Bessie of New York *be cut down to remove what he considered a weak part of the composition. Dove refused. Although indignant (he*

*apparently had to rewrite his first letter), Dove maintained a pleasant tone.*

Dear Dove: . . . This morning Phillips & wife were here for 1½ hours. Enjoyed your things immensely. Thought them the best yet. Has "no money." Am to send 5 to Washington next week. Wants to live with them. Also to have them photographed. Expects to write an essay on you.—Quoted him very low prices. Well, it's well he was here.—I met Gallatin on the street this A.M. Told him he must see the Doves. Said he'd come. Met McBride last night. Said he thought your Show was fine. Liked Reds too. Neither P.'s said anything about her. He too excited about you. . . .

ever your old
Stieglitz

Phillips is eager to meet you & have a talk. There is no hurry. Still it will be well.
YCAL

Dear Arthur Dove:

I am having a grand time enjoying the paintings from your last exhibition which Stieglitz was good enough to send down so that I could study them at leisure. I want to write an article about your work for which I have the greatest sympathy and admiration. There is an elemental something in your abstractions, they start from nature and personal experience and they are free from the fashionable mannerisms of the hyper aesthetic and cerebral preciosity of Paris. Your color thrills me and your craftsmanship in the making of sumptuous surfaces and edges. It is a sharp distress to me that I cannot get three or four of the pictures that were sent down. Unless I succeed in selling a valuable painting which is now under consideration at a museum, I may find it impossible to get more than one and would even have to ask your indulgence in paying for that. The Sun Drawing Water seems to us all to have the largest number of fine qualities, but the best passage of painting you have ever done is contained in the painting entitled "The Bessie of New York". Perhaps I am presumptuous but I wish the picture had been cut off a little to the left of the center. I am sending herewith a photograph to show the part which seems to me complete and a better composition than the painting as a whole. There is too much orange in

the complete canvas and I am disturbed by the suggestion of eyes in the superstructure of the boat. For me the picture is a thrilling landscape with fascinating forms, lines and colors and the humorous feature introduced with those eyes spoils my enjoyment of the real universality and nobility of the conception. Of course the picture made into an upright as I suggest would lose some of its compositional interest in the double curve etc., etc. But I ask you to consider the two photographs and let me know whether you would be willing, in case I should decide to get this picture, to let me make this change in the shape. If you would, it would be my first choice and my favorite example of your work. There is just enough of the orange to serve as an accent and all the colors resound in a perfect harmony. Should you feel that the orange needs to be repeated somewhere else there could be a mere suggestion of it above the gray roof in the rather large area of tan. I certainly hope that I am able to raise money so that I can keep at least two of this fine group. Some day you must come to Washington and see the Dove Room in our house. The newer works are now all assembled in my office. I congratulate you on your courageous and constant devotion to your own point of view and on the really splendid works of art created thereby. Best wishes.

 Sincerely

 [Duncan Phillips]

P.S. Could you send me a personal letter telling me as much about your life and your ideals and intensions for your art as you would care to have me use for my written interpretation? And could you permit me to keep the paintings all summer? The picture I am trying to sell in order to raise purchase funds may not be disposed of until early in the fall as it is to be included in the Century of Progress Exhibition in Chicago and might be acquired by the Art

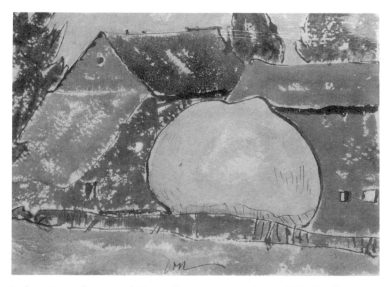

Arthur Dove, *Barns and Haystack,* 1938, watercolor and black ink on paper

Institute out of that exhibition. I shall send back to Stieglitz the Town Scraper but would like very much to keep the others.
TPC

## DOVE TO STIEGLITZ
*[Halesite, N.Y.], [probably May 18, 1933]*

Dear Stieglitz

. . . Well, the letter to Phillips is off anyway.—How far off I know not.

The City Editor [Walter Lister] of the N.Y. "Eve. Post" was here last night trying to get me to let him make a story of it [the *Bessie* incident] in some way. Seemed to think that it could be done so that even Phillips would like it. . . . He thinks it a grand news story, but do not think we want that just now. . . .

This Geneva situation is certainly "mad"-dening. If we only didn't have to go there to live for the summer.

There is something terrible about "Up State" to me. I mean that part anyway. It is like walking on the bottom under water. I did that once there to keep from hitting a boy who thought he was helping me and he was only holding me down.

When I look at the map, I find that Lake George is almost as far as N.Y. [from Geneva].

A man here wants to trade a house for the boat. Wouldn't you know that someone could think of even more property. Another just called from N.Y. about the boat. There are two or three a day but they will not go over $500 and that is the amount of the mortgage that McGovern holds on it. It is about worth sinking at that price. . . .

Think Reds is better. It is not very evident however.

We shall be here seeing doctor for a half month longer anyway. . . .

 As ever

 Dove

YCAL

---

*In his reply to Phillips, Dove chose to focus on the request for personal information, relegating the issue of cutting down the* Bessie *canvas to an indirect refusal in the postscript.*

---

## DOVE TO PHILLIPS
*[Halesite, N.Y.], [probably May 16 to 18, 1933]*

Dear Mr. Phillips;

Thank you for your fine letter of appreciation and the reproductions. I find them on my return from our second trip to Geneva.

We shall have to go back there again for a while as soon as the doctor can get Mrs. Dove in condition to leave.

At present we are overwhelmed with what has to be done before we can think about work again.

This place where we live is a little summer yacht club over the water and I think that this last winter has been too much for her here. We took it as it was offered rent free, and the boat on which we lived was too closed in for the winter.

We feel now that it is best to leave the water for a while and I am trying to sell the boat for the amount of the mortgage on it.

My mother's affairs have been terribly mismanaged, and it leaves the estate with a great many debts and nothing to pay them with. Beside that there are older mortgages and taxes for which I can find no solution. The banks refuse any loan no matter how good, and the whole situation is impossible.

I had started a letter to you in Geneva, but owing to the delicate financial situation I tried to wait, hoping for the best.

My brother and I are executors and it is like being presented with half of a white elephant, making it necessary that I go up there and do what I can to straighten things out.

Some friends of ours in Washington have just written asking us there for a visit.

We did so want to meet you and Mrs. Phillips and see all the wonderful paintings.

Life has become so strenuous right now that we shall have to rush to Geneva and see what we can do. I will let you know from there as soon as there is the slightest lull in this circus which is taking the place of living for the moment.

Am enclosing a few facts about the work and myself which you may find useable, but you probably have a better idea from the distance with the work in front of you, than I have being so near to myself and the work so far away.

The most matter of fact and unflattering description of me is taken from my driver's license.

| Date of birth | Color | Sex | Weight |
|---|---|---|---|
| Mo. 9 Day 2 Yr. 1880 | W | M | 165 lbs |

| Height | Color of eyes | Color of hair |
|---|---|---|
| 5 ft 8 in | blue gray | blonde gray |

We are the possessors of a $40 truck or station wagon bought so that we could move back and forth up state. Having lived on a boat we have not accumulated much furniture so the truck almost solves carfare and freight. We can ship what is left.

For the first twelve years I was an only child and spoiled, I suppose as my family wished me to be. After that I had a brother which gave my family twice as much to think about so I gained twice the freedom.

It was at that age I resigned from the church owing to a difference with the clergy over Bob Ingersoll having a right to his opinion whether we agreed with him or not. I never waited to find what they did about Mr. Ingersoll.

Having studied among other things Latin, Greek, Law, some Spanish, French, German, and Italian, I finally obtained an A.B. from Cornell in 1903.

My father wished me to become a lawyer, but I did even worse. I became an illustrator, and learned to make money.

Having successfully forgotten all of the above studies including the making of money for the interest that came with the new painting. Started painting at the age of 9. Refer to "Modern American Painters,["] by Samuel Kootz, or earlier book on modern art by Arthur Eddy for the step by step work up to this time.

Primarily, I am interested in growing ideas into realities.

There are so few ideas. One seldom gets a real breeder idea.

Two or three in a life time would be enormous.

Rembrandt had fine ones like the Old Testament, the Impressions to me are more like the Christians, the Moderns, I speak of my own work, have a new light finding which allows all things to exist or change in relation to each other.

The days of talent and the things "That please the eye" are about over, Genius is necessary for a thing to exist through the ages and the modern realizes that applies to to-day.

Of course talent is just as busy growing crowds as genius is in growing individuals, but in a hundred thousand years I dare say that genius will agree and talent will be forgotten.

Just at present I have come to the conclusion that one must have a means governed by a definite rythmic sense beyond geometrical repetition.

The play or spread or swing of space can only be felt with this sort of consciousness when it becomes an automatic force.

Paintings should exist in themselves as well as people.

I do hope this will be of some assistance in what you are doing and that we shall be able to talk together soon.

Please give my many thanks to Mrs. Phillips for her fine thoughts and to you for yours,

Sincerely,

Arthur G. Dove.

Dear Mr. Phillips

On reading this over I realize that "The Bessie of N.Y." has not been mentioned. I suppose I just naturally dreaded thinking of a major operation on one of the paintings. They get to be like people to me—Sincerely

Arthur G. Dove.

TPC

*Phillips eventually purchased the intact* Bessie, *but he was never satisfied with the painting and deaccessioned it in 1937. He also purchased* Red Barge, *an oil by Dove.*

*Although he discouraged Dove from visiting during the early summer months, Phillips remained eager to meet with him. As it turned out, they met only once, and that was almost three years later, in April 1936. It may well have suited Stieglitz to keep the two apart, and it seems that Dove, who himself could be difficult, found it easier to avoid a personal encounter and merely continue their correspondence.*

PHILLIPS TO DOVE
*Phillips Memorial Gallery, Washington, D.C., May 25, 1933*

Dear Arthur Dove:

Thank you for your good letter. It will help me a lot whenever I attempt an article. I am deeply sorry that you are having such a trying time and I wish I could help you. Although my situation has not changed for the better and I have not sold any pictures nor in any way raised any funds for purchasing for new American paintings, nevertheless I have decided to take three of your new canvases, namely "Harbour Docks", "Tree and Covered Boat" and "Sun Drawing Water," on condition that I be allowed to pay for them at the very slow rate of fifty dollars a month, and at the price of two hundred dollars each which Stieglitz gave me. If this is acceptable to you would you arrange it with Stieglitz and let me know whether the monthly check should be sent to Stieglitz and by him to you or paid to you directly. That idea would seem to me a more intelligent procedure, but it should be arranged in a way that suits both you and your impresario.

I am sorry that, in spite of the two photographs, what I say about the perfection of the color balance in the smaller version you are unwilling that I should make an upright landscape out of the "Bessie of New York". I would like to hold it here and make a copy of the part I like as I think I could learn a lot about color from this experience. I treat myself to a little spree of painting about once a year and have a wonderful time dabbling in pigments. Would you mind telling me how that particular canvas was prepared as I know I could not get those surfaces without a little coaching from their creator. Should you relent about the division of this picture into two parts I might wish to revise the above arrangement and take this picture at three hundred instead of one of the others at two hundred. With best

By the way my wife and I were delighted by the paintings by Mrs. Dove and I meant to write to your about that in my first letter. I wish that we had had time to go back again to see them. With best

wishes to you and Mrs. Dove,
    Sincerely yours
    [Duncan Phillips]

P.S. You mention the possibility of coming down to visit friends in Washington. I wish that we could ask you to stay with us but from now on the city will be getting intensely hot and we expect to go to Chicago where we have sent our most important masterpieces. I would prefer that you would postpone your visit to Washington until next year when our Gallery is more comfortable.
TPC

DOVE TO STIEGLITZ
*[Halesite, N.Y.], May 26, 1933*

Dear Stieglitz indeed,

More Miracles.—Very friendly letter from Phillips—wishes he could help me more but as yet has sold none of his paintings for funds—nevertheless has decided to take three new ones. "Harbor Docks," "Tree & Covered Boat" and "Sun Drawing Water" on condition that he be allowed to pay $50 each month at the price you gave him of $200 each. Speaks of sending checks directly to me, and that you and I can arrange that to suit us both. Perhaps we'd better let him have his own way and I will do whatever you say by the Place.—

We thought he would forget about the "Bessie," but no! He is still persistently at it. (I referred to it rather tactfully in a P.S. in my letter.) Wants to hold it and make a copy of the part he likes to "learn about color" from *her,* I suppose. . . . If I would consider his making an upright of the "Bessie," he would take that instead of one of the others and allow me $300 for it instead of $200 for one of the others.

Speaks enthusiastically of being "delighted with Reds' things, they wanted to see them again."

Wants us to stay with them in Wash. next year when the gallery will be intact and they will return from Chicago with the paintings.

I mentioned that friends in W. had just asked us there for a visit but we couldn't do it now as we were trying to get Reds well enough to take hurry trip to Geneva. So he "Prefers that I postpone the visit." That suits me perfectly.

A couple of thousand thanks to you and much love from us both.

Will write and accept the $50 per month, if that is satisfactory. We might as well let him store the "Bessie" for the summer? The funny part of it is that he may write in his article about his desire for cutting the "Bessie" and make it that much more important!
    Love ever
    Dove
YCAL

STIEGLITZ TO DOVE
[New York City], May 27, 1933

Dear Dove: . . . I had hoped Phillips would do what he has proposed to you. I had suggested his doing something like that.—As for "prices"—you had "wanted" $350.00 for the three he wants.—I added $250 to your estimate—of which $150 was to go to the Place & 100 extra to you.—But I want you to have *all* the money as I want you to have the whole $500 for the "Red Barge." For the latter, I had given you $150.00 & said that if sold at any time I'd refund myself the $150 & divide the "profit" between you & the Place. Translated—as Phillips is to give you $500 for that painting—I would get my original $150 back & the balance $350 would be halved—you getting $175 & the Place $175. But I am going to let you keep *all* the money. *You must have cash.*—I shall take the equivalent of what the Place & I should receive from you in cash in your work at your figures. I wonder is that clear. I don't want you to feel in any way under "obligation" to the Place in view of Marin & Georgia supporting it, etc., etc. My way is very simple so seems devilish[ly] complex.—With me its always: the human being (artist) first!!—The rest I'll attend to. When the human becomes a pig automatically he disappears into space as far as the Place is concerned. If I should become a pig, why there'd be no Place—so according to the modern Scriptures there would be Business.—(Perhaps.)

. . . Marin had a bit of luck too. Georgia's star is still hidden. . . . As for Bessie, keep her uncircumcised. And as for visiting Phillips, the longer you wait the better. Life is damn queer when people try to "force" it. . . .

Mabel Dodge appears this A.M.!—Returns to Taos this P.M. Mother died.—So it goes—& they go—we eventually too. My love to you both
ever your old
Stieglitz
YCAL

DOVE TO PHILLIPS
[Geneva, N.Y.], May 28, 1933

Dear Mr. Phillips:
Thank you for your fine letter. I gladly accept your generous offer.

The matter of sending checks directly to me is perfectly all right. Stieglitz for some years has accepted nothing except occasionally a painting to cover what I should love to do for the place there, and which I have not been in a position to do.

Your passion for painting has made so much possible, and certainly Mrs. Phillips saved the situation at its vital moment just before the last show. It might be hard for you to realize how vital, but that was the way the show was accomplished.

About the coating on the canvas of "The Bessie". If you will remove the board backing, I think you will find a record of it on the strecher. As I remember in that case the canvas was first coated with a casein size known commercially as "Casco" glue which waterproofs the linen. After it has dried a coat of Permalba white was spred on with a pallette knife. This coat should dry hard and then be washed with a raw potato and distilled water to remove any fat that might arise from the oil during oxidisation. (See Blockx's book.)

Some of the others were coated with white lead, zinc white, and linseed oil with a little coach Japan added as is recommended in a book by Toch which I think I sent you some time ago apropos of mat varnish.

Am sending you a piece of the same canvas uncoated which came from Schneider and Co. N.Y. They get it from Holland.

It would be more convenient for us to see each other in Washington in the fall or whenever you find it expedient, as our invitation to visit friends there seems to be permanent.

May I again send many thanks for the attitude which you and Mrs. Phillips have taken toward the work which has more than given me encouragement.

Mrs. Dove is very happy that you are interested in what she has done.

She joins me in sending best greetings,
Sincerely,
[Arthur Dove]
TPC

## THE "EQUIVALENTS"

*Although photography was not the focus of his collecting, Phillips had long been intrigued by Stieglitz's art, especially his "Equivalents." To Phillips they represented something modern. He recognized the Symbolist theories underlying Stieglitz's images and saw the photographer's abstraction as an ability to remain true to the subject while filtering it through "perception" and "interpretation"—his emotional response to the subject.*

*In December 1934, when Phillips was working on an article, "Personality in Art," he asked Stieglitz for one of his cloud images to illustrate the text. Although flattered, Stieglitz refused for aesthetic reasons: he rarely allowed these images to be reproduced. But that did not deter Phillips from writing about Stieglitz in his article. He appraised him as an artist of great individualism who revolutionized photography by transforming a merely technical act into an art of sensitivity to nature's inherent abstract potential.*

PHILLIPS TO STIEGLITZ
*Phillips Memorial Gallery, Washington, D.C., December 1, 1934*

Dear Mr. Stieglitz:

On the occasion of my recent visit to the Marin Exhibition I forgot to ask you if you would grant me the great favor of allowing me to reproduce one of the photographs in the second of my series of articles for the American Magazine of Art. I think I would choose one of the moon and cloud series but I will leave the choice to you and hope you will not disappoint me. Let me remind you that I would like to have photographs of those three Marins which I especially loved and which I want to keep in mind, also the oil painting of New York from last year's exhibition. Since we cannot get the pictures it will be some comfort to have them in photographs. I am so glad I did not miss that Marin exhibition. In a sense I never enjoyed one quite so much. When the book comes out could I have an autographed copy? It will certainly be a treasure. It was a pleasure to find O'Keeffe looking so well and I hope that it means that she is definitely restored to her important creative activity. With our best regards to you both,

    Sincerely yours
    [Duncan Phillips]
TPC

STIEGLITZ TO PHILLIPS
*The Intimate Gallery, New York, December 12, 1934*

My dear Mr. Phillips: I have been literally swamped that's why you haven't heard from me before. My show framing is endless trouble—man sick—frames wrong size—glass scratched—I desperate. Finally the show is up & attracting much attention. I wish you could see it. But O'Keeffe is down with the grippe, the man still sick—I alone with about 200 visitors a day. Maddening in a sense. As for the Marin photographs they came in to-day—4 weeks late!! And as for one of my Equivalents for the American Art Magazine I'm afraid it would lose all its significance in reproduction. I know it would.—Thanks for wanting it—I wonder what the Book will mean to you.

    Kindest greetings
    Stieglitz

I'm very glad you & Mrs. P saw the Marin show. It would have been a calamity had you missed it.—
TPC

DUNCAN PHILLIPS, "PERSONALITY IN ART: II"
The American Magazine of Art *(March 28, 1935)*

And as for the machine—man can make it a means to unburden his heart and to objectify his vision. Even the sharpest lens of that precise fact-finding instrument, the camera, can be as sensitive to the touch and as malleable to the mind as a violin. Alfred Stieglitz has made the technique of photography not merely self-controlled but sensitive and intensely emotional. He selects a few wonders that he wants out of the innumerable effects in nature and, developing these findings of his sensitive plate, makes them symbolize with crystalline clarity his clairvoyant intuitions. It is not the machine as an instrument which is outside the realm of art. The machine is one of the most valuable raw materials which civilization has added to nature's storehouse for the artist.

---

*In 1937 Phillips and his wife requested an exhibition of Stieglitz's photographs. Marjorie Phillips was in charge, as she had begun to organize shows for the newly developed Print Rooms. In the summer of 1938 Stieglitz agreed to a show, but he suffered a severe heart attack that July and later became absorbed in running the affairs of An American Place; he never found the time to send a representative group of his works to Washington.*

---

## THE RETROSPECTIVES

---

*From February through April of 1937 Phillips was finally able to mount retrospectives for both Dove and Marin, something he had wanted to do from nearly the moment he was introduced to their work at The Intimate Gallery in 1926. For Dove it was not only his first retrospective but also his first solo museum exhibition. It was not Marin's first retrospective, however, that being in 1922 at Anderson Galleries in New York. Indeed, Marin's show at the Phillips was composed of a portion of the retrospective the Museum of Modern Art had run from October 21 to November 22 of 1936. As was his wont, Marin visited his exhibition at the Phillips. By this time a warm and cordial relationship had developed between Marin and the Phillipses. Most of the correspondence between them was private, not part of the museum's records, unlike the correspondence with Dove.*

---

MARIN TO PHILLIPS
*[Cliffside, N.J.], January 22, 1937*

My Dear Mr. and Mrs. Duncan Phillips
For the Exhibition you are about to have of my work and for the many instances of your appreciation and encouragement

    the warm spots (if any I have in my composition) are made to blaze up with renewed life

So that I look forward with great pleasure to the being with Mrs. Phillips and you and friends who may be there on the third of February when I expect to be in Washington

again a warmth for you both in which Mrs. Marin joins

Most sincerely

John Marin

TPC

---

*Although he maintained that Marin's best works were in watercolor, Phillips wanted a few examples of his best oils represented in the collection. From the moment he saw the painting in Marin's 1933 exhibition at An American Place, Phillips had desired* Pertaining to Fifth Avenue and Forty-second Street. *It was, Phillips stated, "the first time that I have been greatly moved by an oil of Marin's." But he felt that the price was prohibitive, and Stieglitz refused to allow him to acquire it through a trade. When the painting (along with the watercolor* Quoddy Head*) came to the museum for his Marin show, the collector could not resist.*

---

PHILLIPS TO STIEGLITZ

*Phillips Memorial Gallery, Washington, D.C., February 8, 1937*

Dear Mr. Stieglitz:

Our Marin exhibition is a great success! It has been received by all who have seen it with more respect and a more open mind than I had really anticipated. Those of us who love Marin's work and feel it is important are profoundly moved by the beautiful group of oils and water colors. We thank you for letting us have the ones we especially wanted and for adding some very interesting pictures which we had not personally selected. Mr. Marin's visit was a delight to us all and each time we see him grow more fond of the man. It was delightful to hear his comments about other pictures and especially to hear the enthusiastic praise of our new Goya.

I have decided to purchase the oil "Pertaining to 5th Avenue" and we all feel that it is an important picture as well as a fine example of his growing mastery of the oil medium. I am really in no position financially to purchase a water color in addition to this oil although I am greatly tempted by several of them. If the "Four Master Off the Cape" were priced at the same figures as the two pictures of Quoddy Head it would be my first choice but we simply cannot afford both the 5th Avenue oil and the Four Master. In fact I feel that I could not acquire any of the water colors unless you would be willing to give us credit for "Pearl River" in case we returned that earlier example. We find in all our books we paid only $1000.00 for it and I do not think it is asking too much to suggest a credit to that amount on the $2700.00 for either one of the two pictures of Quoddy Head. Awaiting your answer I have asked Studio House to put a reservation on one of them, the quiet one which we had under serious consideration a year ago.

Let me remind you of the Dove exhibition in March. I trust that you listed the pictures which we saw that day with you and Mr. Einstein and that in this case, as in the case of assembling the pictures for the Marin show, you will look again through the stock room and send down examples of Dove in the earlier vintages to supplement the ones we saw. Mrs. Phillips is writing to you about water colors and drawings which she would like to show at the same time in her new Print Rooms. It should be the most comprehensive exhibition of Dove ever held and I hope it will help to establish him in this part of the country as an American painter of the front rank. Mrs. Phillips is also writing to express hope we all have that you will consent to an exhibition of your photographs next fall. That would be an event of the utmost importance! My intensive work on the Gorgione book has prevented my going to New York so that I have missed everything since October. I especially regret not having seen the Marin exhibition which from all accounts must have been one of the best ever. We hope to be able to arrive in New York

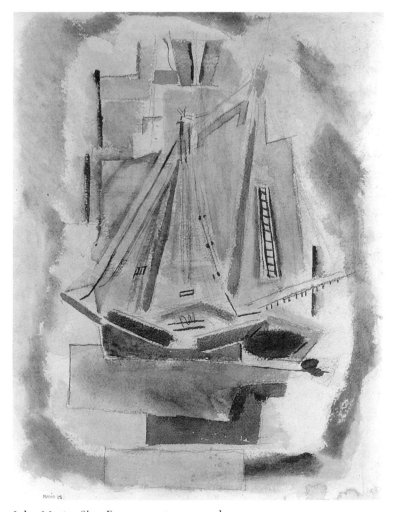

John Marin, *Ship Fantasy,* 1928, watercolor on paper

before the end of the O'Keeffe exhibition and are planning to do so. With warmest regards and again in grateful appreciation for letting Washington see so many fine Marins.

Sincerely yours,

[Duncan Phillips]

TPC

## STIEGLITZ TO PHILLIPS
*New York, February 12, 1937*

My dear Mr. Phillips: It is good to hear that the Marins I sent you for Exhibition and for you to choose from gave you joy and gave joy also to many others in Washington. And that Marin personally gave you much pleasure. What a beautiful person he is. And rare, very rare one. And how glad he is of the days in Washington. His enthusiasm for that Goya of yours knows no bounds. You certainly treated him royally & when I say you I mean you and Mrs. Phillips.

—You have decided to keep the large New York oil. I had always hoped it would eventually become part of the Phillips Memorial Gallery. It is certainly a most important Marin. I feel that in spite of his standing as the supreme water colorist you will become more & more interested in what he is doing with oil. Always he is the great artist. As for the Quoddy head watercolor (the quiet one you want) I am willing to have you make the exchange you suggest, that is the return of "Pearl River" & $1700 in cash.—This I can do because of your having taken the oil for $5000.00.

—As for the Dove Collection to be sent to you in March I'll do my best. And also the best for Mrs. Phillips. But when it comes to my photographs for next autumn I can promise nothing at present. It would entail much expense & work to get such an exhibition ready. We'll see—It's a pity you won't see the O'Keeffe Show at the Place now. It's the "best yet" it is univerally claimed—Even Marin said: "It's the highest level O'Keeffe has achieved." There are some extraordinary paintings on the walls & not one not first class.—For a change she isn't well. As for myself it is merely through will-power that I don't cave in.—My thanks for your kindness to Marin which means a release to a certain degree for me—And for that too I am very grateful—With kindest greetings to you and Mrs. Phillips.

Cordially,

Alfred Stieglitz—.

N.B. of course you can have the other Quoddy picture if you should finally prefer that one.—The Four Master is out of the question.

TPC

## MARIN TO PHILLIPS
*[Cliffside, N.J.], February 18, 1937*

My dear Mr. & Mrs. Phillips

Stieglitz has told me you have become owner of my painting—5th Ave. I do hope it will wear well—whether it will hold its own for you know and I know it will be in Some mighty good Company

But as I respect your judgment of pictures I must respect your purchase and say quite probably you have a good picture—

That Goya still haunts me

It is not that it is just a good picture—there are many in the world—but it has all through it that which I find so lacking that which I am striking so after—rythm—and that to me hooks a picture right up with—music—

You have no doubt read the interview the lady of the—Post—gave me which seems to be a series of—her wishes—of things I should have said but—didnt say—not all of them at least—than about the Mellon Collection and others such as my scorn of nationalities and the—American Scene—etc.

I do have scorn for those who just by giving the American locale—hoist themselves upon us as Artists just because they use the—American locale.—

One thing I told her was that supposing there were two men of Equal calibre one a foreigner the other of—our soil—that in that case—I'd certainly make choise and choose the one of—Our Soil—to do the job—then there's the chap in the Star or Herald—I've forgotten which—who after praising my work has this—"Of course Marin can't draw neither could Mattisse for that matter"—Well my claim is that—if a man is anything of an Artist—he certainly can draw—that he is the consumate draughtsman—too—I think he speaks of a lack of composition—when you are Build a Structure its all Composition—thats my belief anyway—when those who do not know speak—of accepting a croaking from an ill wisher—if they'd only be more careful—if they'd only see for themselves the better—for—altogether—I have more heart for those unsophisticated ones than I have for the breed up here—who—know it all—

There is Something else I must speak about—the heartening those young people of yours gave me—They are the ones—you know—to carry the torch of "the good workman"—they will—they *must* good luck to them.

—Thanking you both—I have told my brother Charles that my stay in Washington was like—a beautiful dream—

You both were greatly responsible for this

Most Sincerely

John Marin

P.S. Must again refer to the work you are doing must refer again to the Exhibition and that the people of Washington will get from

it—if there's anything there to get—then—if they dont—Your still tops—

TPC

---

*Dove finally met the Phillipses on April 25, 1936, at his solo exhibition at An American Place. Stieglitz was then absent from the gallery, and Dove reported to him in his usual acerbic manner: "The Phillipses were much less difficult than I had expected, and we enjoyed them." Duncan Phillips wanted to meet with Dove again and urged him to visit Washington during his retrospective, but Dove decided to remain in Geneva as his work was going well.*

---

DOVE TO STIEGLITZ
[Geneva], [March 17, 1937]

Dear Stieglitz,

Glad to hear from Einstein over phone that the paintings are liked. Said he would write when they were up.

Thank you much for hanging them again this year. And thank heaven that they are safe there before this blizzard came. Can't even get the Ford out of the chicken house. The cases arrived back all right except 2 watercolor cases & one of the smaller oils. Imagine you used them to send on to Washington or somewhere. There were but 5 cases on the bill coming back—8 on the down trip.

Would give anything to see six months ahead. I am stuck just now here with this new kind of taxes. On account of County relief they are making them impossible. Nothing pays—but the Italians, and they are usually on relief & on the street so they do not dare own anything—talk rather large & then back out. Well, so do the Americans. Man whom I hoped would take all these 138 acres is backing now because the N.Y.C. R.R. is taking up a switch that he wanted to use. The switch has been here for 50 years. I have some more prospects so have to do some hustling before March 30 when they begin to talk higher mathematics at the town hall.

You wrote last year, "N.Y. trip was a success."—It was great after so long.—We have to move again May 1. Canvas and all that to be stretched and coated. We are a month ahead of last year and do not want to lose it. And we are not sure of where to go until we see what can be sold. Like L.I. and have written there, but may go and live in the "Dove Block" in some dressing rooms & a huge dance hall for a studio, about 60 x 70 . . .

I hear that the Phillipses are very anxious to have us there while the Show is on. It would probably take two or three weeks TIME. And what little we have left out of the Minnesota thing banked in N.Y. We managed to keep that fairly untouched—$100 out.—And to be social. I recognized my dress clothes, frock suit, silk hat, &

opera snapper in dusty boxes around the dusty hayloft on South Main St., so imagine I must have discontinued membership some time ago.

It will take some time to move to the "Block" if we do. There is a bigness about it.—A large roof overlooking lake, etc. I've never been up there.

We want to see you all, Bill and Marian in Washington and all the things there.

It is the first time in so many years that we haven't been down to nothing. I dread getting there again for anything not absolutely necessary. Work is so much better when one can breathe. . . .

Reds is not so well. If warm weather ever comes, she will be all right, but these cold winds blow through here and she gets sinus and other echoes. . . .

Always from

Red & Dove

YCAL

---

PHILLIPS TO DOVE
*Phillips Memorial Gallery, Washington, D.C., March 25, 1937*

Dear Arthur Dove:

I hope you will be able to come to Washington during the Retrospective Exhibition in our Gallery. It is contained in four rooms. Two of them are devoted to water colors, one to the important early works in collage, pastel and metals, and the fourth to a selection from our large number of oils painted within recent years. The whole show is splendid and I only hope that many people will come and that they will be able to appreciate the subtle distinctions and original inventions of your style. It is interesting that your annual show at An American Place is going on at the same time in New York, and it will be helpful to me to see your new pictures before deciding what to get for next year. We happen to have made some very costly purchases this past season, opportunities which came at an untimely moment but which I could not disregard. That means that we cannot do more than we have done in the past. I did want to supplement our representation of your work, most of which is of recent vintage, with one or two fine things of the earlier years. Mr. Stieglitz has made this almost impossible for me by putting on prohibitive prices and by ruling out trades. A NIGGER GOES A FISHIN belongs to Stieglitz and he would have to be paid at least a part of the price. Personally he does not wish to part with this fascinating creation and I do not blame him. I want it very much myself and after seeing the show in New York, where, by the way, I hope to meet you, I will try to decide what to do. The little picture called "Car" is another favorite of mine. When you come to Washington I would like to talk with you about the present condition of a few of the pictures. Some have cracks. The COWS IN PASTURE

157

Arthur Dove, *Red, White, and Green*, 1940, wax
emulsion on canvas

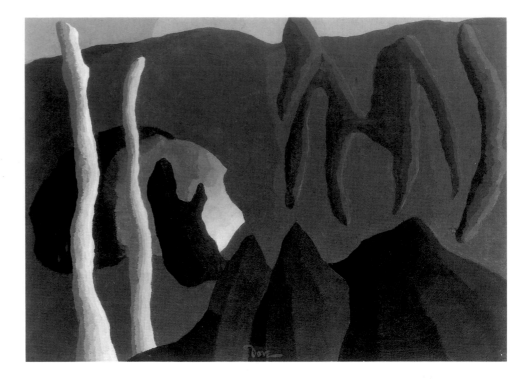

with its surface as smooth as a slate shows light scratches. Can all
this be remedied?

I am enclosing a check for one hundred dollars long over due,
reference to which you made in a letter to Miss Bier. With best
regards and congratulations in which we all join,

Sincerely,

[Duncan Phillips]

TPC

DOVE TO PHILLIPS
*Geneva, March 27, [1937]*

Dear Duncan Phillips
I was very glad of your letter.

Am not worried about the Cows in Pasture as I think a coat of
wax varnish—it has been a year now—would cover any slight
scratch. The other cracks I can manage as with the "Red Barge."
Have had some fine letters about that from people who saw it in
Chicago. The best thing there etc. Enthusiasm perhaps from friend.

This year's show ought to prove what you and Mrs. Phillips have
done for me. I can't quite tell you otherwise.

We feel it very deeply.

We do so want to see it and your show.

Can perhaps manage it on your check—I have to stay here long
enough to manage a mortgage to pay taxes etc. It is a strange situ-
ation here. So much of value and all in the red for years.

It takes so much time!

I too would love to have the "Nigger Goes a Fishing" but never
seem to be able to have any of my best things about.

It was thoughtful of you to send the check just now as last year
at the right moment.

Phillip Goodwin, I believe, took one of this year's things—I do
not know which one. He offered 600 for the "Cows in Pasture" last
year. He is a sensitive person—Has been collecting them from some
years ago.

We hope to and may make it to New York & Washington. Hope
you meet the Boswells. Mrs. Dove and I send our best on and Easter
greetings to you Mrs. Phillips and the boy.

As ever

Arthur G. Dove

TPC

---

*Phillips finally decided to purchase the renowned* Goin' Fishin' *for a
then-unheard-of sum for Dove's work, two thousand dollars.*

---

## THE RAPPROCHEMENT

---

*After the thorny relationship between Stieglitz and Phillips through-
out the thirties, the fallout of their fight in 1927, the two men
gradually entered a period of renewed faith in each other, and indeed
even of friendship. In his letters, Stieglitz invoked words he had not*

*used since 1926, once more relating Phillips to "The Cause" of American art.*

*Phillips rediscovered both O'Keeffe and Hartley during this period, and had begun to discuss Hartley with Stieglitz, considering him as still part of Stieglitz's circle. But Stieglitz and Hartley, although they maintained their correspondence and cordial relationship, were no longer aligned. Throughout his life Hartley moved in and out of Stieglitz's orbit, a risky practice since Stieglitz demanded absolute loyalty.*

*The Phillipses visited O'Keeffe's 1943 exhibition of recent land-scapes and feather paintings just before it closed. They expressed inter-est in two paintings as well as an early work,* Large Dark Red Leaves on White, *painted in 1925. The last O'Keeffe show Phillips had vis-ited was in 1941, when he acquired* From the White Place.

---

## STIEGLITZ TO PHILLIPS

*An American Place, New York, May 7, 1943*

My dear Mr. Phillips,

It was indeed good to see you and your wife. A complete surprise. I had no idea you would show up. I had hoped that you might. It was too bad that you had such a short time, Still, in that short time it was a revelation to me that you and Mrs. Phillips seemed to re-discover O'Keeffe.

Now it was impossible for me to discuss "price". I did not want to introduce the idea of "money" in this meeting of yesterday. I am becoming more and more queer about the translation of pictures that come truly out of the spirit without any thought of audience, exhibitions or selling—or even the introduction of the thing which might be called hope on the part of the innocent artist that he might be permitted to live, or that anyone should *really* care that he con-tinue to live.

So when you asked me the "price" of O'Keeffes, do not think I didn't fully appreciate your wonderful spirit and your generosity and your deep feeling for the creative artist in this country of ours. I told you I would write to you and here is what I have to say.

First of all, the "Leaves" picture, which I consider one of O'Keeffe's most beautiful offspring. That picture has been held at $6000 ever since it was painted. Now I would like to see it added to your collection, if it is at all possible to have it included. Something was said about your having a "Leaf" of O'Keeffe's and you will re-member that I said that what you have is very different from this picture, and that this picture with the other would let the people see something which they could not see if they simply saw the pic-tures single. I am ever thinking of spirit because the older I grow, spirit becomes more and more supreme. Spirit put into form. Spirit realized. And it is the spirit of Marin, the spirit of Dove, and the spirit of O'Keeffe that becomes more and more affirmed in brilliant clarity as the years go by. I might add that my photographs belong in this category, but that is another matter. It is the pictures of these three that I am fighting for. Really the American spirit as evidenced in these three astounding individuals truly American, reflecting nothing foreign.

Now I suggest that you acquire the O'Keeffe for $4000-$3000 going to O'Keeffe and $1000 going to the Rent Fund for An Amer-ican Place. These monies could be paid in the beginning of 1944. They are not needed for 1943. The "Horseshoe and Feather" would be $5000 and the terms would be $3750 for O'Keeffe and $1250 for the Place, Rent Fund, payable also in 1944. The small "White Place in Shadow", which is really a gem, would be $2300, which means $1800 for O'Keeffe and $500 for the Rent Fund. But I do not con-sider this picture as important as the other pictures.

I might as well add to this note about O'Keeffe the proposition I have to make about the Marin "Sailboat", which Venturi said was as good as a Cezanne at its best. I do not remember what was quoted you some time ago when you wanted to know the price for that Marin. I wrote it to you in a letter. I am not going to hunt up what I quoted you. But this picture too I feel that you should have in your collection. As you yourself said, the oils of Marin loom up bigger and bigger as one lives with them. I suggest you give for this picture $4200. Payable to Alfred Stieglitz ( John Marin Fund). You could pay part this year and the balance in 1944. You see, Mr. Phillips, I don't know how long I will still be here to guard An American Place and its workers . . . and you may be surprised if I should add you, Mrs. Phillips and the boy.

In other words, what you are standing for and fighting for. My fight becomes more and more for America, but not in the narrow sense but in the world sense. If we don't lead the world I am afraid we are in for centuries of darkness, and don't think for one moment I am speaking of American in terms of nationalism. When Hartley said to me, "Marin is the greatest watercolorist the world ever saw, but I, Hartley, am the painter of Maine"—I smiled to myself and said, "Yes, my dear man you may be the painter of Maine (whatever that may be), but Marin is the painter of the universe when he paints Maine."

You see, you are doing something that I feel nobody else in this country is doing. I am not stooping to flattery. We have been fight-ing together in a war, each in his own way, shoulder to shoulder for nearly 17 years. I hope you will have many years in which you can lead the fight. I have no wish to continue much longer. It is too hard and too impossible. I do hope that this country will sooner or later awaken fully to the significance of art in whatever form it may ap-pear—even the art of personal relationships, which may be art's highest expression.

Pardon this letter. In a way I would not like to send it. In another way I have no choice, but to let you have it. My most cordial greet-

ings to you and Mrs. Phillips and to the boy and to Miss Beer and the other lady. And my warmest thoughts for the Phillips Memorial Gallery.

Sincerely,

Alfred Stieglitz

TPC

PHILLIPS TO STIEGLITZ
*Phillips Memorial Gallery, Washington, D.C., May 11, 1943*

Dear Mr. Stieglitz:

This is to acknowledge your fine letter of May 7th. We also enjoyed that last visit and as you were prompt to recognize we never liked O'Keeffe's painting as much as we did on this occasion. However it is a melancholy truth that we are in no position to purchase anything more this season nor even to make any further commitments for next season. Perhaps when the time comes we will feel differently but I am apprehensive that we have already been too indiscriminate. Of course if the prices were not so high it would be different but I do not question nor ask for any special prices for our benefit other than those reductions which you have offered in this letter. We will simply have to hope for the arrival of the time when either the beautiful Leaf picture or the "Horseshoe and Feathers" might be paid for out of our budget. I may have told you that we have offered important paintings for sale in order to cover the cost of commitments previously made and the continued support of struggling artists. We are not discarding from weakness but from strength as the artists offered for sale are masters such as Rouault, Derain, Chagall and a Van Gogh drawing. I mention this to show that we are by no means affluent and that we are trying to do our part in helping the war effort and the many agencies for war relief.

However I do regard that Sailboat of Marin's as one of our commitments for the future and I had asked you to put on the back of it my initials as you did on one or two occasions with Marin's oils before we were finally able to consummate the purchase. By the way, you were right about the final payment on the Marins of last year not having been sent to you. I am sorry if they were over due but the check will follow.

You will remember that I received your verbal consent to borrowing for the summer the water colors which have been in the Art Institute of Chicago. I wrote to Mr. Rich telling him of our intention to show them during the summer and of your willingness to let us have them and he replied that he would have to have your release, so could I trouble you to send him a line to that effect? We would keep the exhibition going throughout the summer as we did last year with Klee, alternating the pictures in one room to supplement those in the Collection. During the summer we are also planning to show in the Print Rooms some of Clarence Laughlin's photo-graphs of the old plantation houses of Louisiana and the Mississippi. What do you think of them? I seem to remember that he told me you had encouraged him and admired his work. We look forward to the time when we will be able to show your photographs in our Gallery, for they are the best of all time. We are waiting with eager interest the one you said you are sending.

Sincerely yours,

[Duncan Phillips]

TPC

---

*From August 1 to September 30, 1943, Phillips held another Marin retrospective, again borrowing watercolors from Stieglitz. Phillips mounted a number of exciting shows during the war years, not only to accommodate the influx of personnel in Washington but also because his museum, like other major eastern institutions, had sent much of its permanent collection west for fear of bombing. Stieglitz was perturbed that Phillips had sent his Renoir and Ryders away for protection and yet asked for Marin's watercolors for an exhibition. But the time of battles had passed, and the retrospective went forward.*

---

STIEGLITZ TO PHILLIPS
*An American Place, New York, July 1, 1943*

My dear Mr. Phillips,

The heat and the demands upon me have all but undone me. I am having Andrew (the man here) go over the Marins, the frames and backings and getting labels ready for me to fill out. I hope to have the things ready within a week or ten days. You see, I have no secretary, and unless Mr. Mellquist happens in occasionally noone to take down anything for me. And longhand correspondence has become nearly impossible for me.

First of all, the 20 pictures when ready you might arrange with Budworth to call for them here and ship them to you. George F. Of has become all but impossible. They can handle a picture or two but not a job consisting of 20 paintings. I have no idea now what valuation will be on these 20 Marins, but will know in a few days when I hope to feel strong enough to consider the matter. Of course it will be understood that you are taking the full risk, and will guarantee a return of the pictures in the same condition that they left here, and I to be sole arbiter if any question arise.

It is not with an easy heart that I risk these Marins out in the world—for many of them are very close to my heart. You see, you tell me that you have sent your treasures to the West for the duration, feeling that the risk there is smaller than in Washington. And now I am able to send some of Marin's finest examples to Washington for exhibition. I am ready to do so even now, though there seems

to be something ironical about it. But my whole position is an ironical one. The situation I am in is certainly most ironical. And if you give the matter a little thought you will agree with me. I do not complain nor do I hold anybody outside of myself responsible for this position. I have never looked for glory nor for position. I have believed in an American which may eventually, some day, be, but I fear it will not be so in the near future. I won't go into this matter, for it may seem to you beside the question of the pictures you are asking for your exhibition.

Marin and Dove have both been fortunate that you have been interested in them as artists and let them live—so function, paint, evolve as artists,—both more than worthy. As for O'Keeffe, you have also helped her live, and maybe some day you will realize that she is equal to either of the men. I become more and more aware of that fact as I live with the work of the three artists, and it is not a personal interest in any one of them that makes me say this.

The times become more and more difficult every day for all of us. No matter what this country may be doing in Europe, as far as the Home Front is concerned it is in an ungodly mess. An inevitable mess for which all Americans eventually will have to pay dearly. And when I say "pay" I am not thinking of "money". But I don't want to go on in this strain.

You shall have a list of the Marins with the insurance valuations within a week, if I can—at least I hope so.

Let me hear from you telling me that you accept the conditions. My warmest greetings to all of you. May you continue the good work that you are undoubtedly doing in Washington.

Cordially

Alfred Stieglitz

TPC

PHILLIPS TO STIEGLITZ
*Phillips Memorial Gallery, Washington, D.C., July 3, 1943*

Dear Mr. Stieglitz:
I do appreciate all you are doing for us in enabling us to borrow that splendid lot of Marins. Having shown our own group the most continuously and I believe cultivated quite an enlightened taste here, we thought it might be worthwhile showing a group which are for sale. We have whetted the appetite of many Washingtonians and war time visitors here, for the water colors at least, and I am hopeful that we might place one or two of them. In any case it will be exciting for us all to live with them and to have the Sailboat and Sea to remain in the Collection. Needless to say we will pay all expenses of transportation and insurance and I readily agree to your conditions, namely that you are to be the judge as to whether the paintings are returned to you in perfect condition. As to the risk of air raids, of course one can never tell but the majority are inclined

to feel that the danger has passed and that we should soon be calling our own treasures home from the museums in the west where they have been enjoyed.

I await your list of Marins with their insurance values and I hope very much that it will be possible for you to get them ready for collection by Budworth during the coming week. The Gallery will remain open of course continously but Marjorie and I are planning to go to our place in the country for a brief vacation after the 15th of July and I would be very greatly obliged if you could get them here a few days before then so that we could plan the hanging of the Marin exhibition which is to open August first and remain through September, if that is agreeable to you. Our warmest greetings and best wishes as always and again many, many thanks,

Sincerely,

[Duncan Phillips]

TPC

---

*Phillips purchased another oil by Marin,* Bryant Square, *the third New York scene in his collection. He also wanted to buy the artist's* Storm Over Taos, *which was in Stieglitz's personal collection. Although Stieglitz was willing to let Phillips acquire an early O'Keeffe from his collection because he wanted her work represented more fully in Phillips's museum, he resisted selling him more of early Dove and Marin, both of whom were already collected in depth by Phillips. Stieglitz refused, and never changed his mind.*

*Phillips was planning a memorial show for Hartley, who had recently died. Correspondence about the artist revived some bitterness: Stieglitz had never forgiven Hartley for his defection to other dealers. In one of his final letters to Phillips, he ironically compared Hartley to American artist Max Weber, who had broken with Stieglitz nearly thirty years before. (Weber and Stieglitz had both published accounts of their fight.)*

---

PHILLIPS TO STIEGLITZ
*Phillips Memorial Gallery, Washington, D.C., October 13, 1943*

Dear Mr. Stieglitz:
I hope you are both well, at least as well as the times and conditions permit.

We are almost ready to install the East-West Exhibition of paintings, sculpture, potteries and bronzes, which was shown in New York at the Nierendorf Galleries. We are making a few additions and alterations in the comparisons. For instance we borrowed, without being able to see it, a Demuth water color of peaches to hang with a smaller painting of peaches by a Sung artist. It has arrived and the wide margins of white paper background are too

much of a contrast to the Chinese gold and silk. If you happen to have a Demuth water color in which there are curvilinear fruits in his best washes and most subtle transitions which more or less fill the painted surface could you lend it to us at your earliest convenience?

This educational exhibition will mean that the Marin water colors must come down. It will be hard to see them go. We have so enjoyed them immensely and are grateful to you for having let us show them so long. I must admit that the Sea and Sail has not grown on us but I think it is because of that crude disturbing frame! Framed with craftsman skill in a grayish gold or ivory with a white inset the canvas would be more worthily presented. Our oil painting Bryant Square delights me more and more with its decorative calligraphy and I realize that our Marin Unit has no water color with that particular feature of Marin's inventive genius, his enchanting use of heiroglyphics. I have suddenly become infatuated with his famous water color Storm Over Taos which I enjoy in a small color print. Could I get the original for the Collection instead of the oild Sea and Sail? I do not remember if it was sold or if it belongs to you. We really need it and it would find itself where it belongs in our group of first flight Marins. If it can be arranged, please let me know the price. I also need a better early Marin than our Black River Valley, and the Tyrol which you own would be perfect if you will let it go.

The Leaves by O'Keeffe has been hanging all summer between her Gray Cliff and her Ranchos Church, making a very beautiful wall in a room devoted to her and Arthur Dove. That group must come down too to make way for an exhibition of Marsden Hartley whose death makes a memorial showing timely and interesting. I will send you a catalogue of the two exhibitions. The Leaves are O'Keeffe at her best and I am tempted. If you will let us get the Storm Over Taos at a price which is not prohibitive and make a reduction in the price of the O'Keeffe so that we can afford the two masterpieces I will be in financial danger and distress and yet in a happy frame of mind.

Hoping to hear favorably and soon, with warmest regards and best wishes in which Mrs. Phillips joins me,

Sincerely yours,

[Duncan Phillips]

TPC

STIEGLITZ TO PHILLIPS

*An American Place, New York, October 15, 1943*

My dear Mr. Phillips,

I have your letter of the 13th—my mother's birthday. They say that 13 is an unlucky number. And yet the 13th this year has made me wonder—Am I dead or alive, and if alive, living amongst human beings? Am I the sole mad one in this country or am I the sole sane one? Or can we throw sanity and madness both into the scraphead, for the terms have become meaningless, as so much else.

Here I am, virtually alone, with the walls bare white, but marvelously beautiful, so extraordinarily human—untouched—and I dread the moment when I will have to drive a nail into them. And this because the new Marins, which I haven't seen but which I feel must have some extraordinarily wonderful pictures amongst them, need to be put up and the people given a chance to come and see, if they wish to. I will not move a finger for publicity—I haven't for some years. I have neither the inclination nor the energy nor the money for such seeming necessities, in order to attract attention. Marin is Marin, O'Keeffe is O'Keeffe and Dove is Dove. And who I am at 80 years old, clearer than ever in my mind, with a body that has difficulty to keep up with it—with a heart that fights me, but a heart that fights the world.

Now what's the meaning of all this? Why all this seemingly extraneous talk or whatever you will? I am on the warpath. It is my own path and it's your path, Mr. Phillips, if you have time to realize it. And it is the path of many other fanatics fighting for whatever they may believe in, in whatever field. Above all in our own country, which I love above all things. But not in a provincial sense. And as I love, or as I indulge myself in finally saying I love, I will indulge myself in finally saying I hate, and I hate all that's provincial in this our America.

Now you write that the Marins you have as loan are to be shipped back. And that you feel that they have given pleasure to you and to others. I have not seen the catalog. And you also write that O'Keeffe wears—"Autumn Leaves"—and that it is beautiful. I know how beautiful it is. It's one of her rarest canvases: I know where it comes from. In sending it to you it was insured for $6000. In writing to you and your asking for special quoted (how I dislike that word!) I wishing you to have that picture made a special rate of $4200 with 10% off. Now Mr. Phillips, I can't possibly do more than that. If that O'Keeffe isn't worth that, then no O'Keeffe is worth anything in market terms. In spirit she will ever live, no matter what the "market" may juggle with. I know nothing about art and the more I hear about it the less I want to know about it, as the term is used. I know nothing about painting, I have never painted. I do know a little about photography, but not an iota what I should know had I spent my time at my own photographs instead of trying to liberate the American public from endless fallacies and blindness. So if you wish to keep the O'Keeffe for the special figure quoted you at your own request, which is $3800, I would be only too delighted that you should keep it. O'Keeffe would not wish to receive any money before January 1. That's her express wish, as she was fortunate enough to receive enough before July 1st to see her through this year. She has already made her income tax return and paid what she is in-

debted to the Government. I have nothing to do with this matter. I do not know what her income was, nor what she paid the Government.

So, Mr. Phillips, it is entirely up to you. Whatever you decide to do will be satisfactory. All I can say to you is that if you do not take the picture, no one else will be able to get it for less than $6000.

And now for the Marin question. The "Storm Over Taos" is not in the market. *At any figure.* And by "any figure" I mean any figure. I do not consider this Marin his greatest picture. But for some reason or other it is wanted by a great many people. And I know that Marin will never return to New Mexico. If I felt he would I would not feel about the picture as I do now. If anyone should have it out side of its remaining exactly where it is—here at An American Place while I live—you would be the first I'd consider as its guardian. As for the Tyrolean picture, you speak of, that too must remain here. I have a sentimental feeling about that particular Marin and it means more to me, personally, that it can mean to anybody else.

Now I know that in times like these it is foolish to be a sentimentalist, but I am foolish in so many ways that I don't mind being considered foolish in this way. And is it sentimentality? Perhaps yes, perhaps no. It makes no difference. So many words, that's all.

And now as for the oil. I am sorry that you feel so distressed by its presentation. In framing it as you have in mind you might make a handsomer affair of it, but I am afraid you would rob the picture of what it really is and of what Marin has meant it to be, as it now stands. But if you bought the picture, it is your affair—of how you want to garb it. Professor Venturi has asked several times when that picture will come back, as he is truly in love with it. And the figure I quoted I consider ridiculously low. But I have taken you at your word as to your state of affairs, and have met you accordingly. And I think in a most generous way.

So much for O'Keeffe and Marin. As for the Hartley show that you are arranging, I may say that I am glad that Hartley received recognition before he died. But I do know that if his paintings which have been recently acclaimed had remained under my guardianship, I would still have had to hear: Who wants Hartleys? as I virtually had to hear for twenty-five or thirty years. Hartley's death I consider his masterpiece. Some day I will tell you about it. No one knew Hartley as I did. For thirty-four years I have been his friend. I have been asked to show the Hartleys that are here, either mostly early or middle period, and I refused. What will become of these Hartleys I do not know. I do not want to turn them into money, as I easily could, for they never represented money to me as far as I was concerned—just as the O'Keeffes and Marins and Doves that I may have—which might be called "mine"—do not represent money and I would accept no money at any time for myself for any of them, even if I were starving.

Yes, I am a fanatic. The work that Hartley did in the last three years or so I did not see. I do not—as you know—go to exhibitions, and haven't for six or seven years. And even before that, I didn't go to many. It is the living worker that I am dedicated to, in whatever form he may appear. And I believe you somewhat understand this. The dead can take care of themselves. But I wonder about the living. Particularly those worthy of the name *artist.* There are not many of those. They become rarer every day. The more exhibitions the fewer artists. That's the way I see it.

I hope you will not misread this letter. I am sure you won't. You are often in my mind—you and your lady and your staff and your son. And I will never forget nor overlook your many kindnesses to me. My greetings to you all.

Alfred Stieglitz

P. S. As for Demuth, I have not a Demuth of the type you are looking for. As a matter of fact, I have very few Demuth watercolors. The oils are here. He left those to O'Keeffe to do with whatever she saw fit. The watercolors went to his friend Bobbie Locker, as he felt that they could be turned into money relatively readily, and Locker was apt to need money as the years rolled by. Locker and Demuth were intimates from childhood on.
TPC

PHILLIPS TO STIEGLITZ
*Phillips Memorial Gallery, Washington, D.C., October 27, 1943*

Dear Mr. Stieglitz:
I am very much disappointed that you will not let us purchase Marin's water color "Storm Over Taos" to fill a vacant spot in our Marin Unit. Its colorful calligraphy and drama is not to be found in any of

John Marin, *Bryant Square,* 1932, oil on canvas

our water colors though its heiroglyphics are in the oil "Bryant Square". Although I agree with you that it is not the greatest Marin it is the one we need above all others and I am glad at least that we will have first chance if it is ever put on the market. At a time when taxes are confiscatory and when contributions to war bonds and humanitarian causes are urgent and imperative, and with our Collection already so rich in Marin and even in his oils of the sea, it would be only for a Marin of a unique character especially needed that we would be justified in paying a big price. However as I told you in my last letter, the frame bothered me so much on Sea and Boat, No. 1, I really could not see the painting as it should be seen. In returning the other water colors and oils from our exhibition I am holding back Sea and Boat in order to try another frame on it. Meanwhile I will see the new Marin exhibition which might offer an alternative temptation. Of course you will agree that I am not committed to any new Marin. You will be glad to know we are buying the O'Keeffe "Leaves" for the special price of $2800.

Under separate cover we are sending you the catalog of our current exhibitions. I hope I am correct in attributing to your influence and the influence of an American Place the return of Marsden Hartley to Maine and the self reliance and power that came to him as a result in his last few years. There is a big "Off to the Banks at Night" in our show which is really magnificent[,] a fulfillment of what you first saw in him after many years of discouraging degressions and futile efforts.

Until we meet which may be very soon if we can manage it and if the new Marins are on view when we can go, our best to you as always,

Sincerely,

[Duncan Phillips]

TPC

STIEGLITZ TO PHILLIPS
*An American Place, New York, November 1, 1943*

My dear Mr. Phillips,

It was good to see you and Mrs. Phillips walk into the Place. You really could not see the Marins as they should be seen in the noon light, or the morning light, or any time before three o'clock on a clear day. Today there is an extraordinarily fine light and I wish you and Mrs. Phillips could walk into the Place now and see.—I am sure you would say that you hadn't seen the Marins yesterday. Even your glimpse for that is all it was—could give you but the vaguest idea of what is actually here.

Personally, I believe that the Marins as they are hanging on the walls of this Place are positively classics. There may not be a super-exciting individual picture, as in some of the Marins in past years. But I know most positively that taken as a whole Marin has reached his highest mark. So I hope that before they come down you will see them again in the proper light and in a fresh state of being. But the important thing was that you came and that Mrs. Phillips came. It delighted me that you should have discovered the Marin in the northeast room, and that you liked it as much as you did. As for the Marin you have and for which you think you might find an appropriate frame—a frame to your satisfaction—I leave that all to you. Of course I would like to have the thing off my mind as soon as possible. And I am hoping that the Marins in the loan collection you have there will soon be back here. I am always nervous when they are in transit.

I am more than glad that you should feel about Hartley as you do now. You suggest sending the Hartley you so much admire, for me to live with it for a while, so that I will have a chance to see what Hartley had evolved into. Of course I will be only too delighted to see the picture, but I cannot assume any risk. As you know, the risk will be all yours. You know how careful I am of all pictures that may be within the walls of An American Place, so under my protectorate.

I am glad you and Mrs. Phillips feel about the O'Keeffe as you do. Yes, that picture was painted for me. But when I realized what it might mean to you and Mrs. Phillips, I felt that I had not right to keep it buried here within these walls. For in spite of the feeling of supreme life here, I personally feel ever conscious of a tomb. My own and my babies, whatever their name. I don't want to wax sentimental. We are living in a realist's world. I hope America realizes that. I know I do. Does An American Place belong to the realist's world? That's not for me to say. When you said that Ryder would become a myth and added that I would also become a myth, I was quite startled but pleased. Nothing would suit me better than to become a myth based on the reality of truth. Big words I know but I'll let them go for what they may mean to you.

My thanks and cordial greetings to you and the lady and to your son and to all those who are helping you in your Memorial Gallery.

Sincerely,

Alfred Stieglitz

TPC

STIEGLITZ TO PHILLIPS
*An American Place, New York, April 12, 1944*

My dear Duncan Phillips,

I do hope that Mrs. Phillips will speedily recover and that you will not be laid low with a siege. I know that when you do come to New York and see the Doves, you will have a treat in store for you once more. The longer I live with them the more I am amazed at them, and the more grateful I am to you to have made it possible for the last fifteen years or more to give Dove the opportunity to work. It

Alfred Stieglitz, *The Terminal*, 1892, photogravure, private collection, Washington, D.C.

is amazing how little the significance of Dove is recognized—truly amazing. But I understand it. There has been no ballyhoo about Dove. As you know, I do not believe in ballyhoo when it comes to the question of art or religion or love—which three terms are really interchangeable, as far as I am concerned.

I read with pleasure the essay of yours on Marsden Hartley in the Magazine of Art, which was sent to me. It is a significant coincidence that both Hartley and O'Keeffe should appear in the same issue,—you on Hartley and Mr. Rich on O'Keeffe, and the significance of both in terms of audience covering thirty odd years. . . . One of the pictures of American that I could give the world. Will I ever write it? I doubt it.

I saw Hartley just before he left for Maine. He came to the Place to say good-by. And he said to me, "Stieglitz, I am finally established. I am relatively a rich man." I lay on the cot and listened. He sat on a chair in a corner opposite. Well-satisfied with himself and the world. And he said, "Stieglitz, the first thing I am going to do when I get to Maine is to write about you. You are the most difficult person I have ever met—difficult to give a picture of. We have known each other for 35 years. You are such a bundle of contradictions. But I think I now can get it into words." My impulse was to say, "Hartley, when you sit down and take a sheet of paper into your hand and a pen or pencil, as you are about to write the first word you will drop dead." I did not say what I had in mind, but told him the story about Weber & Fields in 1892, and what they meant to me as one of the saving graces in my life when I returned from Europe.

There was Weber & Fields, there were the car-horses that I photographed in the snow—a now internationally famous picture, a

pioneer—and there was Duse, whom I had never heard of. And I happened to be in the house by "accident" at the first performance, when there were no more than fifty people in the whole theatre. There was a performance of "Camille". I did not care for "Camille," but I had seen Sarah Bernhardt some years before, and as the big bill-poster before the theatre announced "Great Italian Actress" in Camille, I thought I would walk in, and I sat in the first row center. When a certain woman appeared and I saw that face and those hands, I was spellbound. I will not go into the story of myself and Duse. There is a story—a wonderful one.

So Hartley sitting here saying good-by. I said to him, "Hartley, you see the car-horses, Duse and Weber & Fields saved America for me over 50 years ago when I returned from Europe, and found myself a very lonely and unhappy man amongst my own people. The America which I had been led to believe existed as a boy, I suddenly found was merely a fairy-tale." But this again is a story which I won't go into now, to return to Hartley's good-by to me, I said, "Hartley, you know what I went through for nearly 30 years because of the denial of you. And so, too, when Max Weber was introduced at "291" in 1909 and was laughed at and how he, living at "291"— the only one who ever lived there—he, having been saved from the streets, penniless—and he saying, "Hartley is an impostor. His work should be thrown out of the window and he kicked downstairs." And Hartley said of Weber, "Yes, I respect his work. He is a Jewish Chinaman who Whistlerizes all the Moderns." And there I was merely interested in two human beings, both appearing almost simultaneously, and I having a little place with four bare walls—I trying to find out where I belonged in my own country with pictures as a means to the finding out. So I said, "Hartley, we may never see each other again." I had my own miserable heart in mind. I had no idea that Hartley would go first. And I said, "Hartley, 50 years ago or more there was Weber & Fields—a wonderful team, and now there is Weber & Hartley at Rosenberg's." And Hartley coyly said, "Oh, Stieglitz, must you always joke?" I said, "If I didn't have a sense of humor—knowing that the joke is on myself and noone else, I would no longer be amongst what is called the living, most of whom, in the name of this or that, are trying to kill each other." That was the last I saw of Hartley. It was the first summer since I knew him that I did not receive a letter from him. I have hundreds of his letters—all significant.

Marin and Hartley—what a difference! Two American phenomena.

My best wishes for the speedy recovery of your lady, my friend, and that you, also my friend, will escape a contagion.

Your friend,

Alfred Stieglitz

TPC

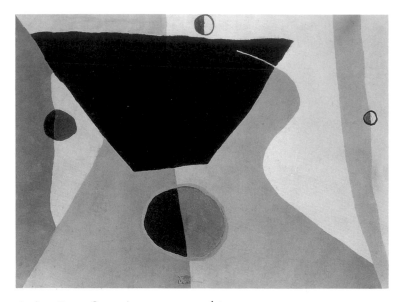

Arthur Dove, *R 25-A*, 1942, wax emulsion on canvas

## THE END OF AN ERA

*The following is the last letter Stieglitz wrote to Phillips before his collapse on July 10, 1946, and death three days later. O'Keeffe immediately flew back from Abiquiu, and she was at his bedside during the early-morning hours of his death. Dove, himself still ill from his collapse in 1945, had seen Stieglitz for the last time in May, when he visited An American Place during his exhibition. Marin was recuperating from a heart attack that spring.*

STIEGLITZ TO PHILLIPS
*An American Place, New York, July 3, 1946*

My dear Mr. Phillips:
The four Doves that you selected—two that are old ones and two new ones—have been sent to you express-collect, insured for $6,000. I am enclosing a statement which speaks for itself. It includes the bill of the two Doves as I understand it that is protected through 1946 and now also through 1947.

I must tell you once more how wonderful those hours are that you know I spend here. I am about at my wits end. The demands made upon me increase hourly, and I have not got the heart to say no when I know that I should do so in order to protect myself.

Of course Marin's condition worries me even though I know that they say he is "better". He will never again be as free as he has been. All I hope is that he will be able to paint his pictures instead of trying to paint his house. That was a rather foolish thing for him to try to do, but now-a-days with workmen mostly on strike, one is apt to become desperate and become one's own workman, and so over-

taxes one's strength. This is bad at any age. But when it comes to 60 and 70 and 80, it is downright stupid. Inexcusable. But you know all this so why write about it.

I wonder how the O'Keeffe show struck you. May be my memory is failing me, may be you have told me. I know my memory is not what it used to be. So pardon me for my lapse, and once again I must thank you for Marin and Dove for your kindness and appreciation. And also for your kindness to me.

My warmest greetings to the wife, to the boy, and yourself.
[Alfred Stieglitz]

P.S.: I hope Miss Bier will be able to decipher the statement. As I see it, Dove is protected through 1946 and there is another $500. due to him outside of the $200. a month, and $500. due to the Dorothy Norman Rent Fund in 1946.

Again my thanks and greetings.
TPC

*Just as Herbert Seligmann had done for Stieglitz at Room 303 in the twenties, Jerome Mellquist often visited An American Place and typed Stieglitz's letters for him. Aware of the frequency of correspondence between the two men, Mellquist informed Phillips of Stieglitz's collapse.*

JEROME MELLQUIST TO PHILLIPS
*[An American Place], New York, July 12, 1946*

My dear Mr. Phillips,
So often I have written you for Stieglitz that it scarcely seems possible not to be doing it again at his behest. But this time it is on my own, to tell you that our dear friend was taken to Doctor's Hospital just 48 hours ago (Wednesday noon) struck down with a paralytic blow. He has not recovered consciousness, I was just informed, upon calling a few minutes ago, that his condition "remains much the same".

This is also to tell you that the last letter I ever took to you for him was the one in acknowledgment of Marin's check, last Saturday. This was some hours after a heart-attack, but he was so insistent about getting it off to you that, to appease him, I took it down (though somebody else then wrote it out). I am now very glad that I did.

O'Keeffe flew back from New Mexico, arriving Thursday night by plane. The relatives have all been notified. I might add that the most stricken of all is the faithful Zoler, that obscure sentinel who has stood at the door all these years. Poor fellow, his temple seems to have fallen in.

We must not forget him, dear Mr. Phillips. His has been a self-effacing but an important part. Can we at least give a little thought to helping him? As you undoubtedly know, he is an absolutely first-rate man with pictures—he knows how to frame, his eye is infallible—and besides that, he is a rare human being. He would not have been Stieglitz' constant intimate had that not been the case. . . . But I fear for him now, and that is why I speak. . . . Please forgive me.

Thanks again for all that you and Mrs. Phillips have done to perpetuate one of our greatest American spiritual ventures—and for your many thoughts to the friend who now lies so helpless.

Most warmly,

Mellquist

TPC

---

*Dorothy Norman, who had been involved in the administrative affairs of An American Place since its inception in 1929, assembled a Stieglitz memorial book, asking his colleagues and friends for contributions. Marjorie and Duncan Phillips each wrote a tribute.*

---

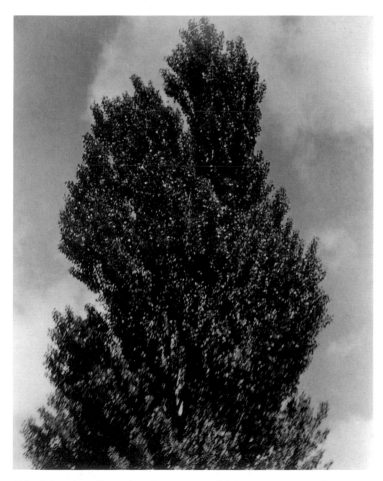

Alfred Stieglitz, *Equivalent* [Bry no. 224C], between 1924 and 1931, gelatin silver print

## PHILLIPS TO DOROTHY NORMAN
*Phillips Memorial Gallery, Washington, D.C., October 14, 1946*

Dear Mrs. Norman:

I have delayed so long in sending you the brief tribute to Alfred Stieglitz that I hope you have not expected too much from it. I found it very difficult to decide just what to include and just what to leave out. For example, I could have been reminiscent and added some Stieglitz stories but almost without exception they would have been connected with my personal or professional relations with him and therefore inappropriate. I have written this note very frankly and simply and if it is not what you want and you would prefer a letter I will do it over again. Mrs. Phillips will send you her contribution separately, she has been very busy with her painting.

We expect to be in New York for a few days around the 25th and when we get there we will call you up and try to arrange a meeting. We do want to talk with you not only about the special Stieglitz issue of *Twice a Year* but also about the future of An American Place, With warmest regards and best wishes,

Sincerely yours,

[Duncan Phillips]

TPC

## DUNCAN PHILLIPS, "TRIBUTE"
*In Dorothy Norman, ed.,* Stieglitz Memorial Portfolio, 1864–1946, *New York, 1947*

The passing of Alfred Stieglitz leaves an afterglow in which we remember him as we recall a long day of *challenging* experiences and of stimulating *affirmations*. Whatever he did was the inevitable result of what he believed. And what he believed was a force not only in his own life but in the story of art in America.

He challenged the misconception that a photograph must remain mechanical and he affirmed that by a camera's mechanism an artist can produce miracles of sensitized individual perception and interpretation while remaining true to the medium's sharpened focus and its concern with objective truth. His own creations—especially the clouds with moon—are proof of his claim.

Stieglitz believed that John Marin's water colors were the best ever painted. He priced them accordingly—refusing to wait for time to confirm his opinion. He denied that a water color is less important than an oil, also that the size of a work of art is a measure of its value.

He affirmed that a place is the habitation of a pervading spirit. A few bare rooms of an office building in midtown Manhattan could be vibrant with the personalities of great people of our own period—great painters whose works he could hang on the walls—whose lives he had liberated from commercial compromise by his constant support and selfless sponsorship. The power of works of

art to expand the lives of those who are made ready to enjoy them, this he proved every day and in so doing he affirmed the inviolable integrity and the human fellowship of art as an ideal.

I will miss Stieglitz poignantly at An American Place where I trust that somehow his work can be carried on. Even though he will never come out again from his little office to greet the old friend or the fellow worker or to fight the never-ending fight against the cynic or the Philistine—yet his challenging and affirming spirit and his crusading zeal cannot be forgotten nor forsaken. What he did for Marin will live on in the immortality of Marin. Such work is never finished. There is always the inspiration afforded for another conceivable collaboration of two artists who trust and supplement each other.

My wife and I could go to see the annual Marins, and O'Keeffes and Doves, and we knew that the exhibitions would be like no others anywhere since there, in the midst of the pictures, an ancient prophet with white hair and dark, burning, searching eyes would stand guard over the latest creations of his friends to defend them from deprecation as if to protect them from defilement. Magnetic, hypnotic, fanatic if you will, aggressive if necessary, Stieglitz was also and *essentially* mellow, serene and kind. I think that he knew we were allies in the same Cause; that we also had an 'experiment station' as well as an Intimate gallery where art can be at home. We became very fond of him and grateful for his appreciation of what we did which was manifested in many ways we will long remember. When we were together in his gallery there was little time for exchange of thoughts for we were all eyes and so was he and we understood and respected our separate purposes and functions. The challenging idealism and technical distinction of the grand old man, the selective and mystical magic of his camera, the tonic vitality of the paintings by the three artists of his choice, each a master of his particular instrument, made an ever deepening impression on us. We knew An American Place as a source of inspiration. Each visit brought fresh insight into Stieglitz as more than the great craftsman, more than the prophetic connoisseur who had been among the few to bring a new age of art to America and more than the champion of three outstanding painters whose genius he nurtured and sustained. We knew him as truly a challenging and affirming philosopher. In his shrewd but never insincere showmanship and salesmanship he symbolized a mission in which rarefied human relations are cultivated and cherished and the conservation and enjoyment of art are recognized as two of life's supreme privileges and passions.

*Dove was devastated by the death of Stieglitz, his closest friend and staunchest supporter since their first meeting in 1909. He wrote this letter of reminiscence and appreciation to Phillips late in the season, as if he sensed his own impending death on November 22. It is a fitting tribute to Phillips's long years of association with both Stieglitz and Dove.*

### DOVE TO DUNCAN AND MARJORIE PHILLIPS
### [Centerport, Long Island], late October 1946

Dear Duncan and Mrs. Phillips,

You have no idea what sending on those checks means to me at this time after fighting for an idea all your life I realized your backing has saved it for me and I want to thank you with all my heart and soul for what you have done. It has been marvelous. So many letters have been written and not mailed and owing to having been in bed a great deal of the time this summer, the paintings were about all I could muster up enough energy to do at what I considered the best of my ability.

Just before Stieglitz's death I took some paintings to him that I considered as having something new in them. He immediately walked right to them and spoke of the new ideas. His intuition in

Arthur Dove, *Silver Chief*, 1942, wax emulsion on canvas

that way was remarkable and I am so glad to have been allowed to live during his and your life times. It has really been a great privilege for which I am truly thankful. A short time ago I had to wire Ive to discontinue writing on the book entirely. She and her collaborator Jon Weeks seemed unconsciously to be trying to destroy the very essence of what I had found in nature in the motif choice—two or three colors and two or three forms. He compared that to Denman Ross and his color scales which was more like making a language out of a dictionary whereas the simple choice of a motif took the color range all the way to infinity and a child could have used it and they instinctively do. At the present I am up and working again and feel ever so much better. So I trust this letter will sound all right to you and Mrs. Phillips.

We both enjoyed that visit in Geneva, from Miss Bier and Miss McGloughlin and hoped it could happen again.

Thanking you with everything in us for all you have done. I am
Very truly yours
Arthur S. Dove
TPC

## DOVE TO ELMIRA BIER
*[Centerport, Long Island], late October 1946*

Dear Miss Bier
Thank you so much for sending on the checks for through October, I am very thankful for them.

Mr. Stieglitz's death about which you have written so finely was indeed a blow from which it will take us all a long time to recover. I can't help wondering how Miss O'Keeffe is surviving out there alone on her mountain top in New Mexico. Maybe she will stay right there.

Some where there are many letters to you unfinished as I have been in bed so much this summer.

We have been hoping for another visit from you and Miss McGloughlin, the one in Geneva was so very delightful.

Thank you again for your part in everything. It has been truly appreciated. Mrs. Dove sends her love to you both along with mine with pleasant memories as always.

Sincerely
Arthur S. Dove
TPC

## TELEGRAM FROM EDITH HALPERT, DIRECTOR, THE DOWNTOWN GALLERY, TO PHILLIPS
*November 23, 1946*

SORRY TO REPORT ARTHUR DOVE PASSED AWAY LAST NIGHT.
EDITH HALPERT
TPC

## MARIN TO DUNCAN AND MARJORIE PHILLIPS
*[Cape Split, Maine], November 8, 1946*

Dear Duncan and Marjorie
So you see I am still up here in Maine

So wonderful here so hard to get away (expect to leave Monday the eleventh getting home Wednesday)

Then of course we have had remarkable weather.

Well fourteen canvases have received their daubings and of course water colors. I would like to have a room one hundred feet long with canvases up there on the hundred foot wall. Pots of paint and brushes and go to it handling one subject matter throughout a stepping along from one canvas to the other with different versions & plannings.

Yes I miss dreadfully our Stieglitz—the yearly letters I wrote to him up at Lake George—Then too the bringing back and a showing to him the Seasons out put and as to how he looked at them how—he really responded—that even if I could never quite fathom nevertheless there was that Something he gave me that was for him to give alone—

As the—room is finantially taken care of for another year—I suppose that Ill have an exhibition maybe beginning some time in the latter part of this month—if so of course I'd let you know—but some how I dont much care—only for a few including yourselves—

Do you know a Doctor Helm up Boston way—has a little private gallery—was up here visiting a friend on the Cape for 3 weeks—is writing an extended article about me and my work with illustrations to be published either in the Life magazine or the Atlantic Monthly.

Also man from Boston Modern Gallery was up—Expects to open up I think in January a one man show of my pictures which were selected I think by O'Keeffe—he—and maybe Mrs. Halpert.

Howsome ever theres your very kind invitation to visit you—the which—I cherish and will make all effort to aceed to—and as you speak of—a visit to Cliffside would make one happy—of course if I do have an exhibition the labor connected with that will have to be taken care of—after which—I'll be at your warm disposal

John Jr. asked me to give to you both his greeting
Affectionately
John
TPC

---

*O'Keeffe began corresponding with Phillips after Stieglitz's death. This letter, the first that she wrote to the Phillipses, signals the change in their relationship.*

---

O'KEEFFE TO DUNCAN AND MARJORIE PHILLIPS
*59 E. 54 Street, New York, December 19, 1946*

Dear Mr. and Mrs. Phillips:

I want to thank you for your letters concerning Stieglitz last summer. They were kind when there is little one can say.

I am sending this with a letter I found from him to you. It was with two other letters that had not been mailed. It seems that I should mail it—it seems to finish something.

Sincerely

Georgia O'Keeffe

TPC

---

*O'Keeffe sought Phillips's advice as she planned the disposition of Stieglitz's collection. Phillips, as a member of the board of trustees, encouraged her idea to leave part of the estate, which included works by Dove, Hartley, Marin, O'Keeffe, and Stieglitz himself, to the National Gallery of Art; he believed Stieglitz and his circle belonged in a museum of national treasures. Phillips hoped in particular that Marin's* Storm over Taos, *which he had never convinced Stieglitz to sell, be given to the National Gallery.*

---

PHILLIPS TO O'KEEFFE
*Phillips Memorial Gallery, Washington, D.C., February 4, 1948*

Dear Miss O'Keeffe:

It was good to see you at An American Place and to have a little talk with you about the distribution of the treasures left by Stieglitz to different museums. I do hope you will donate, as you suggested you might, to the National Gallery in Washington a few outstanding examples of Stieglitz, O'Keeffe, Marin, Demuth, and Dove. Such a standard would be set for the proposed collection of contemporary American pictures by such a gift that I would make it my responsibility to keep subsequent purchases, out of the income of the fund they have been given, on a level not too far below such a beginning. There could not be a better start than a group of photographs by the greatest of photographers, three water colors by the greatest master of water colors, and selected works by you and Demuth and Dove and perhaps Hartley. That may be too much to hope for in consideration of the expectations of the other museums. But please do not leave Washington out of your plans. I hope for at least one great Marin, "Storm Over Taos". It seems that the fund for purchasing American pictures specifies that the works must be recent. The water colors from the current show will therefore be appropriate for my first recommendation. I will keep "Ausable Lake" for our own Collection and give the National Gallery Curator, Mr. Walker, his choice of the other three which I asked John Marin Jr.,

to send down, two of them on approval. The gift to the National Gallery of "Storm Over Taos" would be most gratefully received. With Marjorie's and my warmest regards,

Sincerely

[Duncan Phillips]

TPC

---

MARIN TO DUNCAN AND MARJORIE PHILLIPS
*[Cape Split, Maine], New York, February 21, 1948*

Dear Duncan and Marjorie,

Duncan your last letter tells me you were not feeling any too well—by this time—I hope—Your illness is a thing of the past.

I know it upsets one about the National Gallery, I fully give any—yes—to any thing you wish to do about it.

The purchase of a picture by them if you arrange it and the keeping of one for yourself if you so decide.

I had a talk with O'Keeffe—She tells me that nothing will be definitely decided by her until the Stieglitz estate is finally settled which she thinks will be (well just soon).

I feel though that she is considering (as soon as that is settled) sending three to the National and I hope she can be persuaded to include—Storm Over Taos—She is fully aware that you and I wish it sent

how robbed?

whose robbed?

well—a one—goes into the woods—the Hermit Thrush is singing—Ah says he—Come Hermit thrush quite good—but—*I* am going to teach you—*how* to sing—to sing wonderful—but he has made of hermit thrush Something that was not Hermit thrush

—"Poor Hermit thrush you have been robbed."

Enough of this

Your ancient Mariner

John

TPC

---

*From 1946 to 1949, O'Keeffe, with the help of Doris Bry, organized and planned the dispersal of Stieglitz's collection. In 1949, she announced that it was to be divided among seven institutions: the Metropolitan Museum of Art, the National Gallery of Art, the Art Institute of Chicago, the Philadelphia Museum of Art, the Boston Museum of Fine Arts, the San Francisco Museum of Modern Art, and Fisk University in Nashville, Tennessee. To acknowledge their friendship, O'Keeffe also gave Phillips nineteen of Stieglitz's cloud photographs, mostly "Equivalents," for his collection. Phillips, who had hoped for an exhibition of them since the thirties, was delighted.*

Dorothy Norman, *Alfred Stieglitz with Own Photograph and John Marin Painting Touching up Portrait of Dorothy Norman*, 1936, gelatin silver print, Philadelphia Museum of Art, from the Collection of Dorothy Norman

O'KEEFFE TO PHILLIPS
*An American Place, New York, July 16, 1949*

Dear Mr. Phillips:

Stieglitz often spoke of sending you some Equivalents, so I would like to send you a group that I think he would have liked me to send you, subject to the following conditions:

1. The photographs by Alfred Stieglitz received from me are to be known and designated as the Alfred Stieglitz Collection.

2. All photographs were mounted and matted by Stieglitz. They are to be left mounted and matted as received. They may be framed for hanging if desired. Otherwise they are to be placed as received in rag board handling mats similar to those used for fine etchings and engravings.

If you should consider it necessary to remount or remat the prints for the sake of their preservation, this may be done at your discretion. If it is necessary to remount or remat the prints, it is requested that it be done as nearly as possible to resemble the original presentation, with a rag mat of the same overall size as the original Stieglitz mat. The opening in the new mat is to be the same size and in the same position as the opening on the Stieglitz mat. It is to be placed on the print in the same position as in the original presentation. The exact placement could be made certain by making a pin prick at the corners of the print in the original mat opening, before the Stieglitz mat is removed.

Under no conditions may the dimensions of the mount or mat be changed.

3. It is understood that the Stieglitz prints are to be stored properly in an air-conditioned room, if possible, to minimize the chances of deterioration, that they will be kept in your Print Department, and stored, handled, and shown in the same manner as the fine etchings and engravings.

4. It is understood that all persons from outside the staff immediately in charge of the prints will be watched at all times while handling the prints.

5. No pen or ink may be used on the table while prints are on it.

6. The prints are to be kept in boxes of not more than two and one-half inches depth, inside measurement.

7. No one is to touch the print itself, or the paper on which it is mounted. This means that the prints may only be handled and examined by picking up the handling mat.

8. Prints may not be loaned at any time for any reason to any person or institution. [O'Keeffe did not include a point number 9.]

10. No copy prints or reproductions may be made from the Stieglitz prints except for the purposes of institutional publicity in current publications or publications of the Phillips Memorial Gallery.

11. Prints may not be sold or exchanged at any time for any reason.

12. The Phillips Memorial Gallery is to defray the cost of packing, shipping, and insurance.

If you have any suggestions or changes to make would you kindly let me know. I am ready to ship these prints when I hear from you.
    Sincerely yours,
    Georgia O'Keeffe
TPC

PHILLIPS TO O'KEEFFE, DRAFT
*July 30, 1949 [written on her July 16 letter]*

Dear Miss O'Keeffe.

I am honored and very, very happy to accept the group of photographs entitled Equivalents by Stieglitz. The fact that he wanted us to have them and that you are fulfilling his expressed intentions gives us a deeper appreciation of the gift as the bequest of a great friend and a great artist. The Equivalents, Moon clouds, graves etc., were our favorite prints. Be assured we accept the prints subject to the conditions listed in your letter—We will conform strictly to all the conditions—including the air conditioning which has recently been installed in our storage rooms. We will be ready to receive the prints whenever you send them, again thank you and with warmest regards always
    Sincerely,
    [Duncan Phillips]
TPC

Alfred Stieglitz, *Equivalent* [Bry no. 217A], between 1924 and 1931, gelatin silver prints. Included in the 1949 gift from his estate were two prints made from the same negative by Stieglitz, who considered them separate works of art.

O'KEEFFE TO DUNCAN AND MARJORIE PHILLIPS
*[An American Place], New York, August 11, 1949*

Dear Mr. and Mrs Duncan Phillips:
I have your letter dated July 30th stating that you would like to have the Stieglitz photographs and accepting them subject to our conditions.

I know that I should send them to you because Stieglitz so often spoke of intending to send them himself. I think they will feel very much at home with you.—Miss Bry, in New York, will get them off to you very soon.

Sincerely
Georgia O'Keeffe
TPC

# Kindred Spirits: A Chronology

Leigh Bullard Weisblat

## 1902

December 15: First quarterly issue of *Camera Work,* Stieglitz's influential journal of modernism and photography.

## 1905

November 24: Stieglitz and Edward Steichen, a friend and fellow photographer, open The Little Galleries of the Photo-Secession at 291 Fifth Avenue, New York, with Stieglitz as director; the gallery becomes known as 291. Stieglitz begins to exhibit nonphotographic work in 1907.

*"The Secession Idea is neither the servant nor the product of a medium. It is a spirit. Let us say it is the Spirit of the Lamp; the old and discolored, the too frequently despised, the too often disregarded lamp of honesty; honesty of aim, honesty of self-expression, honesty of revolt against the autocracy of convention."*
Statement by Stieglitz, *Camera Work* (April 1907)

## 1908

January 2: With classmates and teachers from the Art Students League, Georgia O'Keeffe visits 291 to see Stieglitz's exhibit of drawings by Auguste Rodin; it is their first meeting.

December 1: Stieglitz moves his gallery to 293 Fifth Avenue, but it continues to be called 291. Three of his closest allies in the support of 291 are Paul Haviland, Marius de Zayas, and Agnes Meyer.

## 1909

March 30–April 17: Stieglitz exhibits recent watercolors by John Marin, who was based in Paris, in a dual show with paintings by Alfred Maurer.

April: Marsden Hartley meets Stieglitz when he brings his Maine work to 291. Stieglitz immediately holds a solo exhibition of the artist's paintings.

Summer: Stieglitz travels with Steichen to Europe, where he meets Matisse and visits Leo and Gertrude Stein in their apartment in Paris. In June he meets Marin.

Autumn: Arthur Dove, recently returned from France, meets Stieglitz when he brings his work to 291.

## 1910

February 7: Marin's first one-person exhibition opens at 291. It is followed by a Matisse show that continues through March.

March 9–21: Dove debuts at 291 when Stieglitz includes him in *Younger American Painters* in the company of Hartley and Marin, among others.

## 1911

February 2–22: Marin's second solo exhibition at 291 includes his Tirolean scenes.

March 1–25: Stieglitz holds an exhibition of Paul Cézanne's watercolors, followed by a show of works by Pablo Picasso extended through April.

Summer: From June to October Hartley paints landscapes in North Lovell, Maine. Marin spends a month in the Berkshire Mountains, New York, and paints along the Hudson River and on Long Island. Dove, in Westport, Connecticut, since 1910, uses his rural surroundings as his "first research laboratory." All three artists produce work that reflects the European avant-garde currents they have recently seen at 291.

September–October: Stieglitz meets Rodin, Matisse, and Picasso in Paris. A special issue of *Camera Work* devoted to Matisse and Picasso appears the following summer.

## 1912

February 7–26: Hartley's second one-person exhibition highlights his new Maine work. In April Hartley arrives in Paris.

February 27: Dove's first solo exhibition opens at 291, and it includes his pastel abstractions, "The Ten Commandments."

Spring–Summer: Stieglitz reads Wassily Kandinsky's *Über das Geistige in der Kunst (Concerning the Spiritual in Art),* published in Munich in December 1911, and he includes an excerpt in the July issue of *Camera Work.*

Autumn: O'Keeffe becomes the teacher and art supervisor at public schools in Amarillo, Texas, where she remains for two years.

## 1913

January 3: After a brief stay in New York in November 1912, Hartley leaves Paris for Berlin; later that month he meets Kandinsky in Munich.

January 20–February 15: Marin's third one-person exhibition at 291 includes his recent New York images.

*"I try to express graphically what a great city is doing. Within the frames there must be a balance, a controlling of these warring, pushing, pulling forces."*
Catalogue statement by Marin, 1913

February 24–March 15: Stieglitz organizes the only solo exhibition at 291 of his own work, which he shows concurrently with the Armory Show.

Summer: Marin goes to Castorland, New York. He also works extensively on etchings of the Brooklyn Bridge, a series begun as early as 1911. O'Keeffe teaches summer school at the University of Virginia in Charlottesville, returning to Amarillo in the fall.

## 1914

January 12–February 12: Hartley, who had reluctantly sailed for New York in late 1913, has his third one-person exhibition at 291. He returns to Berlin by April 30.

March 12–April 1: Stieglitz exhibits sculpture by Constantin Brancusi at 291.

Summer: Marin discovers Maine when he travels to West Point, and its rocky terrain and coastline serve as his primary inspiration for the remainder of his career. Dove, who had moved to a farm near Westport (and would remain there until 1921), makes abstract drawings in charcoal in addition to pastel.

November 3–December 8: In commemoration of the tenth anniversary of the opening of 291, Stieglitz exhibits African sculpture, with pieces from the Ivory Coast, Nigeria, and the Congo that de Zayas brought from Paris. Immediately following is a show of drawings and collages by Picasso and Georges Braque that continues through January 11, 1915. O'Keeffe, now enrolled in Arthur Wesley Dow's class at Columbia Teachers College, visits the Picasso-Braque exhibition with Anita Pollitzer, a friend and fellow student. In anticipation of these exhibitions, Stieglitz and Steichen had renovated the exhibition space at 291.

## 1915

February 23–March 26: Marin's fourth one-person exhibition at 291 highlights his New York and Maine work; O'Keeffe and Pollitzer visit the show.

March: First issue of *291,* a short-lived journal, edited by de Zayas and financed by Stieglitz, Haviland, and Meyer. It continues monthly until February 1916.

Summer: Stieglitz, in Lake George, New York, resumes his "photographic experimenting" after many years of concentrating on his gallery work. In August O'Keeffe moves to Columbia College, South Carolina, to teach. In late fall, she creates the abstract charcoal drawings she entitles "Specials."

## 1916

January 1: Stieglitz sees O'Keeffe's "Specials" when Pollitzer brings them to 291.

Alfred Stieglitz, *The Street—Winter,* 1902, photogravure, private collection, Washington, D.C.

March 3–25: Dove's, Marin's, and Hartley's works are included in the *Forum Exhibition of Modern American Painters,* held at The Anderson Galleries, New York.

April 4–May 22: Hartley, who had returned to the United States on December 11, 1915, exhibits his "German Officer" series at 291. Given current anti-German sentiment, reviewers are harsh.

May 25–June 5: Stieglitz exhibits O'Keeffe's "Specials" alongside work by Charles Duncan and René Lafferty. O'Keeffe visits 291 to see the exhibition.

Summer: Stieglitz sends O'Keeffe photographs of the installation, and in August she sends him another package of drawings. They become friends and correspondents. In September she moves to Canyon, Texas, to teach at West Texas State Normal College.

*"The plains—the wonderful great big sky—makes me want to breathe so deep that I'll break—There is so much of it."*

O'Keeffe to Stieglitz, September 4, 1916

November 22–December 20: Stieglitz exhibits work by younger American artists. It is the first time O'Keeffe is shown with Hartley

John Marin, *Doorway, St. Mark's, Venice,* 1907, etching on paper

and Marin. Dove, whose artistic output is limited because of financial difficulties, is not included.

## 1917

January 22–February 7: A show at 291 of works Hartley had done in the summer of 1916 in Provincetown, Massachusetts, is followed by a show of Marin's Maine watercolors opening on February 14.

*"What a summer . . . in among those amazing dunes—shifting with the wind before one's eyes—burying young pine trees to their tops."*
<div align="right">Hartley, "Somehow a Past"</div>

April 3–May 14: O'Keeffe has her first solo exhibition, the last before 291 closes its doors. It includes charcoals, watercolors, and oils. O'Keeffe visits New York from May 25 to June 1, and it is during these ten days that Stieglitz photographs her for the first time.

June: Stieglitz devotes the final issue of *Camera Work* to Paul Strand. In July he closes 291. He keeps a small room on the top floor as an address and storage room for unsold issues of *Camera Work;* he stores his photographs and the work of his circle there as well.

## 1918

June 8: O'Keeffe returns to New York and lives in Elizabeth Davidson's studio at 114 East Fifty-ninth Street.

June 14: Hartley arrives in Taos, New Mexico. Aside from a brief trip to California, he remains in Taos and Santa Fe until November 1919.

July 8: Stieglitz leaves his wife and moves in with O'Keeffe; he begins his series "Georgia O'Keeffe: A Portrait."

August: O'Keeffe visits Stieglitz's summer home in Lake George for the first time. They begin a period of shared creativity: he continues to photograph her; she continues her experiments with color.

*"The day is one of great deep blue clarity. . . . O'Keeffe is a constant source of wonder to me—like Nature itself."*
<div align="right">Stieglitz to Dove, August 15, 1918</div>

Late fall: Phillips plans a memorial museum of art in honor of his father and brother, both of whom had passed away within thirteen months of each other. From 1919 to 1920 he sends his growing collection to other institutions in New York and Washington, D.C. On July 23, 1920, Phillips incorporates the museum as the Phillips Memorial Art Gallery. In late fall, 1921, he opens his permanent collection to the public. Phillips's first special exhibition opens in the main gallery on February 1, 1922.

## 1919

Summer: Marin first visits Stonington, Maine, on Penobscot Bay.

*"It seems that Old Man God when he made this part of the Earth just took a shovel full of islands and let them drop."*
<div align="right">Marin to Stieglitz, July 1, 1919</div>

## 1920

Summer: Stieglitz and O'Keeffe, now living in the farmhouse at Lake George, renovate a shanty on the property that becomes O'Keeffe's studio. It is the subject of the 1922 painting *My Shanty, Lake George.*

Fall: Marin purchases a home at 243 Clark Terrace, Cliffside, New Jersey, which will be his winter residence for the rest of his life. Stieglitz and O'Keeffe move to 60 East Sixty-fifth Street, New York, where they stay during the winters of the next four years.

## 1921

Winter–Spring: Stieglitz organizes exhibitions for his artists at other galleries in New York. On February 7 he opens a retrospective of his photographs at the Anderson Galleries, causing a sensation with his nudes of O'Keeffe. In April Stieglitz arranges and hangs an exhibition of Marin's recent watercolors at Daniel Gallery, New York. O'Keeffe writes to Dove of this installation and of her own work.

John Marin, *Brooklyn Bridge,* 1913, etching on paper

*"I've painted a little more about 12 × 16 I guess—on a canvas filled with white lead till it was really smooth—it was about like I imagine learning to roller skate would be."*

<div align="right">O'Keeffe to Dove, April 6, 1921</div>

May 17: An auction of 117 works by Hartley is held at the Anderson Galleries, raising enough capital for him to return to Paris by July.

Late summer: After an almost three-year hiatus, Dove begins to paint again. In the fall he separates from his wife and moves to a houseboat with Helen ("Reds") Torr. Dove earns a living as a commercial artist.

*"It is great to be at it again, feel more like a person than I have in years. Trying to develop an ego—purple or red. I don't know which yet."*

<div align="right">Dove to Stieglitz, August 1921</div>

## 1922

January 24–February 11: Stieglitz organizes a solo exhibition of Marin's work at Montross Gallery, New York. On the twenty-third he arranges the "Artists' Derby," an auction of two hundred works by forty American modernists, including Dove, Hartley, Marin, and O'Keeffe, at the Anderson Galleries.

February: First issue of *Manuscripts,* a short-lived journal published by Stieglitz, Paul Rosenberg, and Herbert Seligmann. Stieglitz devotes the December issue to responses to his query "Can a photograph have the significance of art?"

*"I'd rather have truth than beauty; I'd rather have a soul than a shape . . . I'd rather have today than yesterday; I'd rather have tomorrow than today; I'd rather have the impossible than the possible; I'd rather have the abstract than the real."*

<div align="right">Prose poem by Dove, *Manuscripts,* 1922</div>

Summer: O'Keeffe creates her first paintings of leaves at Lake George. Stieglitz begins work on his cloud photographs, titling his first series "Music—A Sequence of Ten Cloud Photographs."

November: Dove and Reds buy a yawl, *Mona,* on which they live for the next nine years, docking every winter (1924–33) at Halesite, Long Island, near Huntington Harbor.

## 1923

January 29–April 16: Stieglitz arranges back-to-back shows of O'Keeffe's and his own work at the Anderson Galleries.

Summer: Stieglitz begins producing his "Songs of the Sky" cloud series at Lake George. O'Keeffe paints closeups of leaves and flowers, including *Pattern of Leaves.*

September 19: Stieglitz publishes his article "How I Came to Photograph Clouds" in *The Amateur Photographer and Photography.*

## 1924

February 16–March 8: Stieglitz arranges a second exhibition at Montross Gallery for Marin.

March 3–16: At the Anderson Galleries Stieglitz arranges the first and only dual exhibition of his and O'Keeffe's work. The following month, he gives to the Boston Museum of Fine Arts twenty-seven prints that he had carefully printed, mounted, and assembled.

Summer: Marin paints the shore of Stonington, Maine, in *Grey Sea.* Dove, near Halesite, has his most productive year to date, beginning his assemblages. O'Keeffe continues to paint Lake George subjects, and Stieglitz begins his "Equivalents" series.

*"Your sky has been really quite wonderful here. It seems as though I could think into those clouds and you would get the thought."*

<div align="right">Dove to Stieglitz, August 15, 1924</div>

December 11: Stieglitz and O'Keeffe marry in Cliffside Park, New Jersey, with Marin as witness. Upon returning to New York, they move to an apartment at 35 East Fifty-eighth Street.

*"Georgia and I had a narrow escape. . . . Marin drove us. . . . The car skidded—smashed an iron electric lamppost—smashed the wheel to smithereens—bent things out of shape—we should have been killed or smashed up in some way—well we were neither. . . . There never was a funnier marriage."*

<div align="right">Stieglitz to Sherwood Anderson, December 18, 1924</div>

## 1925

March 9–28: In commemoration of the twentieth anniversary of the opening of 291, Stieglitz holds his *Seven Americans* exhibition at the Anderson Galleries. It includes Charles Demuth, Dove, Hartley, Marin, O'Keeffe, Strand, and his own work.

Summer: Marin, unable to travel to Maine, paints in the Berkshires, New York, creating *Back of Bear Mountain, Hudson River Near Bear Mountain,* and in Massachusetts *Near Great Barrington.*

November: Stieglitz and O'Keeffe move to Suite 3003 in the Shelton Hotel on Lexington Avenue, and she creates her first New York skyscraper paintings.

December 7: Stieglitz opens The Intimate Gallery in Room 303 of the Anderson Galleries building in New York, with an exhibition of Marin's work.

## 1926

January: Duncan Phillips visits Stieglitz at Room 303 to see the Dove exhibition (opened January 11). He purchases two paintings by the artist, *Golden Storm* and *Waterfall.*

February: Phillips purchases both *My Shanty, Lake George* and *Leaf Motif No. 1* by O'Keeffe. In March he returns *Leaf Motif No. 1* in exchange for *Pattern of Leaves* and purchases *Flame Colored Canna* (deaccessioned). He immediately includes his newly acquired O'Keeffes and Doves, in addition to the Hartley already in his collection, in a show entitled *Eleven Americans.*

Late February: O'Keeffe, invited by Anita Pollitzer to address the National Woman's Party Convention, travels to Washington, D.C., and visits with the Phillipses at the museum.

December: Rockwell Kent gives Phillips his second Hartley painting, *Mountain Lake, Autumn,* also of the early Maine period, thus rounding out his emerging units of works by the Stieglitz circle of painters.

December 3: Phillips, who had discovered Marin's work in March, purchasing both *Maine Islands* and *Grey Sea* through Stieglitz, visits Marin's second solo exhibition at Room 303 (opened November 9). After much discussion, he agrees to buy *Back of Bear Mountain* and *Hudson River Near Bear Mountain,* and accepts from Stieglitz *Sunset—Rockland County* (deaccessioned) as a gift to Marjorie Phillips. Stieglitz believes that he has sold one Marin watercolor for $6,000 and publicizes the event. Phillips wants the entire transaction to be confidential. The conflict is not resolved until Dove intervenes in December 1927.

Mid-December: Phillips publishes *A Collection in the Making,* his first book about his museum.

## 1927

January 11: O'Keeffe's second solo exhibition in Room 303 opens. Phillips, probably because of the conflict with Stieglitz, does not visit her show, despite Stieglitz's missives urging him to do so.

February 5–April (extended): Phillips includes Marin's watercolors in his Tri-Unit exhibition *Sensibility and Simplification,* calling them his "wall of Marin."

April 12–May 3: Phillips adds Dove and O'Keeffe to *An Exhibition of Expressionistic Painters from the Experiment Station of the Phillips Memorial Gallery,* held at the Baltimore Museum of Art.

November: Phillips purchases from Daniel Gallery Hartley's *Camellias* (deaccessioned). He immediately includes it, along with O'Keeffe's *Pattern of Leaves,* in *Intimate Decorations: Chiefly Paintings of Still Life in New Manners.*

Late December: Phillips and Stieglitz reconcile.

## 1928

January 7: Phillips finally visits Room 303 on the day Dove's solo exhibition closes and buys a collage, *Huntington Harbor I.* He also purchases another watercolor by Marin, *Mt. Chocorua—White Mountains,* which had been included in Marin's November 1927 show that Phillips had boycotted.

May 6: Stieglitz sells six calla lily paintings by O'Keeffe from her solo show for a record price of $25,000, generating great publicity.

Summer: Marin stops en route to Small Point, Maine, to see Hartley, who was visiting with the Strands after his recent return from his six-year sojourn in Europe.

November 14: Marin's solo show at The Intimate Gallery opens. Phillips visits, purchasing *Franconia Range, White Mountains.*

*"Your Marin exhibition did me so much good physically and mentally that I feel more than ever indebted to this great artist. . . . He blows through the art world of today like a bracing wind from the sea or the mountains, seeming to be himself an elemental Force."*

Phillips to Stieglitz, January 2, 1929

*The Phillips Memorial Gallery Building,* gelatin silver print, 1920s, The Phillips Collection, Washington, D.C.

## 1929

January 1–31: Hartley, who had returned to Paris in August 1928, has his first and only one-person exhibition at The Intimate Gallery, primarily showing work created while in the south of France. The show is not a success and comes under special criticism for being too "French." Phillips purchases a still life, *Pears and Grapes* (deaccessioned).

February 2: Marin's first museum solo exhibition opens at the Phillips Memorial Gallery, occasioning the artist's first meeting with Duncan and Marjorie Phillips in April.

April 9–28: Phillips visits Dove's second solo exhibition at The Intimate Gallery.

April 27: O'Keeffe leaves for New Mexico with Rebecca Strand and stays with Mabel Dodge Luhan for four months. (For O'Keeffe this was the beginning of a nearly annual trip that culminated in her move to the Southwest in 1949 after Stieglitz's death and the settling of the estate.)

June: Stieglitz closes The Intimate Gallery.

Late August: O'Keeffe returns to Lake George. Both she and Stieglitz show off their accomplishments: O'Keeffe learned how to drive and Stieglitz to fly.

October–February 9, 1930: Phillips gives Marin his second solo exhibition at the Phillips Memorial Gallery, with all of the pieces drawn from the collection.

December: Stieglitz, with help from supporter Dorothy Norman and fellow photographer Paul Strand, both of whom had found financial backers, opens An American Place, at 509 Madison Avenue, New York. The gallery is austere and cool: its white walls and ceiling and the high-gloss gray on the cement floor were chosen by O'Keeffe. The first show, of Marin's recent watercolors, begins a series of nearly annual shows there for Marin, Dove, and O'Keeffe extending to the gallery's closing in 1950. By contrast, Hartley shows only three times in this new space. Included in the Marin show are both *Fishing Smack* and *Ship Fantasy,* which Phillips requests on approval. (He ultimately purchased them in 1930 and 1931, respectively.)

## 1930

February 3: O'Keeffe's solo exhibition at An American Place opens, and Phillips purchases *Ranchos Church.*

March 22: Dove's one-person show at An American Place opens, and Phillips, unable to visit, has five works sent to him on approval. He purchases *Coal Carrier* and *Snow Thaw;* he also begins to give Dove a monthly stipend of fifty dollars and wants to have first choice of work from Dove's annual exhibition. Phillips plans a small room devoted to Dove's work to appear near his Marin exhibition intended for the fall (opened April 1931). Matisse is planning a visit to Phillips, and the collector wants to impress him with the originality of Dove and Marin.

April 25: Stieglitz opens a group retrospective of Demuth, Dove, Hartley, Marin, and O'Keeffe at An American Place, his first since *Seven Americans* in 1925.

Summer: O'Keeffe returns to New Mexico, accompanied by Marin; it is his first visit.

October 5: Phillips opens two exhibitions at the Phillips Memorial Gallery: *Twelve Americans,* in which he includes Dove and O'Keeffe, and *Marin, Dove, and Others,* his first show of the group, excluding Hartley.

November: Marin's solo exhibition at An American Place highlights work of New York and New Mexico. Phillips, who visits the show twice, purchases *New Mexico, Blue Mountains* (deaccessioned) and *Street Crossing, New York.*

December 15: Hartley's first one-person exhibition at An American Place opens; it includes work he had brought with him when he returned from Europe in March, along with his more recent New Hampshire landscapes.

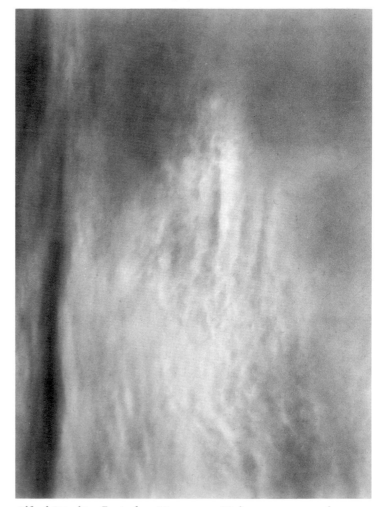

Alfred Stieglitz, *Equivalent* [Bry no. 217C], between 1924 and 1931, gelatin silver print

## 1931

February 2–April 5: Phillips includes both Dove and Hartley in his show *Twentieth Century Lyricism.*

March 9–April 4: Phillips purchases *Sand Barge* from Dove's solo exhibition at An American Place, and Stieglitz gives him *Drawing for Sand Barge.*

*"If there were half a dozen like yourself, some truly creative men in this country might eke out an existence at least."*

Stieglitz to Phillips, May 11, 1931

April 5–June: Phillips gives Marin his third museum solo exhibition; drawn from the permanent collection, it contains nearly every aspect of his work from the twenties.

April: O'Keeffe visits New Mexico. In July she returns to Lake George but discovers that Stieglitz is visiting Dorothy Norman at her summer home in Woods Hole, Cape Cod.

June: Hartley travels to Gloucester, Maine, and first visits an area called Dogtown.

September 27: Phillips's exhibition *Calligraphy in Modern Occidental Art* opens, and it includes two watercolors by Marin.

October 11: Marin's solo show at An American Place opens, but Phillips is unable to visit. He is working on a compilation of essays to be published later that year entitled *The Artist Sees Differently.*

Late fall: An American Place publishes Marin's letters to Stieglitz. The book is edited by Herbert Seligmann, a writer and fellow member of Stieglitz's coterie. Phillips orders a copy for his library.

## 1932

February–March: In New York, Stieglitz holds the first retrospective since 1924 of his own photography, dating from 1892 to 1932. In Washington, Phillips exhibits Dove's recent work alongside Picasso and Braque in a show called *American and European Abstractions.* On March 14, Dove's solo exhibition at An American Place opens.

March: Hartley travels to Mexico City and Cuernavaca on a Guggenheim fellowship. (In April of 1933 he leaves Veracruz for Europe, traveling there through January 1934.)

May: O'Keeffe accepts a mural commission from the Radio City Music Hall, despite Stieglitz's objections.

Spring: Norman starts the Dorothy Norman Rent Fund, in which supporters of An American Place as well as the artists themselves give money for the gallery's operating costs.

November–December: Encountering difficulties, O'Keeffe abandons the mural project and has a nervous breakdown; she does not paint for more than a year. Marin's solo exhibition at An American Place includes his recent oils. They are not well received.

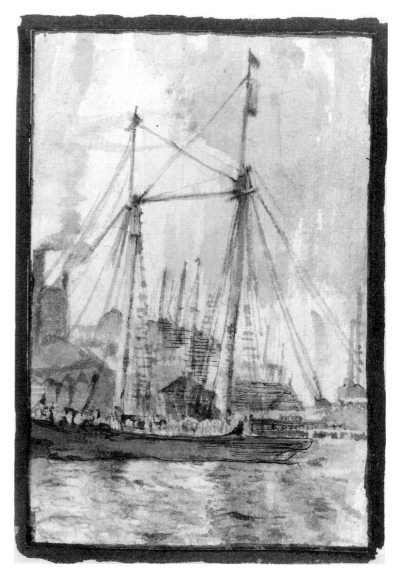

John Marin, *Harbor Scene,* 1905, watercolor and ink on paper

*"I am afraid that in the crazed desire to be modern—to have ideas to be original—to belong to the tribe intellijencia, we have gotten away from the paint job which is a lusty thing."*

Marin to Stieglitz, July 20, 1931

## 1933

January: Phillips sends emergency funds to Dove and purchases his *Red Barge,* which had been loaned by Stieglitz to the Whitney Museum of American Art's *First Biennial Exhibition of Contemporary American Painting* (opened November 22, 1932).

March 29–April 15: Stieglitz holds a dual show at An American Place of work by Dove and his wife Reds Torr, the only one they share. Phillips purchases Dove's *Sun Drawing Water* and *Bessie of New York.*

March: Stieglitz empties his storage space at the Lincoln warehouse, and 418 prints by other photographers that he had acquired between 1894 and 1911 are given to the Metropolitan Museum of Art.

March: O'Keeffe travels to Bermuda to recuperate from her breakdown. In May she returns to Lake George, where she remains for the rest of the year.

*"I seem to have nothing to say. It appalls me but that is the way it is—so I dont work. . . . You have caught something of your own country [in your work] but I would wish that you could look at it only with your own eye—quite forgetting that you ever saw a painting. . . . Try to paint your world as tho you are the first man looking at it—the wind and the heat—and the cold—the dust—and the vast starlit night."*

O'Keeffe to Russell Vernon Hunter, October 21, 1933

July: Dove goes to Geneva, New York, to settle the family estate following his mother's death and, finding problems, endures another period of hardship. Marin discovers Cape Split, Maine, where he spends his summers for the remainder of his life.

October–November: Stieglitz holds a retrospective of Marin's watercolors (1908–32), followed by the opening on December 20 of Marin's recent work. Phillips visits both exhibitions. Desiring the oil *Pertaining to Fifth Avenue and Forty-Second Street,* Phillips suggests returning *Street Crossing, New York* in partial payment. Stieglitz refuses the trade.

## 1934

January–March: Phillips urges Dove to work in the Public Works Art Project, of which he was regional chairman in Washington, D.C. Stieglitz disapproves. Dove refuses the offer.

Mid-February: Hartley arrives in New York and does not leave the United States again; he immediately signs up to work in the easel division of the Public Works Art Project, further driving a wedge between him and Stieglitz, who disapproves of both the government program and Hartley's many years abroad.

February 5–March 15: O'Keeffe has a retrospective at An American Place, which Phillips visits.

April 17: Dove's one-person exhibition at An American Place opens. Phillips is unable to attend but has many works sent to him, and he purchases *Tree Trunks, The Train, Hound* (deaccessioned), and the oil and watercolor versions of *Barn Next Door* (oil deaccessioned). Phillips also increases Dove's stipend to seventy-five dollars per month. O'Keeffe purchases six watercolors from Dove's show.

June-September: O'Keeffe returns to New Mexico, her first visit in three years, and stays at Ghost Ranch, sixteen miles northwest of Abiquiu.

Late July: Hartley returns to Gloucester, Maine, and begins work on his second "Dogtown" series. He also creates *Sea View, New England.*

November–December: Marin's annual solo show is held at An American Place. The catalogue excerpts Phillips's article on Marin first published in the 1930 issue of his journal *Art and Understanding*.

December: Stieglitz holds another retrospective of his own work, which includes sixty-nine prints dating from 1884 to 1934. That season, in celebration of his seventieth birthday, Paul Rosenfeld, Waldo Frank, and Norman publish *America and Alfred Stieglitz: A Collective Portrait,* a book of contributions gathered from his friends and associates.

## 1935

January 4: Hartley, unable to afford storage fees, destroys one hundred paintings and drawings, moving the remainder to a single vault.

*"With stiletto in hand I did quiet murder for four hard days."*

Hartley to Norma Berger, January 14, 1935

April 21–May 22: Dove's one-person exhibition at An American Place is well received; included is a series of the Geneva landscape based on sun and moon motifs, as in *Red Sun* and *Morning Sun.* Phillips visits, purchasing not only these two paintings but also *Electric Peach Orchard* and *Fantasy* (given to Katherine Dreier, the Société Anonyme, in 1949).

October 27: Marin's one-person show at An American Place opens, and *Quoddy Head* is included among the twelve watercolors of Cape Split, Maine.

November: Hartley moves to Eastern Points, a small island off the Maine coast, to live with the Francis Mason family, with whom he has become extremely close.

## 1936

January 7: O'Keeffe's solo exhibition at An American Place opens, and her catalogue includes a foreword by Hartley that Stieglitz had commissioned.

March 22–April 14: Stieglitz holds a one-person exhibition of Hartley's recent work, his first at An American Place since 1930.

April 25: Phillips and Dove meet for the first and only time at An American Place during Dove's solo show. Phillips purchases *Cows in Pasture* and *Tree Forms II.*

September 19: The two sons of Francis Mason drown. Hartley begins to paint memorial images in a Ryderesque style for the remainder of his career—works such as *Off to the Banks, Off the Banks at Night,* and *Wild Roses.*

*The sea is wild and black and black*
*a devil curse is in the dark*
*of the wind,*
*nothing has the strength to be kind*
*the vague would give much of*
*its very breath*

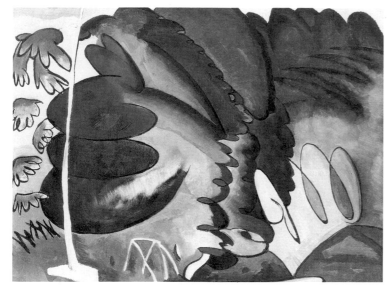

Arthur Dove, *The Park,* 1927, oil on cardboard

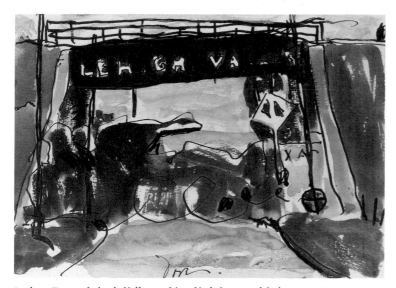

Arthur Dove, *Lehigh Valley—New York Line and Lake,* 1935,
watercolor and black ink on paper

> to be free of the clutch of death
> even if it go blind.
>
> Poem by Hartley, *Sea Burial* (1941)

October: O'Keeffe and Stieglitz move to a penthouse apartment at 405
East Fifty-fourth Street, New York.

October 21–November 22: A Marin retrospective, featuring works
selected by Stieglitz, is held at the Museum of Modern Art.

November 27: Stieglitz opens another group exhibition of his circle and
includes Hartley.

December: Phillips purchases a small work on paper by Marin, *Modern
Gleaners* (deaccessioned), to add to the watercolor-and-ink *Harbor
Scene* he had purchased in June.

## 1937

January 5–February 3: Marin's solo exhibition is shown at An American
Place. In February a portion of Marin's retrospective at the Museum of
Modern Art travels to the Studio House at the Phillips Memorial Gal-
lery. Phillips purchases from it two works he has coveted, *Quoddy Head*
and *Pertaining to Fifth Avenue and Forty-Second Street,* in addition to two
early Marin etchings, *Brooklyn Bridge* and *Doorway, St. Mark's, Venice.*
Phillips also asks Stieglitz for an exhibition of his photographs. The
show never takes place.

March 23–April 18: Phillips mounts Dove's first retrospective. It runs
concurrently with Dove's solo show at An American Place and consists
of fifty-seven works, mostly borrowed from Stieglitz. Phillips purchases
*Reminiscence, The Moon Was Laughing at Me,* and *Car* (deaccessioned),
in addition to eight watercolors (two deaccessioned). Phillips attempts
to purchase early pastels by Dove, but Stieglitz refuses. Phillips buys
instead the early assemblage *Goin' Fishin',* which he had previously
admired.

April 20: Hartley's last exhibition at An American Place opens.

October 27: Stieglitz's large group show *Beginnings and Landmarks,
'291,' 1905–1917* opens, and it includes the work of his circle and his
own photographs. In winter Stieglitz stops photographing altogether.

## 1938

March 29: Dove's solo show at An American Place opens, and Phillips
purchases *Flour Mill II* and both the wax emulsion and watercolor of
*Shorefront,* as well as *Building Moving Past a Sky* (deaccessioned).
Included in the catalogue is an essay by Phillips.

April 10–May 1: Phillips organizes *Picasso and Marin,* borrowing many
works from Stieglitz. Phillips purchases *Heavy Sea* (deaccessioned) from
this exhibition.

June: Dove moves to an abandoned shorefront post office in Center-
port, Long Island, following his first bout with pneumonia, complicated
by Bright's disease, a kidney disorder. He remains a semi-invalid for the
remainder of his life.

## 1939

March 6: Hartley's solo exhibition at the Hudson Walker Gallery, New
York, opens. (Walker discovered Hartley at his 1937 solo exhibition at
An American Place, and from 1938 to 1940 held three spring shows of
Hartley's recent work.) Phillips rediscovers Hartley's work at this 1939
exhibition and buys both *Off to the Banks* and *Sea View, New England.*

April 10: Dove's solo exhibition at An American Place opens. Phillips
purchases from Stieglitz's personal collection *Me and the Moon.*

October 15–November 21: Stieglitz's retrospective of Marin's work
from 1908 to 1937, *Beyond all Isms,* appears. Coincident with this show
is a retrospective of Marin's New York paintings held at Daniel Gallery.

November 15–December 3: Phillips holds a group show of contemporary Americans that includes outside loans; he purchases from it Hartley's *Gardener's Gloves and Shears.*

## 1940

March 30–May 14: Dove's solo show at An American Place is a great success. Phillips buys several watercolors, as well as *Green Ball; Red, White,* and *Green; Yellow Bush* (deaccessioned); and *Willows* (given to the Museum of Modern Art in 1942).

Summer: O'Keeffe purchases the adobe house at Ghost Ranch.

*"I wish you could see what I see out the window—the earth pink and yellow cliffs to the north—the full pale moon about to go down in an early morning lavendar sky behind a very long beautiful tree covered mesa to the west—pink and purple hills in front and scrubby fine dull green cedars—and a feeling of much space."*

O'Keeffe to Dove, September 1942

December 11: Marin's one-person exhibition at An American Place opens, and Phillips purchases another oil, *The Sea, Cape Split, Maine.*

## 1941

January 30: From O'Keeffe's solo exhibition at An American Place, Phillips purchases his second Western example and the only late work, *From the White Place,* which depicts an area near Abiquiu that O'Keeffe often painted.

February 16: Phillips's exhibition *The Functions of Color* opens; he includes numerous works by Dove and Marin.

March 27–May 12: Phillips purchases from Dove's solo exhibition at An American Place *Pozzuoli Red; Yellow, Blue-Green, and Brown;* and *Frosty Moon* (deaccessioned). Stieglitz attends Marjorie Phillips's exhibition at Bignou Gallery, New York.

Spring: After closing his gallery in late 1940, Hudson Walker purchases twenty-three of Hartley's paintings. Hartley joins MacBeth Gallery, New York.

October 17–November 27: Stieglitz holds a group exhibition of his circle, excluding Hartley; he adds to the show his own photography as well as three works on paper by Picasso.

## 1942

Spring: Phillips purchases through Macbeth Gallery another painting by Hartley, *Wood Lot, Maine Woods.*

March 15–April 15: Phillips's special loan show, *Cross Section Number One of a Series of Specially Invited Americans,* includes the Stieglitz circle. He buys a 1933 watercolor by Marin, *Four-Master off the Cape,* from this show.

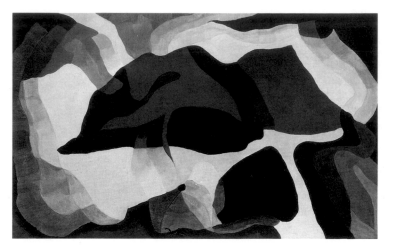

Arthur Dove, *Pozzuoli Red,* 1941, wax emulsion on canvas

April 14: Dove's solo exhibition at An American Place opens, and Phillips purchases *1941.* In appreciation for his continued patronage, Dove gives him *Silver Chief.*

October: Stieglitz and O'Keeffe move to a smaller apartment at 59 East Fifty-fourth Street, New York, because it is closer to Stieglitz's gallery.

November 17: Marin's solo exhibition at An American Place opens. Phillips purchases the 1933 oil *Bryant Square,* which is not in the exhibition.

## 1943

February: Hartley's solo show opens at the Rosenberg Gallery, New York. Phillips, now closely following his career, purchases *Wild Roses.* Dove's annual show at An American Place opens on the eleventh, and Phillips purchases three works, *Rain or Snow, Indian One,* and *Flight.*

March 20: O'Keeffe's solo exhibition at An American Place opens, following her first retrospective, held at The Art Institute of Chicago. Phillips focuses on her early work, purchasing *Large Dark Red Leaves on White.*

April 4–30: Phillips holds another one-person exhibition for Dove, featuring his recent work.

August 1–September 30: Phillips holds a Marin retrospective, with many paintings borrowed from Stieglitz. He wants to purchase from it *Storm Over Taos,* which is in Stieglitz's personal collection, but he is refused.

September 2: Hartley dies of heart failure in Ellsworth, Maine.

October 24–November 23: Phillips organizes a memorial exhibition for Hartley, purchasing from it *Off the Banks at Night.*

## 1944

March 21–May 21: Phillips visits Dove's exhibition at An American Place twice and chooses works to be sent to Washington. He increases his stipend to Dove to two hundred dollars per month.

April 9: *The American Paintings of The Phillips Collection* opens. Consisting of 195 works, it includes many pieces by Dove, Hartley, Marin, and O'Keeffe.

June 25–November 5: Phillips holds another solo exhibition of Dove's recent works, and he purchases from it *Primitive Music* and *Rose and Locust Stump.*

September–October: The Philadelphia Museum of Art holds *History of an American: Alfred Stieglitz, '291' and After: Selections from the Stieglitz Collection,* organized by Carl Zigrosser, Henry Clifford, and O'Keeffe.

## 1945

January 22: O'Keeffe's annual exhibition opens at An American Place. Phillips purchases an early work, *Red Hills, Lake George.*

May 3: Dove's solo show at An American Place opens, and Phillips purchases *Red, Olive and Yellow* and *Green Light* (deaccessioned).

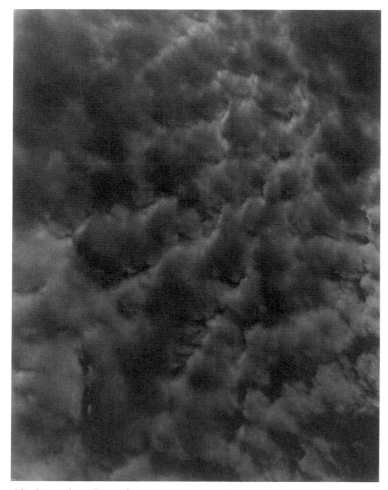

Alfred Stieglitz, *Equivalent* [Bry no. 167A], 1929, gelatin silver print

Summer: O'Keeffe buys an abandoned building on three acres in Abiquiu, New Mexico, and spends the next three years remodeling it. It becomes her primary residence until her death on March 6, 1986.

November 30: Marin's exhibition opens at An American Place, and it includes *Blue Sea* and *Tunk Mountains, Autumn, Maine,* both of which Phillips purchases. Phillips also acquires at this time the 1922 *Camden Across the Bay* (given to the Watkins Gallery, American University, Washington, D.C., in 1952).

*"Two days ago it was a brilliant day—all was washed clear. . . . Everything sparkles when the skys are lovely—blue skys with hanging clouds— and its then I'll play truant and get out and wander to those lovable spots I have discovered not so far away where the Earth has a sweet smell."*

Marin to Phillips, June 11, 1945

## 1946

April 7–30: A retrospective of Marin's New York drawings (1930–46) is shown at An American Place.

May 4–June 4: Dove's final one-person exhibition appears at An American Place. Phillips purchases *Young Old Master, R 25-A, Runway,* and *U.S. 1940* (latter two deaccessioned).

July 10: Stieglitz has a massive stroke and is hospitalized; O'Keeffe flies back to New York and is with him when he dies on July 13. Both Marin and Dove are themselves ailing—Marin had suffered a heart attack earlier in the spring, and Dove was now virtually an invalid.

Fall: O'Keeffe, with Doris Bry's help, begins to catalogue and plan the dispersal of Stieglitz's estate. She paints very little for the next three years.

November 22: Dove dies in Centerport, Long Island, of heart failure.

## 1947

March 2–April 15: A retrospective of Marin's work, organized by the Institute of Modern Art, Boston, comes to The Phillips Gallery. It is followed by a memorial retrospective of fifty-nine works by Dove, many drawn from Phillips's collection, that runs through September. From the Downtown Gallery, New York, which is handling Dove's estate, Phillips purchases *Lake Afternoon, The Park,* and three watercolors (two deaccessioned).

June 10–August 31: The Museum of Modern Art holds a dual exhibition of Stieglitz's art collection and his photographs, which O'Keeffe helped to organize. It travels to the Art Institute of Chicago.

December 8: After Marin and O'Keeffe renew the lease for An American Place, Marin's solo show opens. Phillips purchases from it *Adirondacks at Lower Ausable Lake* and *From Flint Isle, Maine #1* (given to the Corcoran Gallery of Art, Washington, D.C., in 1957).

Arthur Dove, *Young Old Master*, 1946, oil on canvas

## 1949

Spring: Phillips holds two Marin exhibitions, in February showing his recent work and in April presenting a miniretrospective and loan exhibition of his watercolors.

Summer: O'Keeffe announces that Stieglitz's collection, including his own photographs, is to be divided among seven institutions, with the bulk, including more than sixty watercolors by Marin, going to the Metropolitan Museum of Art, and the key set of photographs by Stieglitz to the National Gallery of Art. To Phillips she gives a special set of nineteen cloud photographs, two of which are not part of the key set. He exhibits them at The Phillips Gallery in November.

## 1950

March 20–May 6: Marin's last exhibition at An American Place consists of his oil work only, including his earliest experiments, the "Weehawken Cliff Sequence." (In 1967 John Marin, Jr., gave Phillips an example from this series, *Weehawken Sequence, No. 30.*)

September: Edith Halpert of the Downtown Gallery holds her first Marin exhibition, and the thirty-eight original works are published in a Twin Editions Portfolio, two copies of which Phillips adds to his library.

October 16–November 25: O'Keeffe has her last show at An American Place, and then she and Marin close the gallery. Halpert becomes her dealer.

## 1952

January 6–28: Phillips holds an exhibition of Marin's watercolors from his collection at the same time that Marin has a solo show at the Downtown Gallery.

## 1953

May 4–July 14: Phillips gathers works by Dove from his collection for an exhibition to be held at the Corcoran Gallery.

October 1: Marin dies at Cape Split, Maine, and is buried in Cliffside, New Jersey.

December 13: Phillips opens a small memorial retrospective of Marin's work. He also purchases the late oil *Spring No. 1.*

## 1955

May 15–June 30: A memorial retrospective of Marin organized by the Boston Museum of Fine Arts, which includes numerous works borrowed from Phillips, comes to The Phillips Collection.

# Bibliographic Notes

This chronology relies on many groundbreaking studies on the Stieglitz circle. For Dove, see Ann Lee Morgan, *Arthur Dove: Life and Work, with a Catalogue Raisonné* (Newark, 1984), and Morgan, ed., *Dear Stieglitz, Dear Dove* (Newark, 1988). For Hartley, see Barbara Haskell, *Marsden Hartley* (New York, 1980), Townsend Ludington, *Marsden Hartley: The Biography of an American Artist* (Boston, 1992), and Gail R. Scott, ed., *The Collected Poems of Marsden Hartley, 1904–1943* (Santa Rosa, Calif., 1987). For Marin, see Ruth Fine, *John Marin* (Washington, D.C., 1990). For O'Keeffe, see Jack Cowart, Sarah Greenough, and Juan Hamilton, *Georgia O'Keeffe: Art and Letters* (Washington, D.C., 1987), *Two Lives: Georgia O'Keeffe and Alfred Stieglitz, A Conversation in Paintings and Photographs,* essays by Belinda Rathbone, Roger Shattuck, and Elizabeth Hutton Turner (New York and Washington, D.C., 1992), and Roxana Robinson, *Georgia O'Keeffe* (New York, 1989). For Stieglitz, see William Innes Homer, *Alfred Stieglitz and the American Avant-Garde* (Boston, 1977), Sarah Greenough and Juan Hamilton, *Alfred Stieglitz: Photographs and Writings* (Washington, D.C., 1983), and Sue Davidson Lowe, *Stieglitz: A Memoir Biography* (New York, 1983). Also invaluable are the papers of these artists at the Yale Collection of American Literature, Beinecke Rare Book and Manuscript Library, Yale University, New Haven, Connecticut (YCAL).

# Sources for Quotations

Statement by Stieglitz in *Camera Work,* no. 18 (April 1907), 37.

Catalogue statement by Marin, reprinted in *Camera Work,* no. 42–43 (April/July 1913), 18.

O'Keeffe to Stieglitz, September 4, 1916, YCAL, quoted in *Georgia O'Keeffe: Art and Letters,* 155.

Hartley, "Somehow a Past," YCAL, quoted in *Marsden Hartley: The Biography of an American Artist,* 133.

Stieglitz to Dove, August 15, 1918, YCAL, quoted in *Dear Stieglitz, Dear Dove,* 62.

Marin to Stieglitz, July 1, 1919, YCAL.

O'Keeffe to Dove, April 6, 1921, YCAL.

Dove to Stieglitz, August 1921, YCAL, quoted in *Dear Stieglitz, Dear Dove,* 75.

Prose poem by Dove in *Manuscripts,* no. 4 (Dec. 1922).

Dove to Stieglitz, August 15, 1924, YCAL, quoted in *Dear Stieglitz, Dear Dove,* 106.

Stieglitz to Sherwood Anderson, December 18, 1924, YCAL.

Phillips to Stieglitz, January 2, 1929, The Phillips Collection Archives (TPC).

Stieglitz to Phillips, May 11, 1931, TPC.

Marin to Stieglitz, July 20, 1931, YCAL.

O'Keeffe to Russell Vernon Hunter, October 21, 1933, quoted in *Georgia O'Keeffe: Art and Letters,* 213–14.

Hartley to Norma Berger, January 14, 1935, YCAL.

Poem by Hartley in *Sea Burial* (1941), quoted in *The Collected Poems of Marsden Hartley, 1904–1943,* 293.

O'Keeffe to Dove, September 1942, YCAL, quoted in *Georgia O'Keeffe: Art and Letters,* 233.

Marin to Phillips, June 11, 1945, TPC.

# Exhibition Checklist

## 1900–1919

John Marin, *Harbor Scene,* 1905
Watercolor and ink on paper, 8⅜ × 6½ (21.3 × 16.5)
Purchased in 1936
Acc. no. 1286

John Marin, *Doorway, St. Mark's, Venice,* 1907
Etching on paper, image: 9 × 6⅝ (22.8 × 16.8)
Purchased in 1937
Acc. no. 1281

Marsden Hartley, *After Snow,* ca. 1908
Oil on academy board, 12 × 12 (30.5 × 30.5)
Purchased from Daniel Gallery, New York, by 1921 (possibly 1914)
Acc. no. 0887

Marsden Hartley, *Mountain Lake—Autumn,* ca. 1910
Oil on academy board, 11⅞ × 11⅞ (30.1 × 30.1)
Gift of Rockwell Kent, 1926
Acc. no. 0889

John Marin, *Black River Valley,* 1913
Watercolor and graphite pencil on paper, 15½ × 18¾ (39.3 × 47.6)
Purchased from Daniel Gallery, New York, 1926
Acc. no. 1277

John Marin, *Brooklyn Bridge,* 1913
Etching on paper, image: 10 × 8 (25.4 × 20.3)
Purchased in 1937
Acc. no. 1279

John Marin, *Weehawken Sequence, No. 30,* ca. 1916
Oil on canvas board, sight: 11¾ × 9 (29.8 × 22.8)
Gift of John Marin, Jr., in memory of Duncan Phillips, 1967
Acc. no. 1298

## 1920–24

John Marin, *Maine Islands,* 1922
Watercolor and charcoal on paper, 16⅞ × 20⅛ (42.8 × 51.1)
Purchased from the artist through Stieglitz, The Intimate Gallery, New York, 1926
Acc. no. 1288

Georgia O'Keeffe, *My Shanty, Lake George,* 1922
Oil on canvas, 20 × 27⅛ (50.9 × 68.8)
Purchased from the artist through Stieglitz, The Intimate Gallery, New York, 1926.
Acc. no. 1448

Georgia O'Keeffe, *Pattern of Leaves,* ca. 1923
Oil on canvas, 22⅛ × 18⅛ (56.2 × 46.0)
Purchased from the artist through Stieglitz, The Intimate Gallery, New York, 1926.
Acc. no. 1447

Alfred Stieglitz, *Songs of the Sky* [Bry no. 159E], 1923
Gelatin silver print, 4½ × 3⅝ (11.5 × 9.2)
The Alfred Stieglitz Collection, gift of Georgia O'Keeffe, 1949
Acc. no. 1833

John Marin, *Grey Sea,* 1924
Watercolor and black chalk on paper, 16½ × 20¼ (41.9 × 51.5) irregular
Purchased from the artist through Stieglitz, The Intimate Gallery, New York, 1926
Acc. no. 1285

Alfred Stieglitz, *Songs of the Sky* [Bry no. 155B], 1924
Gelatin silver print, 3¾ × 4⅝ (9.5 × 11.8)
The Alfred Stieglitz Collection, gift of Georgia O'Keeffe, 1949
Acc. no. 1834

## 1925

Arthur Dove, *Goin' Fishin',* 1925
Assemblage of bamboo, denim shirtsleeves, buttons, wood, and oil on wood panel, 21¼ × 25½ (54.0 × 65.4)
Purchased from Stieglitz's private collection in 1937
Acc. no. 0552

Arthur Dove, *Golden Storm,* 1925
Oil on plywood panel, 18⅝ × 20½ (47.2 × 52.1)
Purchased from the artist through Stieglitz, The Intimate Gallery, New York, 1926
Acc. no. 0553

Arthur Dove, *Waterfall,* 1925
Oil on hardboard, 10 × 8 (25.5 × 20.3)
Purchased from the artist through Stieglitz, The Intimate Gallery,
New York, 1926
Acc. no. 0586

John Marin, *Back of Bear Mountain,* 1925
Watercolor and charcoal on paper, 17 × 20 (43.2 × 50.8)
Purchased from the artist through Stieglitz, The Intimate Gallery,
New York, 1926
Acc. no. 1276

John Marin, *Hudson River Near Bear Mountain,* 1925
Watercolor and black chalk on paper, 13 × 16 (32.9 × 40.5)
Purchased from the artist through Stieglitz, The Intimate Gallery,
New York, 1926
Acc. no. 1287

John Marin, *Near Great Barrington,* 1925
Watercolor and pencils on paper, 15⅛ × 18⅞ (38.4 × 47.9)
Purchased from the artist through Stieglitz, The Intimate Gallery,
New York, 1926
Acc. no. 1290

Georgia O'Keeffe, *Large Dark Red Leaves on White,* 1925
Oil on canvas, 32 × 21 (81.2 × 53.3)
Purchased from the artist through Stieglitz, An American Place,
New York, 1943
Acc. no. 1446

Alfred Stieglitz, *Equivalent* [Bry no. 220A], 1925
Gelatin silver print, 4¾ × 3⅝ (12.1 × 9.2)
The Alfred Stieglitz Collection, gift of Georgia O'Keeffe, 1949
Acc. no. 1835

Alfred Stieglitz, *Equivalent* [Bry no. 171E], 1925
Gelatin silver print, 4¾ × 3⅝ (12.1 × 9.2)
The Alfred Stieglitz Collection, gift of Georgia O'Keeffe, 1949
Acc. no. 1836

## 1926

Arthur Dove, *Huntington Harbor I,* 1926
Collage on metal panel, 12 × 9½ (30.4 × 24.1)
Purchased from the artist through Stieglitz, The Intimate Gallery,
New York, 1928
Acc. no. 0555

John Marin, *Mt. Chocorua—White Mountains,* 1926
Watercolor and graphite pencil on paper, 16¾ × 21½ (42.5 × 54.6)
Purchased from the artist through Stieglitz, The Intimate Gallery,
New York, 1928
Acc. no. 1289

Alfred Stieglitz, *Equivalent* [Bry no. 177E], 1926
Gelatin silver print, 4¾ × 3¾ (12.1 × 9.5)
The Alfred Stieglitz Collection, gift of Georgia O'Keeffe, 1949
Acc. no. 1837

Alfred Stieglitz, *Equivalent* [Bry no. 175A], 1926
Gelatin silver print, 4⅝ × 3⅝ (11.7 × 9.2)
The Alfred Stieglitz Collection, gift of Georgia O'Keeffe, 1949
Acc. no. 1838

Alfred Stieglitz, *Equivalent* [Bry no. 228A], 1926
Gelatin silver print, 3⅝ × 4¾ (9.5 × 12.1)
The Alfred Stieglitz Collection, gift of Georgia O'Keeffe, 1949
Acc. no. 1839

## 1927

Arthur Dove, *The Park,* 1927
Oil on cardboard, 16 × 21 (40.6 × 53.3)
Bequest of Elmira Bier, 1976
Acc. no. 0562

John Marin, *Franconia Range, White Mountains, No. 1,* 1927
Watercolor, graphite pencil, and black chalk on paper, 13¾ × 18⅛
(34.9 × 46.0)
Purchased from the artist through Stieglitz, The Intimate Gallery,
New York, 1928
Acc. no. 1284

Georgia O'Keeffe, *Red Hills, Lake George,* 1927
Oil on canvas, 27 × 32 (68.7 × 81.4)
Purchased from Stieglitz, An American Place, New York, 1945
Acc. no. 1450

Alfred Stieglitz, *Equivalent* [Bry no. 141D], 1927
Gelatin silver print, 3⅝ × 4⅝ (9.2 × 11.7)
The Alfred Stieglitz Collection, gift of Georgia O'Keeffe, 1949
Acc. no. 1840

## 1928

John Marin, *Fishing Smack,* 1928
Watercolor, pencils, and black chalk on paper, 14¼ × 18
(36.1 × 45.7)
Purchased from the artist through Stieglitz, An American Place,
New York, 1930
Acc. no. 1282

John Marin, *Ship Fantasy,* 1928
Watercolor on paper, 22⅛ × 16½ (56.2 × 41.9)
Purchased from the artist through Stieglitz, An American Place,
New York, 1931
Acc. no. 1294

John Marin, *Street Crossing, New York,* 1928
Watercolor, graphite pencil, and black chalk on paper, 26¼ × 21¾
(66.7 × 55.2)
Purchased from the artist through Stieglitz, An American Place,
New York, 1931
Acc. no. 1296

## 1929–30

Arthur Dove, *Coal Carrier,* 1929 or 1930
Oil on canvas, 20 × 26 (50.8 × 66)
Purchased from the artist through Stieglitz, An American Place,
New York, 1930
Acc. no. 0547

Georgia O'Keeffe, *Ranchos Church,* 1929
Oil on canvas, 24⅛ × 36⅛ (61.3 × 91.7)
Purchased from the artist through Stieglitz, An American Place,
New York, 1930
Acc. no. 1449

Alfred Stieglitz, *Equivalent* [Bry no. 167A], 1929
Gelatin silver print, 4⅝ × 3⅝ (11.7 × 9.2)
The Alfred Stieglitz Collection, gift of Georgia O'Keeffe, 1949
Acc. no. 1841

Alfred Stieglitz, *Equivalent* [Bry no. 226B], 1929
Gelatin silver print, 4¾ × 3¾ (12.1 × 9.5)
The Alfred Stieglitz Collection, gift of Georgia O'Keeffe, 1949
Acc. no. 1842

Alfred Stieglitz, *Equivalent* [Bry no. 216E], 1929
Gelatin silver print, 4⅝ × 3⅝ (11.7 × 9.2)
The Alfred Stieglitz Collection, gift of Georgia O'Keeffe, 1949
Acc. no. 1843

Arthur Dove, *Sand Barge,* 1930
Oil on cardboard, 30⅛ × 40¼ (76.5 × 102.3)
Purchased from the artist through Stieglitz, An American Place,
New York, 1931
Acc. no. 0575

Arthur Dove, *Snow Thaw,* 1930
Oil on canvas, 18 × 24 (45.7 × 60.9)
Purchased from the artist through Stieglitz, An American Place,
New York, 1930
Acc. no. 0581

Alfred Stieglitz, *Equivalent* [Bry no. 153B], 1930
Gelatin silver print, 4⅝ × 3⅝ (11.7 × 9.2)
The Alfred Stieglitz Collection, gift of Georgia O'Keeffe, 1949
Acc. no. 1844

Alfred Stieglitz, *Equivalent* [Bry no. 175B], 1930
Gelatin silver print, 4⅜ × 3⅜ (11.1 × 8.6)
The Alfred Stieglitz Collection, gift of Georgia O'Keeffe, 1949
Acc. no. 1845

## 1931–33

Alfred Stieglitz, *Equivalent* [Bry no. 149C], 1931
Gelatin silver print, 4⅝ × 3⅝ (11.7 × 9.2)
The Alfred Stieglitz Collection, gift of Georgia O'Keeffe, 1949
Acc. no. 1846

Alfred Stieglitz, *Equivalent* [Bry no. 224C], between 1924 and 1931
Gelatin silver print, 4¾ × 3⅝ (12.1 × 9.2)
The Alfred Stieglitz Collection, gift of Georgia O'Keeffe, 1949
Acc. no. 1847

Alfred Stieglitz, *Equivalent* [Bry no. 217B], between 1924 and 1931
Gelatin silver print, 4⅝ × 3⅝ (11.7 × 9.2)
The Alfred Stieglitz Collection, gift of Georgia O'Keeffe, 1949
Acc. no. 1848

Alfred Stieglitz, *Equivalent* [Bry no. 217C], between 1924 and 1931
Gelatin silver print, 4⅝ × 3½ (11.7 × 8.9)
The Alfred Stieglitz Collection, gift of Georgia O'Keeffe, 1949
Acc. no. 1849

Alfred Stieglitz, *Equivalent* [Bry no. 217A], between 1924 and 1931
Gelatin silver print, 4⅝ × 3⅝ (11.7 × 9.2)
The Alfred Stieglitz Collection, gift of Georgia O'Keeffe, 1949
Acc. no. 1850

Alfred Stieglitz, *Equivalent* [Bry no. 217A], between 1924 and 1931
Gelatin silver print, 4⅝ × 3⅝ (11.7 × 9.2)
The Alfred Stieglitz Collection, gift of Georgia O'Keeffe, 1949
Acc. no. 1851

John Marin, *Bryant Square,* 1932
Oil on canvas, 21⅝ × 26⅝ (54.9 × 67.6)
Purchased from the artist through Stieglitz, An American Place,
New York, 1942
Acc. no. 1280

Arthur Dove, *Sun Drawing Water,* 1933
Oil on canvas, 24⅜ × 33⅝ (61.9 × 85.5)
Purchased from the artist through Stieglitz, An American Place,
New York, 1933
Acc. no. 0582

John Marin, *Four-Master off the Cape, Maine Coast, No. 1,* 1933
Watercolor and black chalk on paper, 15½ × 21⅞ (39.4 × 55.54)
Purchased from the artist through Stieglitz, An American Place,
New York, 1942
Acc. no. 1283

John Marin, *Pertaining to Fifth Avenue and Forty-Second
Street,* 1933
Oil on canvas, 28 × 36 (71.1 × 91.4)
Purchased from the artist through Stieglitz, An American Place,
New York, 1937
Acc. no. 1291

John Marin, *Quoddy Head, Maine Coast,* 1933
Watercolor and black chalk on paper, 15½ × 22 (39.4 × 55.8)
Purchased from the artist through Stieglitz, An American Place,
New York, 1937
Acc. no 1292

## 1934

Arthur Dove, *Barn Next Door,* 1934
Watercolor and black ink on paper, 5 × 7 (12.7 × 17.7)
Purchased from the artist through Stieglitz, An American Place,
New York, 1934
Acc. no. 0545

Arthur Dove, *Tree Trunks,* 1934
Oil on canvas, 18 × 24 (45.7 × 60.9)
Purchased from the artist through Stieglitz, An American Place,
New York, 1934
Acc. no. 0585

Marsden Hartley, *Sea View—New England,* 1934
Oil on academy board, 12 × 16 (30.4 × 40.6)
Purchased from the artist through Hudson Walker Gallery,
New York, 1939
Acc. no. 0892

## 1935

Arthur Dove, *Barn IV,* 1935
Watercolor and black ink on paper, 4⅞ × 6⅞ (12.3 × 17.4)
Purchased from the artist through Stieglitz, An American Place,
New York, 1937
Acc. no. 0544

Arthur Dove, *Cows in Pasture,* 1935
Wax emulsion on canvas, 20 × 28 (50.8 × 71.1)
Purchased from the artist through Stieglitz, An American Place,
New York, 1936
Acc. no. 0548

Arthur Dove, *Electric Peach Orchard,* 1935
Wax emulsion on canvas, 20¼ × 28 (51.3 × 71.2)
Purchased from the artist through Stieglitz, An American Place,
New York, 1935
Acc. no. 0549

Arthur Dove, *Lake Afternoon,* 1935
Wax emulsion on canvas, 25 × 35 (63.5 × 88.9)
Purchased from Downtown Gallery,
New York, 1947
Acc. no. 0557

Arthur Dove, *Lehigh Valley—New York Line and Lake,* 1935
Watercolor and black ink on paper, 4⅞ × 6⅞ (12.3 × 17.4)
Purchased from the artist through Stieglitz, An American Place,
New York, 1937
Acc. no. 0558

Arthur Dove, *Morning Sun,* 1935
Oil on canvas, 20 × 28 (50.8 × 71.1)
Purchased from the artist through Stieglitz, An American Place,
New York, 1935
Acc. no. 0560

Arthur Dove, *Over Seneca Lake,* 1935
Watercolor and pencils on paper, 5 × 7 (12.7 × 17.7)
Purchased from the artist through Stieglitz, An American Place,
New York, probably 1937
Acc. no. 0561

Arthur Dove, *Red Sun,* 1935
Oil on canvas, 20¼ × 28 (51.4 × 71.1)
Purchased from the artist through Stieglitz, An American Place,
New York, 1935
Acc. no. 0569

## 1936–37

Marsden Hartley, *Off to the Banks,* between 1936 and 1938
Oil on canvas board, 11¾ × 15⅞ (29.8 × 40.3)
Purchased from the artist through Hudson Walker Gallery,
New York, 1939
Acc. no. 0891

Arthur Dove, *Me and the Moon,* 1937
Graphite pencil on paper, 7 × 10 (17.9 × 25.5)
Gift of William E. O'Reilly in memory of Leland Bell and
Lawrence Gowing, 1991
Acc. no. 1991.13.1

Arthur Dove, *Me and the Moon,* 1937
Wax emulsion on canvas, 18 × 26 (45.7 × 66)
Purchased from Stieglitz's personal collection in 1939
Acc. no. 0559

Arthur Dove, *The Moon Was Laughing at Me,* 1937
Wax emulsion on canvas, 6¼ × 8¼ (15.9 × 21.0)
Bequest of Elmira Bier, 1976
Acc. no. 1992.13.1

Arthur Dove, *Phelps, New York,* 1937
Watercolor and black ink on paper, 5⅛ × 7⅛ (13.0 × 18.1)
Purchased from the artist through Stieglitz, An American Place,
New York, 1937
Acc. no. 0563

Arthur Dove, *Reminiscence,* 1937
Wax emulsion on canvas, 14½ × 20½ (36.8 × 52.0)
Purchased from the artist through Stieglitz, An American Place,
New York, 1937
Acc. no. 0573

Marsden Hartley, *Gardener's Gloves and Shears,* ca. 1937
Oil on canvas board, 15⅞ × 20 (40.3 × 50.8)
Purchased from the artist through Hudson Walker Gallery,
New York, 1939
Acc. no. 0888

Marsden Hartley, *Gardener's Gloves and Shears,* ca. 1937
Oil on canvas board, 15⅞ × 20 (40.3 × 50.8)
Purchased from the artist through Hudson Walker Gallery, New
York, 1939
Acc. no. 0888

## 1938

Arthur Dove, *Barns and Haystack,* 1938
Watercolor and black ink on paper, 5⅛ × 7 (13.0 × 17.7)
Purchased from the artist through Stieglitz, An American Place,
New York, 1938
Acc. no. 0546

Arthur Dove, *Flour Mill II,* 1938
Wax emulsion on canvas, 26⅛ × 16⅛ (66.3 × 41.0)
Purchased from the artist through Stieglitz, An American Place,
New York, 1938
Acc. no. 0551

Arthur Dove, *Shore Front,* 1938
Wax emulsion on canvas, 22 × 36 (55.8 × 91.4)
Purchased from the artist through Stieglitz, An American Place,
New York, 1938
Acc. no. 0578

## 1939–41

Marsden Hartley, *Wood Lot, Maine Woods,* 1939
Oil on academy board, 28⅛ × 22 (71.4 × 55.8)
Purchased from the artist through Macbeth Gallery,
New York, 1942
Acc. no. 0894

Arthur Dove, *Red, White, and Green,* 1940
Wax emulsion on canvas, 15 × 21⅛ (38.1 × 53.6)
Purchased from the artist through Stieglitz, An American Place,
New York, 1940
Acc. no. 0571

Georgia O'Keeffe, *From the White Place,* 1940
Oil on canvas, 30 × 24 (76.2 × 61.0)
Purchased from the artist through Stieglitz, An American Place,
New York, 1941
Acc. no. 1445

Arthur Dove, *Pozzuoli Red,* 1941
Wax emulsion on canvas, 22⅛ × 36 (56.2 × 91.4)
Purchased from the artist through Stieglitz, An American Place,
New York, 1941
Acc. no. 0564

## 1942–43

Arthur Dove, *R 25-A,* 1942
Wax emulsion on canvas, 15 × 21 (38.1 × 53.3)
Purchased from the artist through Stieglitz, An American Place,
New York, 1946
Acc. no. 0566

Arthur Dove, *Silver Chief,* 1942
Wax emulsion on canvas, 21 × 15 (53.3 × 38.1)
Gift of the artist, 1942
Acc. no. 0580

Marsden Hartley, *Off the Banks at Night,* 1942
Oil on hardboard, 30 × 40 (76.2 × 101.6)
Purchased from Rosenberg Gallery
New York, 1943
Acc. no. 0890

Marsden Hartley, *Wild Roses,* 1942
Oil on hardboard, 22 × 28 (55.8 × 71.1)
Purchased from the artist through Rosenberg Gallery
New York, 1943
Acc. no. 0893

Arthur Dove, *Flight,* 1943
Wax emulsion on canvas, 12 × 20 (30.4 × 50.8)
Bequest of Elmira Bier, 1976
Acc. no. 0550

Arthur Dove, *Rain or Snow,* 1943
Wax emulsion and metallic leaf on canvas, 35 × 25 (88.9 × 63.5)
Purchased from the artist through Stieglitz, An American Place,
New York, 1943
Acc. no. 0567

## 1944–53

John Marin, *Tunk Mountains, Autumn, Maine,* 1945
Oil on canvas, 25 × 30 ( 63.5 × 76.3)
Purchased from the artist through Stieglitz, An American Place,
New York, 1946
Acc. no. 1297

Arthur Dove, *Young Old Master,* 1946
Oil on canvas, 10 × 11 (25.4 × 27.9)
Purchased from the artist through Stieglitz, An American Place,
New York, 1946
Acc. no. 0590

John Marin, *Adirondacks at Lower Ausable Lake,* 1947
Watercolor and graphite pencil on paper, 14⅝ × 20⅛ (37.1 × 51.1)
Purchased from the artist through An American Place,
New York, 1948
Acc. no. 1275

John Marin, *Self-Portrait,* late 1940s or early 1950s
Graphite pencil on paper, 9⅜ × 6⅞ (23.8 × 17.5)
Gift of Marjorie Phillips, 1985
Acc. no. 1985.3.10

John Marin, *Spring No. 1,* 1953
Oil on canvas, 22 × 28 (55.88 × 71.1)
Purchased from the artist through Downtown Gallery,
New York, 1954
Acc. no. 1295